John Singer Sargent and His Muse

John Singer Sargent and His Muse

Painting Love and Loss

Karen Corsano and Daniel Williman

Foreword by Richard Ormond

ROWMAN & LITTLEFIELD
Lanham • Boulder • New York • London

Published by Rowman & Littlefield
A wholly owned subsidiary of The Rowman & Littlefield Publishing Group, Inc.
4501 Forbes Boulevard, Suite 200, Lanham, Maryland 20706
www.rowman.com

16 Carlisle Street, London W1D 3 BT, United Kingdom

British Library Cataloguing in Publication Information Available

Library of Congress Cataloging-in-Publication Data
Corsano, Karen, author.
 John Singer Sargent and his muse : painting love and loss / Karen Corsano and
Daniel Williman ; foreword by Richard Ormond.
 pages cm
 Includes bibliographical references and index.
 ISBN 978-1-4422-3050-7 (cloth : alk. paper) — ISBN 978-1-4422-3051-4 (electronic)
1. Sargent, John Singer, 1856–1925. 2. Painters—United States—Biography.
3. André-Michel, Rose-Marie, 1893–1918. 4. Artists' models—United States—
Biography. I. Williman, Daniel, author. II. Ormond, Richard, writer of supplementary
textual content. III. Title.
 ND237.S3C67 2014
 759.13—dc23
 [B]
 2014006348

∞™ The paper used in this publication meets the minimum requirements of
American National Standard for Information Sciences—Permanence of Paper
for Printed Library Materials, ANSI/NISO Z39.48-1992.

Printed in the United States of America

~

Contents

Foreword by Richard Ormond ix

Preface xiii

Acknowledgments xvii

List of Illustrations xix

Select Family Trees xxiii

Chapter 1 The Painter and the Critic: John Sargent and
André Michel 1

John Sargent, an Artist in Paris 1
André Michel, a Journalist in Paris 4
The Salon 10
Enter Violet Sargent, in a Punt 19
The Players and the Boston Public Library 23
André Michel and the History of Art 26

Chapter 2 The Ormonds and the Sargents 31

The Ormonds of Vevey, Paris, and Sanremo 31
The Eventful Childhood of Francis Ormond 35
Violet Sargent, Ready to Marry 39
Sargents and Ormonds, *Cuique Suum* 45

Chapter 3	Rose-Marie Ormond	51
	Sargent's Alpine Idyll	53
	Rose-Marie and Robert André-Michel	66
Chapter 4	Robert André-Michel	79
	Scholar and Sergeant	80
	Robert Michel, Archiviste Paléographe	83
	Ecole Française de Rome and Archivio Segreto Vaticano	86
	Archives Nationales de France	89
	The Sons-in-Law of André Michel	90
	Abel Gendarme de Bévotte	92
	Robert Married, Juliette Engaged	94
Chapter 5	Robert's War, 1914	101
	Abel's Three-Day War	101
	Sergeant Robert Michel, 169th RI	102
	The 55th Division of Infantry, Reserve	107
	Soissons on the Aisne	109
	Sergeant and Scholar in Soissons	112
	Lessons of Experience	116
	Robert to the Front Line	118
	13 October 1914	122
Chapter 6	Rose-Marie's War, 1914–1918	127
	Sargent in Exile in Austria	127
	Robert's World in Mourning	130
	Les Villes Martyres de France	133
	Madame Robert André-Michel, Widow	136
	Reuilly	139
	Rose-Marie's Refuge in Music	155
	Saint Gervais	160
Chapter 7	The Paris Gun	163
	A Triumph of German Engineering	163
	Good Friday 1918	166
	Mourning for Rose-Marie	171
Chapter 8	Sargent's War, 1914–1919	179
	War in the Tyrol, August–November 1914	179
	The World at War, Sargent at Work, 1915–1917	184

The War Comes to Sargent in America,
 Winter 1917–1918 189
Painting the War, July–October 1918 194

Chapter 9 The End of *The Triumph of Religion* 207

Images and Inspirations 208
Renan's *Life of Jesus* 209
The Installations of 1895, 1903, 1916 213
Synagogue and *Church*, 1919 220
Liberated from Theology 229

Chapter 10 Epilogues 233

Saint Gervais Rebuilds and Remembers 233
André Michel at Montmorency, 12 October 1925 234
Marguerite Ormond at La Tour-de-Peilz,
 11 February 1925 236
John S. Sargent in Brookwood Cemetery, Woking,
 15 April 1925 238
The Tomb of the Spouses at Crouy 239

Notes 241

Bibliography 277

Index of Persons and Places 285

Index of Sargent's Works 303

About the Authors 305

~

Foreword

The story of Rose-Marie Ormond and Robert André-Michel, both victims of the Great War, is a moving and tragic one. The young couple—he the brilliant medieval scholar, she the beautiful model for her uncle, the painter John Singer Sargent—were deeply in love and touchingly idealistic. They had everything to live for, but just a year after their marriage Robert was summoned to war. He fell defending French positions in the hills above Soissons in October 1914. After his death, the heartbroken Rose-Marie took up war work, serving as a nurse to blinded soldiers at the Hospital in Reuilly, before she, too, became a casualty of the war.

Both Robert and Rose-Marie came from privileged backgrounds and distinguished families. Robert's father André Michel was a prominent art historian and art critic, whose writings were widely admired. His son was brought up in an intellectual atmosphere, graduating with honors from the prestigious Ecole des Chartes, a college devoted to the study of early manuscripts and charters. Robert's brilliant research on the medieval Palace of the Popes in Avignon enabled him to read the building and its works of art through the documents. His collected papers on the Palace remain a standard source.

Rose-Marie was the daughter of Swiss and American parents. Her father Francis Ormond was the son of a Swiss tobacco tycoon, Michel Louis Ormond, and of his French house-building, art-collecting mother, Marie Marguerite, born Renet. Rose-Marie's mother Violet, born Sargent, was the daughter of expatriate American parents, who, in the words of one Sargent biographer, "forgot to go home"; her brother was the celebrated painter.

Peripatetic in their early married life, Francis and Violet had parked their two eldest girls, of whom Rose-Marie was one, with their French grandmother, Bonne-Maman Ormond, who refused to give them up when her son and daughter-in-law finally settled in London and Tunis. Holidays were the time when the two sides of the Ormond family were temporarily reunited, and it was in the Alps that Rose-Marie would be immortalized in the ravishing figure studies by her uncle.

Dan Williman and Karen Corsano have told the story of Robert and Rose-Marie Michel for the first time, against the richly textured artistic and intellectual milieu in which they grew up and flourished. Inevitably the older generation looms large in the story, in the persons of André Michel and John Singer Sargent, but never at the expense of the principals. The research has been exemplary, the authors delving into French, English, and American archives (public and private) in search of their quarry. Particularly revealing for me is the new material on the André Michel family and their network of relations; the story of Robert's career as a scholar; and the detailing of his military service from his reconstituted notebooks. Rose-Marie's wartime work as a nurse is documented and brought to life, including a rare illustration of her among a group of nurses, leading a line of blinded soldiers. Fascinating discoveries like that abound in a narrative that is at once poignant at the human level and revealing on the wider issues of scholarship, art, and war.

I grew up surrounded by Sargent's work in the houses of my parents, my uncles and aunt, and my grandmother. Among the pictures were several in which Rose-Marie figured, and I became intrigued by the story of the aunt, forever young, whom I would never meet. She was so radiant and full of life in Sargent's pictures and in the family photograph albums that her death seemed then to me a sacrilege. Why her of all people? The more recent chance discovery by a cousin of mine of a cache of letters Rose-Marie had written to her brother Guillaume gave a voice and a personality to what had been a beautiful face and figure. Her letters, so warm and loving, so selfless and idealistic, were a revelation. She cared deeply for her family and regretted her separation from her parents and her siblings for so much of the year. Living with a dominating grandmother cannot have been easy. Her agony and heartache in the face of Robert's death, her determination to stay true to his ideals, her years of service to the blind, heroic as they are, make for painful reading. Yet Rose-Marie was the last person to look for sympathy. She shared a passion for music with her brother, and through her private griefs she often wrote to counsel and encourage him; he would go on to become a distinguished cathedral organist in Truro, England.

As the coauthor of the Sargent catalogue raisonné, I have come to know Rose-Marie as the model and inspiration for a great painter in a rather personal way. I have recorded her in many moods and poses and I have tracked her to the places where she was painted. But I have never felt closer to her than when I stood beside the magnificent tomb where she and Robert lie buried, close to the place where he was killed, out in the open fields above the village of Crouy in northern France. Beautifully cared for by the local community, the tomb is a place visited by them on Armistice Day. It is a kind of epiphany to know that she and her husband are remembered there, in a place at once so idyllic and yet so haunted by the dead of the Great War.

Richard Ormond
Highgate, London

Preface

This history began to take shape in 1995 when the authors visited the Boston Public Library for the first time together. Dan was in town from New York state and Karen was showing him some favorite sights of her native city. At the top of the final dark flight of the Library stairs we arrived in the narrow rectangular hall decorated with John Singer Sargent's mural cycle, *The Triumph of Religion*. The two dramatic ends of the hall immediately claimed our attention. The north wall shows exotic, anthropomorphic figures from ancient Egypt and Assyria and Old Testament prophets. The south wall is an array of medieval Christian representations of the Crucifixion, the Trinity, the Virgin, and angels. Both walls are encrusted with jewels and ornaments, and the crucifix, Moses with the Ten Commandments, and many other details are actually built out from the wall. The dominant colors are strong reds and blues, highlighted with gold leaf. The *Frieze of the Prophets* is an array of Sargentesque portraits. Even in the poor light and grimy condition of the murals before their restoration in 2003, those walls impressed us as "triumphant" indeed, solemn and glorious. Catholics from birth and trained academic medievalists, we recognized the symbols and marveled at Sargent's facility with archaeological and historical detail and tropes, but we puzzled over his novel iconographic arrangements and juxtapositions.

The two panels on the long east wall, *Synagogue* and *Church*, are not glorious. Their color is muted, their themes not optimistic, and their bleak affect is increased by the large empty grey wall between them. The more famous of the two (because it created a scandal when it was unveiled) shows *Synagogue*

as a strong woman, blindfolded and collapsing in the ruins of the Temple. *Church*, a youthful matron enthroned, stares blankly forward, surrounded by the symbols of the Evangelists and displaying the host and the chalice of the Eucharist. She is also a Pietà, supporting the dead Christ between her knees. We recognized the medieval iconography of synagogue and church, but we found it strangely altered here.

That day as Dan read the small pamphlet the Library provided for visitors, the work of Sally M. Promey, he stopped at her comment that the features of *Church* were those of Sargent's niece and a favorite model, Rose-Marie Ormond. Dan already knew some of her story because Rose-Marie had been the wife of Robert André-Michel, historian of medieval Avignon. Dan's academic research specialty is in the archives of the popes of Avignon, and he knew André Hallays's posthumous volume (1920) of Robert's articles that included an homage to Robert, some of his wartime correspondence, and a brief account of his young widow Rose-Marie, a volunteer nurse for blinded soldiers and then herself a casualty of the War.

When the grand Tate Gallery exhibition of John Singer Sargent's paintings came to Boston in the summer of 1999, we spent a long time studying Sargent's *Gassed*, in which blinded soldiers are led in lines toward a field dressing station. When we left the Boston Museum of Fine Arts that day, our heads were full of the elements of a noble and tragic story.

The murals in the Sargent Hall; Sargent's sophisticated medieval iconography; the world of artistic, scientific, academic excellence that was France before 1914; the Great War that crushed that civilization; the two admirable young lives snapped off short; the evil excellence of the Paris Gun; Sargent's uncanny perceptions of all that, on canvas and on paper and finally on the walls of Sargent Hall: those points of light made a constellation, the outline of a story. The Great War destroyed the lives of eight million soldiers and another eight million noncombatants, each one the center of a story of loss and sorrow. We tell the story of two, and because we are historians and not poets, our story is a history and not an epic poem. The poetry, as Wilfred Owen observed, is in the pity.

This is a story made up of many stories, set in many scenes. Three families came together in the decades around the turn of the century—Sargent, Michel, and Ormond—families that embodied the European civilization of that moment, cosmopolitan artists, connoisseurs and collectors, music lovers, scholars. It was in Paris in the 1880s that John Singer Sargent met André Michel, the one a prodigiously rising painter and the other a critic on his way to becoming the premier art historian of France. While in his twenties, André's son Robert became one of France's leading research historians of

art and culture. Sargent's sister Violet married into the rich Swiss family Ormond, and her daughter Rose-Marie grew up a member of both parents' families and in her teens was Sargent's favorite model in his summertime painting in the Alps. Robert married Rose-Marie in the summer of 1913. Just a year later Science and Engineering were conscripted into a war against Humanity and Beauty that snuffed out those two emblematic young lives—first Robert, then Rose-Marie. Mourning marked and changed the survivors. Sargent suddenly engaged with the War and went to France to paint it. Then he brought his Boston Public Library decorations to an end, not as he had intended when he began them.

The scenes are set and the stories are told here, as far as possible, by the actors and spectators who told them to us, in their own words or in our translation of their French. In the course of our research we met several remarkable witnesses whom it is a pleasure to know and to introduce to our readers. Lucia Fairchild of Boston was a budding painter, thrilled by Sargent's attention, and a close friend of his young sister Violet when both women were eighteen. Lucia's diary and letters give us unique and lively pictures of both Sargents, the painter and his sister and long-suffering model. Henry de Varigny kept a journal too, and as André Michel's brother-in-law he knew all the characters of our story, many before they knew each other. Through Henry's descriptions we become privileged witnesses at the family events of our story: the births, marriages, and funerals, and the lunches, teas, and dinners of his extended family, including the Ormonds on one side and the Michels on the other. Henry was also an eclectic scientist and demonstrator in pathology at the Sorbonne, and so his journal gives us moving details at many crucial points. Nora Saltonstall was a Boston debutante who went to the American Field Service in Paris at the beginning of the war, seeking the kind of clerical social work that her education had prepared her for, but before the end she was a driver-mechanic for a private *autochir* (mobile surgical hospital) and decorated with the *croix de guerre* for her dashing, selfless courage in that service. Dorothy Canfield Fisher was a writer who drew her short stories from her Vermont background and her studies in Paris at the turn of the century, and she was the mother of two children whom she brought along when her husband joined the American Ambulance. She organized the provisioning of Fisher's training camp for ambulance drivers at Crouy, where she gathered under her wing a number of war orphans whom she then shepherded to safety in the Pyrenees. Her stories show us Crouy and its people in peacetime, embattled, occupied, and liberated. Paul Tuffrau was also a writer, a *normalien*, mobilized like our Robert into the 55th Infantry Division. Commanding a machine-gun section, then a company, he went through the worst of the war in France and emerged

with his humanity intact and a *carnet* full of moving descriptions of all kinds of men at war. When Milton Snyder went to Paris as correspondent for *The Sun* of New York, his wife, Alice, went along, on the *Sun* payroll as a fashion correspondent. She volunteered for the most harrowing job possible for a shorthand writer fluent in French: surgical recorder at the American Ambulance, and when her husband was transferred to London she stayed in Paris, fortunately for us, because then she reported to him in daily letters.

Karen Corsano
Daniel Williman
Cambridge and Buzzards Bay, Massachusetts

~

Acknowledgments

Richard Ormond, leader and godfather of Sargent scholars worldwide, received an e-mail in November 2000 expressing our interest in the story of his aunt Rose-Marie, and he wrote back on the letterhead of the Catalogue Raisonné, "I will do what I can to help." He has honored that extraordinary blank check in a hundred ways, especially by giving us access to his family archive, letters, journals, and photographs, and by his steady friendship and encouragement, without which this book would be unimaginable.

We are grateful for the attentive and generous help given to us by:

Descendants of the extended Michel family: Yves and Marianne Antusze-wicz, Martine Bosshardt, Renée Chapeville, Bernard Deverly, Rose-May Langlois-Berthelot, Henri Marcel, Cécile and Patrick Deloche de Noyelle, Claire Seydoux, Daniel Seydoux, Henri-Abel Vermeil

Warren Adelson and Elizabeth Oustinoff of the Adelson Gallery, New York, sponsor of the John Singer Sargent Catalogue Raisonné and our friendly liaison with private collections; Elaine Kilmurray, coeditor of *John Singer Sargent: Complete Paintings*

Muriel Barbier, information officer, Musée du Louvre

Sean Casey, Kimberly Reynolds, Karen Shafts, and Meghan Weeks of the Boston Public Library

Joanne Corsano, our digital photography technician

Francis Delon, information officer, Archives de Paris

Eugenia Dimant, Cynthia Hinds, and Shepherd Holcombe of the Harvard College Libraries

Peter Drummey, Massachusetts Historical Society

Lisa Feldman, Shana MacKenna, and Elizabeth Reluga of the Isabella Stewart Gardner Museum, Boston

John Fox, nephew of Sargent's longtime Boston collaborator Thomas Fox, and the collector of his papers now in the Boston Athenaeum

Ian Graham, archivist of Wellesley College

Michel and Anne-Marie Hayez, formerly of the Archives Départementales de Vaucluse, Avignon

Jaylyn Olivo, lynx-eyed editor, and Dale Flecker, sage counselor

Patricia Panizzi of the International Institute of Humanitarian Law, Villa Ormond, Sanremo

Deborah Richards, archivist of Smith College

Jenny Wood, senior curator, Imperial War Museum, London

~

Illustrations

Color Images

Color 1 Sargent, *Autumn on the River* (1888)

Color 2 Sargent, *El Jaleo* (ca. 1880–1882)

Color 3 Sargent, *Violet Sargent* (1890)

Color 4 Sargent, *The Brook* (1907)

Color 5 Sargent, *The Cashmere Shawl* (ca. 1911)

Color 6 Sargent, *Nonchaloir* or *Repose* (1911)

Color 7 Sargent, *Simplon Pass: Reading* (1911)

Color 8 Sargent, *Simplon Pass: The Lesson* (1911)

Color 9 Sargent, *The Pink Dress* (1912)

Color 10 Sargent, *Rose-Marie Ormond* (1912)

Color 11 Sargent, *Graveyard in the Tyrol* (1914)

Color 12 Sargent, *Wheels in Vault* (1918)

Color 13 Sargent, *Gassed* (1918–1919)

Color 14 Memorial chapel of Saint Gervais, stained glass window

Color 15 The Tomb of Robert and Rose-Marie at Crouy

Figures in Black and White

Sargent and Ormond Family Tree xxiv

Michel and de Varigny Family Tree xxv

Griolet Family Tree xxvi

1.1 John and Emily Sargent, ca. 1867 3

1.2 The de Varigny family at *Les Fauvettes*, Spring 1884 9

2.1 Sargent, *By the River*, 1888 40

2.2 Sargent, *Mme Marie-Marguerite Ormond* 44

2.3 Rose-Marie Ormond, one year old 46

2.4 Three Ormond children in costume, 1900 48

2.5 The six Ormond children, 1904 49

3.1 Rose-Marie at ten, scholar 52

3.2 Rose-Marie in Turkish costume, ca. 1906 56

3.3 Rose-Marie at an Alpine window, 1911 63

3.4 Rose-Marie and her father, 1911 63

3.5 Sargent painting *Simplon Pass: Reading*, 1911 64

3.6 Dolly Barnard and Rose-Marie Ormond posing for
Simplon Pass: Reading 64

3.7 Sargent, *The Two Girls*, ca. 1911 65

3.8 Sargent, Rose-Marie's hand in bronze, 1912 65

3.9 Rose-Marie at eighteen, 1912 68

3.10 Rose-Marie with her mother at Sanremo, January 1913 71

3.11 The wedding of Rose-Marie and Robert, August 1913 76

3.12 Rose-Marie and Robert at their wedding reception 77

4.1 Robert Michel, sergeant, 102e Régiment d'Infanterie, 1905 82

4.2 Robert and Juliette Michel and their nephew Max Vermeil,
Berck-sur-Mer, 1908 85

4.3 Rose-Marie and Robert at Berck-sur-Mer, 1913 95

4.4 Abel Gendarme de Bévotte and his fiancée Juliette Michel, 1913 96

4.5 Rose-Marie convalescent, January 1914 96

4.6 Robert at Crevin, July 1914 99

4.7 Rose-Marie at Robert's desk 100

5.1 The Soissons front, October 1914 110

5.2 Robert Michel, *mort pour la France* 125

6.1 Sargent's letter of condolence to Rose-Marie 129

6.2 The Ormond family summer holiday, Dinard 1915 138

6.3 Paul Renouard, *Learning to Be Blind* 143

6.4 Rose-Marie at Crevin, August 1917 156

7.1 A Paris Gun on the testing range, late 1917 164

7.2 Maurice-Jean Bourguignon, *The Bombed Nave of Saint Gervais* 167

7.3 Church of Saint Gervais, plan 169

8.1 Sargent, *Crucifix in the Tyrol* or *Still Life with Crucifix*, 1914 183

8.2 Sargent, *Ruined Cathedral, Arras*, 1918 199

9.1 Sargent, *Israelites Oppressed*, Boston Public Library (installed 1895) 214

9.2 Sargent, *Dogma of the Redemption*, Boston Public Library (installed 1903) 216

9.3 Sargent, *Messianic Era*, Boston Public Library (installed 1916) 219

9.4 *Synagogue* and *Eglise*, Reims Cathedral, 13th century 223

9.5 Sargent, *Synagogue*, Boston Public Library (installed 1919) 224

9.6 Michelangelo, Sistine Chapel *Cumaean Sybil*, detail 225

9.7 Sargent, *Church*, Boston Public Library (installed 1919) 226

9.8 Michelangelo, *Pietà* 227

9.9 Sargent, sketch for *Church*, 1918 228

~

Select Family Trees

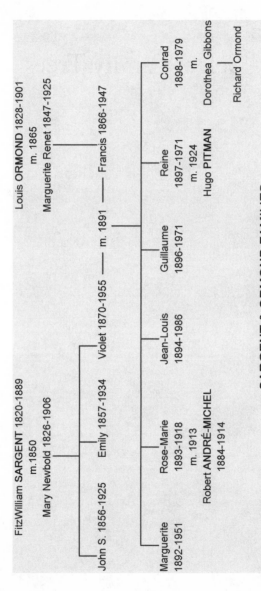

SARGENT & ORMOND FAMILIES

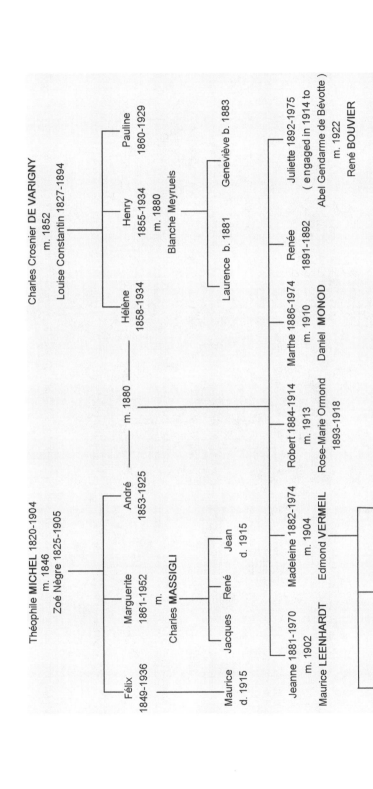

MICHEL & DE VARIGNY FAMILIES

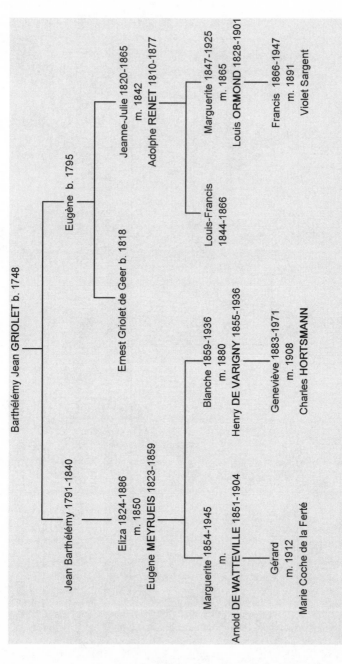

Barthélémy Jean GRIOLET b. 1748

Jean Barthélémy 1791-1840
Eliza 1824-1886
m. 1850
Eugène MEYRUEIS 1823-1859

Eugène b. 1795

Ernest Griolet de Geer b. 1818

Jeanne-Julie 1820-1865
m. 1842
Adolphe RENET 1810-1877

Marguerite 1847-1925
m. 1865
Louis ORMOND 1828-1901

Louis-Francis 1844-1866

Francis 1866-1947
m. 1891
Violet Sargent

Marguerite 1854-1945
m.
Arnold DE WATTEVILLE 1851-1904

Gérard
m. 1912
Marie Coche de la Ferté

Blanche 1859-1936
m. 1880
Henry DE VARIGNY 1855-1936

Geneviève 1883-1971
m. 1908
Charles HORTSMANN

GRIOLET FAMILY

~

The Painter and the Critic

John Sargent and André Michel

John Singer Sargent's charming niece and favorite model Rose-Marie Ormond, daughter of a Swiss father and an American mother, was born in Tunis in 1893. In 1913, in Paris, she married the French academic Robert André-Michel. Our history of her three families begins in Paris in the last quarter of the nineteenth century, when her uncle and her future father-in-law crossed paths as their two spectacular careers were just beginning.

John Sargent, an Artist in Paris

On 26 May 1874, the remarkably talented John Sargent, eighteen years old, entered the atelier of Carolus-Duran in Paris to finish his schooling as a painter.[1] His whole immediate family, his parents and two sisters, accompanied him to Paris, as they had crisscrossed Europe together all John's life. He is known, and was proud to be known, as an American artist, but he had been born in Florence and had yet to visit the country of his forebears and of his citizenship.

Dr. FitzWilliam Sargent was of old New England stock, and he had begun a promising medical career in Philadelphia when he married Mary Newbold Singer. Their first child died in infancy, leaving Mary in a lifelong state of apprehension over her health, and so in 1854 the couple sailed to Europe in search of healing, strength, and cultural distraction. John was born in Florence in 1856, his sister Emily a year later, and the little family began a nomadic pattern of seasonal shifts from warmer to milder city, from seashore to

1

mountains. Mary's inheritance, though modest by American standards, was enough for constant and comfortable travel among their grand hotels and their rented palazzi in Florence, Geneva, Rome, Vienna, Nice, Pau, Biarritz, London, and Paris.

This perpetual grand tour of a life may not have improved Mary's health noticeably, but it does seem that the Old World scenes, arts, and culture sustained her spiritually. She saw to it that her children were nourished with a steady diet of earnest sightseeing, galleries, and museums everywhere they traveled. A serious amateur artist herself, she encouraged them to draw and taught them elementary perspective. She insisted that they observe details and record them faithfully and never leave a day's sketching unfinished. Johnny's formal book learning, by contrast, was quite haphazard: day school in Nice and Florence and a preparatory school for the Dresden Gymnasium, less than a year of each; but he learned the major languages of western Europe from his parents and educated natives, and he read voraciously. He also developed his considerable musical talent, in voice and piano, as he grew. From the age of twelve he took on informal apprenticeships in watercolor, copying, and outdoor sketching, and at seventeen he enrolled in the Accademia di Belle Arti in Florence, but only for a few winter months.

By that time, FitzWilliam Sargent had given up his dream of a career in the US Navy for his son and recognized both the hand of Providence and a well-paying profession in his son's artistic talent and energy. The family then journeyed to the artistic capital of Europe in order to plant their talented son John in the choicest ground they knew. He was soon to take his own apartment and his own studio, without really breaking up their tight little tribe. All his life John had been accustomed to his family's constant motion through a network of American expatriates, some peripatetic like themselves, some handsomely settled in Venice or Nice. In a religious minority (Episcopalian) even among the minority Protestants (Calvinist and Huguenot) of southern Europe, émigrés from the American Gilded Age, they were oblivious of the political and sectarian turmoil of the *fin de siècle*, while happily at home in historic, cultural, secular Europe of the *belle époque*.

John's stable attachments, then, were to the nuclear society of his parents and sisters. Emily was somewhat crippled all her life by a back injury at the age of three and confinement to bed until she was six. She became the patient, quiet, selfless caregiver in the family, loved by all, and John was a particularly close and protective older brother. When he was nine and she was eight, they lost their five-year-old sister Minnie, and four years later their two-year-old brother FitzWilliam. The family bond must have become more precious to them with these experiences of its fragility. Having a family was

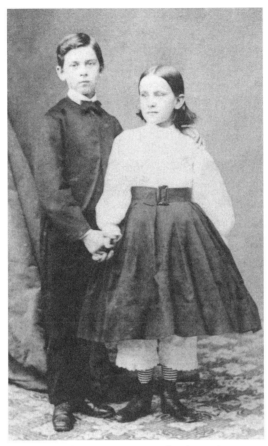

Figure 1.1. John and Emily Sargent, ca. 1867. John, here eleven years old, always re-mained a protective older brother to his slightly disabled sister Emily, one year younger. Private collection.

a precious, temporary gift, and to deserve it Sargent developed a compulsive habit of responsibility. It was the same with friends. In later life, whenever a relative or a friend or professional colleague was sick or injured or dying, in need or in mourning, Sargent wanted to be there to help, and if he could not be, he was truly in pain.

Whenever the Sargents stayed long enough at a single destination for the children to become playmates with other children, John and Emily were quick to make friendships. They worked, with the active help of their mother, to keep in touch as the families wandered in their different orbits. John's spontaneous link with Ben del Castillo, a Cuban American whom he met at age six in Nice, gave rise to an exchange of letters that illustrates

John's youthful enthusiasms and that continued an enduring, and sympathetic long-distance friendship. Another friendship John formed around the same time in the expatriate colony of Nice was with Violet Paget, the daughter of an unsettled English family, nearly the same age as John and Emily. Later, under the pseudonym Vernon Lee, she became a prolific novelist and essayist.[2] The friendship was cemented through a full winter season in Rome in 1868–1869, and the last Sargent child, born in Florence in 1870, was the namesake and goddaughter of her siblings' fourteen-year-old friend. When John settled in Paris, his baby sister Violet was only four, the object of the whole family's watchful care.

It was a moment of ferment in French painting. Three heroes of expressive realism in painting, Corot, Millet, and Courbet, died between 1875 and 1877, leaving behind pioneer works that challenged the rising generation to create something brilliant and original, yet fully disciplined. In April 1874, just a month before John Sargent arrived in Carolus-Duran's atelier, the Impressionists in secession from the annual Salon of the Académie des Beaux-Arts, notably Monet, Renoir, Cézanne, Morisot, Degas, Pissarro, and Sisley, hung their paintings in the photographic gallery of Félix Nadar for the first of many independent exhibitions. The excitable Parisian public was alert and ready to form opinions and claques, eager to exalt or to demean the reputations of the different ateliers and of the painters who emerged from them. Sargent was usually lucky and always able to back his luck with his great talent, his years of disciplined practice, and his steady industry. He found in Carolus-Duran a congenial teacher and one who could prepare him fastest and most surely for the annual entry competitions of the Ecole des Beaux-Arts and for the Salon. He became the master's most favored pupil, and his work was so clearly superior, and himself so charming and unassuming, that his fellow students acknowledged his distinction and admired and learned from Sargent rather than envying and shunning him. In October 1874 he won the first of several semesters in the Ecole des Beaux-Arts, and in the Salon of 1877 he hung his first offering, *Miss Frances Watts*.[3]

André Michel, a Journalist in Paris

Drawn by his urge to learn and to practice and profess the history of art, Charles Paul André Michel arrived in Paris in 1877.[4] The men were close in age, Michel scarcely two years older than Sargent, but they were from different worlds of background, education, and experience. Whereas Sargent's expatriate American family were habitual wanderers, Michel's were firmly rooted in the South of France, in Montpellier, where his father, Théophile

Michel, was a successful wine merchant. While Sargent's education, before he alighted in the studio of Carolus-Duran and the Ecole des Beaux-Arts, had been a sort of international cultural forage, Michel had enjoyed the systematic Lycée program in classical and French literature, mathematics, and science, capped by the License from the Faculty of Letters of the University of Montpellier in 1872. He volunteered early for his compulsory military service, but then he took the deferment that was accorded to *licenciés* for the pursuit of further studies. Michel was ready for any learned career, and like so many brilliant young men, he was directed toward the law by his father. He dutifully registered in the Faculty of Law at Aix-en-Provence. After four years of study Michel was Licentiate of Laws and as tired of Montpellier as was appropriate for a twenty-year-old. He rewarded himself for his success by a traveling vacation away from the law and from France, to Switzerland, Munich, Vienna, Prague, Budapest, Salzburg, Verona, and Venice. Then, in 1877, he "passed under the flag" of the 142nd Regiment of Infantry at Perpignan for his two years' training and service, emerging into the reserve in 1879 as a sublieutenant.

Those two years of compulsory army service allowed plenty of time on leave, and André Michel spent it mostly in Paris, a paradise for an alert young man of culture. He could spend half an hour in conversation with Raphael's *Belle jardinière* in the Louvre and carry that image to a rendezvous with Mozart at the Cirque d'Hiver.[5] Sargent painted the scene; Michel had his journal.

> 8 February [1880]. A Mozart Quintet at Pasdeloup that made me ascend to the seventh heaven and mingle with the choirs of Seraphim. Before me, a woman just made for this music, a girl by Raphael. I left after the Mozart (despite my neighbor) so that the pure and serene impression would not be disturbed by some Suite for Orchestra or other. What a power music has! Of all the arts it is the one that most easily takes us out of ourselves; wakes up by the waves of its harmonies all the elements of sensibility; replaces idea with sentiment; and sometimes brings a thought to birth and pursues it, but always spontaneous as an impression, vague as a memory.[6]

Michel did enroll for the classes in law that would prepare him as a practicing *avocat*, but his real vocation of history and art soon claimed him, and he registered as an independent student in the Ecole Pratique des Hautes Etudes. For four years he studied medieval Latin, texts, manuscript hands, and documents under the guidance of Gabriel Monod at the Ecole Pratique and Arthur Giry at the Ecole des Chartes, and to this preparation in method he added the lectures on art history at the Ecole des Beaux-Arts of Hippolyte

Taine, who taught him to construct the "historic moment" of an artist, an idea, or a work of art.[7]

This was a time of exciting opportunity for a brilliant and professionally trained writer on art, steeped in the Huguenot tradition. André's grandfather Honoré Michel had been minister of the Protestant Temple of Montpellier for an astonishing sixty-three years (1798–1861), after the Revolution finally legalized the Reformed Churches, and at his death he was president of the Consistory of the Reformed Church in France.[8]

Religious toleration was a highly valued civic virtue to thoughtful French Protestants. The sixteenth-century religious wars, capped by the St. Bartholomew's Day massacre of notable Huguenots in 1572, were sedated by Henry IV's Edict of Nantes in 1598, but Louis XIV revoked the Edict in 1685 and the persecution of the Protestants recommenced. Fervent *bigots*, backed by the Catholic clergy and hierarchy, the royal courts, dragoons, and *gens d'armes*, hounded the Huguenot congregations and sent men to the galleys, women to perpetual stone prisons, ministers to the scaffold. Some 400,000 Protestants emigrated, many to North America, depriving France of significant resources of wealth and industrial skill. Then the Revolution ended the privileges of kings, aristocrats, and the Catholic Church, and Protestants enjoyed the Rights of Man and Citizen equally with the rest of the French population. After the disastrous Franco-Prussian War there was a revival of the Royalist cause, and Pope Pius IX called on France to become officially Catholic again. These were worrisome developments for the Protestants, but the Chamber of Deputies finally had a Republican majority in 1876, and it seemed that liberal convictions, and Protestants who held them, had a future in France.[9]

Living in Paris was not cheap, and the record does not tell how André Michel afforded his lodging, meals, books, fees, and travel. His older brother had joined their father in the wine trade, and the brilliant second son was likely indulged with a handsome allowance or a permanent settlement. André could also earn a good living by such work as legal drafting. Whatever the sources, the supply was sufficient: in 1880, toward the end of his academic preparation in the great national schools, he was able to marry, and marry brilliantly. Hélène de Varigny was twenty-two to André's twenty-seven, the daughter of Charles-Victor Crosnier de Varigny, a successful journalist and writer of popular books on Oceania and New World topics.

Charles de Varigny's cachet in the publishing world came from a distinguished and adventurous career abroad. He was only eight when his father died, leaving an aristocratically connected widow and children but not much money. Charles attended the prestigious Lycée Bourbon (now Condorcet).

The revolutionary upheavals of 1848 and the discovery of gold in California the next year, necessity and opportunity, pointed him toward the Pacific. The Lingot d'Or lottery paid his passage, and he obtained a post as a director of the venture group "La Bretonne" and sailed from Le Havre on the *Anna* on 27 November 1850.[10] At the captain's table he met Louise Constantin, traveling with her widowed father to fortune in California.[11] Louise, a native of Avignon and a Protestant, finished her education in the Parisian *pension-nat* or boarding school of Mlle. Anglade, where the educational program was patterned on Jesuit or convent schools, with a professional *directrice des études* and distinct classes, each taught by its own *maître*.[12] The shipboard attraction blossomed in discussions of Michelet, Chenier, and Lamartine, though there were problems. "I was two years older than he," wrote Louise, "and for our sex that was the same as ten." Charles was Catholic and Louise a staunch Protestant. Then there was the aristocratic *de* in his family name, although he had nothing by which to support her but his intelligence. But this was the new world, and within six months of their arrival in San Francisco, Charles was editor of *Echo du Pacifique*, the largest of the newspapers that served the sizable French population, and he had adopted Louise's religious practices, gained his family's approval, and married her. The three years that the couple lived and worked in San Francisco saw it transmuted from little more than a camp of tents and shacks to the beginnings of a metropolis. Louise taught school, kept chickens, and played the organ at church in place of the German who showed up drunk once too often.

The couple decided to return to France in 1853 by sailing west. They paused in the Kingdom of Hawaii with letters of introduction to the French consul, who by chance was in serious need of an English-speaking aide to complete a treaty with the new Hawaiian monarch Kamehameha IV. He offered Charles a job as secretary and English interpreter. The country and climate charmed the de Varignys, and the polyglot European society of ambassadors, merchants, and missionaries that gathered around the Hawaiian court gave the enterprising couple scope for their talents and fantasy. Charles's enthusiasm for the country and the native people, his cordial nature, and his friendly relations with the diplomatic corps and the Hawaiian royal family made him useful to the Consulate, but when he was passed over for the post of consul in 1863 he jumped at the offer by King Kamehameha V to become minister of finance, and in 1865 minister of foreign affairs— essentially prime minister of the Kingdom.

During their fourteen years in the islands their three children were born, Henry (1855), Hélène (1858), and Pauline (1860). Hélène remembered being bathed in a bucket outdoors when a horse frightened her, coming over

to drink. Later she used to order the local boys to climb up palm trees and toss her down the coconuts, and once she foolishly allowed her siblings to bury her in beach sand up to her neck.[13] Hélène was known from the earliest age for her patience. When she broke her shoulder blade at the age of two, she endured being encased in an apparatus that the doctor contrived to keep her arm still for seventeen days, *toujours douce obéissance*. At the age of seven she learned to ride, dressed in a pretty, homemade, grey habit decorated with white braid. Louise did not give a detailed record of Hélène's elementary studies at the missionary school, but languages came to her with her surroundings: her French-speaking parents and mostly English-speaking friends, Chinese cook, and Hawaiian servants. The family was as comfortable speaking English as French. Ever afterward, the children used the English pet name "Love" for Louise because that was what Charles called her.

Louise de Varigny lived large and nobly in Hawaii, in the cosmopolitan royal court and in the magnificent wild landscapes. A near-professional pianist, she frequently starred in the musical circle of Honolulu. On a visit to the Big Island of Hawaii, Louise and a friend ascended Mauna Kea, perhaps the first women ever. "At the summit we had a delicious snack, red-currant preserves mixed with snow made a sorbet which we washed down with champagne toasts to our respective countries. We were higher than Mont Blanc! . . . I triumphantly brought the girls back a handkerchief filled with snow." Louise not only acted the hostess for her husband but took an active official role when she could. During the first royal visits to the Island of Hawaii after the volcanic eruption and tsunami of March 1868, she and her son Henry, aged twelve, accompanied her husband in the official party, encouraged the panicked and starving people with a picture of normality, and organized relief efforts on the spot among the native women of the devastated areas.

The need to place Henry in a good school in a climate that would alleviate his asthma, and the stresses inherent in Charles's position, persuaded the family to return to France. In September 1868, Henry, Hélène, and Pauline, ages thirteen, ten, and eight, saw their ancestral homeland for the first time. Charles was persuaded to retain his Foreign Affairs portfolio and to try to negotiate commercial treaties for Hawaii with the European governments. The times were profoundly unsuitable for the effort, as the great powers were working themselves up for war and the American annexation party in Hawaii was gaining power; Charles had to resign his impossible post. When the Prussian army invaded France in 1870, he placed himself at the disposal of the government and served it through the war, the wearing siege of Paris, and the bloody disaster of the Commune, while Louise and her daughters found safe haven in Avignon and Geneva and the girls studied to improve their French. As the Third Republic struggled into life

and a new French society sought to arrange a new equilibrium, Charles de Varigny returned to professional journalism and produced a series of popular books, filled with material gathered in his years abroad and written in an elegant, plain French prose.[14] Old friends from the Lycée, such as André Michel's teacher Hippolyte Taine, were helpful connections. The family prospered and Charles was able to build a delightful vacation home in the still-rural Parisian suburb of Montmorency where he had grown up. The wooden villa, *Les Fauvettes*, was built in the airy style they had come to enjoy in Hawaii, both floors encircled by wide verandas. Three generations gathered to be photographed on the lawn of *Les Fauvettes* in the spring of 1884. From left to right in the front row are André Michel, with his daughter Jeanne on his lap and his daughter Madeleine alongside on the grass; on the right, Henry de Varigny with his older daughter Laurence. Seated behind them are André Michel's wife Hélène and his mother-in-law Louise "Love" de Varigny, his sister-in-law Pauline de Varigny, Henry's wife Blanche and her brother-in-law Arnold de Watteville. Standing behind them is the patriarch Charles de Varigny and a nurse holding the newest family member, Henry's baby daughter Geneviève.

Figure 1.2. The de Varigny family at *Les Fauvettes*, Spring 1884. Shortly before reviewing Sargent's *Madame X*, the rising art critic André Michel (left front) posed among his in-laws with his own growing family: his little daughters, Jeanne on his lap and Madeleine on the grass, and seated behind them his Forty-Niner mother-in-law and his Hawaiian-born wife, then pregnant with son Robert. Private collection.

Details of Hélène de Varigny's education are missing, but we can deduce that it was an excellent one from two facts: that she was the daughter of Charles and Louise de Varigny and that André Michel chose to marry her. Her father's advanced ideas about the education—and coeducation—of women had been formed by his service on the Hawaiian Board of Education. He had visited Punahou School, where the sexes were mingled in the classroom and "all the young people have been brought up as Protestants, and from an early age have been accustomed to exercising their individual moral responsibility."[15] For de Varigny, liberal education and the Protestant morality of women were a single progressive force. He had seen it at work in the United States, where the majority society was Protestant. He wrote that

> by the degree of influence that women exercise we can measure the degree of civilization of a social milieu. . . . In the evolution from Catholicism to Protestantism, women had an important role. Protestantism emancipated them from all guardianship. It gave them rights equal to those of men, recognizing in them the same natural enlightenment, the same faculties of appreciation and of reasoning, the same duties and the same responsibilities in the present life. The sense of *responsibility without limits* replaced that of *obedience without discussion*.[16]

André and Hélène Michel had six children: Jeanne was born in 1881, Madeleine in 1882, Robert in 1884, Marthe in 1886, Renée in 1891 (but she died as a baby), and Juliette (called Poupette) in 1892. As the family grew, so did André Michel's career of writing and teaching about art, beginning in journalism. *Le Parlement: Journal de la République Libérale* was founded by ex-prime minister Jules Dufaure with editor in chief Alexandre Ribot.[17] André Michel had his byline in *Le Parlement* throughout its brief existence, from October 1878 through December 1883. When *Le Parlement* dissolved, *Journal des Débats Politiques et Littéraires*, with its "uninterrupted traditions of good grace, good sense, and good taste, of delicacy, honor, and probity,"[18] took over that niche in the journalistic ecosystem and attracted some of *Le Parlement*'s writers, including, in 1886, André Michel.

The Salon

It was the Salon that first brought the names of Sargent and Michel together, at a moment when the ground was shifting under that grand old institution.[19] Established by Louis XIV as a series of shows of the paintings of his Academy, the Salon was a cherished property of the state, first royal, then twice republican and twice imperial. When the catastrophes of 1870, the Franco-

Prussian War, and the crushing of the Paris Commune by the government at Versailles put a formal and real end to monarchy in France, the Third Republic became the proprietor of the Académie des Beaux-Arts and of its annual Salon. The Salon was housed through May and June each year in the Palais de l'Industrie, built on the Champs Elysées in 1855 for the World's Fair. In the 1870s the Salon was lit by electricity, and attendance kept increasing, as did the number of works shown. After the Salon jury, dominated by members of the Academy, made their selection, the paintings were varnished to prevent *pentimenti*, afterthoughts painted in or out, while the show was on. This *vernissage* on the eve of May Day was the true opening of the Salon, and all Paris, at least all artistic and fashionable Paris, wanted to be there. After his debut with *Miss Frances Watts* (1877),[20] Sargent showed in every Salon until he moved his studio to London: *En route pour la pêche* (1878)[21]; *Carolus-Duran*[22] and *Dans les oliviers à Capri*[23] (1879); *Fumée d'ambre gris*[24] and *Mme Edouard Pailleron*[25] (1880); and *Edouard Pailleron,*[26] *Mme Edouard Pailleron* again, and *Mme Subercaseaux,*[27] with two Venetian scenes, in 1881.

André Michel reviewed the Salon in *Le Parlement* each year from 1879 to 1883, and he certainly had perused each of the earlier Salons more than once, so he knew Sargent's work and had begun to respect its technical and expressive excellences. Perhaps he had already encountered Sargent himself, either in the Salon or at the Ecole des Beaux-Arts, where they were each pursuing their different studies. They came to be on friendly terms, but because both were protective of their personal privacy, and because there was a delicacy to be observed about friendship between an exhibiting artist and a publishing critic, they did not trumpet it. The two men would have found much in common. Michel was a fine pianist, if not as close to performance quality as Sargent, and they both knew a great store of French poetry by heart. It is possible that Sargent attended some of the free lectures on art history that Michel had begun to give at the Protestant Temple de l'Oratoire du Louvre.[28] They were both attentive students of the history of art. When Sargent began his serious study of medieval iconography in connection with his mural work, André Michel may have been among his resources: he would have been a rich and generous one.

The foundation of André Michel's practice as an art journalist and as an art historian was the principle expressed in a slogan by the Louvre conservator Louis Courajod, "a work of art is a living person." His attention was drawn to works that touched him emotionally. He visited a museum or a Salon not to stare critically at art objects and take notes but to keep a rendezvous and have a conversation. Michel's art journalism, and later his art history, was mediated by his own sensibilities. He considered his personal lens a necessary

instrument, not a prism that distorted his perceptions. In a review of paintings shown at the gallery of Georges Petit, he wrote that he was content

> to seek out the changing dream of restless humanity. Each nation and each man has remade it in their own fashion, this dream that is always taken up and never finished. In the last analysis, mankind is always in search of mankind, and in the end, when we have dismissed all questions of craft, system, and doctrine, what remain at the base of the history of art or the history of literature are the confidences exchanged across the centuries.[29]

He had no use for theories of art history or of any history, and the categorization of works and artists by schools or -isms had no place in his critical articles. For André Michel as for Hippolyte Taine, the proper subject of art history was the work of art, and he built his conception of a national art or a period of art inductively, from his knowledge of individual works.

> What touched and attracted us above all in the new teaching [of Taine] was, if not the *explication* of the work of art, at least its placement in the milieu which it expresses and of which its creator has made himself the herald to posterity. We have come to understand better the inability of a system with its formulas to embrace the inexhaustible variety of human invention, and these things always escape it: the indomitable element, the unfathomable mystery of the artist's personality, the divine gift of genius.[30]

And so this critic's direct personal relation was to the work of art and not to the artist. Nevertheless he had favorites, artists whose works he was predisposed to respond to—Ary Renan, Max Leenhardt, and Alfred Roll can be named—and others to whom he warmed up only over time. Although he did not shake hands with Pierre Puvis de Chavannes until 1888, Michel was a constant and candid admirer in print of the senior artist, for many years one of his few steady admirers. But at first he retained an objective distance from Sargent and from Whistler, the other American who frequently showed in the Salon.

Michel's first reviews in *Le Parlement* in 1879 gave no notice of the two Sargents in that year's show, and the next year he merely mentioned the brilliant foreigner. The Salon of 1880 was more crowded with submissions than ever before: almost four thousand paintings, two thousand drawings and watercolors, plus engravings, architectural plans, and sculptures. The Academy was experimenting with a new grouping of the works by its own class-ranking of the artists in descending order: (1) *hors concours*, (2) otherwise exempt from the jury's selection, (3) non-exempt but selected, and

(4) foreign. Michel advised his public to ignore those official divisions, and in his fourteen articles from 1 May to 14 June he followed his own advice. In his tenth article on 2 June he reviewed paintings of Manet and Alma-Tadema and then, before turning to other media, he regretted, "If we only had the space and the time, we would not be limited to merely naming . . . [nineteen painters including] Sargent."[31]

Sargent had three portraits and two watercolors in the Salon of 1881, and *Mme Subercaseaux*[32] won him his second-place medal and, in André Michel's last article in *Le Parlement* on 9 June, a glowing note:

> A young painter, a student of Carolus-Duran, already known for the portrait of his master, has just obtained, with his "Young girl at the piano," one of the best deserved medals of the Salon. This is an original work, and one of exquisite distinction. The young girl is seated, one hand still resting on the keyboard; she turns on her chair to respond to some unseen speaker. We are drawn by I know not what irresistible charm toward that simple and luminous interior, where blue traces run discretely over the milky whites of the curtains, where each element is placed in a clear harmony and each is part of an admirably appropriate frame for the charming face of the model. We look for the secret of this charm, and we discover that it resides simply in the sincerity of the artist, who perceives life delicately and expresses it as he perceives it.[33]

In the Salon of 1882 Sargent placed his expressive, evocative, and large *El Jaleo*, (Color 2)[34] and his portrait of Charlotte Louise Burckhardt, *Lady with a Rose*.[35] André Michel gave a full and laudatory account of each in *Le Parlement*, the first on 8 June.

> If M. Roll is coming from Rubens,[36] M. John Sargent is coming from Goya in his painting of the "Spanish Dancer." Our readers have undoubtedly put up some resistance to this strange and heady work; nevertheless, we doubt that they will go so far as to deny its disturbing charm, if they will take a fresh look at it. We are in the bare hall, its grey walls flecked blood-red, of some Spanish *posada*; the light comes from below as if from a rank of footlights, and the painter has indicated that, rather oddly to an inexperienced viewer, by making it gild the inner face of the background of the painting. A dancer, a pretty, brown, excited girl in a white satin dress with a mantilla of black lace, her hair daringly swept back in the manner of Mérimée's *Carmencita*, is caught in mid-dance.[37]
>
> Her body is thrown backward, one hand lifting her swirling skirts, her arm extended, her eyes half closed, half swooning, she follows the rhythm of the demonic music sent to her by a little orchestra as transported as she is. Sitting like a row of onions at the back of the hall, it is composed of four guitarists,

whose hands furiously pick the vibrating strings, and a big *torero* bent back against the wall, showing only his tense, wide-open throat, from which are issuing those rough and guttural cries that sound out the popular songs of Spain, while two other dancers, waiting their turn, throw up their arms and cheer on their comrade, themselves already carried away by the universal vertigo. *Ohé! Ohé!* Everything is dancing, the shadows on the wall, the chairs in the room, the bodies, the hands, the arms.

This is all seen through an intoxicated atmosphere or fog, like a troubled vision; this is movement, painted. It seems that the painter wanted to fix in place, less the image of the figures than the luminous vibrations of bodies launched into the space. The smoky light of the oil lamps throws grey reflections on the dusky complexions of the dancers; the effect of these lean, passionate faces, accented by their burning eyes, emerging from a red mantilla or from black hair relieved by a flower placed devilishly but with an infallible rightness, is as new as it is powerful.

It is impossible to deny that there is a great audacity here, an extraordinary gift for life, and a marvelous ability. Too much ability, perhaps: that is the warning that has to be flashed to M. Sargent, but I have enjoyed the work too much to have the courage to limit my praise of it. She is contagious! After a quarter of an hour one feels the crazy desire to leap onto the banquettes, which would destroy a critic forever in the esteem of respectable folk.[38]

Velázquez was one name that Carolus-Duran conjured with, and Sargent had made a pilgrimage to the Prado in Madrid in October 1879, to make that revelation his own by copying the master's paintings. In *Lady with a Rose* Sargent was beginning a handsome repayment of his debt to Velázquez and echoing that painter's *Calabazas.* He was also poking subtle fun at the Salon and at André Michel's favored painter Puvis de Chavannes, who had shown his *L'Espérance* there in 1872.[39] Puvis's wan, melancholy, allegorical, seated girl in white rests her negligible weight on her right hand on the rock, stares at the viewer, and holds out a sprig of olive in her left hand. Sargent's friend Charlotte Louise Burckhardt stands up in fashionable black, her right fist on her hip, holding out her definite white rose in her left hand, and her wry smile comments wittily on the pose. If Michel noticed the parody, it cast no shadow on his review of 18 June.

M. Sargent has painted a good pendant to the portrait of a young girl that we made note of last year. Perhaps "pendant" is not the right word, because the two paintings do not make a pair. In place of the crafted background, the carefully detailed interior that he painted last year, he has been content this time to place behind his model a putty-colored curtain with a few carelessly draped folds. The model, a young girl, is standing, one hand on her hip, holding in the

other, in the empty air, a yellow rose at which she does not look. She is dressed all in black, with black gauze at the throat and arms. It is a fine head, slightly mocking, slightly dreamy, with a charming expression of mischievous kindness. The execution of the whole is crisp, precise, and savory. The ensemble, "made out of nothing," as they say, has an impressive originality. This is one of the works of the Salon that we go to see again at each visit, and that consoles us for all the tasteless, pretentious, stupid, or mediocre portraits that pullulate there and of which we will not speak.[40]

In 1884, the Year of Madame X,[41] André Michel had joined Gazette des Beaux-Arts; his review article on a show of "Drawings of the Century" appeared there early in the year. But the Gazette assigned the Salon that year to Louis de Fourcaud, who so well appreciated Sargent's notorious canvas that Sargent gave him a drawing of the portrait's iconic profile to use like a medieval illuminated capital at the head of his enthusiastic "Part Six."[42] Michel got himself accredited to the Salon by the journal L'Art: Revue Hebdomadaire Illustrée, and wrote five articles. His first impression was of "total lassitude . . . the portraits are numerous; the good portraits rare." But he lyrically praised Puvis de Chavannes's Le Bois Sacré cher aux Arts et aux Muses, and when he came to Madame X he scolded fashionable society, not the artist.[43] "Another foreign painter, an American, Mr. John Sargent, is showing the portrait of a woman of the world, Mme G., which has raised a small riot among the viewers of the vernissage, and which we certainly must talk about. 'This matter is always delicate,' as the author says."

Those were the days! André Michel could drop five words from Molière and expect his full meaning—that he was on friendly terms with John Sargent—to be appreciated by the readers of L'Art. (In act 1 scene 2 of Le Misanthrope, Orontes asks his friend Alcestis for a frank and face-to-face critique of his very bad sonnet, and Alcestis replies Cette matière est toujours délicate.)

The critics of the generation to follow us will be freer to comment on this strange and troubling work. They will no doubt try to find in it a "document" of the "high-life" of the year of grace 1884, and of Woman as an overheated and artificial civilization has made her, and of a certain kind of taste, less responsive to frank and healthy blooms than to the artificial plants of the boudoir, and less responsive to a complexion from the open fields than to one sold by the cosmeticians who have the pleasure of fashioning her. And if it is true that each generation remakes the work of nature to its own image, those future critics will see here one manifestation of the ideal of our Parisian cosmopolitanism, and they will then understand better why our modern art has not been, like that of the Renaissance, a creator of living bodies and heroic shapes. On this

fertile theme they will be able to say original and profound things which we do not know how to discover or how to write. To speak only of the painter, I am among those who are interested in his audacious work and his original talent.

Our colleagues of the future, to whom we leave the task of talking about this portrait, should be on guard against too absolute generalizations.[44] They should not imitate the Englishman who, just landed at Boulogne and meeting a red-haired lady, wrote in his diary, "The hair of French women is red." Not all the classes of society have adopted these fashions; and these methods of "beautification" of the complexion have not penetrated all dressing rooms.[45]

Paul Leroy's *Portrait de sa mère*,[46] almost a parody of Whistler's *Arrangement in Grey and Black: Portrait of the Painter's Mother* (1871),[47] won the *Prix du Salon* in 1884, and Michel turned to it as the perfect foil for *Mme X*.

Now, over here is a good city woman in a cotton dress, seated, in profile, holding in her hand one of those fans that the novelty stores price at ten cents, peacefully at home, lost in a reverie of domestic combinations and household arrangements. We would greatly surprise her if we spoke to her about "the bitter juice of contemporary living." This uncomplicated soul will die without ever using any custom makeup. And her painter, M. Paul Leroy, shows her to us as she lives, in her dowdy morning dress and the bourgeois calm of her entire being. This is a Grand Prize portrait, and I add, a portrait of grand charm, on account of its clear, full, fine painting and its just, sincere, living sentiment.[48]

When he wrote those lines comparing sun-tanned honest nature to cold fashionable artifice, André Michel was surely thinking of the women of his own family—his mother from the Midi, his Honolulu-born wife (pregnant then with his son Robert), and his Forty-Niner mother-in-law, and, with a proud hope, his two little daughters Jeanne and Madeleine. (See figure 1.2.)

André Michel's review, though favorable to Sargent as an artist, reflected the majority opinion of the critics that his society portraiture had gone in a risqué direction. The immediate future for profitable sitters seemed bleak. The *Gazette des Beaux-Arts* entrusted the 1885 Salon to André Michel, and Sargent showed *The Misses Vickers* and *Mrs. Albert Vickers*.[49] Michel, still attracted by Sargent's work but coolly objective, took notice of the triple portrait: "Mr. Sargent, always uneven but always interesting, has grouped into a curiously cropped frame three young girls, three strangers. This savory painting has some very persuasive seductions, which make us pardon him for more than one sleight-of-hand trick."[50]

Henry James, head over heels in civilized admiration for Sargent, helped convince him that London would be more welcoming than Paris, and that

he could open doors and bring sitters for portraits. Early in 1885 Sargent had begun to arrange his artistic emigration to England. He painted the portraits *Mrs. Alice Mason*[51] and *Mrs. Edward Burckhardt and her Daughter Louise*,[52] in which neither his audacity nor the Velázquez charm of a breathing presence are to be seen. He showed the first at the Royal Academy that year, and Claude Phillipps reviewed it in *Gazette de Beaux-Arts*.[53] Already Sargent held the lease on Whistler's former studio in Tite Street, Chelsea, where his most stable residence and workshop would be for the rest of his life. He was *hors concours* for the Salon, able to hang what he pleased without the jury's approval, and he sent in the double Burckhardt portrait for 1886.

The regular reviewer of the Salon for the *Journal des Débats* was Charles Clément, who handed in annually a workmanlike eight articles between *vernissage* and mid-June. But in 1886 Clément was called away from Paris by family necessities. A disaster, wrote the *Débats* editor, for the Palais d'Industrie was packed solid: "2,488 paintings; 1,279 statues, bas-reliefs, and busts; 927 drawings, cartoons, watercolors, pastels, and miniatures; 46 engravings on medals and fine articles; 302 etchings, copperplates, and lithographs; and 174 plans, wash drawings, and architectural restorations."[54] André Michel bravely stepped in to sort out this warehouse of jumble, delivering eleven articles before 19 June. He found much to praise, including *Vision antique*, *Inspiration chrétienne*, and *Le Rhône et la Saône* by Puvis de Chavannes, and work by Puvis's pupil Ary Renan, son of the historian of religion Ernest Renan; also Max Leenhardt's *La Pastorale*, "bathed in such a fine blonde light."[55] The exhibition catalogue listed, in Room 10 (the first stage of a complete circuit of the Salon), "John Sargent, Portraits des Dames." It was that double portrait, *Mrs. Edward Burckhardt and Her Daughter Louise*, and André Michel got around to it on 28 May in his sixth article, dedicated to portraits. If he gave Sargent short shrift (thirteen words), we must remember that most of that mountain of art got no shrift at all: "We have to warn Mr. John Sargent that he is not making progress."[56] Written like a junior art-school report, possibly with a wink that only Sargent would see, and true only as narrowly applied to the painting in view, where Louise Burckhardt, the charming, wry *Lady with a Rose* of 1882, had become a positively dour spinster in spite of her flaming red attire, and it was her mother who wore mourning and looked interesting.

Sargent was already beginning to flourish in England when André Michel visited London for the first time in 1887.[57] Did the two men meet, and did they establish an artistic sympathy, or deepen one that had begun in Paris? It seems likely. Sargent showed *Mrs. William Playfair*[58] and *Carnation, Lily, Lily, Rose*[59] at the Royal Academy summer show in 1887 and neglected Paris that

year; but the next year he sent *Mrs. Playfair* to the Salon. It was as if André Michel had been waiting to be enchanted again as he had been six years before by *Lady with a Rose*. The very last words of his *Gazette* articles on the Salon of 1888 were a credit and a joy to Sargent and to himself.

> Mr. Sargent signed one of his most delicate works the day he finished the portrait of *Mrs. Playfair*. She is dressed for a ball in a white satin gown, trimmed with lace, with a full dark green velvet cloak lined with pink casually thrown over. Her head and shoulders are bathed in a light on which mother of pearl and pale amber lights seem to play. Everything is indicated with a supreme lightness, charm and distinction. And it is light, the gentle counselor of all fine painting, which shows its benign magic here.[60]

Anchored in Tite Street, Chelsea, John S. Sargent made his living, then his fortune, by painting portraits, over 350 of them between 1886, when he transplanted himself from Paris, and 1907, when he declared an end to his service in the "pimp's profession" by finishing a self-portrait that he owed to the Uffizi.[61] His original location on the ground floor of 33 Tite Street, a three-story block of rented studios, proved insufficiently grand for the quality and number of his sitters, and in 1901 he bought the building next door, number 31, and broke a doorway through from his studio in 33. Both buildings had been purpose-built in 1880 with "luxuriously fitted out studios," aimed at attracting artists to the newly created and developing Chelsea Embankment area, where real estate was still more reasonably priced than in the adjacent "West End and its picture-buying public."[62] Sargent's studio was a landmark in artistic and fashionable London. Oscar Wilde, who lived across the street, recalled the Shakespearian diva Ellen Terry arriving in costume: "The street that on a wet and dreary morning has vouchsafed the vision of Lady Macbeth in full regalia magnificently seated in a four-wheeler can never be as other streets: it must always be full of wonderful possibilities."[63] One of Max Beerbohm's amiable caricatures of Sargent shows him at the window of number 31, gloomily counting a queue of six fashionable ladies who have come to sit to him—and uniformed page boys holding the places of four more.[64]

Between sitters, he dined out incessantly and cultivated the friendship and careers of artists and musicians. Some of his sitters came into the circle of Sargent's close friends: Isabella Stewart Gardner, the flamboyant Boston art collector and patron, and Mary Hunter, the similarly inclined wife of an English mining baron; and some brought their entire families: the Fairchilds of Boston and later the Sassoons of London. He summered in the Cotswolds

and later in the Alps with select groups of artists and their families and friends. He traveled to the United States and established a similar style of profitable work and artistic highlife there.

In January 1888 FitzWilliam Sargent suffered a disabling stroke, and when John returned from America in early June, he was shocked to think that he could have been on the other side of the Atlantic when his father died. He leased a house for the whole family at Calcot near Reading and took care to be constantly near his father there, and later at Bournemouth, where FitzWilliam was hospitalized. "The day's work over, John would take his father's arm, and with quiet care lead him from the dinner table, to talk until time for bed. 'I am going to sit and smoke,' the old man repeated night after night, 'with my son John,' an obvious pride in his weak voice never failing in the repetition."[65] John had already taken on the role of head of the family by gathering it around him in England. But 1889 brought an invitation to join the jury of the Salon, and he was in Paris on 25 April when his father died at Bournemouth.

Enter Violet Sargent, in a Punt

A charming witness to the personalities and relationships of Sargent's world was a young American, Lucia Fairchild, the daughter of Charles Fairchild, whose wife Elizabeth or "Lily" Sargent painted in Boston in 1887.[66] The next year, at age eighteen, Lucia with her older sister Sally visited Broadway in Worcestershire.[67] They stayed first with Frank and Elizabeth "Lily" Millet, then with the Sargent family at Calcot. Lucia admired the sweet-tempered Emily, patient caregiver of her parents; and, an accomplished painter herself, she became a fervent admirer of John and the close and confidential friend of his sister Violet, also eighteen that year. In her letters home Lucia gave quick and lively pictures of Violet, a serious developing pianist and a dutiful model in service to her brother's art.[68] The nucleus of the Broadway summer colony was the house of Frank and Lily Millet; Lily's birthday in September was an annual feast day. Fred and Alice Barnard and their daughters Dolly and Polly (the models for *Carnation, Lily, Lily, Rose* in 1885 and 1886) were back in 1888. Henry James, Paul Helleu and his wife, and the young American painter Dennis Miller Bunker were frequently in the party at Broadway or Calcot. Lucia Fairchild plunged happily into this artistic idyll and recorded it for her family back in Boston.

> Broadway [n.d., 1888]. Since I last wrote Sally and I have been staying at the Sargents' [at Calcot] and have done a lot of "shopping." . . . Our visit to the

Sargents' of course was much more than that, really the pleasantest week of the whole summer, it seems to me, for not only Mr. Sargent himself but all the family are delightful, and instead of putting themselves out for us they let us quietly drop into their ways, and treated us like members of the family all the time. The poor old man, Mr. S., is very ill, having had a paralytic stroke or something, and being deaf and a little wandering from it, but they speak of him as better than he has been for some time. Violet and Emily are the two girls, Emily 30 or over, and slightly deformed, and Violet only 18, very pretty, and almost as charming as her sister. They both sang and so did [Dennis Miller] Bunker who was staying there, so every evening almost we tried glees and so on, so that, having dinner at 7:30 we never got to bed before 12. We used to paint all day and play tennis in the twilight—rather difficult at times to see the balls, but what of that?

Now at Millets' [Broadway] for Mrs. Millet's birthday [18 September]. . . . Violet is coming down tomorrow to stay as long as Sargent will let her with us, but that is only a day or two, as she figures in his pictures, and he wants to go on.

Friday September 21, Broadway. Violet goes tomorrow [to Calcot] to our sorrow, and I really think, to hers, but Mr. S., while she poses for him is the most greedy of brothers, and insists on her return so that he may be able to get on with his picture. . . . [recounting Lily Millet's birthday party on 18 September:] We sat down 20, all most glorious in wreaths, and Sargent looking more handsome than you can imagine, and after it was over Geoff Barnard came in and we danced or played dancy games until 2:30, a few of the men staying 'til 4. It got to be a great romp finally, the men all took off their coats and everyone did what they felt like, but I think I never enjoyed anything more in spite of Sargent's and Mr. James' going off to bed when all the rest felt they were but just beginning. It is grand to be thrown in this way with that crowd—your "queer friends." And Neil in a speech to Violet yesterday expressed a certain truth thus: she said something about "What fun it must be to have a lot of small brothers"; "Ah," said Neil, morosely, "you'll soon find out what idiots we all are."

October 21, 1888 [Lucia was visiting the Sargents in Chelsea]. Before the gentlemen came in, I had been drawing a head of Violet; and I had to finish it under Sargent's critical glance, and Mr. H[elleu]'s too. They said "très ras-semblante."

October 29, 1888. Violet is still posing in the punt, but he allows her to wear two jerseys under her dress so she is just kept alive enough to go on. But she must be awfully cold, there is a frost here every night.

Wednesday [at Broadway, with the Helleus]. I found Violet waiting for me to walk with her, so we went around our old circuit and got back very cold and late to breakfast. Violet was obediently in her 'Arry dress, which pleased Sar-

gent and for almost the first time that summer she didn't have to change. . . .
Violet nearly froze as she posed. She put on great thick, knitted mittens, and
two jerseys, and a rug under her skirt, and we all got so cold Sargent went back
for some Chartreuse, after an hour or so of it, and then, the gentlemen liking it,
somehow both arranged to spoil their drawings, and shocked Nurse—by laying
it all to the wine. "Mais je ne vois plus de contours," Sargent said, and they
both repeated that to Nurse and Emily, who came around to inspect just before
lunch. Nurse believed it actually, and said "The Hidea," looking really angry.

Abashed by that episode, Sargent relented. In the finished picture *Autumn
on the River*[69] (Color 1) black fur envelops Violet's upper half and a brown
rug the rest, her arms are sleeved and her hands gloved; but she still wears
the little blue-green sketch of a hat from that summer.

Sarge suddenly seized my pencil and called out "Don't move," just as I was
most uncomfortably bent, and drew me swiftly down in my own book, signing
it thus which is his caricature for himself.[70] . . . Violet—she sings "Ouvre tes
yeux bleus,"[71] but she has gotten so shy of singing she would only do it before
the Helleus came down to dinner. . . . It was impossible not to get occasionally
cold, especially Violet who had on a thin dress and who was not allowed her
shawl and mittens as the tyrant Sarge was working on her arms.

Tuesday 21 November 1888. He [Sargent] has ordered V. up to Bournemouth
where she is to be painted, and I call it unkind of him not to allow her to be
done here instead, as she wishes; but after all it is true he himself has to be with
his father—Violet is more charming and dear than ever and sang sweetly last
night, "Chanson de Florian"[72] and "Ouvre tes yeux bleus" and then . . . Violet
did a little water color "all for chic—how John *would* hate it!"
 Violet has promised Alma Stehte [Strettell] to do five-finger exercises one
hour a day and I did them with her Wednesday from 9 to 10:15. . . .
 Besides poor V. caught cold and had another rheumatic attack in the after-
noon, so that all she could do was lie and knit mittens till tea-time and groan
over the stupidity of our walk.

In Lucia's brisk and eloquent journal Violet is scatterbrained, prone to
colds and rheumatic attacks, a bit oppressed by her big brother's artistic
demands, but always charming, lively and brave, ready for whatever that
wet winter of English country life had to offer. Eventually it was the village
bellman crying "Lady's jewel stickpin lost on the meadow path to Russell
House, reward!"

Thursday November 22, 1888. . . . We set out to walk to the town. It was very,
very windy and rather cold, but till we got there it seemed great fun, we not

having felt the full force of the wind. Then however, off flew Violet's hat, my umbrella went inside out, the clouds were so thick we saw no view and the number of stiles coming back across the fields so disgusted V. that she was almost reduced to tears (literally).

We had just reached home when Violet discovered she had lost a long stick pin from the front of her dress and came to me in great distress to consult as to what was to be done, finally choosing to have it cried. And moreover we walked all the way down to Russell House again, backwards, so as to keep the lamp from blowing out (which it only occasionally had that effect) and looking everywhere along the ground for it, escorted meanwhile by all Broadway's rustics and two women from the Lygon Arms with a lantern—only to have it sent up to us, in a sweet note from Mrs. Millet at about half past nine. . . .

I can't tell you how very fine and splendid Violet's character now seems to me—I used to think of her as extremely amusing and dear and all that, but as missing the grand qualities which both Sarge and Emily have; but since this visit I admire her more than almost anyone I know, and I have put her distinctly on my list of people to be followed.

[n.d., 1888]. At about 9 o'clock after Nurse and I had eaten all the dinner, through the roar of the elements we heard a carriage drive up to the door and the next moment in rushed Violet, as sweet and charming as ever, and very properly apologetic for none of them having let me know their train. We managed to find a pigeon pie and some veal for her, and the "Woolwich Infant" (as she is called at home)[73] did ample justice to the meal, and then rushed to the piano and set her and myself down to five-finger exercises til eleven (Sargentesque hour), and then talked in my room for an hour more. She is five-fingering now, which is not inspiriting, and has sent her love.

Sarge is looking very fine and big, as usual, and is about to do a portrait of V. "a serious full length."[74]

At some point in 1888 Violet began to be courted by Francis Ormond, the footloose son of a Swiss cigar magnate. The widowed Mary Sargent disapproved of the connection, but "I won't be an old maid," Violet declared, and so, in order to distract her from Francis and to introduce her to eligible Americans, John, now head of the Sargent family, sailed with her for New York on 4 December 1889. They were away for a full year, during which Violet or Francis Ormond or both were expected to lose their urge to be together, assuming that it was not serious or well founded. Violet began her first visit to America in Boston with the family of Charles and Lily Fairchild in the mansion at 191 Commonwealth Avenue that the Fairchilds divided with Henry Lee Higginson, founder of the Boston Symphony Orchestra. The Fairchilds were wealthy and prominent in Boston society, artistic rather than conventional in their values and the company they kept. Sargent's third and

most serious portrait of Robert Louis Stevenson was painted on commission for Lily, Stevenson's admirer and once his hostess at Newport.

John had portrait commissions to fulfill and his American artist friends to cultivate, and for these purposes he made New York his base. In February he went to a performance at Koster & Bial's Music Hall by the "Spanish Gypsy" Carmencita, whom he had first seen dance in Paris.[75] He resolved to paint her, and when he mentioned Carmencita to Isabella Stewart Gardner, she wanted to have a private studio performance, perhaps even to have her beloved *El Jaleo* come to life with music. John's New York studio was too small and, with only two gas jets, too dim for an evening party; but William Merritt Chase had as a studio the street-level gallery of the famous Tenth Street Studio Building, and when Sargent asked him to share it with Mrs. Jack, Carmencita, a supper, and a very few friends, Chase set the date: Tuesday 1 April 1890. After some initial noisy cross-cultural contretemps (Carmencita's stage-Gypsy business), the party was a smashing success.[76] Carmencita danced to the music of guitars, including Violet's—documented by the bronze bas-relief portrait of her by Augustus Saint-Gaudens, who met her that night for the first time. John repaid Saint-Gaudens with the charming double portrait of ten-year-old Homer Saint-Gaudens with his mother in profile behind him, reading him the story of a battle at sea to keep him from fidgeting.[77]

The Players and the Boston Public Library

One month after the Carmencita soirée, Sargent began the discussions that would end in the most important commission of his career. The revered tragedian Edwin Booth had recently bought a house in Manhattan, at 16 Gramercy Park, to be home for himself and for the Players Club that he intended to found. The club was incorporated on 7 January 1888 with fourteen charter members including Booth himself, the equally famous comedian Joseph Jefferson, their fellow actor Lawrence Barrett, and notable non-players General W. T. Sherman and Mark Twain. In January 1890, on the commission of Jefferson, Sargent painted Booth standing before the Players Club fireplace, over which the painting long hung.[78] The portrait of Lawrence Barrett (whom Sargent had met in Paris in 1884) was also done in 1890.[79]

On 7 May 1890 Sargent joined Augustus Saint-Gaudens and his friend from the Broadway summers, Edwin Austin Abbey, at The Players to dine with the famous architects Charles Follen McKim, William Rutherford Mead, and Stanford White, and to discuss mural decorations for the new Boston Public Library. The architects, hired in 1887, understood their task to be the creation of a republican temple of culture and intellect, a building

that would worthily house a treasury of knowledge and written civilization, open to the whole public. The building was then under construction in Copley Square, the public focus of the new Back Bay, built on land reclaimed from the mud flats of the Charles River. The Library was rising to the right of the Museum of Fine Arts in its original Gothic Revival home and facing the "Richardson Romanesque" Trinity Church across the Square and just across Boylston Street from the Italianate New Old South Church. The library would become the serenely elegant classical focus of that cultural ensemble, and McKim had been given a free hand to embellish the building worthily with marbles and mosaics, bronze doors, sculptures, and murals; it was to be "the greatest combined work of the architect, painter and sculptor ever achieved in America up to that time."[80] McKim was taking a chance on the two young expatriate American artists: Abbey and Sargent were not yet muralists. But they were ready to seize the opportunity and take on projects that would be highly challenging and public, potentially to be counted among the great mural programs of Western art.

The architects asked if Abbey and Sargent would consider taking the themes of their murals from the two precious special collections already in the Library: Thomas Barton's collection of Shakespeare folios and quartos, and George Ticknor's select library of Golden Age Spanish literature, and in principle the painters agreed. They both praised the public mural work of Puvis de Chavannes, but no one at that dinner would think of assigning the French master a subject. One week later McKim brought Sargent and Abbey to another dinner meeting in Boston with the Library trustees, where they made oral agreements on their projects. Abbey had changed his mind: he would paint the Grail Legend in the second-floor Delivery Room. Sargent would do the end walls of the third-floor hall that led to the Special Collections rooms. He took the measure of his walls and immediately began planning to fill them. In the course of that summer he also shifted to a more universal and challenging subject, and his first formal contract (in January 1893, for $15,000) named the program *The Triumph of Religion*.

Sargent's idea for his *Triumph* was not to picture the glorious celebration of a conquest, but to make his own contribution to the dramatic European tradition that included Carracci's *Trionfo di Baccho ed Ariadne* in the Palazzo Farnese in Rome and Carpaccio's *Trionfo di San Giorgio* and Coli's *Trionfo di Minerva*, both in Venice. The Boston Public Library mural series was sometimes called *The Progress of Religion*, sometimes *The Pageant of Religion*. As applied to paintings, the three names all mean the same: a narrative parade of allegorical images. Sargent himself usually called his program "the Library

decoration," by which he did *not* mean a prettification. For him the summit of artistic achievement was the monumental decoration of a public building with pictures that were beautiful, suitable, and worthy of the place, such as Puvis de Chavannes's in the Paris Pantheon and Carolus-Duran's in the Luxembourg Palace (where Sargent himself had assisted).

McKim went to Paris in 1891 to persuade Puvis to decorate the walls and the loggia of the grand entry stair, and finally contracted with him in July 1893 for a quarter of a million francs (about $50,000) and a completely free hand.[81] We can account for the great difference in fees by remembering that Sargent was a newcomer to mural decoration, willing to oblige the other artists and the architects, and responsible for a much smaller expanse of wall, while Puvis was a famous veteran of the craft and reluctant to take the commission.

Late in the summer Sargent was visiting the Fairchilds in Newport and then at Nahant, where he painted a portrait of Violet that hangs in the Isabella Stewart Gardner Museum (Color 3). She looks rather odd until the viewer realizes that she is blushing and singing, perhaps "Ouvre tes yeux bleus" with repeats *da capo* so that her demanding brother could get the mouth quite right.[82] In September Sargent went south to a Cape Cod house party. Joseph Jefferson was warming his grand new mansion, "Crows' Nest," on the eastern shore of Buttermilk Bay (a northern appendix of Buzzards Bay) with a continuous party through that summer of 1890. The house was Jefferson's own design and, like The Players, a trophy of the success of the American professional theater. The main entry door was flanked by life-size portraits in stained glass of Edwin Booth as Hamlet and William Warren as Falstaff.[83] Booth himself, silent and fragile as his glass image, came in June. Jefferson was an accomplished landscape artist, with a purpose-built new studio over the stables and a new Dutch-style windmill from whose gallery he could enjoy views of forests, water, and salt marshes as far as Plymouth, twelve miles north, and Woods Hole, fifteen miles south.[84] It was there that Sargent painted his two oil portraits of Jefferson, one in the character of Peter Pangloss in *The Heir-In-Law*, an 18th-century comedy that Jefferson was reviving in New York, the other an intimate oil sketch.[85] Jefferson was experimenting in monotype, and Sargent made one print on the press in the Crows' Nest studio, *A Dream of Lohengrin*, after a performance by the Metropolitan Opera of New York.[86] Sargent became fond of Jefferson during his acquaintance in New York and Buzzards Bay. When Jefferson was being buried at Sandwich, Massachusetts, in 1905, Sargent arrived, on the private rail car of the governor of New York, just in time to stand in silent recollection at the grave before it was filled.

Sargent's brilliant successes of 1890 in the United States did not include finding an American fiancé for Violet. They sailed back to Europe at the end of December.

André Michel and the History of Art

In those last years of the nineteenth century André Michel, like John Sargent, was rising to the top of his profession. Or rather, professions: without ever ceasing his work as a journalist, tracking modern art and art's modern public, he earned favor in the academic world by his knowledge of the history of art and his facility in explaining it in public lectures and in articles for Gabriel Monod's *Revue historique* beginning in 1883. That favor brought him increasingly honorable academic posts and increasingly onerous projects of research and publication. On the register of his son's birth in 1884 he designated himself merely as *publiciste*, though he was already a substitute professor of art history at the Ecole Speciale de l'Architecture. That professorship was his with its full title from 1887 to 1893, and he was traveling again, preparing himself for a new specialty in the history of sculpture. Louis Courajod, conservator of the department of sculptures in the Louvre, a former student of law, of the Ecole des Chartes and of the Ecole Pratique des Hautes Etudes, and a regular contributor to *Gazette des Beaux-Arts*, knew André Michel, his training, and his capacities, and chose him as adjunct conservator in 1893. When Courajod died in 1896 André Michel succeeded him as conservator and held that post, and the professorship in the Ecole du Louvre that went with it, for twenty-four years.

In 1896 the publishing house Armand Colin recruited André Michel to direct a monumental multivolume history of Western art from late antiquity to the present day. The design of the work was relatively easy because Michel did it all himself: the allotment of space to epochs and regions, media and national traditions; the structure of each volume; and the standards and rules to be followed in the layout of the pages and the proportion of illustration and bibliographic citation to expository text. Getting authors for the articles, specialists who knew their own subjects down to the ground and up-to-date and who (nevertheless) would agree to conform to the spirit and design of a whole volume—that was a fierce struggle in management and diplomacy. And when it was accomplished, when a whole team had been assembled, briefed, and put under contract, there arose a difficulty that Michel, veteran journalist that he was, had not anticipated: that herd of cats could not be made to keep deadlines.

The detailed agreement between the publisher and André Michel was signed on 24 August 1897. A month later he wrote from the *Mas du Ministre* to Max Leclerc that he had aged ten years since signing "The Paper." To his family he called it his death warrant. The first fascicle (not even the first volume) only appeared in February 1905. But Michel persisted, and before he died in 1925 seven tomes had been printed, each in two volumes, and the eighth was in proof.[87]

While the first authors of the *Histoire* were busy researching, writing, and procrastinating in the winter of 1903, André Michel arrived in New York aboard the steamship *La Touraine* for a herculean lecture tour of the northeastern United States, arranged by the insurance heir and generous francophile James Hazen Hyde, who had founded the American branch of Alliance Française and endowed the chair of French Literature at Harvard.[88] The tour began with a dinner and reception in Cambridge honoring the French ambassador M. Jusserand, the cultural entrepreneur Hyde, and the lecturer Michel. The following evening and the next week, he gave twelve free lectures on the history of French art, illustrated by *projections photographiques*, in Huntington Hall of the Massachusetts Institute of Technology; then at Harvard, a lecture on Reims Cathedral. He packed his days with visits to "the delicious colleges nestled in their countrysides," Harvard, Dartmouth, and Williams. Because he had four intellectually and morally vigorous daughters, aged ten through twenty-two, he was particularly interested in the famous womens' colleges. On 9 November he spoke at Wellesley on "The Transition from the Middle Ages to the Renaissance."[89] Two days later it was "French Painting in the 19th Century" in Chemistry Hall of Smith College. The anonymous college reviewer gives us a picture of Michel as platform historian.

M. Michel said that in order to show the logical development and moral significance of contemporary art he must trace it back to the early part of the nineteenth century. The period between 1800 and 1820 was characterized by a distinct reaction toward classical models. . . . [David] lacked individuality, striving alone to discover the beautiful. . . . Meanwhile the revolution brought gradually a new element into art. It emphasized the personal and thus made art more real [Delacroix, influenced by Ingres]. . . . The natural outgrowth of this desire for the personal was an attempt to get at the truth [Courbet]. . . . Out of the realistic was developed the famous school of landscape painters sometimes known as the school of Fontainebleau [Corot]. . . . The whole world was a work of love [Rousseau]; . . . a tone of sadness and unrest [Daubigny], . . . the wild beauty of peasant life [Millet], [painters] who not only give the realistic touch of nature, but also express the emotions of

the artists. . . . Meissonier . . . followed popular taste . . . thus not creating as true an art. . . . Chasseriau, by his beauty and harmony influenced Moreau, whose pictures have a certain melancholy which arises from a spirit of too much introspection. . . . Puvis de Chavannes followed Moreau only in his technique. He was preëminently a mural painter. He always tried to represent the essential in his work. . . . He combined the best elements of the classic and romantic schools in his art. His decorations in the Boston public library well represent the peculiar genius of this greatest artist of the century.[90]

We can imagine his enthusiastic wind-up, describing the work of Puvis de Chavannes with that graceful local reference to the Boston Public Library murals. Michel was charmed by his Smith and Wellesley audiences, "the young girls, their appearance, their bearing, their number. So many understood French, and not a few spoke it well!" His report to *Journal des Débats* gives the state of the art at the Boston Public Library:

I couldn't wait to see again the paintings of Puvis de Chavannes: *Les Muses accueillant le Génie, messager de lumière; Les Bergers chaldéens observant les astres; Homère; Virgile; Eschyle; La Physique; La Chimie,* and the rest. You have not forgotten them, have you? So I don't need to describe them. But what joy I felt to see them again, those noble and beneficial messengers of French genius. They have been affixed in a setting of marbles that are a bit too stark; but the library remains open free until ten at night, and by the electric light, admirably and discreetly arranged within the moldings of the ceiling, all the harshness is softened, and the blues play in a delightful way with the placid ochres, and there is a great harmony of poses, simple and pensive, and of admirable landscapes grandly imagined, that quietly invites us to contemplation and dreaming. . . .

The painter Abbey was invited to paint the story of the Grail in the hall where readers come to pick up and carry home their borrowed books. These murals, which resemble miniatures that have subsequently been enlarged for their monumental purpose, have been conceived with a fervor, and executed with a conviction, that make them thoroughly persuasive. . . .

The painter Sargent has begun a great biblical cycle which will count among his masterpieces, but it mostly remains unfinished. Nothing is more unexpected, less like what we know of him. On one side, filling a large tympanum, the vault and the walls below and beside it, there unfolds a symbolic representation of the Old Testament. The Hebrews have turned from Jehovah and Jehovah has delivered them into the hands of their enemies. To the left a Pharaoh, a Chaldean king to the right (both exact and archaic copies from the British Museum) strike deliberate and heavy blows on the Hebrews, who reach out their arms in despair toward the menacing hand of the vision that appears to them in the clouds. Below, in a long frieze, the prophets lament,

enveloped in heavy drapery (distant cousins of those on the Moses Well of Claus Sluter), to the right and left of a wrathful Moses who stands out in relief, as if carved in stone. In the vault, the false gods to which the faithless people sacrifice: the monster Moloch, the goddess Neith, mother of the universe, carrying the firmament upon her breast and the zodiac as a collar, with the eastern dragon twined in her hair, and Algerian Astarte, symbol of masterful and triumphant sensuality. A notice printed in fifty copies and placed at the disposition of the visitors, always numerous, attentive and considerate, informs them that here is a "cosmic conception of wonderful grandeur." And in fact, if there is a lot of confusion there, and if we need rather too much time to set ourselves straight in the midst of these tangled and violent forms, there is an unarguable power here that leaves us many recollections. Opposite, there is the Trinity and the angels. On the side wall, we await a "Sermon on the Mount" and other Gospel scenes.[91]

New York was Michel's base for the rest of 1903. There he gave ten different lectures at seven different halls, interspersed with flying visits to Baltimore, Philadelphia, Princeton, Nashua, and Buffalo. "Subject to the severe regimen that the Alliance Française reserves for its lecturers," he complained to *Journal des Débats*, "I will leave this country without having seen any of it but what can be glimpsed from the window of a Pullman car or from atop the platform of a lecture hall." When he sailed away on 28 January 1904, he had delivered seventy-three lectures from his prepared stock of about a dozen.

Their professional activities kept Sargent and Michel in touch, and fate and their families eventually made them in-laws, as Sargent parenthetically noted to his New English Art Club colleague D. S. MacColl on 6 August 1913.

I have given a card of introduction to you to M. André Michel one of the "Conservateurs des Musées Nationaux" and more particularly the head of the department of Renaissance sculptures in the Louvre. (His son is marrying my niece Rose Marie Ormond here today.) M. André Michel is probably going to London for a few days at the end of August or in September, one of his reasons being that he has promised to write something about the Wallace Collection. He is anxious about the chance of its being closed on account of Suffragettes or for some other reason. If there is any fear of this would you be so good as to drop me a line soon to 31 Tite Street (I am returning there tomorrow), and I will let him know. Also is it likely that you will be in London at this time? M. André Michel is a very agreeable man, as well as a very capable one. I shall not be in London, after the next three days, until the end of November.[92]

CHAPTER TWO

~

The Ormonds and the Sargents

The mutual attraction of Francis Ormond and Violet Sargent survived their year apart, her two ocean voyages, and her brilliant American debut. Their wedding took place in Paris on 17 August 1891. The marriage of Rose-Marie's parents brought together two families from different worlds. Dynamics within the Ormond family caused the children to be separated, and Rose-Marie grew up francophone, raised by her grandmother Marguerite Ormond in palatial homes in Switzerland, Italy, and France.

The Ormonds of Vevey, Paris, and Sanremo

This Francis Ormond was the only child of a Swiss cigar manufacturer, Louis Ormond (1828–1901), and his much younger French wife Marguerite Renet (1847–1925). It is to her that we owe some details about Francis's notable immediate antecedents, framed and focused by her viewpoint and selective memory.[1]

Francis's father, Louis, was the only son of Marc-Etienne Ormond (1782–1854?) of La Tour-de-Peilz near Vevey on the north shore, Lake Geneva in Canton de Vaud. A violent and imprudent man, he gave his wife, Jeanne Ruchonnet, no joy. She was a pious Protestant, "dignified, patient, kind, modest, sensitive, endowed with perfect kindness," as her daughter-in-law Marguerite wrote. "Her motherly love knew no bounds for the son who never gave her anything but honor and satisfaction." The family was prosperous, and Louis was educated from the age of six at strict boarding schools near

his home, and then from eleven to sixteen at the Château de Lucens.[2] He recalled that he had been hungry the entire time he spent there. "His companions hit upon the idea of buying chocolates and pastries in the village, at the peril of their lives, by letting themselves down from the high walls of the château on a rope." Regardless of his hunger, the novelty and romance of his life at the castle impressed on him a passionate love of reading and history. After boarding school he began training at a banking firm. He showed such competence and business sense that at the age of eighteen a court gave him power of attorney over the affairs of his mentally disabled father. In those years he developed a love of excursions into the countryside and began to make the acquaintance of artists, including the young painter Marius Steinlen (1826–1866). Unlike André Michel, who yielded to his passion for the arts and abandoned the career in law that he had dutifully prepared for, Louis Ormond, while keeping his intense interest in the arts alive, put his training and expertise into business successes one after another. He became, in the gilded age of entrepreneurs and industrialists, the kind of person whom Sargent found among his great clients.

But Louis inherited little more from his father than a large vineyard.[3] He transferred to Paris and took a position with the banking and management house of Thomas, which sent him to Avignon to consult on financial issues regarding the future development of the Paris–Lyon–Marseille railroad. He was so successful in that position that in 1852 he was able to buy half-ownership of a cigar factory in Vevey, where his widowed mother resided. The local economy was still primarily rural, but small industries were beginning to emerge. In the next decade, with a growing population of workers drawn there from the countryside, Vevey also became a center of chocolate production; it is still the headquarters of the most successful *chocolatier*, Nestlé. Louis's partner died in 1854 and the business became Ormond Cigars. Their fine products, *Vevey-longs*, *Vevey-fins*, and especially *Vevey-courts* in packets of twenty, were welcome in markets as far away as New Zealand. George Sand, herself a notorious cigar smoker, described the contemporary vogue for cigars without exaggeration: "The cigar is everywhere. It is the indispensable accompaniment of every leisured and elegant life. Any man who does not smoke is an incomplete man."[4] In his earlier years Sargent smoked cigars constantly—he is said to have *eaten* his cigar to entertain Carmencita and coax her into keeping her pose.[5] On that tide of addiction and fashion the Ormond firm grew steadily, employing over a thousand workers by the turn of the century, and with its growth the family's fortune and influence steadily mounted. Louis became a deputy in the grand council of the Canton de

Vaud, a founder of the gas company of Vevey, and president of the Western Swiss Railway Company.

In April 1865 Louis Ormond, by now established as one of the major businessmen of the area, met Marguerite Renet at a service in the Protestant church of Petit-Saconnex, a rural village then, just north of Geneva. Marguerite was an elegant Parisian lady of eighteen who had been sent to Geneva by her family to complete her education. She was staying with her maternal uncle, an extraordinary gentleman, Ernest Griolet de Geer, who, although deaf and mute from birth, had become an accomplished amateur archeologist, historian, and numismatist and a serious alpinist with a delight in travel.[6]

Marguerite's memoir reveals little of her own life and upbringing, but makes much of her notable forebears. She was the second child of a marriage between two socially and politically prominent families. It is illustrative of her attitudes that late in life, looking back at her ancestry, she does mention that her maternal grandfather, Eugene Griolet, was mayor of a Paris Arrondissement (it was the Fifth, home of the Latin Quarter, the Sorbonne, and the Pantheon), but not that M. Griolet had made the family fortune in the spinning business and had won gold medals for his innovations in factory production.[7] Marguerite's paternal grandfather, François Renet, was also politically prominent as the mayor of Bercy, now the Twelfth Arrondissement. In the nineteenth century Bercy, on the right bank of the Seine upstream from the Ile de la Cité, was still a separate suburban town. Bercy's wharves and rail station connected it to the vineyards of Burgundy, and merchants there were free from the *octroi*, the excise charged on all goods that passed the *barrière* into the city. The town had become the largest wine depot and emporium in the world. And so MM. Griolet and Renet were two eminences of the Parisian political scene, the mayor of heroic, intellectual Old Paris and the mayor of the vibrant, burgeoning commercial and industrial France of the future. The marriage of their offspring, Jeanne-Julie Griolet and Louis-Adolphe Renet, with King Louis-Philippe himself signing the marriage contract, would have made an allegorical picture worthy of Puvis de Chavannes.

Marguerite's mother Jeanne-Julie (1820–1865) was the second child of the cloth baron Griolet. This lady was the great formative influence on Marguerite, as her memoir tells in detail. Jeanne-Julie was serious, bookish, and pious, and she had the best education available. She preferred the intellectual discussions of men to the usual women's gossip and chatter about fashion and babies. Her daughter observed that she was a strong woman, more typically male than female in temperament and mentality, and, had the times

been different, she would likely have been a *femme scolaire*, a bluestocking. Her one vanity was her beautifully tapered fingers, slightly turned up at their ends. She wore gloves constantly to protect them. At the age of twenty-two Jeanne-Julie Griolet was swept away by a *grand amour* with a debonair banker, a man of the world ten years her senior, an excellent huntsman and yet sensitive, with a refined taste in art, Louis-Adolphe Renet. But the joys of wealth, social prominence, and art were the façade of a bitterly disappointing marriage. Jeanne-Julie learned soon after the wedding of her husband's failings, including his continued attachment to a mistress who had borne him a child, and his permanent disinclination to make his marriage more than one of social convenience.

Their first child, Louis-Francis Renet, was born in 1844, then Marguerite in 1847. The home atmosphere of her childhood was one of thinly veiled rancor between her parents. Jeanne-Julie's self-defense was a stoic toughness; her personal severity inspired "fear as much as respect" in her daughter. She forbade little Marguerite to change her tone of voice even when excited by the pleasure of greeting her friends. As Jeanne-Julie's health declined she composed a sad and bitter testament in which she detailed her sorrows and grievances against her husband and that she left with her lawyers to be given to her children at her death. Although Marguerite knew all her father's faults, she left them unrecorded in her memoir, but she closed her cameo of him with a snap: "He was feeble in character and intellectually inferior to his wife."

By the age of eighteen Marguerite was, by her own testimony, "a charming woman of society, of medium height, with light chestnut hair, her face lit up with clear, large eyes; and her delicate body contained a refined and energetic nature." Louis Ormond fell in love with the pretty, decorous granddaughter of the wool baron, and he proposed urgently, but the girl was naturally unwilling to marry at all. Jeanne-Julie Renet, mortally ill in 1865, knew how much worse her daughter could do for a husband, and urged her to acquiesce. Four months after the proposal the couple were wed, and four days later Jeanne-Julie died.

Louis Francis Ormond (always called Francis) was born on 2 November 1866. The young mother's health, as she tells us herself, "remained thereafter permanently uncertain," and she had no more children. Marguerite's only sibling was a brother who died young that same year, and so Francis would grow up with no brothers or sisters and no cousins. Much like Mary Sargent, Mme Ormond enjoyed a full social life with frequent travel from villa to city to mountains to sea, as the seasons and society called. A year later, in 1867, the cigar magnate enjoyed a particular honor when he was chosen to represent Switzerland as a wine-growing region at the International Exposition in

Paris. Switzerland was one of only five countries recognized at the exhibition for their wine growing, and so Louis Ormond's honorary position was a prestigious one. His official duties involved tastings and jury awards at the wine depot of Bercy. The position brought with it invitations to the official receptions, and at her husband's side Marguerite Ormond returned in triumph to Paris and cast a critical eye on the highest society of the Second Empire.

> At the Tuilleries in particular there used to meet, as they have never done before or since, the crowned heads of Europe: Tsar Alexander II (emancipator of the serfs, who was killed by a bomb in 1881); Wilhelm I, King of Prussia, the future German Kaiser; his son Crown Prince Frederick (whose reign was cut short at one hundred days by throat cancer); General Moltke (mastermind of the German victory over the French in 1870); King Victor Emmanuel II (who realized the unification of Italy); Edward of England (Prince of Wales until the age of sixty); Franz-Joseph (the unfortunate emperor of Austria whose son committed suicide after killing a woman in that decadent country); Leopold II, more King of the Pleasures than of the Belgians; Sultan Abdul Azis Khan, (deposed a little later); and Charles XV of Sweden.[8]

Looking back at the Exposition after a half-century of war and revolution, the occasion seemed spectacular and unique. Even with that perspective, however, Marguerite's eyewitness judgment on the Exposition, "the apogee of prestige for the court of Napoleon III," was severe.

> There was a striking lack of decorum in the circle of Empress Eugénie, that vain Spanish lady, whose fanaticism and lack of judgment brought about the abasement of France four years later and cost her husband Napoleon III his throne. At the opening of the Exposition, Prince Metternich was posing as such a grandee, so at ease in the presence of the Empress Eugénie, that he kept his hands in his trouser pockets while speaking to her. In the salons of the Tuilleries, guests maneuvered about and shouldered each other as if to get near the buffets in a railway station.[9]

The Eventful Childhood of Francis Ormond

Returning to Canton de Vaud, the little family moved into a great house, the Villa Mirabaud at Clarens on Lake Geneva. The factory of Ormond Cigars was five miles away northwest, and halfway there, above La Tour-de-Peilz, was the vineyard of Relliet.[10] Francis, heir apparent of both, grew up at Clarens. Marguerite's father, who moved in with the family, took the toddler on alpine hikes, and Marguerite attributed Francis's robust good health and "iron" muscles to that early exercise.[11]

When Francis was just four, decades of political tension climaxed in the French declaration of war against Prussia. News of the shocking events of the Franco-Prussian War, the quick disaster of Sedan and the surrender of Napoleon III, the declaration of the Third Republic, the decision of the Paris Commune to fight on and the ensuing Bloody Week in Paris (21–29 May 1871) brought fear and worry to the Ormonds. They waited anxiously for news from Paris, where relatives of Marguerite were trapped. Her uncle, the deaf adventurer Ernest Griolet de Geer, had managed to get *into* Paris, voluntarily. There, as usual, the first to suffer in the time of crisis were the poor and the disabled. "When distress began to appear" within the deaf and mute population, Ernest "displayed a tireless activity, moving among them, distributing whatever was needed, either in the form of money, food, or encouragement. By his efforts, many were saved from despair and possibly starvation."[12]

At home at Clarens, the Ormonds offered aid and hospitality to refugees from France, notably the Swiss-born painter Charles Gleyre (1806–1874).[13] Gleyre was a French patriot, outspokenly liberal, and engaged in the day's political debates. He tried to enlist in the French forces in 1870 but was rejected because of his age—sixty-four. As the Prussian army approached Paris he fled to his native Switzerland. There he took on commissions, including portraits of the Ormonds. He did the preparatory work at the villa of Clarens in that anxious autumn. The finished portrait of Marguerite, a pretty matron of twenty-three, confirms the details of her self-portrait in her memoir. She is the image of unbridled decorum, to borrow a phrase from Max Beerbohm.[14] Wearing a fashionable mauve dress with lace at the elbows and modestly glittering with a necklace of pearls and jeweled pendant and bracelets of gold and cloissoné, she sits in a cane-backed chair before a sunny vista of trees that blaze with seasonal foliage, Lake Geneva in the distance and the Alps beyond. She rests her cheek pensively on her hand and looks sweetly out at the viewer, a little smile on her open lips. Louis Ormond's portrait shows him in three-quarter length, handsome and erect, still young, with an aquiline nose, curly chestnut hair, and full beard, turned and looking diagonally to the viewer's left.[15] He holds a walking stick in front of a mountainous vista.

Louis Ormond continued his early interest in the arts as he built his fortune. He especially patronized two Swiss artists. François Bocion (1828–1890), from nearby Lausanne, was known for his Corot-inspired views of Lake Geneva. Albert Anker (1831–1910) of Canton Bern had abandoned his early calling to the ministry to study painting; he specialized in optimistic genre scenes that accorded perfectly with the taste of the new Swiss republic. He would become famous as the Swiss national painter. Louis commissioned him to paint his wife's portrait soon after their marriage.[16]

The Ormonds became well acquainted with the artistic and intellectual elite of both Switzerland and France. Marguerite, inspired by her artistic circle, produced a quantity of poetry and rhythmic prose on various lofty and learned topics over the years.

The couple came to Paris every year in spring or fall or both. They visited Marguerite's phalanx of cousins, second cousins, in-laws, and acquaintances, mainly of the close-knit Protestant élite. They had the entrée to the salon of the leader of liberal republican opinion Hippolyte Taine—his wife, Thérèse Denuelle, was Marie-Marguerite's childhood friend. In the Taines' salon they met such intellectuals and popular writers as Alexandre Dumas *fils*, Gaston Paris, and Ernest Renan, "whose conversation made all ugliness disappear," wrote Marguerite. Another habitué of the Taine evenings was the Hawaiian statesman-turned-author Charles de Varigny. When Charles's children Henry and Hélène both married in 1880, Charles de Varigny became the father-in-law of Marguerite's cousin Blanche Griolet-Meyrueis and also of André Michel. In the Paris seasons there were museums and galleries and opera, concerts and balls, dinners and teas to attend and to give. And there was shopping. Marguerite was a serious connoisseur of lace, embroidery, and gems; her collection is now housed in the Salle Ormond of the Musée d'Art et d'Histoire, Geneva. The top couturiers—Worth, Caillot Soeurs, Paquin, and the chic yet restrained newcomer Jeanne-Marie Lanvin—were showing their latest designs on live mannequins and keeping their best customers' measurements stored on dress forms, so that Marguerite could simply designate the fashions, fabrics, and colors that were to be made up for her.

This was the environment in which Francis grew up: Swiss decorum in a milieu of wealth and privilege plus familiarity with notable artistic, intellectual, and political figures. His pious paternal grandmother Jeanne Ruchonnet, who "confined her reading to an enormous ancient Bible bound in leather," was carried off by pneumonia at the age of 81 in February 1875.[17] His last surviving grandparent, Louis-Adolphe Renet, who had taken him on Alpine hikes as a child and given him an example of brute masculinity, became corpulent and died of a heart attack in January 1877 at the age of 68. But his great-uncle Ernest Griolet de Geer continued to sally forth on his amazing globe-trotting adventures. In 1877, aged 59, he climbed the volcanic Mount Merapi in central Java, which had erupted in 1872. In 1880 he traveled through Siberia.[18] Among his other destinations were Persia, Tonkin, and Japan, and archeological conferences and deaf-mute congresses in France, England, and the United States.[19] His stories may have expanded young Francis's horizons and nourished his thoughts of escape from the big houses where the young man felt caged.

Louis Ormond, in his quest for a climate that would suit his wife's delicate health, bought another splendid home, the Château de Crevin in Bossey-sous-Salève in France, six miles south of Geneva.[20] And in 1875 he found another, even grander, in Sanremo, a fashionable Italian resort on the Ligurian coast. The villa, formerly owned by the noble Rambaldi family, was situated at the top of an olive-tree-covered gently sloping hillside that extended to the sea a few hundred yards to the south. It was this setting that fired the imagination of the couple. Marguerite set about transforming the olive grove into a splendid semitropical formal garden filled with date palms and colorful exotic blooms. An earthquake on Ash Wednesday of 1887 caused extensive damage in Sanremo, and the Villa Rambaldi would have required substantial repairs. Instead Louis and Marguerite replaced it with a much more opulent Villa Ormond.[21] The Swiss architect Emile Reverdin, known for his public buildings including the recently opened Geneva Opera, designed a stately neoclassical villa fronted with white marble loggias serenely overlooking the gardens to the sea. The *piano nobile* is a series of vast rooms with coffered ceilings, parquet floors, dark wainscoting, tapestries, and heavily hooded fireplaces. The great arched doors and windows open onto the startling Mediterranean sun and year-round mild breezes. Over the years Marguerite filled the home with antique and made-to-order furniture, hangings, jewelry and lace, and objets d'art. In short, she created a palace fit to receive and impress the nobles and notables who took the air in season at Sanremo and who accepted invitations to her receptions, salons and teas, dinners, and dances.

Francis was privately tutored in these various homes until, at the age of fourteen, he was sent to the Collège de Lausanne. Stubborn and willful, he put up an unwavering resistance to the idea of following his father in the cigar business, or any other. In 1882, when he was sixteen, he ran away to Canada. He was brought back home by Pinkerton detectives, uncontrite and unreformed by the experience.[22] The industrious and proper Ormond parents could think of no way to control him. Demonstrating his love for his son and a desperate wish that he would settle down, Louis commissioned a bronze bust by the young Parisian sculptor Jean Carriès (a friend of Sargent's).[23] The bust shows that Francis had grown from a sturdy child into a handsome youth of eighteen. Perhaps his wanderlust might find a constructive channel in exotic ethnography, or journalism? Casting about, Louis asked Henry de Varigny, who asked his colleague Jules Héricourt, who said that a man named Richard was planning an expedition to Massawa to report on the colonial squabble between Abyssinia and Italy.[24] There is no evidence that Francis joined that expedition, but he did sail to Tunis, later a favorite spot of his. In October 1889 he was 350 miles south, at Biskra in the Algerian

Sahara, and sick. But he responded to the news that his mother was coming to care for him with a telegram announcing that he was all better.

Marguerite and Louis decided that a proper wife would be the best solution to the Francis problem. It is said that Marguerite introduced Francis to young Violet Sargent with just that idea in mind, and perhaps Violet was only one of a series of young women whom she auditioned for the role of Francis's anchor.[25]

Violet Sargent, Ready to Marry

In her late teens Violet was a pretty young woman, intelligent and candid, a serious pianist and a charming singer. As the sister of an internationally famous and wealthy painter, she would have been considered an unusual but suitable match in many circles. In the summer of 1888, when Lucia Fairchild first met Violet, another guest of the Sargent family, the American painter Dennis Miller Bunker, wrote to Isabella Stuart Gardner, "The youngest Miss Sargent is awfully pretty—charming. What if I should fall in love with her? Dreadful the thought, but I am sure to—I see it coming."[26] And it may have come for Bunker, but not for Violet. Sargent's *By the River* (figure 2.1) shows them both, but not together: Violet's mind is elsewhere.[27] Lucia Fairchild's letters report hours-long chats with Violet but, well aware that her letters would be read aloud to her entire family, Lucia played the sisterly confidante: there is not a hint of Violet's feelings, which had already begun to focus on Francis Ormond. Violet probably met Francis in Sanremo, where the family of Sargent's boyhood friend Ben Del Castillo had a villa and some rental properties close by the Ormonds, and they exchanged visits and dinners.[28] When Henry and Blanche de Varigny dined with the Ormonds on 22 November 1887, Henry sat next to Ben Del Castillo and found him *causeur agréable*. The Ormond and Sargent families with their young members (he twenty-three and she nineteen) probably mingled at the Universal Exposition in Paris between May and October of 1889. Sargent exhibited six oil paintings at the Exposition.[29]

Violet Sargent had a childhood like that of her two older siblings John and Emily, traveling with her parents from one cultural capital to another as the seasons changed, and she was immersed in the world of art from her earliest childhood. But her life was radically different in one important respect. She was the youngest child of the family, born in 1870 when John and Emily were already in their teens and her parents no longer young. While John and Emily had each other as constant playmates and confidants, whose stable, small society protected each of them from a sense of rootless

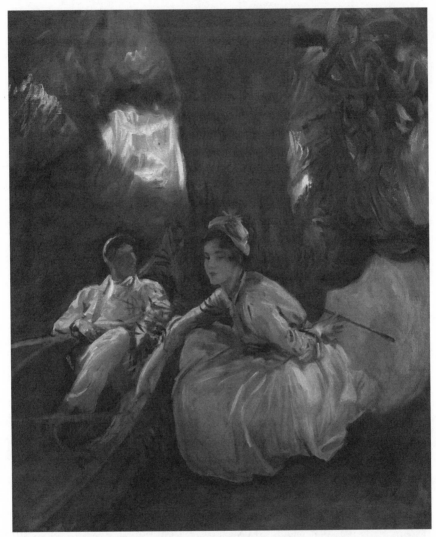

Figure 2.1. Sargent, *By the River*, oil (1888). Dennis Miller Bunker lounges in a canoe; Violet Sargent dreamily holds the gunwale, with her mind elsewhere. Private collection.

loneliness, Violet felt rather like an only child living with adult siblings, no more her playmates than her parents were. They felt the gap of age too: they nicknamed Violet "Baby," and later "The Woolwich Infant" for her hearty appetite.[30] Her offhand comment, reported by Lucia Fairchild, "what fun it must be to have a lot of small brothers," is a hint at how she missed having playfellow siblings. Perhaps that was one attraction of the boyishly irresponsible Francis Ormond.

Violet returned with John from her year in America, quite undistracted from her attachment to Francis. From Marseille, where their ship docked, they set off with Emily and their mother Mary on a major sightseeing excursion, together for the first time since John had taken up the artist's life in Paris and England. They realized that this might be their last chance to be nomads together. This tour was to follow the program of visual archeology that John had set for himself as he began to develop in significant images his ideas for the murals in the Boston Public Library, and so the family headed for Egypt and the eastern Mediterranean. John's original plan for the Library, to picture Spanish literature of the age of Cervantes, had come to seem too narrow, and he had turned his attention to a much more ambitious theme, religion in Western civilization. He was working out a pictorial program based in part on the ideas of the controversial and widely read French thinker, Ernest Renan.[31] On the recommendation of Isabella Stewart Gardner, he was studying deep antiquity in Egypt and the Near East; he had begun to fill up his repertoire of symbolic images of Judeo-Christian religion. The family's planned itinerary led to Egypt, to Greece, and finally to Turkey in search of the background emotion and iconic details that John wanted for his mural decorations. Beginning in Alexandria and Cairo, Sargent pursued his images, then in Upper Egypt: Luxor, Thebes, Aswan, and Philae.[32]

One oil painting that Sargent finished in Cairo had nothing to do with his Boston Public Library research: his only full-length female nude, *The Egyptian Girl*.[33] The model is viewed from behind in mid-step, turning to her left, her weight on her right leg as she plaits her braid, so that her right buttock is tense and high, the other relaxed and full. The great antecedent of the girl's pose is the classical marble *Venus Callipyge*, which Sargent had seen in the Museo Archeologico in Naples. A more immediate inspiration may have come from Sargent's acquaintance with the Ormond family and the artists they patronized. Charles Gleyre, who painted the portraits of Francis's parents in 1870, had traveled to Egypt and the Near East at the very beginning of his career and produced documentary studies of the archaeological sites and exotic locations and peoples, just as Sargent was doing. Sargent knew Gleyre's paintings; probably the most famous, the so-called *Le Coucher de Sappho*, was based explicitly on *Venus Callipyge*.[34] Sargent was following Gleyre's lead in his site research and his nude studies, and exhibiting his mastery of these fields in which Gleyre had excelled.[35]

During the family's sojourn in Egypt, on 9 February 1891, Violet turned twenty-one. That changed things. Even if the laws granted her no rights when she left her minority behind, American custom and the mutual respect

within the family allowed her to make her own choices for her future life, including the choice of a partner to share it.

Sargent left the ladies in Cairo and pursued his research in a camelback expedition to see the Bedouins of El Fayoum in late March. He returned with stacks of watercolors and sketches of everyday Egyptian scenes, and especially studies of local characters, the Egyptians and Bedouins who suggested ancient Semites in their robes, headdresses, and turbans. The family then set off for Greece, where John again left his mother and sisters in comfort in Athens while he pursued the picturesque and the evocative in horseback trips to Olympia and Delphi. One imagines the conversations about the future as Mary Sargent and her daughters toured the sights of Athens and worked diligently over their own sketch pads. The final leg of the expedition brought the family to Istanbul, where John made studies of the interior of Hagia Sofia, the sixth-century Byzantine basilica converted into a mosque. The entire family was back in Paris by May.[36]

Realizing that Violet was now able to direct the course of her own life, Francis Ormond made her a serious proposal of marriage. Her protective and worried older brother John knew that she would accept, even if she had to elope, and he made his own plans for the linking of the families—he was not contemplating "giving her away." He discussed his plan with Lucia Fairchild and her parents as they toured the Louvre, probably on 14 June.[37]

> Sunday morning Sargent came, and went with all of us to the Louvre. He was looking wonderfully handsome and tanned and rather thin, with the Legion of Honor ribbon in his button hole. It was one of his very gentle and human days. He told us of the plans for Violet's marriage; and then later we reached the Louvre itself and the talk all fell on pictures and the few statues we went to. . . . Going home [in confidential talk with Lucia] he began to talk over V.'s proposal from F. O., and wondering whether she would accept it or not. I said that Vi, I knew, was much keener than I on only marrying if she was in love, and he said it seemed to him a pity, as she was always so emotional, and might so easily get carried away, and pitch headlong into this very sort of a match, when she would be horribly disappointed in the man. I said, well, she believed in separating if that happened.—Sargent—"Believes in it—yes of course—but practically one can't do that sort of thing."

"This very sort of a match . . . horribly disappointed" sounds like the worry of a concerned relative who knows, from male-club gossip, some quite discreditable facts about the impending husband. Ben del Castillo may have told Sargent tales that involved his Sanremo neighbor's wayward scion. But within days Violet wrote from Sanremo that she had made her decision.

Sargent quickly followed her. He wanted to persuade Violet to put the marriage off for two months in exchange for his approval and a cordial joining of the families in a formal society wedding. He alerted Lucia with a note postmarked boulevard Malesherbes, 17 June 1891:

> Wednesday. Dear Lucia, I am off tomorrow to Sanremo for two or three days. By Saturday the 20th the engagement will be public and you can write to Violet. She has written me and seems perfectly happy. I was sorry to have missed you: last chance I have of calling (with the Abbeys). Will resume our interrupted sightseeing when I get back. Love to the children.
> Yours sincerely, John S. Sargent
> [PS] Vi's address is Villa del Castillo, Sanremo.[38]

Brother John's mission was to negotiate an understanding with the Ormond parents, that the permanently unemployed Francis should have a sufficient settlement to support Violet, and that he would behave like a husband toward her. It may well have been tacitly understood that if Francis made Baby Violet unhappy, he could expect to be publicly caned. Violet went back to Paris in time to exchange confidences with her friend Lucia.

> Monday night, June 22nd; 83 Avenue Kléber.
>
> Dear Family, I am quite fagged out tonight, from two hours of the dentist in the morning, and a long afternoon shopping, and you must excuse it if I only write to you a very short and dull letter. The one I enclose from Violet is just like her, and will make up for my deficiencies. JS has made us decide to stay on until Friday night or maybe Saturday, so as to see her a little minute by herself before she gets married. The boys [Lucia's brothers Neil and Blair] won't write to her. "Very well, then—if I must. I'll tell her I'm sorry," Blair says, and I think perhaps silence is better. [39]

Then came the two-month *fiançailles* required to arrange the announcements, invitations, and receptions, the church and the dress and the trousseau, essential for a *belle époque* wedding. This was perhaps Sargent's opportunity to draw in pencil a prudent, sweetly reserved Marguerite.[40]

The high contracting parties, the senior Ormonds, had John and Violet Sargent to dinner on 4 July. Henry and Blanche de Varigny were invited, and Henry wrote in his Journal, "Mlle Sargent is quite pretty, healthy, nice, and natural. Her brother is charming." John was setting up familial defenses of Violet's future happiness. He took an apartment in Paris where his mother and both sisters could invite friends to call and meet Francis on his best behavior. Violet Paget (*nom de plume*, Vernon Lee), John and Emily's

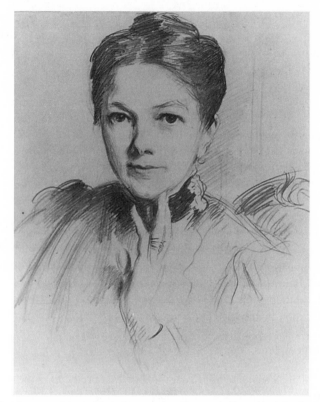

Figure 2.2. Sargent, *Mme Marie-Marguerite Ormond*. Rose-Marie's Bonne-Maman, a self-possessed, decorous lady of Geneva, Sanremo, and Paris society. Open-access image, The Metropolitan Museum of Art, New York.

childhood friend and Violet's godmother, might have been expected to be coolly critical on the subject of Baby Violet's consort for life. But like her god-daughter and namesake, Violet Paget was much younger than her only sibling, and had also been nicknamed "Baby."[41] She was in sympathy with the adventure, and she sent a favorable review to her own mother. "The fiancé M. Francis Ormond was there. Good looking, quite French. Much in love . . . evidently a lovematch. . . . The young man is really a delightful creature. He has travelled & suffered hardships in various parts of the world, been a workman & cook in the far West, and wandered without water in the Algerian Sahara. Yet quite young and modest."[42]

The marriage took place on 17 August 1891 at Holy Trinity, the American Episcopal cathedral of Paris.[43] Now that it was certain that Francis would never be the heir he had hoped for, his successor to Ormond Cigars and the vineyard of Relliet, Louis Ormond sold the house at Clarens later that year.

Sargents and Ormonds, *Cuique Suum*

The Ormonds had hoped that with his marriage Francis would become less footloose. Instead, in Violet, he had found a perfect traveling companion, already familiar with southern Europe and the Mediterranean shores, multilingual, a trained traveler from her infancy, who loved him passionately and permanently. Their first winter together, in Majorca, charmed them and annoyed her brother. Sargent wrote to Lily Fairchild from Fairford on 6 March 1892: "The young Ormonds have positively settled in Majorca, buying land there, etc. We all feel a little bit sold, especially Francis' mother who I think, thought that in marrying her son she would cure him of his love of travel."[44] Majorca did not hold them long; they moved to Barcelona long enough for their first child, Marguerite, to be born there on 16 June 1892, with Mrs. Sargent and Emily in attendance. Mary Sargent was happy and proud finally to be a grandmother. After three months in Barcelona they all rented a lovely little place in Camprodón, the new parents and baby on the second floor and the elderly grandmother with Emily below. It was there, in the foothills of the Pyrenees, that they escaped the summer heat of 1892, and at the end of July Sargent visited the family for ten days and painted several local streetscapes.[45] Violet and Francis were in Tunis for the birth on 5 November 1893 of their second child, Rose-Marie. Sargent visited them there that winter. Tunis would become Francis's favorite destination, and he eventually built his own Villa Ormond nearby, in Hammamet.[46]

The next year, more prosaically, Violet gave birth to their third child and first son, Jean-Louis, at Villa Ormond, Sanremo. Mary and FitzWilliam Sargent had never considered their young children an impediment in their constant travels, never left them behind or put them into boarding school, but Francis and Violet chose to leave their infant children with the Swiss grandparents for long periods in those first years of their marriage. Marguerite Ormond was still only in her mid-forties, and despite her *état physique* troublé she encouraged Francis and Violet to do so. So it is that we find bonny one-year-old Rose-Marie sitting to the celebrated Geneva photographer Frédéric Boissonnas at Crevin in 1894. The French pet expression for "grandmother," *bonne-maman*, means literally "good mama." It was the title of Marguerite Ormond that the whole family used without irony. She had the greatest maternal influence on the early lives of her grandchildren, and on the whole life of Rose-Marie. Another boy, Guillaume, was born at Sanremo in 1896. The third sister, Reine, was born in Paris in 1897, and the last child, Conrad, at Sanremo in 1898.

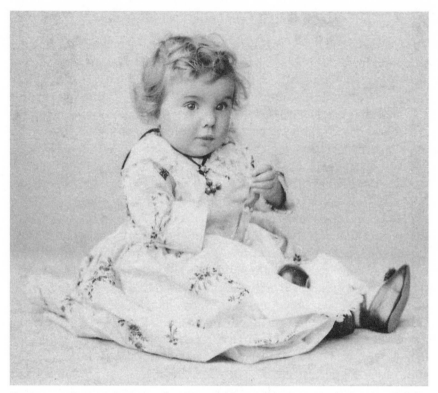

Figure 2.3. Rose-Marie Ormond, one year old. Rose-Marie Ormond, already a delight-ful model, sits for the celebrated Geneva photographer Frédéric Boissonnas for her first portrait. Private collection.

Meanwhile, during the first years of Violet's marriage, John was in the midst of his Boston Public Library project and fired with enthusiasm for it. He and Edwin Austin Abbey, who was painting the Grail Legend for the Library, had worked together at Broadway and Fladbury during John's first summers in England. For the Boston Public Library project Abbey rented a farm on the river Coln in Fairford, Gloucestershire, thirty-odd miles south of Broadway, and erected a huge makeshift studio suitable to house the big mural canvases. John joined Abbey and his wife and mother-in-law there in the autumn of 1891 and continued to work on the murals as his primary task, with only brief intervals for portraits in London and holidays abroad. It was at Fairford that Sargent hired Nicola d'Inverno, originally as a model; he would become more and more indispensable as a porter, valet, and majordomo of Tite Street.

Abbey was somewhat prepared for his own Boston Public Library project by his years as an illustrator, but Sargent had never done anything like the

mural pageant he envisioned for the Library. He had always painted what he saw, and now he had to make pictures out of his historical knowledge. He wrote to his friend the painter Paul Helleu on 5 January 1892, "I am working slowly. This is such a business of reflection, combination, research, up to the point that everything is properly arranged. The execution will probably go more quickly." Later that winter he explained to Lucia Fairchild's mother, a member of the Boston public waiting for the results of his labor, that it was quite different from portrait painting. "It is getting on very slowly as it needs must . . . and requires more brain work than is good for a would-be impressionist."[47] Sargent also began to involve himself in the architectural details of the hall. From the beginning he took the initiative to ask for minor and major changes in the structural details and lighting of the hall and its vaults to enhance the impact of his pictorial scheme. In letters to McKim, Sargent made specific requests about the exact width of the molding below his *Frieze of the Prophets* so that it would not hide his figures' feet from the viewers below.[48] His Boston liaison was the architect Thomas Fox, who became a trusted friend over their decades of collaboration on the project.

Sargent was campaigning to get his widowed mother, aging but as resolute a traveler as ever, to settle in a place of her own near his Tite Street studio. With this in mind he leased a flat for her and Emily in the autumn of 1891. After a two-year procrastination, while Mary Sargent and Emily wandered Europe, often to visit Violet's growing family, they did finally take up residence in the fourth-floor apartment looking over the Thames at 10 Carlyle Mansions, Cheyne Walk, Chelsea. It was Mary Sargent's first stable home since she moved to Europe in 1855, and Emily's first ever. Sargent celebrated it by usually dining there and entertaining his close friends there, rather than at his Tite Street studio. He also eventually moved his mural work from Fairford to a studio in Fulham Road, a short walk from Carlyle Mansions.

Abbey's narrative mural cycle of the Holy Grail and Sargent's decorations for the north wall of the Special Collections corridor (*The Israelites Oppressed, The Pagan Gods, Frieze of the Prophets*) were finally installed in 1895 (figure 9.1). Sargent's Egyptian sketches informed the Prophets with the dramatic immediacy of full-length portraits. His research into museums, art books, and travel guides and even the London Zoo (for a serpent study) brought an authenticity and freshness to this ensemble, his visualization of historical ideas. The reaction to Sargent's wall was enthusiastic. Private donations were raised to extend his commission to painting the lunettes at the ceiling level and the long east wall. He would need all that space to carry out the program that he had in mind. Meanwhile, the demand for his portrait painting would itself have kept him busy full-time. For several years

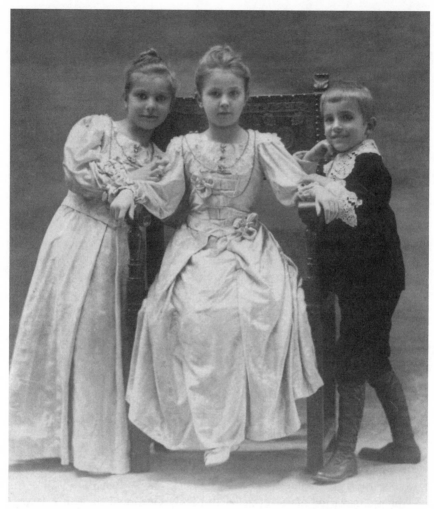

Figure 2.4. Three Ormond children in costume, 1900. The fashionable Paris photographer Otto Wegener recorded the children as their Bonne-Maman fancied them: Rose-Marie and Jean-Louis, courtiers of rank, support the enthroned noble lady Marguerite. Private collection.

Sargent had to arbitrate between his dedication to the mural cycle and the press of other work. Before beginning to paint the south wall, the *Dogma of the Redemption*, he required research campaigns in Spain, Sicily, and Rome. Work proceeded more slowly than ever on account of the competing calls on his time, not now because of any unfamiliarity with the mural genre or any deep hesitation over the form his work would take.

Violet and Francis had expected that they would be able to reclaim their young children from their grandmother at their convenience, but Bonne-

Maman had developed a strong maternal bond with the children, a bond that had perhaps never been so strong, or so well reciprocated, with her son Francis as he grew up. When the parents were off adventuring and the grandparents had all six children in the Château de Crevin and the villa in Sanremo, they were a charming brood of princes and princesses who all called her "Bonne-Maman." She shared fables of magic and fairies with them and encouraged their imaginations with plays and dress-up. Ormond family lore remembers how each child had a favorite storybook fancy: Marguerite had *Alice in Wonderland*; Rose-Marie the Oriental fantasies of the *Thousand and One Nights*; Jean-Louis loved adventures like *Twenty-Thousand Leagues Under the Sea*, while Guillaume's favorite was "The Little Match Girl"; Reine loved *Heidi*; and Conrad had a special rapport with *Pinocchio*.[49] A photograph from 1900 captures one fantasy, showing Rose-Marie, Marguerite, and Jean-Louis costumed as 17th-century courtiers.[50]

Eventually there came a September when Bonne-Maman allowed the parents to take the boys and the youngest daughter away with them, but she would not give up the two oldest girls. There never seems to have been a "scene." Perhaps the girls had lessons that couldn't be interrupted; perhaps it was their health. In 1901, when the girls were nine and eight, their grandfather Louis Ormond died, and Bonne-Maman wanted Marguerite and Rose-Marie for

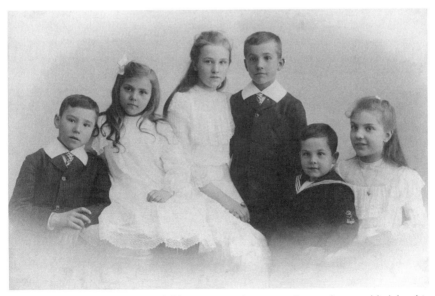

Figure 2.5. The six Ormond children, 1904. The young Ormonds assembled for this group portrait in Geneva in 1904: from left to right, sad-eyed Guillaume, unimpressed Reine, distant Marguerite, handsome Jean-Louis, chubby Conrad, and enthusiastic Rose-Marie. Private collection.

company. And so the six children, all born within the space of seven years, would not know a year-round family life together and with their parents. Rose-Marie Ormond lived her entire childhood and adolescence under the care of her loving, decorous, wealthy, formidable grandmother, only gathering with her parents and siblings at holidays.

Bonne-Maman continued her own itinerary. In autumn she visited Paris, and in early winter she was at home in her beautiful Château de Crevin. The view eastward from the Château was a landscape of fields and woods ending at the limestone escarpment of Le Salève less than two miles away and 4,300 feet high. Later in the winter she and the girls went south to the splendid Villa Ormond at Sanremo. The entertainment that she provided there to the rich, the royal, and the artistically and intellectually notable was as grand as the house. When spring arrived, Bonne-Maman went again to visit relatives and friends and to shop in Paris. Marguerite and Rose-Marie joined their parents and siblings in London at the Easter school holiday, and they spent the summer together once school was out, both in England and in the Alps. The end of summer brought the six children back to Château de Crevin, and there Marguerite and Rose-Marie remained.[51]

CHAPTER THREE

~

Rose-Marie Ormond

There is no record of the schooling Marguerite and Rose-Marie received. Bonne-Maman's frank admiration of her own mother's bookishness suggests that the girls were given the best possible tutors, at home. A studio photograph of Rose-Marie at the age of ten shows her in a sort of school uniform, standing at ease. For the recitation she is about to give, it is clear that she doesn't need the copybook she holds casually at her side. Her commonplace book, with its passages of Latin as well as French, indicates that she received a typical elite education of the day, focused on the classics, history, geography, languages, drawing, music, and elementary mathematics. It is unlikely that she studied English with a native speaker. Her English writing is charming and clear, regardless of her lapses: for example, she will spell the French form of a word such as *bal* for "ball," write English phrases that are verbatim translations of her French thoughts, and use the English "miss" for all the different senses of the French *manquer*. Her meaning is never in doubt.

Although the two girls had each other for company and were surrounded by palatial luxury, they must have missed knowing many children of their own age. The time that Rose-Marie spent with her siblings on holiday was precious to her. Marguerite, less than a year and a half older than Rose-Marie, to whom she was attached as if to a twin, began showing signs of mental instability and retardation in her early teens. The family kept hoping for a recovery, but eventually Marguerite was committed to the Préfargier Hospital in Canton de Neuchatel, where she remained until her death in 1951.

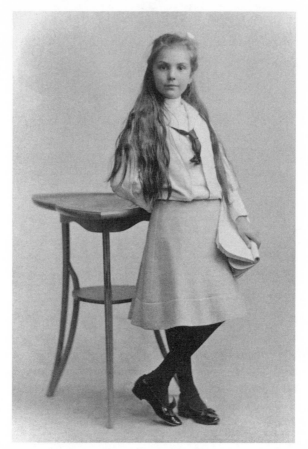

Figure 3.1. Rose-Marie at ten, scholar. Madame Ormond honored her mother Jeanne-Julie as an intellectual, and she gave Marguerite and Rose-Marie the best tutors that she could hire. Here ten-year-old Rose-Marie poses ready to recite, her superfluous copybook at her side. Private collection.

While his Swiss niece was growing up, John Sargent was constantly busier and richer, thanks to his fame as portraitist to the noble and wealthy. His Boston Public Library program, *The Triumph of Religion*, still claimed his attention and his historical imagination. The decoration of the south wall, perhaps less intellectually challenging than the north, was taking a longer time to complete. The endlessly discreet patrons of the mural showed some concern if not impatience. Finally the *Dogma of the Redemption*, dominated by a crucifix sculpted in high relief and the representation of the triune Godhead, was installed in 1903.[1] This dark tableau combines images of medieval Catholic piety and popular devotion with representations of dogmatic

theology. The title that Sargent gave to the wall recalls Ernest Renan, who wrote that the dogmas and institutions that began to be developed after the Crucifixion were complications and perversions of the pure message of Jesus. Sargent had determined that the entire cycle would conclude on the long wall over the stairs with a representation of the Sermon on the Mount, in Renan's judgment the simple epitome of Christ's teachings.[2]

Sargent's Alpine Idyll

John Sargent, never forgetting his mother's example and teaching, had always traveled extensively and painted wherever he went. His portrait business in London and America throve and became more demanding, and he chafed at the demands. He quipped that "a portrait is a picture with a little something wrong about the mouth."[3] He stopped filling his summers up with research sketches and canvases for sale and exhibition, and began painting for his own pleasure and satisfaction. From 1904 through 1914 his summer and autumn itineraries began in the Alps. In 1904 he spent a pleasant and productive holiday working with a group of Italian painters including Ambrogio Raffele, who would become a great friend. They had found a spot called Purtud, a couple of miles from Courmayeur in Val Veny at the foot of Mont Blanc, where a little hotel offered hospitality in the tourist season of June to October.[4] It matched Sargent's interests perfectly: a beautiful and isolated spot, yet easily accessible, less than an hour from a tourist center. The Alps looming above were spectacular, while the valley itself had easy walks, pretty woods, and bubbling streams. The altitude meant that even on sunny days it was cool, an important consideration as Sargent put on weight in middle age and his working costume was shirt and tie, waistcoat and jacket. Late September and October, when storms threatened and the temperature dropped, was soon enough to leave.

These were truly working vacations. Sargent painted outdoors while there was light and the weather was good, indoors if it rained. He brought together a sort of rotating house party of travelling companions, many of whom were also artists. The painters of the party would go off to the site of the day accompanied by the non-painters who would read or watch or pose. Lunch might be a picnic or a hotel meal followed by a nap before an afternoon's painting. The crew would return to their lodging for dinner and conversation, chess and music.

It was much the same routine as Sargent had found so congenial in his first summers in the English countryside from 1885 through 1889. In fact, many of his favorite traveling companions were people he had met during

his first years in England. One of the leaders of the artists' group at Broadway, Frederick Barnard, had died tragically in 1896 after suffering from depression and addiction precipitated by the early death of his son, Geoff. Sargent stepped up with his customary generosity and compassion for the remainder of the family. Mrs. Alice Barnard and her daughters, Polly and Dolly, were always welcome participants in Sargent's circle and were, individually or together, frequent companions on the Alpine trips. Those sisters, who had learned to pose as the little girls in Sargent's first English masterpiece *Carnation, Lily, Lily, Rose*, were still, fifteen years later, willing and frequent models. It was also in those early years that Sargent met the Harrison brothers, Leonard "Ginx," a businessman, and Lawrence or "Peter," a painter who married Alma Strettell, a folklorist and poet friend of Sargent's. Wilfrid de Glehn had been hired by Sargent and Abbey in their Fairford years to help with the Boston Public Library murals. He had married an American artist, Jane Emmett, in 1904 and they painted and were painted during a number of trips with Sargent.

During these expeditions, Sargent was painting for himself, not for a model-cum-employer, and he never had trouble finding a subject. He would set himself in front of a scene and paint, and, as in his early English summers, he posed in his scenes whatever friends he could persuade.[5] Sargent had learned to be kind to his volunteer models. Like Violet supine in her punt, his models were settled in comfortable poses, seated or reclining to make their duty easy: they lay in meadows, napping, daydreaming, or reading, or they sat concentrating on their painting and sketching. But unlike Violet, shivering in a punt in late autumn, his models now were amply wrapped in shawls if necessary. Sargent's pleasurable challenge was to capture the transitory play of sun and shade on the garment folds, hummocks, woods, pools, and rocks, and casual poses in natural surroundings.

In 1905 Sargent returned to Purtud for another Alpine summer painting campaign. Violet and her younger two daughters, Rose-Marie and Reine, were along for the first part of the trip. Quite possibly the motive in bringing them together was consideration for Rose-Marie. Her sister Marguerite had begun having emotional difficulties, and John and Violet wanted to distract Rose-Marie from distress over her older sister's condition. It was a successful trial of compatibility, but a short holiday for Violet and her daughters. Rose-Marie and Reine were back with their Bonne-Maman by the middle of August, because Violet needed to follow Francis to Los Angeles.[6] Sargent continued his tour to Giomein near Breuil on the flank of the Matterhorn, about 2,600 feet higher than Courmayeur[7] with his friends the Harrison bothers, Alma Strettell, Dorothy Palmer, Polly Barnard, and Lillian Mellor.[8]

The spectacular scenes, the challenging painting, and the companions who shared artistic and musical tastes were pleasures that Sargent then sought to recreate year after year.

That autumn of 1905 Sargent traveled on to Syria and Palestine for more research for the Boston Public Library. He was east of the Jordan near Jerusalem in January of 1906 when he received by telegram the news that his mother had suddenly passed away. He telegraphed Emily asking that the burial be put off until he could get back to England, and to his cousin Mrs. Ralph Curtis he wrote, "It is dreadful not having been there, and not being with my sisters—then and now. They were both with her. There has been no steamer and will not be one until day after tomorrow and I cannot get to London before February 2nd. . . . She will be buried at Bournemouth with my father. You remember her wonderful enjoyment of life and things—the letters that still come to me are full of it."[9]

The woman whose health had required the family's open-ended cultural itinerary through Europe, "the enchanting, indomitable, incomparable Mrs. S.," had passed from their midst.[10] Her death brought them all closer together, with John as head of the family. He strove to fit Emily more constantly into his plans, encouraging her to join him in his travels whenever she chose. A belated nesting instinct began its work on Violet too: she and Francis, with their three sons and youngest daughter, found a permanent home near John and Emily at 94 Cheyne Walk, Chelsea.[11] When John dined there, he was given the head of the table, and at Christmas he was the one who ignited the plum pudding.[12] He enacted the role of a Bon-Papa in contrast to the perennial absentee Francis, and he extended his kind patronage to the Swiss daughters too.

In the summers of 1906 and 1907 Sargent again organized parties of friends and family to vacation with him at Purtud. He asked Emily to come along, and Violet Ormond and her children. Sargent included in his baggage an exotic cargo of oriental clothing, veils, and caps.[13] These were the summers of delightful, incongruous faux-harem scenes where pretend Turks relax in shifting groups by shaded alpine brooks and pools. It has been surmised that Sargent's oriental moment was inspired by his 1905 trip to the Holy Land, by the various orientalizing fashions of the day, or by his own repressed feelings.[14] Whatever inner urges or thoughts Sargent may have been sublimating, and whatever message viewers and critics may take away from these so-called Zuleika[15] paintings, it is likely that when he packed his trunks with theatrical costumes his purpose was to draw Violet's children into the fun, just as the young girls at Broadway had shared those glorious summers in the 1880s. He knew Rose-Marie's fascination with the fables of

the east. In later expeditions he was content to paint his models in more or less everyday clothes with few extra props, but at Purtud he was looking to amuse his nieces, and he seems to have succeeded. Sargent's true oriental and exotic studies are of actual oriental subjects, such as his Egyptian water carriers and Palestinian shepherds. This was a special moment for him. He was handsomely rewarded for his outlay on the seraglio wardrobe. The girls entered into the spirit of the occasion and were willing and delightful models, especially Rose-Marie, whose Arabian Nights fantasies had come true in the happy summer surroundings.

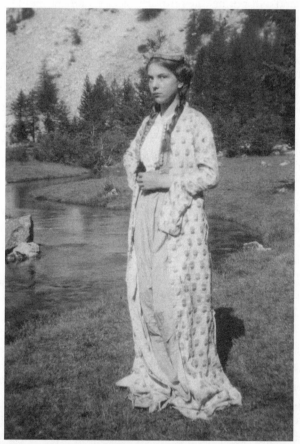

Figure 3.2. Rose-Marie in Turkish costume, ca. 1906. In the summers of 1906 and 1907 Sargent painted his holiday traveling companions dressed in theatrical oriental garb relaxing in Alpine meadows. Rose-Marie was fascinated by the Arabian Nights tales; here we see her costumed as an alluring, haughty odalisque and trying, with little success, to get into the role. Private collection.

These summers' masterpieces of easy watercolors and oils of veiled ladies and their exotic companions in essentially silly tableaux are tours de force of color, shade, and sun glinting and reflecting on shallow rushing freshets, tumbled rocks, gauzy veils, shiny silks, shrubs, and grasses. One critic noted that in the watercolors of these years "the casually posed figure suggests that [Sargent] was finding great delight in his freedom to treat the figure as simply another element in the landscape."[16] But just as in "abstract" dance, the mere presence of persons in the scenes prompts the viewer to create a story.

The ladies are mostly veiled, and both men and women are in voluminous pants, coats, and blouses of bright, shiny reds and greens, blues and whites. They lie on the grass, play chess or watch chess players, lean against trees, read, and nap. Jane de Glehn wrote, "Yesterday I spent all day posing in the morning in Turkish costume for Sargent on the mossy banks of the brook. I and Rose-Marie, one of the little Ormonds. He is doing a harem disporting itself on the banks of the stream. He has stacks of lovely Oriental clothes and dresses anyone he can get in them."[17] Emily's maid Margaret O'Regan, interviewed fifty-seven years later, remembered that she had posed as a "Turkish lady," wearing "all kinds of veils so only my eyes showed." It wasn't as easy as it looked, she said, because a sitting lasted about two hours, "and my arms were swollen from not moving by the time a session ended."[18] Rose-Marie was a particularly attractive subject in these first experiences as a model for her famous uncle. She was well developed and poised for her age. As her nephew Richard Ormond remarks, "There are few images of girls so tender and sensual as those in *The Brook* [color 4], where Rose-Marie appears with her sister Reine in Turkish dress as decorative odalisques."[19]

After these experiences it must have been harder than ever in September for Rose-Marie to leave her siblings and her mother, her aunt and uncle, and their artist friends, and return to life with Bonne-Maman. This was about the time that Mme Ormond required her oldest grandson, Jean-Louis, at the age of fifteen, to leave his parents and England and begin learning the cigar business, eventually to take the helm of Ormond Cigars, the post that his father had declined. But he was then usually at school or in Vevey and not with his sisters.

It was Guillaume, Rose-Marie's second brother, who became her special confidant and friend over these years. In her letters to him she candidly expresses her love and admiration, and she always ends with a shower of kisses. She knew how Guillaume needed such tenderness. His early pictures show a melancholy child, a sensitive musician-to-be. In children's literature he identified with "The Little Match Girl." His he-man father rather bullied him, and unlike his younger brother Conrad, he never learned to shake off the tyranny.[20]

Uncle John was giving priceless gifts to the family that he called "The Ormond Synod" by gathering them together for the late summer weeks in the Alps. For the children (aged eight to fourteen in 1907) the trips to the Alps were magnificent adventures. There were hikes in the woods and dips in the glacier-fed streams. They gathered wild strawberries, kept the inquisitive cows away from the painters, and at night snuggled warm and safe in their feather beds as titanic thunder rolled and echoed through the mountains. Sargent's valet, Nicola d'Inverno, was recruited into their games and willingly gallumphed with the littlest ones on his back.[21] It was the only time the siblings were together and at ease, unfettered from the rigid decorum of Bonne-Maman's rules, with Violet and Emily at ease as well. And if their father was along, as he rarely was, he would have been on his best behavior under Sargent's observation. These summer weeks were the closest to a full family life that Rose-Marie would know as she grew up.

In 1908 the party gathered again at Purtud. This year Sargent made the cashmere shawl the leitmotif of his pictures. In many paintings over the next years he depicted these large creamy white shawls with bluish oriental borders wrapping his female models as they sat, stood, and reclined. For Sargent the folds of abstract whites and shadows and reflected shades and patterned designs presented a challenge at each new sitting. For a model at that altitude, the great expanse of cozy drapery offered lovely warmth and comfort.[22] That summer Sargent featured eleven-year-old Reine in one of his most fascinating and lyrical paintings, *Cashmere*.[23] It shows seven figures, each wrapped in a shawl, passing an indistinct meadow scene and walking toward and out of the right side of the painting. The five faces that are visible are all portraits of Reine. Reine just wasn't the sitting or reclining or patiently posing sort. The right-most figure in the procession is stretching, her hands interlaced behind her head. *Her* arms were not going to swell up from being held motionless.

Over these years, in the little club that Sargent brought together in his Alpine trips, he included older people like Raffele and Mrs. Barnard; his peers (he was 52 in 1908) including Emily and her friends like Eliza Wedgwood, the painters Adrian and Marianne Stokes, and Alma Strettell; younger people close to Violet's age, Henry Tonks, Peter and Ginx Harrison, Wilfred and Jane de Glehn; and younger still, the generation of the children of *Carnation, Lily, Lily, Rose*, Dolly and Polly Barnard, and Dorothy (Dos) Palmer; and finally the teen and preteen children of Violet. Those lucky children were included in a close society of artists, painters, poets, musicians, and writers. There was bit of free-loving Bohemia too, as Peter Harrison was having an affair, perhaps with Polly Barnard and certainly with Dorothy

Palmer, the daughter of the best childhood friend of his wife, Alma Strettell. But the great lesson of these summers was the exhilaration of creating, the call of work for the artist, the serious pleasure of interesting conversation among comfortable friends.

When she was fifteen, encouraged no doubt by her grandmother's poetic activity, Rose-Marie sent a poem she had written to Emily. She dedicated *Où vont les hirondelles?* "To my dear aunt Emily, to whom I would have preferred to send some better lines, but who will forgive me my rhyming fit." The poem is full of youthful yearning to escape to a better world. She begins with the swallows, *Fuyez, hirondelles légères | Fuyez, fuyez, vers d'autres lieux*, and ends, not with thoughts of far overseas migrations like her father's, but hoping for the salvation of her well-catechized soul. There was a natural, tender sympathy between Rose-Marie and the kind, sensitive, caretaking Emily; they each had a selfless and loving nature, amiable and patient. Rose-Marie, living in the palatial homes of her grandmother, watching her dear sister's losing battle for normal emotional stability, and aspiring to a different happiness, was sharing her feelings confidentially.

In 1909, 1910, and 1911 Sargent's holiday base was further up the Alps, at the Bellevue Hotel, 6,500 feet up on the Swiss side of the Simplon Pass.[24] The scenery was more open and steep than at Purtud, and his painting shifted from dappled shade and meandering brooks to vast expanses of sunny, rugged vistas, tumbled boulders, and rushing water. On the other hand, when Sargent posed figures in these works, they frequently take up almost the whole composition with no scenic setting visible at all. Billowing skirts and parasols catch and diffuse the light, and the models are in the poses by now customary—napping, daydreaming, and reading. As at Broadway for *Carnation, Lily, Lily, Rose*, Sargent in these Simplon campaigns wanted his models in white so that he could explore the varieties of the possible tones of light and shade to the fullest.[25]

The Barnard sisters, Jane de Glehn, and the Ormond sisters as they grew up, were all similarly tall and slim, and when Sargent was looking for a particular effect of light on material or shapes in a landscape, these models were interchangeable. Sargent called his crew of frequent sitters his "intertwingles." He rarely aimed at creating recognizable portraits of his models. The faces are often summarily sketched, and are often obscured by bonnets and shawls. Even though Sargent carefully arranged his models, the scenes he posed often purport to be informal glimpses of unaware subjects, hastily sketched by a casual observer who has just stumbled upon them and who wouldn't dream of disturbing them. The great exceptions to this general rule are the depictions of Rose-Marie. More often than any of Sargent's other

amateur models she strikingly interacts with the observer. Rose-Marie's boundless vivacity combined with her good-natured patience both prompted and permitted Sargent to catch the quality of her charm, her lively and mobile features, on paper and canvas again and again.

It was in these years that Rose-Marie became the definite young star of Sargent's figure studies. Richard Ormond writes, "He was attracted by that mysterious quality of dark beauty in her, which was a feature of all his favorite models, and by a warmth of personality she seemed to radiate. Her broad features, framed by luxuriant dark hair, arching eyebrows, full mouth and retroussé nose, are immediately recognizable in his painting, lit up and alive. . . . [She] lights up and transforms these pictures with her lovely features and bright spirit."[26] It was not that Rose-Marie is more conventionally beautiful than the other women among Sargent's traveling companions, but that her personality shines through with a sparkling immediacy. Rose-Marie was growing into her midteens and charming her family, friends, and acquaintances. To all the members of the late-summer Alpine circle she brought a playful, fresh liveliness. Sargent treasured her as much for her delightful character as for her qualities as a model.

A watercolor, perhaps from 1909 or 1910, *The Cashmere Shawl*, (Color 5)[27] shows Rose-Marie standing in front of a wall, just turning to glance away, tightly wrapped in the shawl against a gusty wind. Rose-Marie is attentive. Will she speak? Or turn back to us from the interruption? We want to know what comes next.

In 1911, when Rose-Marie was seventeen, the great partnership between Sargent and his niece produced one of its most finished and delightful results. The Ormond family vacationed at Wendover in the Chilterns that year, but Rose-Marie was not with them. She sat in London for a finished genre painting that Sargent intended for sale, called *Nonchaloir* or *Repose* (Color 6).[28] This is a clear homage, a visual echo of *Repose*, Manet's 1873 portrait of Berthe Morisot.[29] Rose-Marie is posed, as so often in the Alpine pictures, wrapped in a cashmere shawl and reclining, only this time in a fine drawing room, her skirts spread over a sofa upholstered in muted paisley. "She appears among rich accessories, and, like them, an *objet de luxe*. Her hair spread across the back of the sofa, the contorted folds of her shawl, and her entwined fingers impart an air of strangeness and intensity to the figure that is anything but relaxed. This effect is heightened by pervasive and eerie tones of green. She might be a character from a Henry James short story whose secret we are shortly to learn."[30] One contemporary review of *Nonchaloir* said "Mr. Sargent while pretending to be occupied with pose, and distribution of drapery, has given us one of those delightful representations of femininity with which he

now likes to confute those who used to mark as a limitation on his part the inability to represent women with a Meredithian sympathy."[31] But Sargent was also slyly responding to Walter Sickert's envious essay "Sargentolatry"[32] by portraying, one might say, *A Sargentolatress at Home*. Intense and yet cool, her lovely hands poised, this fashionable young woman's nonchalance extends to the *objet* behind her, a *very* large oil painting in a gold frame, the artist's signature just visible: it's a Sargent.

Sargent's summer painting campaign began earlier than usual in 1911 with a trip to Munich in May with painter friends, Adrian Stokes and his Austrian wife Marianne, but at the end of June he received word that his old friend Edwin Abbey, his colleague in the Boston Public Library decorations, was dying in England. Sargent returned to England the next day and at Mrs. Abbey's request he supervised the final touches that Abbey had wanted on his mural *Apotheosis of Pennsylvania*, the last of a series commissioned for the State Capitol Building in Harrisburg. She later wrote, "Mr. Sargent's kindness and generous helpfulness are so well known that they need no emphasizing. It was noble of him to come back to London from Munich, in that hot summer of 1911, but being Sargent he could not fail to come."[33]

In August Sargent was back on the continent and in the Simplon Pass with the usual confraternity of congenial painters, family, and acquaintances. That year the entire Ormond family was present, including Francis, and the boys brought cricket to the Alps.[34] Two photographs of Rose-Marie at a guesthouse window are priceless memorials of her eighteenth summer. One shows her alone and alive with mirth, and in the other she has her arms around her father's neck, delighted to be so near to him. But Francis is, as he preferred to be, far away.[35]

That summer Sargent was energetically producing a batch of watercolors that were more finished than his usual summer output. He had agreed to supply dozens of watercolor pictures for a joint show in New York and Boston with his friend Edward Darley Boit.[36] Some of the most charming of these featured Rose-Marie. *The Tease* shows Rose-Marie tickling her dour older companion with a gesture or a joke. The companion, her full expression hidden behind dark glasses, may not want to react, but the viewer does. In the watercolor *Simplon Pass: Reading* (Color 7), Dolly Barnard reads next to the reclining Rose-Marie who looks expectantly out at the viewer with a question or an invitation to join the group. Possibly on a rainy day Sargent made a charming charcoal sketch of Polly Barnard snaring Rose-Marie with the cashmere shawl, miming "We won't let you go back to Crevin!" Another picture illustrating one of Sargent's familiar themes, *Simplon Pass: The Lesson* (Color 8) shows Emily Sargent at her easel, one paintbrush held ready

between her lips while she works on her watercolor sketch. Reine to her left watches the brush; she would go on to attend the Sloan School of Art in London.[37] Rose-Marie on Emily's right holds a parasol against the glare for Emily and also observes the painting intently. We have no evidence that Rose-Marie ever was among the artists on these outings. But she was accomplished enough at drawing a few years later to provide studies of the Papal Palace at Avignon for her husband.

Starting in 1912 we have a precious record, kept in the family archive, of Rose-Marie's thoughts and feelings expressed in a series of some sixty letters to her brother Guillaume. Guillaume was developing as a professional musician at Westminster School and the Royal College of Music, Kensington; he continued his study, particularly of the organ, at Exeter College, Oxford, and under Percy Grainger. He was organist of Truro Cathedral for forty years before his death in 1970. The overwhelming impression conveyed by the letters is Rose-Marie's selflessness, her generosity in love, and her enthusiasm. She thought more about others than herself and she was keen to enter into the lives and thoughts of those she loved. She is touchingly grateful to her brother for corresponding so regularly with her, tries to imagine all the things he is doing, and encourages him in his efforts.[38]

Sometime in 1912, perhaps during Rose-Marie's visit to London at Easter, Sargent had Rose-Marie "sit" for a special process, absolutely unique in his artistic career. He took plaster molds of her beautiful hands and had them cast in bronze. Madame Ormond fondly remembered that Rose-Marie, born on the same date as her great-mother, Jeanne-Julie, had marvelously inherited her exquisite long, tapered fingers.[39]

That Easter holiday or later in 1912, Sargent broke his "no more paughtraits" rule to paint *Rose-Marie Ormond*, among his last pictures of her, but the only one to bear her name (Color 10).[40] This is a portrait such as those he used to paint of rich and aristocratic beauties, carefully costumed and posed. Sargent framed Rose-Marie's face and torso as she sat poised and erect. She holds around her shoulders a cashmere shawl, relegated this time to the minor role of a happy souvenir. Those exquisite hands, which he had recently done in bronze, are here in motion, as if she has just flung the shawl across her left arm and taken the pose. She is about to speak or to laugh. The portrait is Sargent's testimony to Rose-Marie's sparkling character and to his own delight at how she has grown into her beauty. No doubts cloud the painter's or the sitter's joy and enthusiasm. Rose-Marie epitomized the virtues of the women in Sargent's tiny family, his mother's endless joie de vivre, Violet's music and spontaneous vivacity, his dear Emily's patience and selfless kindness. For the last seven summers he had documented her charm as she bloomed, and here he proudly displayed his muse in her own adult person.

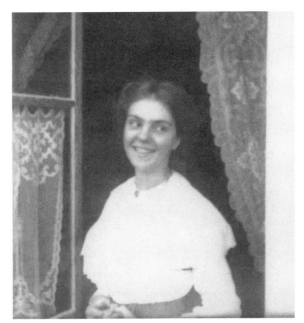

Figure 3.3. Rose-Marie at an Alpine window, 1911. Rose-Marie, almost eighteen, was the star of the watercolors that Sargent was preparing for a show in New York and Boston. The photographer caught Rose-Marie in a guesthouse window, sparkling with the vivacious good humor that inspired Sargent again and again. Private collection.

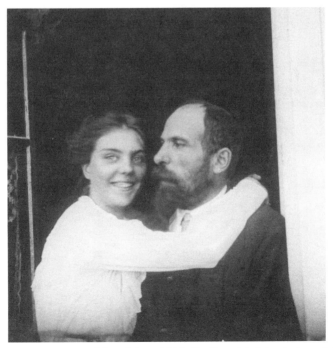

Figure 3.4. Rose-Marie and her father, 1911. To Rose-Marie's obvious delight, her chronically absent, dour parent was persuaded to get into this picture, but as usual Francis remained emotionally far away. Private collection.

Figure 3.5. Sargent painting *Simplon Pass: Reading*, 1911. Emily watches approvingly as Sargent works on his watercolor, *Simplon Pass: Reading*, seated on his camp chair slightly downslope from his models, with the big umbrella to shade his eyes and easel. Private collection.

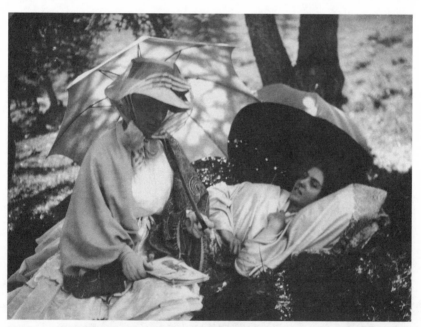

Figure 3.6. Dolly Barnard and Rose-Marie Ormond posing for *Simplon Pass: Reading*. The camera swiveled right on its tripod to capture the models, Dolly Barnard reading an illustrated magazine and Rose-Marie reclining, shaded with umbrellas, as Sargent painted them. He thoroughly planned and posed *Simplon Pass: Reading* so that it appears to be the impromptu discovery of a charming scene. Private collection.

Figure 3.7. Sargent, *The Two Girls* (ca. 1911). At the end of an idyllic August, Sargent caught Rose-Marie and Polly Barnard together, laughing. Polly has snared Rose-Marie in the cashmere shawl, miming, "We won't let you go!" Sargent inscribed the picture to Rose-Marie's mother, Violet. Private collection.

Figure 3.8. Sargent, Rose-Marie's hand in bronze (1912). In 1912 Sargent took plaster molds of his niece Rose-Marie's exquisite hands and had them cast in bronze for a three-dimensional record. Madame Ormond noted that Rose-Marie, born on the birthday of her great-grandmother Jeanne-Julie, had marvelously inherited that lady's beautiful hands. Private collection; photo by Karen Corsano.

Rose-Marie and Robert André-Michel

By this time Bonne-Maman's Paris home was at 42 avenue du Bois de Bou-
logne (now avenue Foch), on the sunny side of that spectacular tree-lined
ray of the *Etoile* extending west from the Arc de Triomphe. Number 42 was
(and still is) a mellow limestone, six-story, luxury apartment complex with
understated details, sculpted floral swags, and classical heads and motifs.
Narrow balconies with delicate wrought iron rails front each window. From
their windows on the *3e étage* (in American, the fourth floor), the Ormonds
looked over the treetops to the Arc de Triomphe a few elegant blocks away.

Music was an interest that Guillaume and Rose-Marie shared passionately
and one of the reasons that Rose-Marie felt most at home in Paris. The
music, the arts, and the intellectually vibrant city offered her much more
emotional oxygen than the great houses she shared with her grandmother for
most of the year. She was there in Bonne-Maman's apartment for the spring
season of shopping, exhibitions, opera, salons, and the Salon when she wrote
Guillaume a revealing letter.

42 Avenue du Bois de Boulogne, 15 juin 1912
I am ashamed of myself not to have answered sooner, as I meant to do it; you
know how my days are full; it is so hard to find a few minutes in the day. At
Crevin the life will be calmer and there I will be able to write a little more. . . .
You heard of course about Gérard's soon wedding and about his fiancée? I saw
her several times; she is very pleasant, easy going pretty and nice. The wed-
ding will be on the 4th of July, and we will go to Crevin directly after. The
only pityful person about that is Gérard's mother, whose life will be at first so
changed and sad. She looks at present very tired and thin. . . .
June 16th—I can only today finish this letter, as my time yesterday was over-
filled. After lunch I had a lesson; then Bonne-Maman took me to an exhibi-
tion of ancient Persian miniatures, then had tea at our cousine Robellaz, and
then I went with Bonne-Maman and the de Varigny to the Opéra where was
played "L'Or du Rhin."[41]. . . The "Gold of the Rhine" was the first opéra of
Wagner I heard. We were all delighted of it. The orchester was extremely
good; generally the trumpets are much to noisy but yesterday they were soft
and violins had been added to the usual orchester. It was conducted by We-
ingartner, a German, who is very well known and perfectly good. The scenery
was beautiful and the singers were generally excellent. I suppose you know the
music of it.
Today is Marguerite's birthday. How terribly sad to think she is in a sanatorium
for her birthday. I do hope she does not feel sad of it. She writes sometimes
to us, but the change doesn't seem yet very great. We know she looks gay and
enjoys the country and that is a consolation though very small. She happily

likes her life there but it is all the same terribly sad. . . . I am longing too for the holidays and to see you again. Very often I try to follow you in your life; how lovely to be soon together again.

When Gérard de Watteville married Marie Coche de la Ferté, Rose-Marie was one of the six bridesmaids, naturally: Gérard was the son of Virginie Marguerite de Watteville (née Meyrueis), who was Bonne-Maman's second cousin. Consequently, Gérard was Rose-Marie's third cousin once removed, and she called Gérard's mother, Virginie, "Tante de Watteville." Virginie had a sister, Blanche Meyrueis, who in 1880 married Henry Crosnier de Varigny, a young academic star in the field of medical science and human evolution and the son of the popular writer Charles Crosnier de Varigny.[42] Henry was born in Hawaii like his sister Hélène, and Hélène married André Michel in 1880. *Their* only son, Henry's favorite nephew, was another rising academic star—this one in medieval history and the Archives Nationales: Robert André-Michel. In a nutshell, Rose-Marie's Tante de Watteville and Robert's Tante de Varigny were sisters.

The Michel family was prominent among the liberal Protestant society of which the Ormonds were a part in their Paris seasons. Robert's sisters had married into three distinguished families of the Protestant establishment: Leenhardt, Vermeil, and Monod. Bonne-Maman always remained close to her Parisian Griolet relatives. Favorites among those relatives were her second cousins, the Meyrueis sisters Virginie Marguerite de Watteville and Blanche de Varigny. They hosted dinners for each other whenever the Ormonds were in Paris, and the Meyrueis sisters and their families visited the Villa Ormond in Sanremo. It is likely that Rose-Marie and Robert had been acquainted for years while Robert was finishing his studies and beginning his career and while Rose-Marie grew up year by year at dances, services, concerts, and salons with her grandmother in the Paris spring and fall seasons. Possibly she had attended a lecture by Robert's father at the Temple de l'Oratoire.

Rose-Marie encountered Robert several times at the dances and at-homes leading up to Gérard's July wedding. Robert may even have been in that box at the Opéra for *Das Rheingold* with his uncle and aunt de Varigny, Rose-Marie, and her Bonne-Maman. We suspect a matrimonial intrigue by the Parisian Protestant Meyrueis aunts. Rose-Marie was lovely, charming, accomplished, and eighteen. Inevitably she would be courted, and they knew that persuasive suitors could make abominable husbands. It would be wise to foster her acquaintance with a man of her own class and religion, a man of good reputation, and a mature one, whose reputation had survived the

tests of ages sixteen to twenty-six. With luck, he would have some appeal-
ing qualities and achievements too, and be a Parisian—Rose-Marie wanted
to live in Paris. Robert André-Michel was at the top of the aunts' list. They
wanted to settle him as well. He was twenty-six, a southerner, who had spent
considerable time in Rome and would probably go there frequently in the fu-
ture. And Rome was known to swarm with beautiful Catholic girls. He could
do better, and the Meyrueis sisters could show him how.

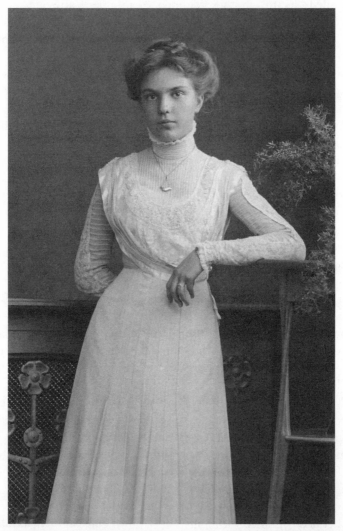

Figure 3.9. Rose-Marie at eighteen, 1912. Posing for the last time for Boissonnas, Rose-
Marie is an elegant, serious, serene Geneva debutante. Private collection.

Rose-Marie may have guessed that the senior women were conspiring to have her and Robert frequently in the same room, intending that she should begin to love him. She perceived that she was doing so. But when she imagined marrying, she promptly felt sympathy for her Bonne-Maman, who had already lost her first *petite-fille* princess to mental illness and would be left alone in her great houses when the second went away. Rose-Marie projected that sympathy onto the widowed mother who was about to lose Gérard. "Poor Tante de Watteville must feel terribly sad and lonely; she is coming this evening for supper. Happily her son and his wife will live next door to Mme de Watteville, so it won't be so hard for her."

Tante de Varigny possibly brought Rose-Marie to one of Mme Michel's *soirées*, where she would play the piano, maybe duets with André, while Robert listened and watched and saw how tall, elegant, and accomplished his distant-cousin-by-marriage had become. Robert was present at the wedding of Gérard and Marie on that sultry July morning, and he surely did what bachelors customarily do in that hothouse of hymeneal emotion: he imagined marrying the prettiest bridesmaid. Independent of any aunts' conspiracy, Robert was intrigued and charmed, and he began a serious courtship.

That summer of 1912 Sargent and the Ormonds had a new venue for their mountain expedition. This time his party went to the French Alps, to the remote and picturesque village of Abriès among ten-thousand-foot peaks.[43] Sargent's work included close-ups of the traditional wooden houses of the area and a series of portraits more subdued and shade dimmed than those of the Simplon years. Rose-Marie continued to star in pensive, quiet poses in the *Girl in a Pink Dress: Reading*[44] and *The Pink Dress* (color 9).[45] A picture of Rose-Marie and Reine sitting on the bank of a stream, *Two Girls Fishing*, shows them both solemnly intent on their task.[46] We notice in these quieter pictures that Rose-Marie is all grown-up, only a couple of months short of her nineteenth birthday. She had reasons to be pensive, thinking of Robert and of her sister's worsening condition: Marguerite had not been well enough to come to Abriès. After the holiday was over, on 12 September, Rose-Marie wrote Guillaume, "Never the holidays seemed to me as short as this last time, but I had a delightful time with you all and enjoyed you very very much. I do hope that next year Crevin will see us all again, and with Marguerite, and that a lot more times we will be able to all join for the holidays."

That year Madame Ormond's usual shopping trip to Paris was clipped to a few days, and those were packed with significant events. Rose-Marie reported to Guillaume from Crevin at the end of November,

> We only passed three days at Paris, and so they were overfull by shopping, visits to the family, etc. We arrived at Paris Wednesday evening of last

week [20 November]. Thursday Tante de Watteville lunched with us. In the afternoon Bonne-Maman did lot of shopping and I went with Tante de Watteville to see an opera called "Louise."[47] It was perfectly played and the orchestra was excellent. The music of it is very pretty. I daresay one would be soon tired of it, but for once it is very nice. Friday we saw again Tante de Watteville and Geneviève Hortsmann. The afternoon we did shopping until the evening. Saturday morning I went to see Aunt Emily. We went together to the Musée du Louvre for the pictures. I enjoyed it very much. We saw the Italian primitifs, which are sometimes so charming. And we saw the French ones too. Aunt Emily lunched with Bonne-Maman and me and after, while B-M was at the dentist she stayed some time still with me. I was so happy to see her, who would not be? Sunday morning we took the train back to Crevin where we arrived the evening. We will soon start for San Remo but we are kept here by Bonne-Maman's cold.

So! Rose-Marie saw Virginie de Watteville each day of that busy visit: the aunt was energetically matchmaking. The opera *Louise* is about a romantic working-class Paris and the love of Louise, seamstress in a shop, for the bohemian artist Julien. In act 3, at the humble cottage to which they have eloped (it's on Montmartre, overlooking the city) she sings "Depuis le jour," celebrating her happiness in freedom, in love, and in Paris. Tante de Watteville brought Robert's cousin Geneviève de Varigny Hortsmann to lunch. And behold, Rose-Marie's beloved Aunt Emily was in town; was their visit to the 14th century in the Louvre guided by an expert? They had most of the Saturday *tête à tête*, and lunch with Bonne-Maman. This is our first hint that Madame Ormond was complicit in the aunts' benevolent conspiracy. Confidences were exchanged that Rose-Marie did not yet share with Guillaume.

From the winter palace at Sanremo Rose-Marie wrote accounts of her activities that tell us how keenly she felt her exile from her family, how lonely she was, and how she welcomed distractions.

You know, I think, that Mr. Cramer, Maggy and Hélène de Beaumont arrived at home last Friday. Since then I did about nothing but stay with them the whole day. . . . Maggy and Hélène are coming with me and we do every day something new. The morning we generally go to the Sport Club to play tennis, as they are both awfully fond of it. The afternoon we go for a drive and sometimes to teas. Yesterday afternoon we had tea at the del Castillo. The day before Bonne-Maman gave a dance in the afternoon. It was quite successful and they both enjoyed it awfully. The evening of that same day we went to a bal given by a Mrs. Milburn. It was very amusing. . . . Maggie and Hélène enjoyed the tennis and the dances and were very nice.

The letter does not give the impression that Rose-Marie herself enjoyed these doings so awfully, but they were at least a relief from the formality of Madame Ormond's household and a dinner table set for two.

Violet Ormond visited Sanremo at the end of January 1913, to continue discussions of the matter face-to-face with her mother-in-law. "I am enjoying immensely to have Mother; every time I see her I admire her more. You surely miss her dreadfully!" A poignant word, "admire." It seems that Rose-Marie was no closer to her mother than Lucia Fairchild had been in 1889 when she wrote, "Since this visit I *admire* her more than almost anyone I know." It was Rose-Marie who "dreadfully missed" that admirable acquaintance, her mother, most of each year. By the end of February she was longing to be with her family when summer came and working to improve at the piano.

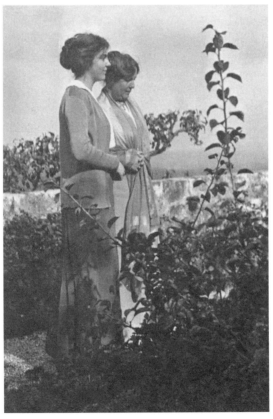

Figure 3.10. Rose-Marie with her mother at Sanremo, January 1913. Rose-Marie's coming engagement to Robert André-Michel was the reason for Violet Ormond's visit to Sanremo, a rare chance for a tête-à-tête. Private collection.

I will be awfully pleased to read again music with you at Crevin this summer. I hope to be a little better at it than last holidays, because twice a week since the beginning of this month a professor of piano comes after dinner to read music with me at four hands. It is delightful and very useful too. By that way we played the charming "Dances" of Brahms, his "Symphonies," quartet, quintet of Schumann, a few pieces of Schubert, Beethoven, Mendelssohn, Grieg, Sinding and Dvorak—Do you already play pieces of Bach on the organ, it must be beautiful!

That was her last banal letter to Guillaume. Easter came that year on 23 March, and Rose-Marie holidayed with the family in London. Robert was the major topic of the meeting. With their approval of Robert in her grasp, she crossed back to Paris escorted by her brother Jean-Louis, and she wrote to Guillaume on 16 April that Madame Ormond was planning a dance; it was the next stage of knitting the families together. The fifth of May brought the "second Ormond soirée, where the affairs of Robert and Rose-Marie are going well," Henry de Varigny wrote in his journal.[48] The Michels and de Varignys considered the matter settled on the 15th, and on the 21st Henry wrote, "Robert and Rose-Marie became engaged yesterday, the Francis [Ormonds] being here and approving." In her letter the next day Rose-Marie was in full flight. "My very dearest Guillaume," she wrote,

I just received your so exquisite letter, and I don't tell you the pleasure it brought me. My happiness is twice greater, by feeling this love of you dearest, and the other members of my family. I am longing that you should know Robert, and I feel sure you will like him as he will like you. I feel certain you will very much understand each other by the deep and sometimes unconscious understanding of the soul. More I see Robert, and more I see the beauty, the nobleness and the kindness of his heart. Never I saw life so shining and bright, that is the great secret of love. There is many things I would like to tell you still about him, but I am afraid time misses. So I will just tell you thank you with all my heart for your dear letter and ever so many kisses and love from your very loving sister Rose Marie!

At the end of the month, as the de Varignys were dining with the Ormonds at the Michels', Bonne-Maman suddenly announced that Rose-Marie was overtired by the excitements of the *fiançailles*, and she was sending her off with her father to Granville on the Normandy coast for two weeks. A great nuisance, noted Henry in his journal: was it really a matter of her health, or uncertainty about her sentiments? The trip would give Rose-Marie some confidential time with her father, a luxury she had never had enough of, and

Francis could get in some sailing. And Rose-Marie needed a very private consultation with a doctor over a small but ugly dark rash on her chest. Anyway, after her fortnight of reflection she was back in Paris, just as engaged as ever.

If Marguerite Ormond felt any sadness, any apprehension of loneliness to come, she gave no sign of it. No one had license to call her "poor grandmère Ormond." She truly wanted Rose-Marie to be happy, and this was a match that she could not oppose on any rational grounds. Her memory of her own mother Jeanne-Julie, mated with her faithless and intellectually inferior father, softened any opposition she might at first have felt. Perhaps John Sargent had a word or two with her, as twenty years earlier he had negotiated the marriage of Violet and Francis. Sargent strongly approved the match of his dear niece with the brilliant son of his esteemed critic. We know Rose-Marie's own feelings because she confided them to Guillaume after a Sunday visit with her fiancé and the de Varignys to the vast rose garden of L'Haÿ-des-Roses: she was ecstatic.[49]

> You understand more than I can tell you the quality of my love for Robert. Love is such a marvelous joy when it is pure, and goes all round everything. It is like a great light through what all people, all things, all life appears, more beautiful than ever. Through it the great, vital ideas grows more strongly, and the others takes less place. I feel as if I always had known Robert, because I understand him without words. We have the same ideal that we want to keep high, and we feel our hearts beat already like one heart. . . . I am sure Robert will like you very much, I hope he will be like a brother to you. He has a great power of sympathy and interest to everyone; is it not a great thing to give happiness to others.

When she wrote that letter, the plans for the marriage were taking shape. On 26 June Robert signed the lease and moved into the apartment where he would receive his bride, 68 rue de Bellechasse. That grand, gated house, built in 1883, had a carriage drive and a small park behind it with trees and a pond. The premier of France lives there now. When Rose-Marie showed her loving grandmother just where her happiness lay, Madame Ormond was engaged too, heart, taste, and purse. "Bonne-Maman, in a flurry of activity, is setting her up in high style, ordering dinner services with their entwined monograms, canteens of plate, buffets of silver, quantities of inscribed linen, the full paraphernalia of a conventional trousseau with no expense or detail spared."[50]

Rose-Marie had doubts, but only about herself: "I have *so much* to do before approaching to what I wish to be." Her letters indicate how passionately and

deeply she was in love with Robert. The poetic and spiritual language she uses to express her happiness at the bond they feel is unmistakably heartfelt and moving. There is no doubt that this was a love match that carried both the mature, intellectual Robert and the still teenaged Rose-Marie along in harmony. Rose-Marie does not mention any of the prosaic good reasons for entering into this marriage, reasons she would certainly have recognized. Robert had grown up as the only boy and the middle child of five. While he might have been spoiled in another family, the Michels practiced the equality preached by Madame Michel's father de Varigny in the raising and education of their daughters. Their brother needed to compete, and to do so like a gentleman. It is likely that some or much of his charm for Rose-Marie was the sensitivity and respect he had learned from his interaction with his sisters. With this background, it was also natural and easy for him to honor the skills her education had given her. By the time of the engagement, the three oldest Michel girls had all married and moved away from the parental nest, but the bonds among the scattered parts of the family were strong. There were already several little nephews and nieces enlarging the clan. Rose-Marie was swept away by Robert's courtship, offering as it did, along with his own bright professional prospects, the stable, united family she had always longed for. Just as they had absorbed three sons-in-law into their nuclear family, André and Hélène Michel welcomed their *belle-fille* as a daughter, and Rose-Marie was at home in Paris. The date was set for the beginning of August.

Emily Sargent wrote an account of the wedding, beginning with the civil ceremony.[51]

August 5th 1913—Paris. At 10.30 am John and I went to the Mairie of the XVI Arrondissement, rue Henri-Martin. Robert André Michel's *témoins* were M. Boutroux[52] et M. Massigli.[53] Rose-Marie's *témoins* were John and M. de Varigny.[54]Rose-Marie was pale and looked a good deal *émue*—She looked charming in a white lace dress with blue sash, white hat lined with black velvet, trimmed with blue ribbon and pink roses. Violet wore her black dress; Madame Ormond wore purple. Eighteen to lunch at Madame Ormond's flat, 42 Av. du Bois. The children were all at the Mairie, and came after lunch. When all the guests had left, Madame Ormond took us all to see Edmond Foulc's collection.[55] In the evening John dined Francis, Jean-Louis and me at Le Doyen's, and afterwards took us to the Ambassadeurs, not good performance, excepting two clowns with balls and musical instruments.

Violet was suffering from rheumatism and probably preferred a quiet evening with her daughters and Bonne-Maman.[56]

August 6th. Breakfast with John, soon after eight o'clock I took the maids to the Magazins du Louvre, and by the Métro to the Eglise de l'Etoile, and to 42 Avenue du Bois—Met Violet, Rose Marie and Reine just driving in. Rose Marie took the maids up to see the presents. I went to Hottinguer's, and drew frs. 5,000 (£ 200).[57] Went with John to lunch at Madame Ormond's with all the children and Robert, who seemed very nice, and Rose Marie seemed very happy. Afterwards we went to see Rose Marie's apartment, 68 rue de Bellechasse, charming. Evening we dined at the André Michels': Violet, Rose Marie, Francis, Madame Ormond, the Boutroux, John, I, and some others.

August 7th—Rose Marie's Wedding Day. She looked *exquisite*, the ideal of maidenhood, simple, tender, serious. At about 1:20 John and I arrived at the sacristy of the Eglise de l'Etoile. At about ten minutes to two o'clock, Rose Marie arrived. She seemed to hesitate a moment on entering the door, and then she went round very sweetly and shook hands with everyone and kissed some, John & me amongst them. Then we all filed in to the church. John took in Mme de Varigny,[58] M. Massigli took me in. Francis, Violet, Rose Marie, Robert, M. and Mme André Michel sat on a row of chairs in front. Pasteur Wagner[59] preached a splendid sermon. Guillaume played on the organ when we went out from the church to the sacristy, and shook hands. Then back to Madame Ormond's flat. At five o'clock Rose Marie and Robert left. Violet, Madame Ormond, Rose Marie and I were crying, but I think Rose Marie was very happy. John and I drove about—and dined at the Hotel—John and Jean L played chess in the evening. John returned to London at noon next day. I joined the Ormonds at Combloux.[60]

Rose-Marie's youngest brother Conrad, then fourteen, wrote his own account of the event to Susie Zileri, an artist and friend of the family. After putting on his best suit and going to the barber, Conrad reached his grandmother's apartment at 1:30 pm and.

[I] started for the church, where I met my young girl, whom I was to conduct to her seat.[61] The procession was then formed and of course I was very near the front, being one of the family, and crowds of cousins brought up the rear. We walked slowly through the church and took our seats. Then the clergyman gave a splendid sermon, which was very impressing; after this I and my young girl, with two other couples had to hand round the bag for the poor. I had to hold on to the hand of my partner, so to speak, while she held the bag (you can imagine what an ass I felt, parading round the church, with everybody staring!!!!!!!!!!!!!!!!!!). After the two had been married we marched into the vestry and general congratulations began. Then we started to march out of the church, while Guillaume was playing on the organ.[62]

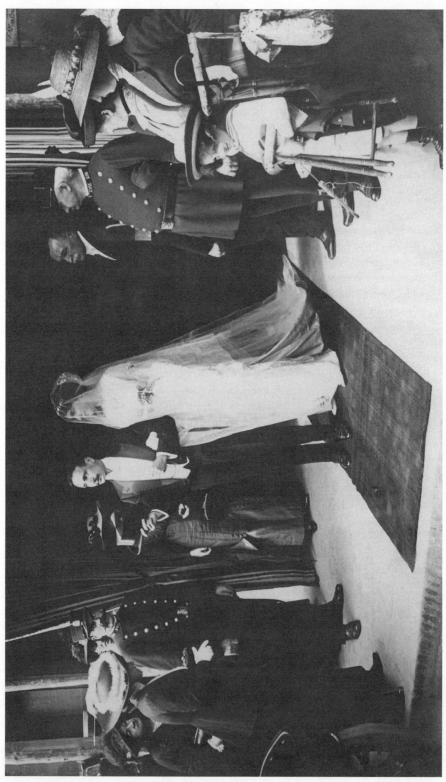

Figure 3.11. The wedding of Rose-Marie and Robert, August 1913. Rose-Marie and Robert solemnly pause as they leave the church of the Étoile. Aunt Emily is on the left, and on the right Robert's sister Madeleine Vermeil with her seven-year-old son Max. Private collection.

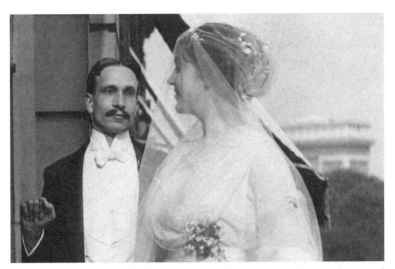

Figure 3.12. Rose-Marie and Robert at their wedding reception. Rose-Marie posed with an adoring Robert on the balcony of her Bonne-Maman's apartment, with the Arc de Triomphe in the distance. Private collection.

It was a sudden change for Rose-Marie, hitherto the waif of a vagrant marriage, uncomfortable in her elegant surroundings. She had jumped at the chance for a life of her own, in Paris, in a large stable family with a man she could not have known well yet, but with whose ideals and hopes her own chimed in glorious harmony.

~

Robert André-Michel

André Michel's only son, Robert, was his father's loving friend and professional disciple, and his pride and joy. Robert Félix Henri Michel came into the world at the Mas du Ministre, the family farm near Montpellier, in the small hours of Sunday, 12 October 1884. The sixteenth-century *mas*, a farm and *domaine viticole* just outside Montpellier, had been the property of André Michel's pastor grandfather.[1] The farm was a refuge from Paris for the family, and Robert grew up to school age as much there as in the capital. The sunny, peaceful, fruitful country of Languedoc-Roussillon, bordered by the Rhône to the east and the Mediterranean to the south, was dear to him all his life, and it was the stage for his first published historical research. It is a country steeped in recorded history. It had been Roman Aquitania, then a part of the great County of Toulouse, and then governed by the French kings' steward, the seneschal of Beaucaire. It was also the country where Robert's Huguenot religion had been rooted for generations, where his great-grandfather Honoré Michel had been pastor of Montpellier and president of the Protestant Consistory of France.

The year of Robert's birth saw the abolition of Catholic public prayer in France, a development of the secular republic that was congenial to the Protestant population. Robert Michel grew up in a modern, liberal, secular France, and became an avid student of the medieval Christian France in which his ancestors were members of the one Church like all the other Christians. Following the teaching of Gabriel Monod, he adopted the recently canonized Joan of Arc as a secular patriotic saint. Another was King

Louis IX, whom he consistently called "Saint Louis" just as Catholic France did: it was merely that king's medieval name, as free of sectarian connotation as the name of his grandson, "Philip the Fair."

At home in Paris, André Michel established his growing family in the ground-floor apartment of 59 rue Claude-Bernard, a short trip by tram from his work at the Louvre. The young children enjoyed day trips, weekend getaways, and longer holidays at their grandparent's Hawaiian-style villa at Montmorency. Charles and Louise de Varigny moved full-time to the villa once their children had married. Hélène's brother Henry had set up a scientific laboratory on the grounds of the villa, and there would be excursions looking for plants and tadpoles in the neighboring woods. Grandmother "Love" raised chickens, ducks, and turkeys, and kept a vegetable garden. The family usually returned to Paris with some of her fresh produce. [2] In the autumn of 1891, around the time of Robert's eighth birthday, his uncle Henry recruited him to hunt spiders of the genus Epeira in the woods of Montmorency—just the two scientists, no squeamish girls.

Scholar and Sergeant

Robert Michel was "brought up in the cult of the beautiful," wrote his friend Robert Burnand, and he developed his interest in history in conversations with his father, the foremost historian of art in Europe, as he underwent the same old-fashioned preparation for a learned profession as his father had done. His elementary education included Latin and French literature, mathematics, music, geography, and basic science, followed by the lycée. The Lycée Henri-IV in the Latin Quarter was a ten-minute walk from the family apartment at 59 rue Claude-Bernard. An elite public school since the Revolution, named in honor of the king of toleration by the new Republic in 1873, the Lycée Henri-IV was, and remains, the chief preparatory school for the Grandes Ecoles: Ecole Normale Supérieure, Ecole Pratique des Hautes Etudes, and Ecole Nationale des Chartes. The college course of four years ended with the baccalaureate degree. In the first week of August 1901, a couple of weeks before his baccalaureate examination, Robert had a bicycle accident that left him with a swollen face and entailed stitches on his lips and eyebrows. But he was well enough to sit and and pass the exam on 16 August. Students like Robert who aimed at the Ecole des Chartes took a further two years and wrote a licentiate thesis in history. His studies were complicated, though not seriously, by his compulsory military training and service.

Robert was in the recruitment class of 1902, his eighteenth year, but his pending licentiate in letters gave him the privilege of a year's deferment, and

so it was in November 1903, one week after his admission to the Ecole des Chartes, that he "passed under the flag" of the 102nd Regiment of Infantry (RI) as a volunteer for three years.[3] He would be free during the academic year to live at home in rue Claude-Bernard and attend his classes at the Ecole—in uniform and with his bayonet in its leather sheath at his belt. His barracks life and military training would be concentrated in the summertime. His *bulletin de recrutement* gives the military description of his plain face: "Hair and eyebrows chestnut, eyes chestnut, forehead high, nose long, mouth medium, chin round, face oval. Height 1 meter 66 centimeters [5 feet, 5.5 inches]."[4]

After his initial months of service and training, in September 1904 he was promoted to corporal and released to his studies. His promotion to sergeant came in March 1905, and while he was with the regiment in barracks at Chartres that summer he was photographed, probably by his father, an experienced recorder of significant scenes. Robert stood for his picture in a punt on the river Eure, with both arms poised to show his recently acquired sergeant's insignia, a single stripe of gold braid on a black velvet patch, canted thirty degrees forward on each cuff of his dark blue *ras de cul* ("butt-shaver") tunic. He was wearing the red infantry *kepi*, the short-brimmed pillbox cap embroidered with the 102 of the regiment, and the *pantalon rouge garance*, the red trousers stubbornly retained by a sentimental General Staff (even though they made each *poilu* terribly visible on the battlefield) until they were phased out beginning in October 1914, after Robert's death.[5] For four weeks in the summer of 1906 Robert was on training exercises with his regiment, exercises which ended for him on 19 August, when the grand national maneuvers began. In November his three years "in the active" were up, and he went on the reserve list of the 102nd RI.

The life of a citizen soldier of the 102nd RI was described by Robert's friend and fellow sergeant Abel Gendarme de Bévotte, who experienced it in 1912 and 1913.[6] Abel's daily letters to his doting parents from the Chartres barracks at first caused them nothing but anxiety. Communicable diseases were all around him: bronchitis, pleurisy, typhoid. Abel reported angry rages among the troops, the chronic stupidities of military life, obscene incidents. There was theft in the barracks, sabotage of gear, and bullying of those too simple or too weak to resist, and the subofficers showed favor to the rich and well connected. No band of brothers there, but *chacun pour soi*. The officers seldom appeared, but left the direction of the troop to the sergeants and corporals. Half the assigned tasks and exercises were a waste of time—unplanned, uncoordinated, and useless. In one letter Abel told about a day when three orders arrived simultaneously: to vaccinate the troops, to change their bedstraw, and to shower the lot. In rapid succession they were vaccinated with a scratch on

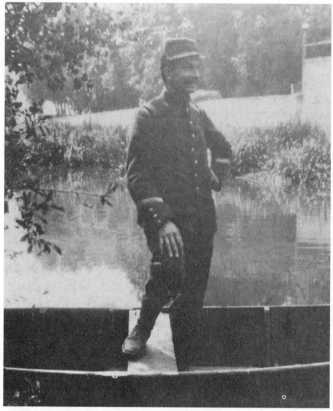

Figure 4.1. Robert Michel, sergeant, 102e Régiment d'Infanterie, 1905. Robert displayed his new sergeant's gold braid while casually posed in a punt on the River Eure. The red trousers and cap, though dangerously visible on the battlefield, were favored by the traditionalist General Staff until after Robert's death in October 1914. Private collection.

the arm, showered (washing off the vaccine), and set to shake out their dirty, dusty mattresses (undoing the showers).

The realities of marching and campaigning, even the tactics of combat, including rifle exercise, were neglected, while the soldiers were trained and retrained in cookery, camp laundry, and sweeping. Trenches had proven essential to an army's survival recently in Manchuria and the Balkans, but the 102nd RI was not being trained to dig them. "Why not?" innocently asked Abel. His captain responded by stating the operative principle: "Listen, my boy: the French soldier is not a rabbit." Abel was learning principles too. "To obey inexact, simultaneous, and contradictory orders instantly: that is military discipline." He formulated his conclusions: "Order + supplementary order + counter-order = disorder." But when summer

field exercises came, though they were brutally laborious and though the officers in command, with higher officers watching and judging, were despotic and unsparing, the platoons, companies, and regiments came out of them with a disciplined cohesion, a shared experience of suffering, and a unit pride that felt like brotherhood and affiliation in a splendid national tradition. Eventually there was rifle exercise and firing practice with the elegant Lebel 1886, and Abel came to be "attached to this superb instrument, to love it for its simplicity and its power."[7]

Robert Michel, *Archiviste Paléographe*

At the Ecole des Chartes in the academic years 1904–1908, Robert Michel became a master of medieval manuscript books and documents, and of the archives and libraries where they are preserved. The Ecole was founded in 1821 and planted within the Sorbonne, the medieval heart of the University of Paris, with the purpose of training a professional corps to preserve, organize, and exploit the treasure of manuscript books and documents that the Revolution had made the property of the French nation. The training courses were intense, and examinations, both oral and written, were severe. Graduates received the certificate of *archiviste paléographe* and went forth (as they do today) with appointments to the archives and public libraries of France. The subject matter was medieval, and the institutions that produced it had been royal and feudal, but the Ecole that Robert knew was strongly liberal, scientific, and republican, as it proved in the acid test of the Dreyfus Affair, when the handwriting of a certain very modern manuscript document, the infamous *bordereau*, had to be identified with certainty.

It was in November 1903 that Robert Michel sat for the entry examination to the Ecole des Chartes. His knowledge of classical and French history and his ability to read Latin were his most important assets in that exam. He passed eighth of the twenty-one enrolled into the first year of the Ecole, beginning classes in September 1904 after his first year in the uniform of the army. The work of his first year can be judged by the content of the week-long examinations in July 1905, in which Robert placed fifth of twenty students. He had to read some lines of a fifteenth-century Latin manuscript from the Bibliothèque Nationale; likewise, some lines of a French manuscript; name the sovereigns of France in the years 1100, 1200, 1300, 1400, and 1500; name and date all the treaties that changed the eastern and southern boundaries of France between 1648 and 1795; translate a notarial act from the Archives Nationales; comment on the grammar of six verses from the Norman-French *Roman de Rou* (otherwise known as *Wace*). That was the oral test. The written test: transcribe

a Latin manuscript page from the Ecole's collection of photographs, and one in a Romance language; translate a printed medieval Latin text, and one in Provençal; and create index cards for two historical monographs in an author catalogue and in a subject catalogue.

July 1906 found Robert admitted to the third year of the Ecole, ready for some solo research and alert for a subject. In the Archives Nationales he found it: an enormous bureaucratic creation that opened the door for him into the daily lives of the common people of his nation in the thirteenth century. This was a register of the complaints and pleas for justice collected by traveling commissioners for Louis IX when the king was about to depart for his second Crusade in 1270. For the rest of Robert's life Saint Louis was one of his historical idols, a morally responsible king of the French and an efficient administrator and prudent record keeper. In July 1907 he received permission to present the thesis that he had already begun to assemble. Now free from the active army, he spent the rest of the summer and all the fall in research and writing, mainly in the departmental archives in Nîmes and in his native Montpellier. Theses were defended before the faculty of the Ecole and their specially invited colleagues in a three-day academic festival, 27 to 29 January 1908. Robert Michel defended his *Etudes sur la politique royale à l'égard de la noblesse et des villes consulaires dans la sénéchaussée de Beaucaire au temps de saint Louis*. First in order of merit of fourteen theses that year, it received the prize endowed for that achievement in memory of Auguste Molinier, who had died just before Robert entered the Ecole, but whose work on the Seneschalsy of Rouergue had inspired his choice of subject.

The Protestant Molinier had been one of the three champions from the Ecole des Chartes who, by expert handwriting analysis, had scientifically demonstrated the innocence of Dreyfus in three trials. Two others also helped to form Robert professionally: Paul Meyer, director of the Ecole des Chartes, was Robert's professor of romance philology, a Catholic—although the venomous Edouard Drumont in his *La France Juive* referred to him as "*le juif allemand Meyer*."[8] And Arthur Giry, an atheist (brought up Protestant), was the author of the indispensible *Manuel de diplomatique* and had been another of André Michel's teachers twenty years earlier.

André Michel's family vacationed that summer of 1908, as they often did, in a rented villa at Berck-sur-Mer (Pas de Calais), and Robert posed in his usual beach attire of dark wool suit and tie with his youngest sister Juliette, sixteen, and their two-year-old nephew Max Vermeil.[9] Jacques Massigli, the son of André Michel's sister Marguerite, was in a tuberculosis sanatorium at Berck, and Hélène Michel would take a house there for part of the summer to bring her children together with their Massigli cousins. Also at Berck were

other young friends of the Michels, the large family of Pastor Alfred Boeg-
ner, the head of the Paris Missionary Society. The oldest Michel daughter,
Jeanne, had already married a protégé of Pastor Boegner's, Maurice Leen-
hardt. The pastor's older son, Henri Boegner, born the same year as Robert,
was his best friend.[10] The Boegners came to Berck because one of the six
Boegner sisters, Geneviève, called Vivette, suffered from coxalgia and was
treated by being encased in a type of plaster corset from the age of fifteen
to twenty.[11] That experience led her to dedicate her life to the plight of the
chronically ill. She became Rose-Marie's best friend.

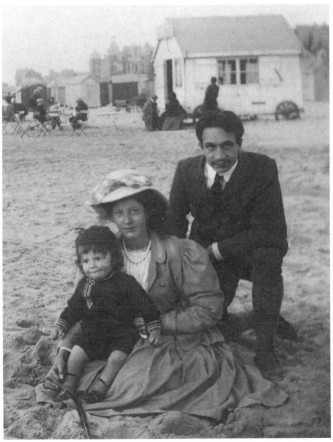

Figure 4.2. Robert and Juliette Michel and their nephew Max Vermeil, Berck-sur-Mer,
1908. The Michel family rented a summer cottage at Berck to be close to the tuberculosis
sanitaria where their cousin Jacques Massigli and their close friend Geneviève Boegner
were being treated. Private collection.

Ecole Française de Rome and Archivio Segreto Vaticano

In October, Robert was off to the Ecole Française de Rome, the school of archeology that had been established in 1875 in the top story of the Palazzo Farnese, above the French Embassy. The Palazzo had been finished by Michelangelo for Pope Paul IV Farnese in the 1530s and decorated with contemporary masterpieces of painting and a collection of sculptures liberated from such classical ruins as the Baths of Caracalla. Most of the marbles went to Naples in the eighteenth century, but the broad monumental staircase still has a heroic statue or two to greet a scholar as he climbs Parnassus to the great library of the Ecole Française. Who could ascend those stairs daily and then write less than a masterpiece of eloquent scholarship? Not Robert. His first task was to finish his grand monograph, *L'Administration royale dans la sénéchausée de Beaucaire au temps de saint Louis*, some two-thirds of which had been his prize-winning Ecole des Chartes thesis. This appeared in 1910, a masterpiece of systematic and searching history, and Robert's only monograph. The Académie des Inscriptions et Belles-Lettres gave the Gobert Prize each year for "the most profound work on the history of France and the studies attached to it."[12] In 1910 the prize was worth 10,000 francs, and Robert's *L'administration royale* shared it with Emile Mâle's two volumes on medieval religious art in France.

Robert had a room in the Palazzo Farnese and profited from the Ecole's library and lectures in the afternoons and evenings, but the Vatican Archives opened only in the mornings, and there he found the work for which he had been made *archiviste paléographe*. As Wordsworth sang in a different connection, "Bliss was it in that dawn to be alive / But to be young was very heaven!"[13]

It was an inspiring twenty-minute walk to work, especially delightful on the clear, mild mornings that are customary in Rome in October. Robert would step out into the Piazza Farnese and in two short blocks would come to the narrow Via Giulia with San Giovanni dei Fiorentini framed at its end, a third of a mile ahead. (Ponte Vittorio Emanuele II would have been a short way across the Tiber, but it would not open until 1911.) Robert continued up Via Paola to Ponte Santangelo and crossed between its rows of Bernini angels to the armored gate of Castel Sant'Angelo, then into the maze of streets and alleys of the Borgo—the broad Via della Conciliazione was an unimaginable future away. Borgo Pio brought him to the Cancella Sant'Anna, where he entered the grounds of the Vatican Palace and was saluted (once he had become a familiar worker) by the papal gendarme on duty. Straight uphill to another gate, the Cortile del Belvedere, and finally the door of the Archives.

Robert's heaven was the world of medieval archival research, a complicated paradise open to few. The documents were handwritten and in Latin—not classical but medieval Latin—a bit barbarous in grammar and spelling and overlaid with the contemporary bureaucratese, legal and quasi-theological periphrases and formulae. The record script of the fourteenth century was a tricky "gothic minuscule," whose letter *i* was usually undotted, just a "minim," a little vertical tick, while *m n u v* were groups of three or two minims. So ιιιιιιιιιιιι spells *minimum*, all right? Every second word was abbreviated, as parsimoniously as possible; for example, *miā* is *misericordiam*. And mind the *P*s and *Q*s! Tiny differences could make *per / pro / pri / pre* or *qui / que / quod / quoniam / quare / quo / qua* and more. The accounts of money were in several different obsolete systems, and the dating was just as arcane. Never mind. Robert could meet a new document each morning in the Vatican Archives and devour it as readily as his daily *Messaggero*.

The Archivio Segreto Vaticano (to give the institution its full Italian name) had been open to scholars only since 1881, and members of the Ecole Française were already at work on their greatest gift to medieval historians: publishing the letters of every single pope from Gregory IX (1227) until the Great Western Schism began (1378) in chronological calendars. Those earliest harvesters were picking the ripe, low-hanging fruit: the popes' letters had originally been copied into hundreds of properly labeled volumes, *Registra Vaticana*, *Registra Lateranensia*, *Registra Avinionensia*.

The rest of the Archives was a baffling jumble. Over the centuries, the various and shifting departments of the papal state and the Roman Church had made use of documents from various sources and then neglected to put them back where they came from. *Respect des fonds*, the archival principle of keeping documents in their original order, was supercomplicated in the Vatican Archives of 1875 because *rispetto dei fondi* had never been consistently practiced. There were indices of some collections, but they were themselves hard to find and many were incomplete. There was no general guide or catalogue of the Archives. In short, a chaos, but to Robert Michel, *archiviste paléographe*, it was Aladdin's Cave.

While he was finding his way into his principal subjects, Avignon and art, he stumbled on material too intriguing to pass by, the sources for three completely different articles that he published in a rush, all in 1909. There was a brotherhood of knights that made the Roman amphitheater of Nîmes their barracks and fortress in the twelfth and thirteenth century. Robert sent his article about them to Gabriel Monod's *Revue Historique*. The other two studies appeared in the Ecole Française's own journal, *Mélanges d'Archéologie*

et d'Histoire: one about the first mechanical clocks in the papal palace at Avignon, and the other about a particularly brutal phase of the popes' long battle against the Visconti lords of Milan. At the end of each article we find the *pièces justificatives*, full transcriptions of the archival documents that it was drawn from. Robert Michel always provided such a documentary appendix to his works, just as a research physicist gives tables of his instrument readings, so that any reader could, and still can, assess his research ability and the validity of his conclusions.

The Ecole Française was most deeply engaged with the Vatican Archives' records of the fourteenth century, when the popes were all francophones, lived in Avignon, and built their magnificent fortress palace there. Avignon was not in France then, but just across the Rhône in the Holy Roman Empire. Those documents are richer and better kept than those of earlier centuries, and easier for a researcher to discover, because there were fewer departments and they kept their books in more standardized ways. Early in that century, Pope John XXII reorganized the office of the chamberlain, a bureau called the *Camera*, to make it a more efficient collector of his taxes and keeper of his treasures. Instead of having a figurehead cardinal-chamberlain of the Roman Church, he appointed an archbishop as his own papal chamberlain, head of the *Camera Apostolica*, and left the cardinals to choose one of their own as chamberlain of the College of Cardinals. The records of the *Camera Apostolica* in the Vatican Archives constitute the *Fondo Camerale*, material enough for whole bookshelves of good economic, social, military, and artistic (though not much religious) history. There are ledgers of the income and expense of the Treasury, of the bonds and receipts of thousands of debtors, of the activities of scores of collectors throughout Europe from Ireland to Hungary and from Norway to Sicily, and the official letters of their commander, the chamberlain. The documents that were not bound in books were numbered and preserved as *Instrumenta Miscellanea*. Ten years before Robert Michel arrived in Rome, Joseph de Loye, a scholar of the Ecole Française, had actually made a sketch inventory of the *Fondo Camerale*,[14] and Robert was able to mine that resource systematically.

For two crowded years Robert divided his time between the Vatican Archives and Avignon. The fourteenth-century papal palace there had been rather neglected for four-and-a-half centuries by the papal legates and vice-legates who governed the city for its lord the pope. Then, in 1791, the city was annexed by the newborn French Republic, and the palace served as an army barracks, stable, and prison until the troops marched out in 1906, the same year that the army released Robert himself from active service. It was a mess, and the art had suffered horribly. Prisoners had left some touching

graffiti in the tower cells where there once had been a library and treasure store, but soldiers elsewhere had subtracted: saints were missing their frescoed faces, chipped off the stone with bayonets for sale to art lovers. One of Europe's earliest monumental Last Judgments, which had dominated the Audience Hall, was hacked off entirely by order of the commandant: its message was incompatible with military discipline. Military necessities had pressed on the popes at Avignon as well, and Robert studied their defense of the town and palace, the construction of the ramparts that still encircle the town, the retreat palace of John XXII at Bonpas, and the defense of the Comtat-Venaissin (the papal state east of the Rhône) against the plague of *routiers* or freebooting mercenaries. Following the example of Auguste Molinier, Robert told the full story of one instance of the blood libel, this one against the Jews of Uzès in Languedoc. At this point he had his sights fixed on the degree of doctor of letters from the Sorbonne, for which he would have to present two theses. His article on the ramparts of Avignon had been accepted as his *petite thèse*; his *grande thèse* was to be on the fortified towns and castles of the popes of Avignon. We have only chapters of that work, printed as posthumous articles.[15]

Archives Nationales de France

When he turned twenty-six in October 1910, Robert Michel quit being a student, subject to qualifying examinations. It was the end of his second year's research appointment, and he was named *hors cadre*, a permanent member of the Ecole Française de Rome. Another winter in the Vatican Archives was followed by an early spring in Avignon. He produced a short, sensational article for *Revue de l'Art Chrétien* in which he gave a name to the sculptor of the monumental tomb of Innocent VI (he found it in the Vatican Archives: Bartholomé Cavallier). Then, in May 1911, in the smooth and natural course of things for a superstar, Robert Michel was appointed one of the archivists of the National Archives in Paris and returned home to 59 rue Claude-Bernard. His research journeys to Rome and Avignon continued while he performed a serious clerk's job in the Archives, making an inventory of some of the earliest records of the central royal court, the Parlement de Paris. He signed the work "Robert André-Michel," and that was his surname from then on, his father's name hyphenated, an affectionate homage to his friend and first teacher.

The name André-Michel stood out like a dedication at the head of three remarkable short articles that followed, each one a landmark in the history of painting in the papal palace. Robert described the small chapel of St. John

that one enters from the Consistory Hall, with photographs of the frescoes to illustrate his iconographic readings. Those were complicated, because the pictures represent events from the legends of three different St. Johns: the Baptist, the Evangelist, and the Divine. He proved that two earlier attributions of the chapel frescoes—to Giotto and to Simone Martini—were impossible, though he stopped short of identifying the real artist, Matteo Giovanetti of Viterbo. He was the first to name Matteo Giovanetti as the painter of the twenty prophets pictured in two arches of the Audience Hall. And he gave the first complete description of the charming scenes of hunting and fishing in the *Chambre du cerf* of the Wardrobe Tower, the private study chamber of Pope Clement VI and his successors. This was the last article that Robert André-Michel ever finished; he submitted it to the *Gazette des Beaux-Arts* in the last week of July 1914.

The Sons-in-Law of André Michel

The little world of 59 rue Claude-Bernard, ground floor, was itself developing and changing while the only son made his way to the heights of French medieval research. As professor of the Ecole du Louvre, free lecturer at the Temple de l'Oratoire, and directing editor of *Histoire de l'Art*, André Michel met and befriended many young men of high intelligence, sound (often Protestant) moral conscience, and earnest purpose for their lives, and once a month Madame Michel presided in a *salon* where an intellectual and moral elite enjoyed choice conversation, music, and the bright company of their equals, including the four Michel daughters. Hélène Michel's attitude to her children's upbringing reflected her parent's advanced ideas. She "encouraged independence in her daughters, allowing them relative freedom that was the envy of their Parisian friends,"[16] and they exercised that independence in the choice of their life-companions, like the American Protestant women their grandfather Charles de Varigny had described.[17]

Jeanne was the oldest, born in 1881. She was one of the first women to pass the "modern" baccalaureate. At fifteen she took up the Calvinist faith of her ancestors with a heartfelt dedication and pursued charitable works alongside her studies and her collaboration with her father's editorial work. Meanwhile, her mother's stories of her childhood in Hawaii inspired Jeanne with an enthusiasm for the foreign missions.[18] Her zeal was shared and echoed by young Maurice Leenhardt, a fellow Montpelliérain, the son and brother of pastors, who was studying in preparation for missionary work, and they fell in love. Maurice's father was a cousin of the famous painter of historical Huguenot scenes, Max Leenhardt, one of André Michel's favorites. Maurice had

been especially entrusted to the tutelage of the missionary society director Alfred Boegner.[19] His parents feared that their son's devotion to music and art might overtake his missionary zeal in Paris; instead, it created another link with his missionary helpmate, Jeanne Michel. It was a perfect match. Their engagement survived Maurice's year of study in Edinburgh, and ended with their marriage in Montpellier in 1902. Then they were off to the largely pagan French colony of New Caledonia. André Michel stoically surrendered his daughter to her vocation in the antipodes, accepted Maurice warmly as a son, welcomed the grandchildren, and stayed in close touch with letters, postcards from his own travels, and surprising gifts, even a plaster copy of the Winged Victory in the Louvre.[20]

Madeleine, a year younger than Jeanne, did not finish her baccalaureate. She and her father seem to have agreed that her time was better spent in studies of her own choosing and in holding copy for proofreading as his editorial assistant. Madeleine later wrote articles on childhood education and children's books; her *Si nous lisions: L'Histoire de deux enfants* came out from her father's publisher Armand Colin in 1920. A mutual friend, the sculptor Henri Vallette, introduced Edmond Vermeil to the Michel *salon* and to Madeleine in March 1902. Their first conversation was about Beethoven.[21] Vermeil came from Madeleine's own Protestant world of Aquitaine (though he was born in Vevey). After the lycée in Montpellier and Nîmes, he was completing his studies of German language and culture in the Sorbonne.[22] The politically harmonious Madeleine and Edmond (both later members of the Anti-Fascist League) were also enthusiasts of literature, art, music, and German culture. They married in 1904 and went to Göttingen as lecturers in the university, he in *Germanistik* and she in Romance literature. Returning to Paris in 1907, Edmond taught German language and culture at the Ecole Alsacienne. He enlisted in the infantry in 1914, was wounded, and took a post in military intelligence. Between the wars he wrote studies warning of the conservative revolution in Germany and the menace of Nazism, and he was in the Resistance in Montpellier before joining De Gaulle's Free French in London.

The third daughter, Marthe, continued the family practice and chose her life-companion from the same Protestant elite, from the Monod family, which had many links to the Michels. A Swiss ancestor had traveled to Copenhagen after the French Revolution to serve as pastor of the émigré French Protestant Church there, and the large Monod family moved to Paris in the 1830s. Daniel Monod received his doctoral degree from the Protestant Theology Faculty of Montauban in 1909 and married Marthe Michel on 18 April 1910. In the 1914–1918 War he served as a Red Cross stretcher-bearer, then

as a military chaplain. During the German occupation from 1940 to 1944 he preached courageously to the Paris congregation of St. Esprit, including several German officers, and in another way he proved himself worthy of his ministry and of the example of his cousin Gabriel Monod, tireless captain of the Dreyfusard cause. Gabriel had written polemical pamphlets under the pseudonym Pierre Molé. Pastor Daniel Monod created false baptismal certificates for the many Jewish children who were hidden in the Catholic college of Avron near Fontainebleau.[23]

Had André Michel looked back at his review of Madame X in 1910, he would have recognized in his daughters the "frank and healthy blooms" that had not fallen into the belle époque "idea of Parisian cosmopolitanism" embodied in Madame X. It is remarkable with what unanimity these three young women, brought up with the most liberal educations and opportunities, each chose a scion of one of the prominent Huguenot pastoral families, a young man of extraordinary intellectual and moral energy. The hackneyed consolation to the parents of a bride, "You're not losing a daughter but gaining a son," really applied to Hélène and André Michel. They proudly claimed and welcomed each new gendre who offered one of their daughters an ideal married life. The youngest daughter, Juliette, played a novel variation on the same theme.

Abel Gendarme de Bévotte

The company at one of Madame Michel's last monthly soirées of 1910 included a nineteen-year-old student of law, Abel-Camille-René Gendarme de Bévotte. The next day he wrote in his journal, "The disadvantage of these gatherings is the intoxication that comes with them, the desire for conversation with girls, the desire of love and youth, that intoxication so well expressed in the waltz of the Symphonie fantastique. But after these dream flights, how monotonous and sad reality seems!"[24] Abel was ready to fall in love with the last unmarried Michel daughter, the intoxicating Juliette with her shy glance, her charming smile, and her silvery laugh.

Abel was an only child and an exceptionally tall, handsome, earnest, and accomplished young man. His father Georges was a professor of Romance literature in a succession of elite schools, culminating in the Lycée Louis-le-Grand (where young Abel earned his own baccalaureate), and author of enduring works on the literary figure of Don Juan and the topos of the Stone Guest. Abel's mother, Cécile, was an accomplished classical pianist and a connoisseur of European painting, and Abel devoted a daily heure de maman to music and conversation with her. From his early teen years Abel

had frequented the Louvre, the concerts of the classical orchestras, and the Comédie Française. He was a fervent Wagnerian from his first *Tannhäuser* at age sixteen.[25] He was a better than amateur landscape painter and an outspoken Impressionist. The family was Catholic in its tradition, but Georges, Cécile, and Abel were all sturdy freethinkers; Abel's instructor for First Communion was a Dreyfusard *abbé*, and he read Renan's *Life of Jesus* at seventeen. The Michel and de Bévotte parents may have met in Montpellier, where the lycée professor Georges Gendarme de Bévotte belonged to a sort of Epicurean garden club called *l'Enclos*. They were intellectually related through Gabriel Monod, Georges's and André's teacher at the Ecole Pratique des Hautes Etudes. But the children, Abel and Juliette, met in Paris, where, at ages twelve and eleven, they were neighbors, the family de Bévotte in rue du Val-de-Grâce and the Michels ten minutes' walk away in rue Claude Bernard. The summer he turned fourteen, Abel needed dancing lessons to teach him the graces, since he had no sister. In an informal dancing school at the house of a friend, he learned the waltz and all the fashionable modern dances, and "he found there a charming milieu of young girls [and likely the thirteen-year-old Juliette], learned social ease, and shook off his timidity. . . . After the lesson, when the master had gone, Cécile took her place at the piano, the whole little society swirled around, chattering, and their parents joined in the dance."[26]

Earnest and wholehearted in everything, Abel in love drew on the art he knew to create a Romantic sentimental world in which he was Romeo to his Juliette Michel, Tristan to his Isolde. A few months after that intoxicating evening at her home, he was surely looking in opera for the Protestant girl he loved when he went with his mother to a performance of Meyerbeer's *Huguenots*. Incidentally, this patriotic Frenchman seems to have ignored the French composers, except Berlioz. His enthusiasm was for the Germans, especially Wagner. His father wrote about Abel's admiration for

> the realism, the slightly heavy discipline, the vigor and the order of the German spirit. He did not hide his sympathy for that spirit, which was able to bend itself to a rule. And for him Germany was the country of Beethoven, of Schumann, and of Wagner. Later, on the eve of the war, in his last letter to one of his friends, he wrote of his intention to do his duty (and God knows he exceeded it!) and also of his sorrow at having to fight a people which he loved from the bottom of his heart.[27]

For more than two years Abel's love grew deeper and more fervent, while he finished his legal studies; took the advocate's oath; began his military service in the 102nd Regiment; was promoted to corporal, then sergeant; and

spent long holidays traveling and summers in Provence. Proposing marriage to Juliette, it seemed, could wait until his release from the service. But the crisis over Morocco in July 1911, when the German gunboat *Panther* steamed into the port of Agadir to challenge French influence and test the Anglo-French Entente, made Abel consider that war might come to keep him in the active army indefinitely. Then, in August 1913, he passed up his chance to register for training as an officer, and his father knew the reason at once: Abel did not want to be away from Paris and Juliette.

Robert Married, Juliette Engaged

It was on the 7th of that August that Juliette's brother Robert married Rose-Marie Ormond and they began their married idyll. Their honeymoon began at the seaside. Then Robert was back to work in the National Archives and Rose-Marie plunged into his Avignon research, brushing up her Latin, learning the fourteenth-century handwriting and the bureaucratic style of the papal records, making fair copies of Robert's transcriptions and of his articles for the journals.[28] So went their autumn of marriage, at home at 68 rue de Bellechasse. Thinking of one of André Michel's favorite murals in the Pantheon, Puvis de Chavannes's *St. Genevieve keeping watch over Paris*, Robert photographed his wife looking over the little park behind their flat. As she adopted the pose she may have been thinking of Louise's aria *Depuis le jour*, "Since the day when I gave myself / My destiny seems all in flower!"[29]

In October began the unofficial engagement of Juliette Michel and the warm familial embrace, customary to the Michels, of their worthy son-in-law-to-be Abel Gendarme de Bévotte. "Cultured, an artist, preoccupied with moral questions as he was, with this marriage he would enter a family that corresponded in all points with his ideal. . . . Only the difference of religion separated them, but given Abel's ideas this could be no obstacle."[30] The engagement was made public only at the end of November; the wedding was to wait until the end of Abel's compulsory army service in October 1914, but Abel signed the lease for their future home at 284 boulevard Raspail, and they happily set about furnishing it.

"A sad surprise on the subject of Rose-Marie's health," Henry de Varigny wrote in his journal on 15 January 1914, "she has a malignant melanoma on the sternum, started around May. Sabouraud burned it, and this seems to have energized the germ. Morestier is going to operate, but we must wait six months to know if the operation was successful. What a tragedy, after just six months of marriage!"[31] The operation was done in the surgical clinic of the Hôpital Saint-Louis, with Dr. Darier in attendance to take lymph nodes

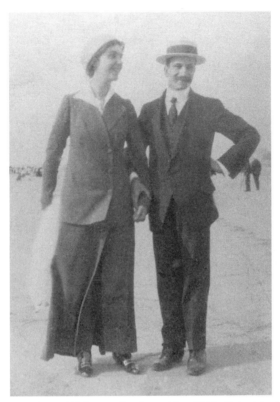

Figure 4.3. Rose-Marie and Robert at Berck-sur-Mer, 1913. Robert took Rose-Marie to the Michel summer home at Berck for their short honeymoon. Walking in their summer beach attire, they glow with pride and happiness at the sunny beginning of their life together. Private collection.

from the arm for biopsy.[32] Bonne-Maman hurried to Paris, fearing the worst. Guillaume came too, and went for distraction to *Parsifal* (an opera to which Henry de Varigny was becoming addicted). Violet Ormond feared that her daughter's cancer would grow again, but Sargent was more optimistic. "These things are not at all bound to return, and we must hope she will be free of it after this operation. I am awfully sorry there should be any element of uncertainty. She is such a charming creature!"[33] Early signs were good: Rose-Marie was home again on 24 January, and Henry noted that Dr. Darier had found no cancer in her lymph nodes. She reported to Guillaume:

> I came back at home yesterday afternoon with a joy above all words. I never felt perhaps so strongly the delight of home. . . . My arm is still very invalid, and I can't do much with it, but little by little it will be wright again. Only I

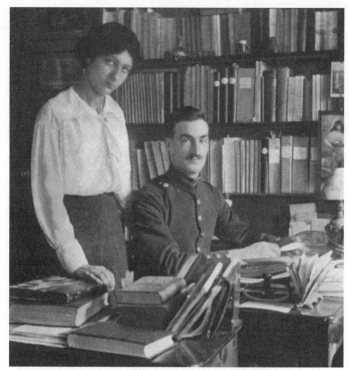

Figure 4.4. Abel Gendarme de Bévotte and his fiancée Juliette Michel, 1913. A serious amateur artist, law student, and sergeant in his compulsory military service, Abel Gendarme de Bévotte poses in his study with Juliette, the last unmarried Michel daughter. Abel's father wrote, "Cultured, an artist, preoccupied with moral questions as Abel was, with this marriage he would enter a family that corresponded in all points with his ideal." Georges Gendarme de Bévotte, *Notre fils* (1916), 388–89.

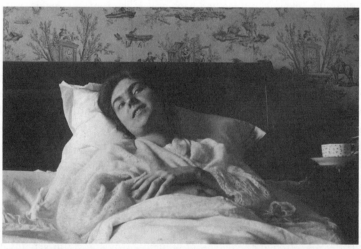

Figure 4.5. Rose-Marie convalescent, January 1914. After a successful surgery for a melanoma early in the winter of 1914, she wrote to Guillaume, "I came back at home yesterday afternoon with a joy above all words. I never felt perhaps so strongly the delight of home." Private collection.

won't be able to take my ordinary life just yet. At the Clinique my two nurses of day and night were really as nice as possible, and I was very lucky to have visits especially those of Robert and Bonne-Maman. Robert is taking again his work here at home, which I love seeing, because he is always so happy when he feels the day did not pass in vain.[34]

She wrote her last word on the subject in mid-May: "I went to the doctor Darier for my scar, and he says it will be extremely long to disappear but not dangerous at all."[35]

Early in spring, Robert took research leave and the couple enjoyed a working holiday in Rome, where they planned future campaigns in the Vatican Archives, and (with a visit to Sanremo *en route*) in Avignon, where Rose-Marie made sketches of the vandalized frescoes. André Hallays never forgot his impression of the happy couple in Avignon that spring. "Vibrant with enthusiasm and joy, he was doing the honors of *his* city, of *his* palace, of *his* archives to the charming and admirable young woman he had recently married."[36]

While Robert and Rose-Marie were staying with her Bonne-Maman in Sanremo, word came of the death of Frédéric Mistral on 25 March, together with an urgent request from the editor of *Foi et Vie* for a contribution to a special number in memory of the poet responsible for the revival of Occitan, the antique language of Provence and Languedoc.[37] Robert began immediately to outline "Au pays de Mistral," of all his published articles the most personal and joyful. His deep erudition in medieval southern history is in it, his fluency in Occitan, his broad knowledge of Mistral's works, and his marital bliss, too: he cites and quotes Mistral's young lovers Vincent and Mireille in the epic song cycle named after her. In Avignon, where he found copies of all the texts of Mistral, Robert finished the article as a pastiche of direct quotations from Mistral set within his own original frame. Here is their collaborative description of the broad, slow-moving lower Rhône as it flows by Avignon.

> And the river who, in all his glory, turns his floods toward the foot of the Rocher des Doms before Notre-Dame, Mistral paints anew for us, at the end of his course, when *with his weary waves, sleepy and tranquil, lamenting the Palace of Avignon, the farandolles and the symphonies, like a grand old man as he dies, he seems all melancholy, to go and lose in the sea his waters and his name.*[38]

Back in Paris early in May, Robert was stricken with German measles and quarantined in his bedroom. Rose-Marie wrote to Guillaume their regrets that Robert could not see him when he passed through Paris during Oxford's Easter vacation. Furthermore,

I could not write to you till today because of the microbes possibly sendable, but there is today a fortnight Robert began his German measles so every danger is supposed to be gone. He got awfully thin, the poor, but he feels quite well and we both start next Tuesday to spend four days at Chantilly to breathe country air. He will go back to the Archives on the 25th. His eyes were tired because of German measles, and it is still bad for him to read, so he won't have that temptation in the country. I did not take the *contagion* so I hope to be out of danger.[39]

Chantilly was and is the home of the Musée Condé, rich in illuminated manuscripts, which can be enjoyed without reading. Once quite recovered, reading and writing again, Robert finished composing his study of the Wardrobe frescoes in the palace at Avignon, and in two Wednesday lectures illustrated with transparencies, on 17 and 24 June, he revealed his findings to a rapt audience at the National Society of Antiquaries.[40]

At the beginning of July, Rose-Marie and Robert went, with Robert's mother Hélène, to join Jean-Louis and Reine at Crevin. Rose-Marie offered to her sister-in-law Juliette and Abel an introduction to her beloved Alps. Abel got leave from the regiment and they went off to Evian on Lake Geneva. That holiday was all the honeymoon Abel and Juliette were to have. "Their letters breathe a divine intoxication," wrote Abel's father, who followed their itinerary by the postmarks on those letters, to Finhaut, to Chamonix-Mont-Blanc, to the neighboring village of Montenvers, then back to Geneva. Abel returned to Paris on 12 July and on the 14th he paraded with the 102nd RI in the Bastille Day review at Longchamp racecourse.[41]

Rose-Marie and Robert planned to finish their summer vacation with her family on the Normandy coast. They were hoping that the growing quarrel between Austria and Serbia would not bring on war with Germany. Sargent was making his own plans, in careless ignorance of such matters. On a small sheet of his blue notepaper stamped "31, Tite Street, Chelsea, S.W." he wrote:

July 17. *Ma chère Rose Marie*, a thousand thanks for the lovely photograph. I am so glad to have it. It is very nice of you and Robert to offer me your hospitality when I pass through Paris, but I am flying to Tirol by way of Basle in a day or two, to a place that I have never been to, but that the Adrian Stokes report as being very nice—it is higher than the Simplon! I am so glad that you are all going to be together at Sotteville, and I wish I could be of the party. Affectionate messages to Robert. Your loving uncle, J. S. S.[42]

Figure 4.6. Robert at Crevin, July 1914. On the eve of the war, Rose-Marie and Robert, with Robert's mother and his sister Juliette and her fiancé Abel, visited Mme Ormond at Crevin. Robert posed sitting on the low, stone coping of the elegant reflecting pool that dominates the courtyard of the Château de Crevin. Private collection.

Did that party actually assemble at Sotteville-sur-Mer? Perhaps: the rendez-vous was only a half-day's journey from Paris or London.[43] But by the time Sargent's note reached rue de Bellechasse, Austria's brutal and demeaning ultimatum to Serbia was in the Paris newspapers and war had become probable and imminent. Robert hurried to finish or to delegate his ongoing projects at the National Archives, and he and Rose-Marie performed a triage on his Avignon research, setting aside the mere notes and sketches as dreams for the future, and marking up their transcriptions and the chapters of the *grande thèse* for revision and the addition of documents and citations. They actually finished two articles, and Rose-Marie made fair copies to be handed in at the *Gazette des Beaux-Arts* and *Bibliothèque de l'Ecole des Chartes*.

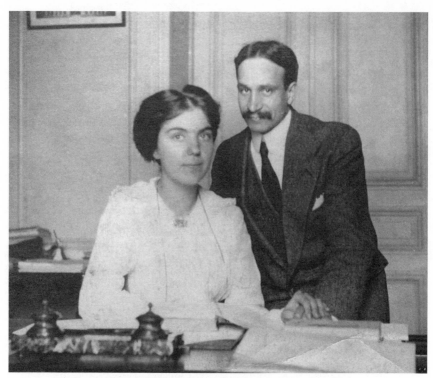

Figure 4.7. Rose-Marie at Robert's desk. As the War approached, Robert hurried with Rose-Marie's help to finish two articles he had nearly ready for publication. We see them in his studio in the National Archives. Private collection.

At four in the afternoon of 1 August the great tricolor poster announcing the General Mobilization began appearing all over Paris and France. Henry de Varigny dined that evening with the André Michels, where Rose-Marie was distracted and clumsy despite her pose of cool sophistication. The young men of the family had their orders. Edmond Vermeil's unit was temporarily assigned to duty in Paris. Daniel Monod had enlisted as a stretcher-bearer and was sent to Vernon, 47 miles down the Seine, for Red Cross training.[44] André Michel's 20-year-old nephew Jean Massigli enlisted in the 239th RI. Abel de Bévotte was already on active duty, busy every day in the barracks of the 102nd RI, preparing his section for active service on the frontier, and mounting guard at government buildings and rail stations, until he marched to his train on 7 August. As a reservist, Robert reported for assignment to the headquarters of the Fourth Military Region. He was given orders to join the 169th Regiment, stationed at Toul and soon to be in action, and he reported to the regimental depot at Montargis, also on 7 August, the first anniversary of his marriage.

~

Robert's War, 1914

Robert André-Michel and Abel Gendarme de Bévotte were two of thousands who had to wrap up and shelve their civilian professions in the last days of July 1914. Signs of the approaching war had become unmistakable to everyone who read the daily newspapers. The armed forces were forbidden to respond to the sharpening crisis by making moves that the English Cabinet might consider aggressive against Germany, but the commanders of active troops were making their forces ready to throw the invasion back as soon as the mobilization could be ordered and implemented.[1] The major shock was expected in Lorraine, in the zone that had been fortified against it, anchored by two fortresses, Verdun and, 50 miles to the southeast, Toul.[2]

Abel's Three-Day War

On the evening of 7 August, to the music of the regimental band, Abel Gendarme de Bévotte marched off at the head of his section, smiling, freshly embraced by his parents and kissed by his fiancée, Juliette Michel. The 102nd Regiment of Infantry (RI) boarded trains at Gare de Vaugirard to join the Third Army between Verdun and the enemy. From camp near Verdun, Abel wrote to Juliette,

> In this moment of danger, it is the intellectuals, the lucky ones, who ought to give an example of courage, because they have within them the power of their inner happiness which must urge them on and help them. Your love gives me that kind of power, so that I march toward danger with serenity and confidence.[3]

Three days later Abel was dead from the wounds he received while shepherding his section back to safety from an exposed forward position at Billy-sous-Mangiennes.[4] His father tells how he and his wife Cécile got the news.

> On the morning of the 17th I had just got dressed when Counsellor B. was announced. I went out to receive him without any misgivings. He was solemn, and stumbled over his words. It was with intense emotion and infinite gentleness that he gradually disclosed the dreadful, the unspeakable news. M.P., the father of one of Abel's friends, hadn't had the courage to bring me the sorrowful words himself and so had asked B. The letter said with terrible brevity that Abel had fallen bravely and that he was mourned by all his companions. I didn't understand at first; my head was very heavy, and it seemed that my blood had disappeared. I suddenly had a terrible vision: the grief of Cécile, who suspected nothing and whom I would have to tell. I went into her dressing room and, I don't know how, I managed to tell her, the mother who had given her all to him, her only son, for whom he was everything. I don't have the strength to tell what happened next. It seems that we broke the bounds of human grief. Cécile had more courage than I; while I sprawled on the couch weeping and sobbing, she had the energy to go out immediately to tell Juliette. She met her in the street near the Odéon on her way to our house. At the mere sight of Abel's mother, Juliette understood everything.[5]

Toward the end of August, Juliette went south with Abel's grieving parents.[6]

Sergeant Robert Michel, 169th RI

Robert's new regiment, the 169th, was part of the mobile brigade of the crucial fortress city of Toul behind the Second Army's front in Lorraine. Colonel Brault's headquarters began to keep the regiment's *Journal des marches et operations* a full week before mobilization.[7]

> Sunday 26 July, JMO 169th RI: A telegram from the 20th Army Corps commands generals and corps commanders to return to their posts without delay and cancels all new furloughs, but does not compel those now furloughed to return. Consequently the colonel, who was to have departed on the 27th on a leave of twenty-five days, remains with the regiment. . . .

> Wednesday 29 July, JMO 169th RI: The colonel receives the order to report the names of officers considered incapable of campaigning. He names M. M. de Marolles, commandant of the 1st Battalion, and Captain Rey of the reserve cadre.

> Sunday 2 August. First day of mobilization. Departure of the office staff for the depot of the 169th at Montargis. . . . Taking the same train are the officers of the reserve cadre passing over to the 369th.[8]

Mobilization was a turbulent reorganization of the male population of military age, breaking up the civilian order to create a military one. The process turned Robert André-Michel from a National Archivist and reserve sergeant of the 102nd RI to a sergeant of the mobilized 169th. The 102nd RI had received its classes of conscripts from the most thickly populated part of France and its major center of higher education, where hundreds of young men from the provinces turned twenty each year because they were then in Paris for their studies. In the decade before 1914 all the active regiments that recruited in the Department of the Seine had on their reserve rosters several times the number of men they needed or could equip for service. The 102nd reported the names, ranks and numbers of its superfluous reservists to the office of the 4th military region, and there, following the standing orders in the pink pages of his *Livret de mobilization*, Robert Michel (as his name appeared on his recruitment form) reported in uniform on mobilization day and was recalled to the active army as a member of a regiment already deployed, Colonel Brault's 169th. On 7 August he reported to the depot of the 169th RI, 71 miles south of Paris at Montargis. Expecting to be sent to Toul soon, and at short notice, that day he wrote Rose-Marie a letter that included his patriotic testament, quite different from Abel's.

> We have not lived in vain if we can give our life for the great cause of France. She is being faithful to her beautiful historic mission. After forty years of peace, during which she has silently allowed the wound in her side to bleed,[9] today she rises up to defend her rights and her life. It is not enthusiasm for war that animates us, not the dangerous desire for empty conquests. What enflames and animates us is the will to be the champion of liberty in Europe, and to see that liberty take shape under our flag, the emblem of all that is dear to us, of everything in old Europe that wishes to live free and that refuses to surrender to the Prussian saber. We place our confidence again in our secular ideal and in the spirit of our nation, which cannot die.[10]

But the 169th RI did not want Robert at Toul. Colonel Brault was concerned for the efficiency of the 169th, a newly created active regiment, and for its reputation (and his own). He preferred tough and trained men to large numbers. The regiment was already at full strength with 3,029 soldiers and subofficers before mobilization, and as the new drafts of reservists arrived, the regiment kept the most likely men and sent the rest, along with the "clerks, auxiliary services and malingerers," back to the regimental depot at Montargis. In the first month of war, before he was himself badly wounded and evacuated, Colonel Brault had sent back more than three hundred men, two-thirds of them reservists.[11]

Robert remained on duty at Montargis, training and instructing the recruits. His candid and historically informed patriotism perfectly suited him to the work.

> 19 September, *Carnet*:[12] Lecture to my men: the war; its causes; the pan-Germanist party; the German plan of attack; Germany infatuated by its material strength; its gamble: to crush France; English realism.
> The true, the only immortality is not to fear death; it is to appreciate the duties we have to the French nation, past and future. France will triumph, if she has within herself the will to win and the ideals which made her great over the centuries and which she treasures. It is a select few who make history; it is *esprit* that wins battles. Above life, honor; above happiness, sacrifice.

Two weeks into the war, when Robert had seen off a draft of replacements for the fight that was going badly in Lorraine, he wrote in his *Carnet*,

> 16 August, *Carnet*: A magnificent equality reigned at their departure. We will always remain happy to have seen a great democracy animated by a unanimous sentiment. This erases many mistakes and consoles us for many bad scenes. We must have confidence. We do not have the right not to win: that would be to betray France and justice.

Through her Bonne-Maman in neutral Switzerland, Rose-Marie wrote to her uncle John Sargent, temporarily stranded without a passport at Kolfuschg in the Austrian South Tyrol, that her husband was fretting in the safety of the regimental depot while his comrades were in the field, and that he was eager to get into the fight, eager enough to ask for transfer to a regiment that wanted him in action. Sargent responded on 24 September, in French:

> It naturally entered my mind that Robert could well be called to arms, and I was worried by the way in which you might take it. Your courageous letter reassures me and gives me great pleasure. I understand his being disappointed to be kept on at Montargis, but he is doing his duty there just as much as anywhere else, and I definitely hope that he won't think of moving. Can you write to him? In that case, greet him on my behalf and convey to him all my sympathy. Your experiences in Paris and on the journey must have been atrocious—I hope that the Ormond synod and Emily have not been similarly stricken on their return from Sotteville to London. I am glad that they returned in time, for if they had delayed, a return journey might have been very difficult. The newspapers have been saying for a long time that there is no steamboat service, that the Channel is patrolled by warships and sown with torpedoes.[13] I have tried every means of getting letters through to Emily, and I hope that they will have received some of them. I have received none from them yet.[14]

But Robert had already transferred. He said his farewells at Montargis and marched to the Gare du Nord with a draft of replacements out of the 169th, but for what regiment? That was unknown. When Robert set off with his section for the front, Rose-Marie volunteered for service with the Red Cross and began vacating the luxurious nest on rue de Bellechasse to move in with her *beaux-parents* in rue Claude-Bernard, the place in Paris where she was most at home and most needed. Robert recorded his journey toward the War and his patriotic and artistic passions in his *Carnet*.

20 September, 19 hours, *Carnet*: In the train, ready to depart from Montargis, destination unknown. Le Bourget? The Aisne? Finally the desired day has come, and after a month and a half spent at the depot of Montargis, I depart with a detachment of the 169th. Some days ago they gave me a section, the first section to depart, and we made ready. My men [the recruits in training] were attached to me, and I wanted to go with them. They sincerely regretted seeing me go. "It is the sergeant who teaches us the *reason* best"—did I really hear that? And on our departure there were hands cordially offered and affectionate hugs. A corporal from my section, Lambé, has arranged to go with me. He is a little fellow, resourceful and resolute, the true type of a French soldier. Then the departure, bugles and drums, *vive* this and that, enthusiasm, disorder. And then a stream of friends, Richer, Dujardin and the others. On the platform, the embrace of my friend Beighede, my comrade from La Flèche, so sure, so straight at heart, so good.[15]

Night in a comfortable first-class carriage with the head of the detachment, adjutant Deigaux, and another sergeant, Bagge, very congenial, the son of a Swede, but naturalized French. I think gratefully about my beloved wife, about all the happiness she has given me for a year now, about France, about those who have died, like Abel, about those who are going to die, happy, for the loveliest Fatherland.

21 September, *Carnet*: Arrival at Le Bourget at two in the morning. Some English soldiers ride on the freight car of the train, great strapping men, well built and cool. There are trains of wounded, most of them dying. Muslims who seem crushed by fate. Artillerymen, gay and high-spirited. We wash at the water spigot of a tender. Moonbeams on a field. Billeting in the town of Le Bourget. It is difficult to keep my men in hand. Many have wives in the vicinity. For 200 men we have only 2 sergeants and an adjutant because there are still not enough *cadres* [active-army officers].

The papers confirm the dreadful news: destruction of the cathedral of Reims.[16] It is unbelievable. Few pieces of news have caused me more incurable pain since the beginning of the war. How will educated Germans dare speak of their culture after this? The Vandals have passed through.

Robert's rhetorical question, and the roar of international protest over the crimes of Reims, and of Louvain back at the end of August, were soon answered by *An die Kulturwelt! Ein Aufruf*, commonly called in English "Manifesto of the 93 German Intellectuals" published in Berlin on 4 October.[17] Many of the signers of this mendacious apologia for the human and cultural atrocities in Belgium had not read it: their "signatures" were secured by telephone.

22 September, *Carnet*: Crowded with the men in a printing works, on the ground. It is cold and the ground is hard. Departure at 3 in the morning. We are crossing Valois, which seems to be untouched. Few inhabitants in the villages. Villers-Cotterêts. The news isn't too bad; the battle of the Aisne goes on. May we see victory!

An evacuated reservist told me yesterday that the retreat after the battle of Charleroi was really a rout. He is going back to the fire with confidence and ardor now, because it is *their* turn to retreat. So it is in the Ile-de-France that I will be fighting, in the cradle of our culture, before Paris! The train stops at Longpont. We march before the admirable abbey to the hollow of the valley. It is occupied by transports and artillery parks. From there we reach Soissons by way of the Montagne de Paris.

My pack is heavy and the first stage is hard, but then one gets used to it. The guns roar without a break. The landscape opens out magnificently, and over there is the valley where St. Jean des Vignes proudly lifts its two towers, which the Vandals have not respected. The bluish hills outline their successive crests against the immense heaven of an autumn twilight full of clouds. It is truly a battle panorama, a spectacular image forever imprinted on my eyes. On both sides of the road and in the mown fields, the carcasses of horses, equipment, shells.

16:05 hours: The last hourly halt before Soissons. French airplanes crisscross the sky. German shells burst near them without touching them. We break out our packets of cartridges. The men are somewhat nervous. We have no *cadres*. I have a hundred men under my command and four corporals at my orders.[18]

I am possessed by the beauty of the hour and the place. Some Taubes fly over us. The road is dangerous, exposed day and night to the shells of the German artillery. They fire even at single horsemen, at automobiles. We get ourselves by sections into the woods and give up the idea of reaching Soissons this evening. We have already done 15 kilometers and the men, not well trained, are overburdened by the weight of their packs. We reach Vauxbuin, a little village at the bottom of a valley, and bivouac there. The fine family of a gardener named Victor Charidan offer us—the adjutant, sergeant Bagge and me—a touching hospitality. The smiling, charming daughter is used to the cannonade that rages day and night. The son is under suspicion on ac-

count of an anonymous letter, to the great indignation of the parents. The Germans have passed here twice. They looted, but did no harm to anybody. The French have behaved well, apart from the very first troops, composed of Parisian *Apaches*. The old man was in the war of 1870: he shows us his *dolman*.[19] He invites us to dinner.

20 hours. The sub-officers are called together. A captain of rangers who has taken command of the detachment (250 men from the 164th and 200 from the 169th, come to reinforce the 204th) lets us know the route that we will follow tomorrow.[20] We will march section by section, 5 minutes apart, in silence, by a narrow path. In case of a volley of artillery, or a searchlight, we lie flat, then go on as soon as possible.

And with that, Robert became a sergeant of the 204th Regiment of Infantry. After the sufferings and losses of the regiment in six weeks of the War, the reinforcements he brought were desperately needed.

The 55th Division of Infantry, Reserve

The 204th RI was part of the 55th Division of Reserves (DR), which had performed bravely, at a heavy cost in casualties, from the beginning of the war.[21] In the battles of the frontier, the fighting retreat of late August, and the bloody success of the Marne, the 204th had suffered 14 percent casualties (267 dead, wounded, and missing) and received no replacements. Its fruitless work at Soissons would be even more costly.

While an active division usually had three brigades of three regiments each, reserve divisions had only two brigades, and most of their officers were commanding above their rank, from lieutenant colonels at the head of regiments down to lieutenants leading companies and sergeants in charge of platoons.[22] The soldiers of the reserve were almost thirty years old on average, many of them fathers of families, less apt to heedless bravery than the young bachelors of the active army. The French commanders, knowing the weaknesses of the reserve units, used them at first only in support and as *troupes de couverture*, who would meet and slow the enemy's advance while the active regiments formed up behind them for a victorious counterattack. But the reserve units, some quite early in the war, battled bravely and effectively alongside the active. The German commanders also underestimated the French reserve units, a costly mistake.

The 55th Division had had its first serious fight on 25 August on the Orne east of Verdun, helping to stop the advance of Crown Prince Rupprecht's Fifth Army and to create the long-lasting and murderous Verdun salient.[23]

In that battle the 204th RI's losses were 6 dead, 73 wounded, and 36 missing (either dead or prisoners) from its theoretical strength of 1,920 men. Then the 55th and 56th Divisions were transferred to the new Army of Lorraine commanded by General Maunoury. In the retreat, after Lorraine had been lost to the Germans, the division saw combat west and south of Roye, and the 204th RI lost 30 more men. At that point Maunoury's command was restructured as the Sixth Army and committed to the mobile defense of Paris.[24] At first, its mobility was just a continuation of the retreat: beginning on 30 August it drew back more than 50 miles, leaving Soissons an open city that the Germans occupied on 2 September. The 55th Division rested and reequipped in the area of Dammartin, about 20 miles from the walls of Paris. Marshal Joffre's intention for the Sixth Army was to prevent General von Kluck's First Army from outflanking the French left. But von Kluck swerved from his direct drive on Paris, turning the First Army eastward. He meant to envelop and destroy the French Fifth Army, worn out by its long fighting retreat that hot August. Von Kluck considered the forces that Joffre had hustled together before Paris unimportant, and so he left a relatively small flank guard, his IV Reserve Corps, to face them. Joffre seized the opportunity to release his Sixth Army against von Kluck's turned right flank, opening the Battle of the Marne.

The 55th Division was commanded by General Louis Leguay. Sixty-two years old at mobilization, Leguay had been a teenaged *franc-tireur* or irregular in the Franco-Prussian War of 1870. He had risen steadily in the peacetime and colonial service and gained the three stars of a general of division in 1912. He was credited with opening the Battle of the Ourcq with the 55th Division, receiving and returning the first artillery fire. To put it less gently, he sent the division into an ambush, and he did not lead it: he was at Plessis-aux-Bois, over six miles to the rear of his nearest troops engaged at Barcy. The 55th Division drove almost unopposed through Iverny into ambush at Monthyon, then advanced fighting to the plateau of Barcy overlooking the Ourcq. The German rear guard was standing with its back to the Ourcq and with choice fields of fire for their artillery and machine guns, and on 5 and 6 September the 55th Division was wasted in repeated massed attacks, in which the agile and rapid-firing French 75-mm field guns were worse than useless.[25]

6 September, 4 pm, JMO, 109th Brigade: A new assault is launched, but the batteries from Paris supporting the attack keep shooting too short, and soon the whole assault line falls back.

5 pm. Inspired by the 110th Brigade, which is trying a third assault with heroic tenacity, the 109th Brigade undertakes a new desperate attack, reinforced by the 6th Battalion of the 204th RI which has just arrived north of Barcy. The bugles sound "Charge," but in a short time the 204th RI and the 289th RI are decimated. Lieutenant Colonel Guy of the 204th RI takes a bullet in the head. He is carried on two rifles back toward Pringy. Along the way his men present arms.[26] Ducros, commanding the 289th, is struck by bullets. Captains Auger and Bigoudot and Lieutenants Jaluzot, Joussot, Moulin, and Demay are killed.

6 pm. The line begins to waver. Lieutenant Colonel Courtin of the 282nd, to stop an incipient retreat, orders the regimental banner unfurled and the bugle to blow "To the flag." The fight redoubles in intensity, the 204th, 289th, and 282nd regiments all engaged and mixed together. . . . But again our 75's are shooting into the ranks of the 109th Brigade: our gunners are misled by the uniforms of the Algerian riflemen and take them for Germans. And the brigade is also under fire from a machine gun battery of the German 38th field artillery.

The "Miracle of the Marne" turned the Germans' advance to a retreat, preventing the quick victory that was the only victory possible for them.

Soissons on the Aisne

After a pause to rest and refit, beginning on 10 September the 55th Division pursued the retiring Germans to the Aisne at Soissons, crossing the river and retaking the city on 13 September. The enemy had already dug in among the limestone quarries and outcrops of the high ground north of Soissons, and so the 55th Division was likewise compelled to dig in the next day around Crouy, the tiny agricultural village just across the Aisne north of Soissons. This was when, and where, the war of movement, of banners on battlefields, of cavalry charges and bugle calls, ended, and the war of position—the trench war—began. Soissons, with its national treasures of medieval architecture and sculpture and its association with the victorious campaign of Joan of Arc, was the moral key to the dilemma of the Crouy position. It was impossible for the French Army to break out of the Crouy salient, and wasteful of lives to stay entrenched there under the German guns;[27] but falling back across the Aisne would mean giving up Soissons to German occupation and pillage. That catastrophe came to pass in January 1915.

Before Robert André-Michel arrived with his draft of replacements on 22 September, the fighting north of Soissons had fallen into a tactical pattern. The six regiments of the 55th Division took turns in the line between Crouy

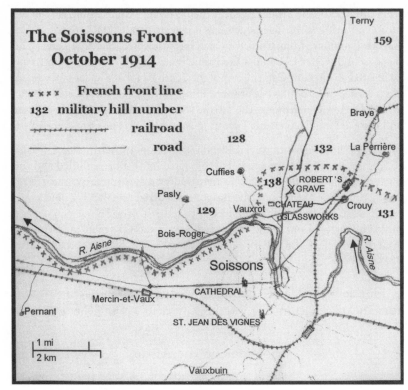

Figure 5.1. The Soissons Front, October 1914. Map by Karen Corsano after the *Journal des marches et opérations*, 246th Regiment of Infantry.

and Bois-Roger on the Aisne, with two regiments in the trenches at one time, while two more were in support in the relative shelter of the Distillery of St. Paul and the Glassworks of Vauxrot, and the remaining two, in reserve, rested in bivouacs on the left bank, the safer side of the Aisne, at Vauxbuin, Mercin-et-Vaux, and Pernant. Those reserve troops were also charged with preparing defensive works for an eventual fallback to the Montagne de Paris.

The French line on the right bank of the Aisne looked up, over a natural glacis of dead ground covered by intersecting fields of German machine-gun fire, toward German trenches to the west, north, and east—trenches protected by barbed wire. And behind those trenches German field and heavy artillery were placed on higher ground. The whole French position was constantly subject to German shelling, and so was Soissons. For the first three weeks of the standoff, General Leguay ordered attacks by his French and Moroccan forces, which all failed. Disregarding the rule, printed on its

own first pages, against any "discussion of orders," the division's *Journal des marches et opérations* takes care to blame the wastage on higher commanders.

15 September, JMO 55th DR: The enemy has entrenched very strongly above Cuffies and Pasly [Hill 129], thanks to the particularly favorable undulations of the ground and the chalky nature of the soil. Our troops can advance only very slowly and under a storm of projectiles. A sharper offensive, such as ordered by the general commanding the Sixth Army [Maunoury], would result in abundant and fruitless bloodshed.

16 September, JMO 55th DR: General Order no. 37 for 16 September reads: "Starting at 5 am, attacks will be made again on the whole line with the greatest violence, and carried out, regardless of cost, to the end." Consequently, all the troops of the division (excepting one regiment) and the batteries, were found at daybreak on the right bank of the Aisne, facing four enemy army corps which offered great resistance. Their defenses of Hill 129, on Montagne Neuve [Hill 138], and on the hill of Cuffies are particularly formidable. On our right, the Quiquandon Brigade[28] was able to reach the crest of Hill 132 but not to get beyond it. Under these conditions the progress of the division, subject to a constant rain of shells from high-caliber guns, was very slow. The bombardment of Soissons continues, principally in the area of the rail station. Headquarters of the 55th DR is at the Town Hall of Soissons.

16 September, JMO 204th RI: The regiment is in reserve at the Glassworks of Vauxrot at the disposition of the general commanding the 109th Brigade [Arrivet]. The order is given for one battalion to go on the attack against the nearest houses of Cuffies. The 5th Battalion (Captain Fabiani commanding) is charged with this mission, and crosses the ravine toward the northwest, 18th and 19th Companies in the first line, 17th and 20th Companies in the second line. After encountering the small enemy trenches, the battalion is fired on from the west. The companies of the first line turn in that direction, the 20th Company on the left of the 19th, two sections of the 17th deployed north along the right flank. The battle line of Captain Fabiani's 5th Battalion makes some advances as far as the slope of the ravine of Cuffies, under violent fire from machine guns on hills 129 and 159. Taken from the front, the flank and the rear, the 17th and 18th companies turn toward the northeast on the order of Captain Fabiani. The 19th and 20th companies receive the order to stay in place facing the ravine of Cuffies. The companies, with their right flank uncovered, are fired upon by the enemy on the plateau above. The 19th Company turns north-northeast, bayonet against cannon, followed by the 20th Company. Some elements of those units, coming under fire from the right, take shelter in a quarry where, having exchanged some shots, they are surrounded by an enemy superior in numbers. The 6th Battalion (Captain

Chalet), directed to the wood northeast of Cuffies, is able, by inflicting serious losses on the enemy, to protect the retreat of the 17th and 18th Companies. The battalion meanwhile receives artillery fire from hill 159, their right flank, and from hill 132, their rear. At 6 pm the regiment gets the order to place itself on the right of the 289th, facing the ravine of Cuffies, to fill the gap between that regiment and the Algerian riflemen. The regiment executes this movement and passes the night in these positions. Losses, two officers wounded: Captain Fabiani and Sublieutenant Carivenc; four officers missing: Sublieutenants Gosset, Périlloux, Hensz, and Mathé [and 310 other ranks].

Sergeant and Scholar in Soissons

In that ill-conceived and chaotic fight of 16 September, the 204th Regiment lost half its remaining men, so the next day a battalion of the 289th replaced it in the line and the battered remnant of the 204th was sent into reserve in Soissons to await reinforcements.[29] There it was resting under artillery fire when Robert André-Michel marched in with his hundred men, and there it remained for the rest of September, while Robert exercised command of a section and marveled at the medieval beauties of the town.

23 September, *Carnet*: Reveille at 2 hours, departure at 3 hours. I march at the head of two sections, the 3rd and 32nd. The men obey and understand the orders that are given to them and the reason for everything. I feel completely happy, responsible, and calm. The war is a hideous thing, but beautiful in the energy it arouses and puts to use.

Here we are in Soissons. The paving stones are piled in barricades. Everywhere are traces of the bombardment. The two spires of St. Jean des Vignes have been damaged. The Vandals respect nothing. My heart bleeds to see these ravages. But with what enthusiasm I go toward the enemy and toward the cannon that steadily roar! It seems that all the beauty of our land, of our art, comes to show me the wounds that a sacrilegious hand has done to them, the better to enliven my courage. Forward for France, for the shining civilization of our beautiful fatherland, the loveliest there is in the Christian world!

I visit the Chapter Hall, cut off at the level of its beautiful capitals, . . . and the ruined cloister. What an elegant simplicity, what a purity in the profile of these vaults and these ogival arches. It is the great art of a great epoch that still remains although the shells have broken the roof in many places and blown up the third arch. The façade is magnificent with its three portals and two levels. They say that the nephew of the mayor of Soissons has been shot as a German spy. He had a telephone in the *cave* of his house, they say, and he went every day to the front lines and informed the Germans on the movement of our troops. Is it true?

There has been a call for a detachment of 25 men. The Germans are very close; they came down last night from their high positions. We are a company in reserve, billeted near St. Jean des Vignes. Two lieutenants, an adjudant, a sergeant and a sergeant major from the 204th are coming to train us. The company is getting organized. I regret that I'm no longer with the men of my company of Montargis.

7:25 pm. The marvelous façade of St. Jean des Vignes is purple in the setting sun. Bloodied so, she shows the wounds that the enemy of all beauty has done to her. The German shells whistle constantly over us. The men are cheerful and carefree, except a few young soldiers. We are told to sew on again the stripes that the captain made us take off yesterday.

I drink into my soul the beauty of the hour and of the place. St. Jean des Vignes, the pure summit of French art. I climb easily to the top of your towers. I want to reign on your peaks.

Evening falls in the cloister where the arcades bow in mourning. I am alone. It is lucky for me that my heart understands it better than anyone else here. I tell it secrets that no one else can hear. It is the ancient, the magnificent language that my beloved one, ever more present in my heart, uses to speak to me. She says to me, "Amid these ruins and this death, may your soul still be cleansed and enlarged. Such is our law, our ideal, our destiny."

2 am. During the night, a fearsome explosion. The men are frightened awake with a start, but it is nothing, just a warning for moral effect. A half-dozen shells have just exploded in the courtyard between us and St. Jean des Vignes. No one has been wounded, but it is hard to make the men put out their fires and not go wandering around. The Taubes fly over constantly and spot us. The French soldier, when the first moment of fear has passed, regains his habitual nonchalance, and his hereditary cheerfulness always has the upper hand. For my part, I believe I'm more nervous.

One of the shells has again struck the south bell tower of St. Jean des Vignes, already seriously damaged. Both towers had already been damaged in 1870, and five or six days ago the two pinnacles were partly destroyed, a resident tells me. Two shells have damaged the refectory of the abbey.

10:25 It will be sacred to me, this cloister of St. Jean des Vignes in ruins. I have heard cannon and machine-gun fire there, and heard shells whistle overhead. French grace and simplicity. The cannon fire is coming closer and the air is cut more and more by the spinning whistle of the German shells. A little statue on the gable of the central portal has just been half destroyed. Everywhere fresh wounds in the centuries-old stone.

10:45. An English car arrives with some officers, come to find some bags of salt at the warehouse. While we chat with them a shell passes over our heads and covers us with dust and debris. The English are very *chic* and show no emotion.

The lieutenant sends us back to our billets. More shells land. Nobody wounded. The cannonade stretches out, and we take advantage of that to have lunch.

A shell has fallen in the courtyard of our billet. That's fifteen or sixteen in all in our neighborhood.

The sculptures of St. Jean des Vignes, west front. Statues in the niches, south tower: one with a great beard, hand on the pommel of a sword, on the south buttress of the south tower, the other with a big knotty club; on the north buttress, one with a great square head, naked sword in hand, the other beardless, with a charming face. I will demand that in every destroyed church the German vandalism is commemorated by tomb inscriptions that will recall for all time the savagery of our enemies.

25 September, 9 am, *Carnet*: Last evening while we were having dinner the lieutenant [Martin] taking the place of a captain and the sub-lieutenant [Moreau] give an order for various works to be done during the night. I go off with the 1st section and sub-lieutenant Moreau. The conduct of this one is unspeakable. After explaining to us what had to be done, he pretended fatigue, lay down in the shelter of a wall, and had nothing more to do with us all night, a very eventful night. While we were digging our trench the German searchlights probed the horizon and we had to fall flat every so often to avoid being hit by their bright beams. To our right the German shells (some 99 of them exploded in mid-flight over our heads) set fire to the town and it burned all night. Divided into two teams, the men worked and rested by turns. All these reservists, with some exceptions, aren't worth much. Even though they are familiar with the shells that have been making their intermittent music for 24 hours, they are badly shaken by the frightful uproar. While we were resting, rifle and machine gun fire broke out quite close to us. I sent a patrol to our right to investigate different movements and to put us in touch with the neighboring companies. I had to put on an act of authority to make my chosen men go. Some words I spoke seemed to pick up their morale.

Until 2 in the morning, the time we returned, the battle had been intense. Our batteries of 75s suddenly opened up behind us, and we had the impression that they were doing good work. There was movement beyond our right and in front of us. It seemed that the Germans were preparing a counter-attack (perhaps they had attempted to cross the Aisne) which did not succeed—our trench was not put to use.

On our return we found that vile sub-lieutenant cowering at the foot of his wall. He declared to us that St. Jean des Vignes was in flames, that we could not go back there, that we had to spend the night under the stars. Disgusted by his attitude, I answered that I was going to verify for myself the truth of these statements. I knew very well that he hadn't budged! I placed my section under cover and went back to our billet near St. Jean des Vignes. It was untouched. I called back the section. I would never have imagined such cowardice on the

part of an officer. He had made a bad impression on me from the beginning, swaggering and posing as a hero. He is a craven coward. There is nothing in the world so unbecoming a man, and I never dreamed that anyone could be so lacking in self-respect. It seems that he is a schoolteacher. Those that I have met so far, with one or two exceptions, don't do honor to the guild. France, France, rise up and reclaim yourself! The towns are burning, sinister hearths in the night. I keep forever the indelible image of Soissons burning in the night. I will not forgive the Vandals. But the French should not make us blush for shame. There are brave ones, but it is painful to see the contemptible ones like sub-lieutenant Moreau. It is even more inexcusable because we did not receive a single shell during our work on that trench, and we did not have to fire a single rifle.

The cannonade has begun again, but, while I write, less frequent and further away than yesterday. We are quite familiar with this noise.

In the afternoon we work on the trench. We see clearly the country round about, and the outline of last night's combat.

At 2 o'clock that afternoon Robert wrote to his parents, observing the rules of military secrecy and striking a pose of unflappable *chic* with regard to the bombardment:

> The German artillery displays its lack of tact and its desire to impress. We recognize in them a people lacking in delicacy. They choose the dinner hour and the night to deafen us. But alas, they set on fire the towns of France. I will never forget what I have seen tonight, one of the most charming towns, set on fire by shells, flaming in the night. Senseless and ferocious ravages that we will never forget. It is an atrocious war.[30]

> 26 September, *Carnet*: The cannonade has stopped, so to speak, yesterday afternoon and last night. The enemy must have withdrawn; we hear only our own cannon, dull and far away. In the town, ruins everywhere, houses collapsed and gutted, their walls sliced open. The cathedral has not suffered much. The south tower had never been built. The gallery of the west front above the rose window has been damaged only toward its north end. The interior of the cathedral has not suffered, except the glass, which is in fragments.

Beginning in January 1915 and continuing through the War, whenever Soissons was not occupied by the Germans, they used the cathedral as an artillery target, and it was badly ruined.

> 26 September, *Carnet*: The war is going to hasten the reconstruction of our old towns, and so, bit by bit, the ancient French province will disappear with the exquisite historical diversity surviving in its monuments. This charming

little market square planted with plane trees, pocked with shell holes! . . . On the houses, German graffiti. During my walk the bombardment starts again. 8 am. Inspection of boots and reserve rations. Found at the rail station, an abandoned *Fables* of La Fontaine, which delights me:
Solitude, where I find a secret sweetness / Places I have always loved . . .[31]

5:15 pm. The sweetness and peace of the cloister at twilight. The trees are taking on their autumn colors, and the evening falls even more tranquil after the noise of combat. The refectory of St. Jean des Vignes. The north rose window. Christ comes forth from the tomb, wearing a great purple mantle. Soldiers sleeping, angels and saints.

Lessons of Experience

While Robert was kept in Soissons with the convalescent companies of the 204th RI, learning how to command his half-section and communing with the suffering masterpieces of thirteenth-century architecture, Leguay's 55th Division was proving by repeated wasteful experiments that the German line on the right bank of the Aisne could not be broken or even budged. Leguay's headquarters was placed in Vauxbuin, his command post in Soissons, both on the safer left bank. To direct a general attack against the German defenses at Perrière Farm and Hill 132 on 23 September, Leguay had to cross to the château of Vauxrot on the Terny road (now route D1). The brigades designated for that attack were General Mainbray's 110th and General Quiquandon's 90th, on loan from the 45th Division, consisting of the 2nd Zouave Regiment and the 2nd Moroccan Rifle Regiment. Leguay's adjutant, writing the day's journal, coolly reported, "This attack was conducted with prudence to avoid all useless bloodshed before the formidable defenses organized by the enemy. The attack permitted a slight advance."[32] The clerk of the 246th RI, who was there, provides a nuanced variation on the theme "useless bloodshed":

> 23 September, JMO 246th RI: The troops on the right bank of the Aisne have received the order to attack. The operation is only possible by way of hill 132, and it is conducted by the Zouaves. . . . This attack, like the earlier ones against the formidable German entrenchments, was not prepared by heavy artillery, and that was indispensable. The attack had no success, but the two regiments of Zouaves on our right lost there almost a hundred dead and two hundred wounded, six officers killed or wounded.

Ordered to try again the next day, Leguay was more cautious.

24 September, JMO 55th DR: By reason of the resistance encountered the night before, this was no more than a reconnaissance, a few exploratory strikes, aimed at a slow and sure progress in the direction of Hill 132 and the route to Terny on Hill 159. In the evening of the 24th the general commanding the 45th DR takes over from the general commanding the 55th in command of the troops on the right bank of the Aisne.

And so General Leguay's newfound prudence led to his replacement as commander of the front line. What had brought about such a conversion in the fire-eater of the Marne? In one of the striking life-sketches in his journal, Paul Tuffrau relates the story of an officers' protest in the 55th Division that exposed the lethal foolishness of the strategic slogan "Attack! Always attack!" applied to trench warfare. Leguay's senior commanders had combined their indignant eloquence, "discussing the orders" of 23 and 24 September.

6 October, Tuffrau: Everybody agrees on the criminal incapacity of General L[eguay], who shouts, gives orders, rages, but gets personally involved very little. Many of these chiefs of the active army have scarcely any regard for the lives of their men. They want their victory, or they want stripes. Quoting a captain whose men hadn't been able to take a trench, to his lieutenant: "Name of God! A hundred meters more and I would have had my fourth stripe [been promoted major]." . . . As for that division general [Leguay], they tell various anecdotes about him, especially the epic scene on the morning when the 246th RI had received the order to attack [24 September]. The colonels of the regiments were gathered in the château of Vauxrot. [Alexandre Léon] Bonnet, commandant [of the 6th Battalion], very abruptly: "I will never accept the responsibility for leading my men to slaughter. I have to have a written order. And you to take the head of my troops!" "Name of God! I have given the order to march. You refuse?" "I don't refuse. You give me the order to go get myself killed, and I'm going to do it. But I have 2000 men with me." And the colonel of the Zouaves, Dechizelle, always courteous and ironic, steps in to throw some cold water: "General, you aren't taking their positions into account: they are impregnable. They have already cost me four hundred men. Come see them." Finally, the word that won the jackpot came from General de Mainbray [110th Brigade], suddenly raising his tall, thin, slightly bent frame, "General, it would be murder!"[33]

Leguay was convinced, he interpreted his orders with a liberal dose of caution, and he was relegated to the function of a quartermaster across the Aisne, supervising the defensive works of a fallback position. The direction of the division's troops in the front lines was exercised alternately by the two brigadiers.

Robert to the Front Line

The regimental JMO for 27 September announced that the reconstitution of the 204th RI was complete and the call back to action was imminent: "Lieutenant Colonel Duroux takes command of the regiment. He salutes its flag." Commandant Hasenwinkel, who had been acting in command since the death of Lieutenant Colonel Guy in the Marne battle, stepped back to the head of the 5th Battalion. Two days later the regiment was alerted for action against the same old impregnable defenses, but not ordered to march.

30 September, JMO 55th DR: The attack commanded by General Order no. 54, led by the 89th Brigade on Hill 132 and Perrière, and by the 109th Brigade on Cuffies, with the hill of Cuffies and Hill 128 as its final objective, with the cooperation of the III Corps of the English Army, obtained no appreciable result but to keep the enemy constantly on the alert. The following days are employed in advancing slowly by saps [trenches leading forward at right angles to the line] and organizing the positions according to the directions of the command. The fall-back positions on the left bank are not being neglected.

30 September, *Carnet*: After some gray days, an alert last night, and this morning an order from the colonel. The regiment is to stand ready for a coming attack, a short and violent one. . . . We are ready. Is this finally the battle? Even though life is infinitely sweet to me, my heart desires the battle and calls out for it. Forward! I am eager to learn if I really know how to fight, if my courage and my coolness are up to the level of my enthusiasm. Life sings within me and laughs at death. I am thirsty for devotion, for sacrifice to the fatherland, to the ideal that leads me and inspires me, and that I have placed burning at the base of my great love. It is the hour, the hour is here. . . .

1 October, *Carnet*: It hasn't come. And in this magnificent setting, among the splendors of autumn, under the menace of the cannon, we carry on meanly, a mediocre life filled with the noise of disputes and jealousies.

2 October, *Carnet*: This is the day we had fixed, Rose-Marie and I, for our departure to Rome. 1914 will not see us there again. That adorable dream that our happiness was to climb to, will it ever come? But no regrets. The further life goes on, the better we see its direction and accept the necessary sacrifices.

6:35 pm, *Carnet*: Once again, an alert. We are going to move, they say, between 7 and 8, or else during the night; we will see! I want to go. I am weary of the atmosphere we live in here. . . . I would like to be useful. But how I regret not having a chief who would be a friend, who would claim my loyalty and to whom I could give it! You beautiful, smiling stone statues, thank you for the instruction you have given me. . . . You form the choir of heavenly voices. In you the French ideal of nobility and generosity survives. . . . I would willingly

die to make France greater, more beautiful, more worthy of her secular genius, less attached to base interests, to egotistical pleasures. . . . It is for the ideal France that I fight, for the France of Saint Louis, of Joan of Arc, of Henry IV, of the Revolution; . . . for the France we wish to regenerate today: a peaceful France, her hands weaving the France of a new age.

That manifesto in one sentence identifies the ideal France of a Republican nationalist patriot and historian of the glorious age of French architecture who was also a political liberal and a Protestant. Robert revered King Louis IX as a patron of art and architecture and a model of just and modest government; Joan of Arc defended France against the foreign invader; and Henry IV was the author of the Edict of Nantes (1598), which guaranteed the liberties of the Huguenots. Robert's zeal for France and civilization would finally be put to use at a crucial time and place, where the French forces, already thinned by casualties, would be stretched even thinner to cover a longer trench line. Montagne Neuve Farm (now Ferme du Meunier Noir), between Crouy and Cuffies, was the northern tip of the Soissons salient.

The rail station of Crouy was the point where the right of the French Sixth Army touched the left of the British Expeditionary Force (BEF) under Sir John French. Specifically, when the 55th Division arrived in the line at Crouy, it contacted the 3rd Division of the British IV Corps, which was enduring terrible losses from the German artillery placed on the higher ground north of the Aisne. The British commander wanted to extract his force from the slaughter on the right bank of the Aisne, and in general he was anxious to move the entire BEF out of the Aisne line and into Flanders, to save the Channel ports if possible.[34] His proposal was welcome to Joffre and to General Franchet d'Esperey, commanding the Fifth Army on the right of the BEF.

Back in the middle of August, General French had retired prematurely and left that Fifth Army unsupported and compelled to retreat. Now the Fifth and Sixth Armies could have each other, trustworthy partners, in liaison. Joffre agreed on 30 September to cooperate with the British shift, provided it was done unit by unit, because the railroads could not accommodate the whole BEF at once and the Sixth and Fifth Armies could not extend toward each other, occupying the 20 miles of British positions between Soissons and Villers, in one night. The British 3rd Division was relieved by the French 69th on 5 October.[35]

3 October, JMO 55th DR: The 45th DR passes into the reserve of the Army: it is relieved by the 55th DR and the mixed brigade. . . . The mission of the troops on the right bank of the Aisne remains the same: a) to make the occupied front

impregnable and to pursue the advance by saps; b) to keep the enemy under close surveillance in order to signal without delay every movement of retreat and to profit from all opportunities to gain ground forward. The principal objective of the 55th DR remains Hill 128 and the spur of the hill of Cuffies Farm.

3 October, *Carnet*: In the trenches north of Soissons. We crossed the Aisne on a bridge of boats under moonlight obscured by thick fog. On the right bank some houses are in ruins. . . . We climb the plateau that overlooks Soissons . . . a new impression. . . . All night we dig the trench deeper and repair some shelters. And the dawn light finds us freezing, watching over the vast plain. Behind us, the Montagne Neuve that we occupy; before us, the German trenches; airplanes fly overhead; we fire on them, line after line. The corpses of Moroccans and Zouaves are rotting on the road. One of them, struck by a shell, stretched on his back, grins with white teeth. The men, frightened during the night, become reassured as day breaks. Peace and easy living have softened us reservists. To my great surprise I feel a taste for responsibility and initiative coming to me. Never have I felt myself more calm, more resolute, more energetic.

1:45 pm, *Carnet*: Our part is to obey orders, cost what it may, without discussion, without recrimination; to do our duty to the end. Long live France!

4 October, JMO 55th DR: The general commanding the 55th DR is charged to direct a short and violent attack, whose results do not visibly modify the situation of our forces.

4 October, Robert to his parents: In the advance posts for 36 hours now, where we are replacing the heroic Zouaves. I am happy, although sleep has bidden us an indefinite *au revoir*. . . . I have had the chance to recover with two squads [a half section, 30 men] a trench that a section [60 men] had abandoned in a stampede. Now I am quite a seasoned fighter; the morale couldn't be better. My men have confidence in me and this gives me motivation.[36]

Robert's success in the heavy fire-fight of 4 October, rescuing a threatened trench with his half-section of the 23rd Company, made him the obvious choice to do the same on the night of the 13th.

5 October, JMO 282nd RI: We attack on the whole front. The 5th Battalion, leaving one company in reserve, has the village of Cuffies as its first objective, then the saddle to the northeast; the 6th Battalion, the hill of Cuffies. The troops reach the crest at 6 pm, but the village of Cuffies being re-occupied by the enemy, and the 6th Battalion coming under violent artillery fire, the crest is not held, and we return to yesterday's positions at 10 pm.

6 October, *Carnet*:[37] From the château [of Vauxrot] I climb onto the plateau where the view extends to infinity. Evening falls. Motionless silence. Immense

horizon. Tranquil quiet. Profound peace. The Germans are dug in on the hills to the east. The valleys are already turning crimson, as autumn reddens the slopes. You dead, scattered there on the plain, how serene is the peace that descends this evening upon you all. May the deathly grimace that disfigures your faces now disappear. Forget everything, the fatigue, the suffering, the anguish of death. We will not forget you. . . . Abel, dead on the field of honor, I think of you tonight.

6 October, JMO 55th DR: The English III Army Corps is relieved by the 5th Group of Divisions of the Reserve, which must then extend its front toward the east and proceed to a new partition of troops. Two sectors are established by General Order no. 59. The left sector extends to the ravine between Crouy and the round hill 131 occupied by a brigade of the 55th DR, whose post of command (exercised alternately by the two brigadiers) is placed in the château of St. Paul [Vauxrot].

Then the regiment went into reserve, and Robert's unit, the 23rd Company under Lieutenant Café, was billeted at Mercin, "in a charming and picturesque village," he told his parents.

9 October, Rose-Marie to Robert: You will see Victory, our Fatherland delivered . . . Justice will be done . . . [referring to his coming 30th birthday:] What a beautiful anniversary! A first-class feast day, on the soil that will remain consecrated for us by all the young lives freely, joyously sacrificed for the Fatherland in danger. My Robert, I am sick to think of all that may come in this new year, that opens for you in such tragic hours. . . . I wish to do more and better for all those whom the war will leave desperate, wretched, stripped of everything and of all hope. I have received so much from you! My first desire will be to give in my turn.[38]

11 October, Carnet: We have come again to occupy the advance posts at Beauchamp Farm by Mercin. . . . The farm where we are is very simply built, and furnished in charming taste. . . . Everything is there that makes for the charm of country life. A tennis court in a pretty garden, elegant furniture, a plain decor well suited to the architecture. All this has been abominably pillaged and wrecked.

11 October, Tuffrau: Sunday, in Crouy. Sun on the poplars. Wind from the northeast. I am writing, when suddenly there comes a bass melody, religious music: a chorale, one would say. It comes from Braye, a kilometer away, hidden by the trees. It is the German Sunday service, and the wind carries its echoes to us. For a time the rifle fire is interrupted and the music floats over the countryside as the dawn lifts the mist. That was pretty.[39]

Monday 12 October was Robert's thirtieth birthday. He spent it preparing his men for their return to the trenches that night: they were to relieve units of the 276th on Montagne Neuve.

12 October, *Carnet*: Heroism is nothing but what one is, deep inside, what is illuminated by the light of a bonfire. . . . Patriotism isn't scorn or ignorance or hatred of the foreigner. It is the desire to see your country realize its own complete destiny and develop its own full genius. Just as each man ought to plow his own furrow according to his abilities, each nation should work to realize a superior human ideal, following the tradition of its own genius.

12 October, André Michel to Robert: It is your birthday today, dear child, and I am seeing again that morning in October when, at the break of day, I ran out onto the road to Montpellier to announce your birth. You arrive at the age of full manhood, at the finest age of man, in these tragic days. This will be a magnificent orientation for your whole life. . . . Oh, if I could march at your side—and a little ahead.[40]

If Robert had survived that October and the months and years of the War yet to come for the French armies, would his idealistic patriotism and his romantic humanism have stayed alive in him? We cannot know, but some veterans of those same experiences, such as Tuffrau, came through them still human, intelligent, and liberal. When Robert died, was his death not a meaningless one among the hundreds of thousands in that World War that did not end war and that saved France only temporarily from German occupation? It seems only just to declare that, while others may have failed to find meaning in the War, or a meaningful death in the War, Robert went into the War in full possession of the meaning of his victory or his death. He knew that he would possibly die defending Soissons, and the knowledge did not frighten him or deflect him. He was ready to spend everything for France, and he did so.

13 October 1914

Circumstances combined to take Robert's life on 13 October. His company, the 23rd, under Lieutenant Café, was kept in support at the command post of the regiment, the Glassworks of Vauxrot, until the intense fire-fight of that night broke out and the 23rd Company was ordered up to stiffen the trench line on Montagne Neuve. And so, instead of firing from the trenches like the rest of the 204th regiment, Sergeant André-Michel was leading his half-section of reinforcements over open ground toward the front line. The

French heavy artillery, which might have discouraged some of the German fusillade, was slow getting into action. And the whole French line was illuminated by burning haystacks and German flare shells.

13 October, JMO 55th DR: From 7 to 10 pm, a heavy fusillade breaks out over the whole front of the Division, accompanied by a violent cannonade. The enemy does not actually advance, but limits himself to an attack by fire.

13 October, JMO 246th RI: During the day, nothing to note. About 7 pm some flares are launched by the enemy; they seem to come principally from the heights of Cuffies (hill 129). Rifle fire immediately breaks out over the whole front from Bois-Roger to Crouy. The companies of the 5th Battalion at Soissons and those of the 6th on the right bank of the Aisne immediately take up arms.

13 October, *Carnet*: The morale of the men is poor. Honor, fatherland, these are nothing but words. The most depressed are the ones who have been on campaign since the beginning of the war. I try to make them understand what the defeat of France would mean for each of them. Death is better than slavery. Some understand. For the others the war is the greatest of evils. Each one thinks of his family. Reservists thirty years old and more, who are fathers of families and just beginning to harvest the fruit of their long effort. . . . The minority [here Robert's writing ends].

13 October, Tuffrau: The night of the 13–14th, alert. Everybody gets equipped in haste. Indecisive waiting in the dark. Rifles and cannons fire, the sky is lit with flashes. "Tuffrau, since you're on a bicycle, go see the companies and tell them to hang on." I head toward the 18th Company, which is firing on the bridge of Bois-Roger, and on the way I meet two gunners of the 9th heavy artillery. Spent bullets whistle through the gardens in the night. "Lieutenant, we're from the orderly, going to warn the 155s that they have to fire in case of attack." "Come with me." We set off toward the point where there is a telephone and three 155 mm. guns, the two men running alongside my bicycle. When we reach the big trees there is a violent explosion, very near. "That must be us firing." They guide me to the emplacement where, in the dark, I can make out the breastworks of three guns. Immediately I ask for the telephone to call Montagne de Paris and get the order to fire on Bois-Roger. In the course of that call I am astonished to hear that Pasly has not been bombarded. "Tell that to our lieutenant." "Is he energetic?" "Him? Oh, he has nerve, but he has been forbidden to fire." I come out from the dugout. The sky is red-purpled by the glow of haystacks that have been set on fire with gasoline and the countless flare shells of the Germans. A poplar is silhouetted against one fire burning far off on a hilltop. "Lieutenant Gibert?" "Who calls?" A shadow comes nearer along the trees. It lights its pipe. "I am firing without orders. I'm not waiting

for the 75 [to fire a signal shot]. It is at Vauxbuin, the 75, in bivouac. Why? For moral effect. Let's go, number two, why are you fucking about? Will you fire, name of God!" In the dark hollow a shadow gets moving with a candle shielded in its hand, then the voice of the gunnery sergeant: "First gun, ready! Fire!" A violent bang, few flames, but a rapid shower of sparks, immediately snuffed out. Far off, below Pasly, after a moment, the flash of the explosion. The fusillade calms down and I cycle off toward the companies. They are in the trenches, ready to fire. The field of fire as far as the Aisne is lit by the burning haystacks. None of the four companies has been attacked. The 155 mm. shells, the "coal sacks," amazingly, have hit the bridge of Bois-Roger.[41]

13 October, JMO 204th RI: The regiment keeps the positions given to it yesterday. The day passes relatively calm, a few shots exchanged between the French and German trenches. At 6 pm the night becomes particularly dark and the calm is absolute. At 7 pm, explosions along the whole line, the enemy far enough away that we can just see the flashes and hear the shots. A violent fusillade, giving the impression of a general enemy attack, concerted and organized for a fixed hour. The lieutenant colonel [Duroux] commanding the 204th orders his reserve (the 23rd Company) to take arms, and he renews the order to his two battalions to stand firm in the trenches. This order is punctually executed. The intensity of the fusillade, at first uniform, diminishes little by little toward the east, remaining very violent toward the west and mixed now and then with a cannonade directed toward the trenches and toward Soissons, and led by the German field artillery. At 9 pm the combat was almost entirely ended, though isolated shots continued for about a half-hour. A short, violent cannonade was again directed at the Glassworks, then all went silent again. At 11:30 pm a new and violent fusillade came from the direction of Vauxrot, lasting about a quarter hour. In the course of the action our troops did not move from the trenches: there was no hand-to-hand, either because the enemy was limiting their action to rifle fire, or because their offensive had been broken up by our response, which was immediate. Cartridges consumed: about 50,000. Our losses were 3 killed and 6 wounded.

14 October, Rose-Marie to Robert: Nothing from you today—by letter, I mean, for I am constantly receiving messages from your dear thoughts . . . and you know well, I am sure of it, that I am ceaselessly sending you, over the sad fields that separate us, the best of my soul, limitless messages of courage and of love. (The letter was returned, stamped "Return to sender. Addressee could not be reached in a timely manner.")[42]

Figure 5.2. Robert's military death certificate, from the French Ministry of Defense website Mémoire des Hommes.

CHAPTER SIX

~

Rose-Marie's War, 1914–1918

Sargent in Exile in Austria

John Singer Sargent had been in Austrian territory since the last week of July 1914. Careless of politics, he had crossed from Switzerland into the Austrian South Tyrol without a passport just in time to be trapped there, on one of the last days before the mobilization made that document indispensable for any American moving between belligerent and neutral territory. He kept busy painting, but his movements were increasingly hampered by the police and the scarcity of transport, and he fretted incommunicado about the ones he loved. He was a foreigner without papers and short of money, his letters were returned without explanation and mail from his family arrived late or not at all. Rose-Marie sent letters to her grandmother in Switzerland for re-posting to her uncle, but he knew nothing of her shattering loss for several days.

St. Lorenzen, Pusterthal, Tyrol, 14 October. *Ma chère Rose Marie*. It's kind of you to have found the time to write to me, among all the preoccupations of moving house and of the Red Cross.[1] Yet I think it is much better that you should have plenty to do at a moment like this when the idea of the danger facing Robert could take you over completely. Consider instead that it's a source of pride, both for him and for you, that he is taking an active role in that noble resistance which the whole world knows to be just—and don't be surprised if you receive no letters. Here as well [Austrian] officers' wives are having to manage without news from their husbands, who are not yet over the border. . . . And dear Rose-Marie, remember that I share your worries and concerns. I hope that you will soon receive good news.

St. Lorenzen, Pusterthal, Tirol, Austria, 18 October. *Ma chère Rose Marie*. Please be so kind as to put this letter in the post—and to forward the reply to me here, if one comes. I hope that you have had good news of Robert and of his people. I have received many very satisfactory letters from Emily, and we are all well. My respectful kind wishes to Madame Ormond, and remember me to Marguerite if she is there. With kisses, your affectionate uncle, John S. Sargent.[2]

Then, a week after Robert's death, he learned of it by a telegram from Rose-Marie's Bonne-Maman.

St. Lorenzen, Pusterthal, 20 October 1914, *Ma chère Rose Marie*, I pity you with all my heart—your sorrow must be dreadful—and it will be a long while yet before you become aware of what those who love you are attempting to say to make your grief less painful. Their presence alone can do you some good—I hope you won't delay going to your mother's in London, if the journey is possible at this time—she must want to see you with all her heart. Your affectionate uncle, John S. Sargent

Please give this note to Monsieur André Michel.[3]

When he wrote to his sister Emily later that week, he was still thinking only of the London family as a haven of loving comfort for Rose-Marie:

Dear Em, I have had more than one letter from you lately, but nothing since the news of Robert's death that Madame Ormond wired me on the 18th. I have written to Rose Marie and to Mr. André Michel, did so at once, also to Violet. I wonder how Rose Marie bears up. I suppose she is still in Paris—but I should think it would be a good change for her to come to London. I wonder if Violet or Francis have gone over to her. Not easy to do I daresay. She had better come to London I should think. . . . I got a letter from Violet—ours must have crossed—she must be awfully distressed about Rose Marie—I can't think how she will spend the next few years. Alone in Paris would not be very pleasant.[4]

But Rose-Marie had gone to her Bonne-Maman, who had treated her as a daughter all her life and whom she loved tenderly, while she rather longingly admired her mother Violet. Crevin was no longer her home either— she stayed at the Hotel des Bergues in Geneva.[5] From there she wrote a letter to her uncle John that told him, in the nobly elevated language that she and Robert always used to write about patriotism, devotion, and each other, that she was now a member of the family André-Michel, a Frenchwoman, and, as Robert's widow, his successor in the service of France and the suffering French people. She may have told her uncle the motto that she and Robert had blazoned on their marriage, "Above life, honor; above

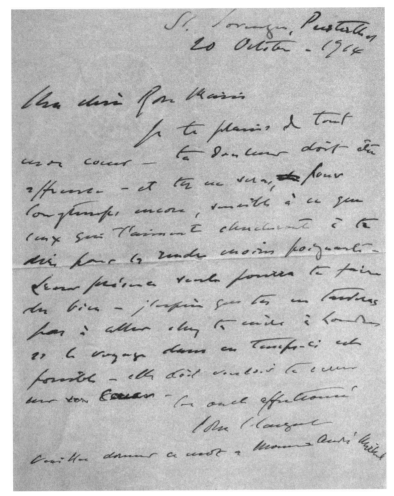

Figure 6.1. Sargent's letter of condolence to Rose-Marie. Sargent wrote to Rose-Marie immediately when word of Robert's death reached him in the Tyrol. His handwriting is hard to read, but his deep sympathy for Rose-Marie is unmistakable. Private collection.

happiness, sacrifice." Pleasant or not, she would be living in Paris. Sargent answered immediately.

St. Lorenzen, Pusterthal, 29 October. *Ma chère Rose Marie,* I see from your letter from Geneva, all vibrant with noble emotion and courage, that you are valiant in your grief, and that gives me joy. You and his afflicted parents can take pride in the thought that his was an heroic death. And when one thinks of the long agonies of thousands of victims from their wounds or their sickness,

one can in a sense regard as lucky those who were struck down on the field of battle. Some letters have come from London, telling me of the grief of Emily and your parents. I hope that you all will find a way to get together.

May I ask you to tell Monsieur and Madame André Michel the depth of my sympathy for them in their grief. I wrote to him as well as to you on the 18th or 19th, but one never knows if the letters get through. Above all, he should not think of sending me a reply.

I kiss you very tenderly. Your affectionate uncle, John S. Sargent[6]

Two months of such painful exile was enough for Sargent, and he made concrete plans to get home to London, visiting Rose-Marie in Paris on the way if he could. At St. Lorenzen he was living in the great house of his old acquaintance and now indispensable friend Carl Maldoner, who had arranged an internal travel pass for him and guaranteed his bona fides and good behavior to the authorities. In anticipation of a passport from the American Embassy in Vienna, he sent his heavy luggage and paintings ahead to Trieste in the care of his trusty factotum Nicola d'Inverno. After a long delay, what came from Vienna was the word that he had to go there in person, over 300 miles by road, to get the passport, which he did on 19 November. A temporary passport, good for just one week! But Sargent, whose acquaintance with Bradshaw's *Continental Railway Guide* had begun when he was in pinafores, rose to the challenge: almost 400 miles by rail, including the scenic Semmering Railway, brought him to Austrian Trieste on the 21st, and the next day a steam packet landed him on the Lido of neutral Venice, where his trunks and paintings were consigned to the care of Thomas Cook & Sons. He continued by rail through Milan and Turin to Geneva. Thanks again to that rapidly melting passport, he was able to leave neutral Switzerland and continue by rail through Dijon to Paris, Gare de Lyon. If he was lucky with his connecting trains in Italy and France, he had two days to visit in Paris with Rose-Marie and the André Michels; if not, just one day, 26 November. Sargent being Sargent, no one will ever know what they said. Rose-Marie gave her uncle a brave goodbye at Gare St. Lazare on the 27th and he was at Le Havre that afternoon—with an expired passport. The American consul provided him a fresh one and he landed in Portsmouth two days later.[7]

Robert's World in Mourning

Casualty lists were not released for publication by the armies, but officers would notify parents. It fell to Lieutenant Café, commanding the 23rd Company, to write the condolences of the 204th Regiment to Robert's father. Café's letter

was the chief or the only source of some crucial details that were repeated as the sad news spread through the network of Robert's family and friends.

> At about seven in the evening, leading his men to the aid of a section that was breaking up, he received a bullet straight to the heart. When his body was recovered, his hand was stretched out toward the enemy, gesturing the command "Forward!" . . . He was a man of the highest merit, intellectual and moral, of an ardent patriotism, of a steady high courage. He had a prodigious influence over his men, often speaking to them of the grandeur of France and the nobility of the soldier's task.[8]

Henry de Varigny got the news from André Michel and noted it in his journal: "20 October: Sad news. Our poor Robert has been killed by a bullet to the heart, we don't know where. He was my favorite nephew and I will miss him greatly. His poor parents."

And under the heading *Les Tués* on 22 October, Henry wrote in *Le Temps*: "Our eminent brother and friend, M. André Michel, has just been cruelly struck again: his son Robert André Michel, former student of the Ecole de Rome, archivist at the National Archives, has been killed by the enemy. M. Robert Michel was a sergeant in the 204th Regiment of Infantry."

Henry James and his sister-in-law Alice James had met Rose-Marie about the time when Sargent painted her portrait, and James was deeply moved by her loss. He wrote to Edith Wharton in Paris on 20 October,

> Mrs. [Daniel] Curtis, . . . who had been lunching with Emily Sargent, further brought me in the dismal news of the death of the so distinguished little French husband of her niece, Violet Ormond's daughter, the Rose-Marie whom Sargent so exquisitely painted a year ago; the said André Michel having been killed in one of these last engagements. But you of course hear nothing but the like all round you.[9]

James soon had the news more directly and accurately from Emily Sargent herself, his neighbor in Carlyle Mansions, Chelsea, and he wrote to his niece Margaret Mary James,

> I try to think of any personal bits that will connect themselves for you; I think for instance of how it will sadden you to hear of the death, in action, of Violet Ormond's fine little son-in-law, that beautiful Rose-Marie's husband of only a year, Robert André-Michel; of whom Emily S. told me two days ago that his father had wired to Violet here: *Robert tué; balle au coeur; mort en héros; son lieutenant le dit.* He at least died, without any of the prolonged horrors of so many, on the spot; that he was the most accomplished and promising of the

young distinguished scholars formed by the Ecole des Chartes; it was a love match with that exquisite girl; and it's as lamentable as you can judge.[10]

The Ecole des Chartes responded eloquently in their quarterly journal to the death of their brother scholar. The list of those *Tués de l'Ennemi* gave him the name by which he had matriculated, and the editor designated a wrong regiment and place of death: "Robert MICHEL, sergeant of the 89th Regiment of Infantry, killed near Coucy-le-Château, 13 October." Henri Stein, president of the Society of graduates, in its last meeting of 1914, paid an extensive homage, naming all of Robert's important contributions to medieval history:

> I can say so much about Robert Michel, killed by a bullet to the heart on 13 October, as he was leading his company in an attack in the vicinity of Coucy-le-Château. He was an elite spirit and a charming comrade who was just beginning his life—he had turned thirty the day before, and had been married little more than a year—and had won the most lively sympathies wherever he went. . . . A tenderly loved father, who initiated him to the beauties of art and who derived such pride from each of his successes, will do everything possible and more so that his unfinished works will not be completely lost. And since it had to be that our young friend was one of the victims fallen in defense of the soil trampled by the enemies of art and civilization, the sacrifice seems greater yet when we see him disappear in the holocaust, one of those who seemed by their studies best designated to evoke one of the most marvelous phases of that art and that civilization.[11]

Robert's parents, his widow, and her grandmother endowed a scholarship in his memory. The *Bourse Robert André-Michel* was to pay 900 francs each year to a new *archiviste paléographe* who needed to travel in order to study monuments or consult archives and libraries to finish a work on premodern national history.[12]

Charles-Victor Langlois, director of the Archives Nationales, submitted his usual dry annual report to the minister of public instruction, adding a note of real mourning:

> III. Personnel. Successively mobilized: two of four principal archivists, fourteen of sixteen archivists, two of three clerks, eight of fifteen guards.
>
> This is not the place, and the time has not yet come, to speak of our bereavements: one killed, two missing, three wounded, one prisoner. However, I cannot pass by the grave of archivist Robert André-Michel, sergeant of infantry, killed the 13th of October 1914 on the Aisne, without a salute. He was a young scholar with the greatest expectations and one of the best of us. He did us the honor to love us, and everyone loved him. He died as nobly as he lived.[13]

Robert's grave at Crouy on the active Aisne front, marked by a white wooden cross, was inaccessible to his grieving friends, and in January 1915 the German army overran it and occupied Soissons: no monument on the scene was possible until after the War. But in the Temple de l'Oratoire du Louvre, his name is first among the MORTS *pour la FRANCE*. He is one of the 497 *Ecrivains Morts sur le Champ d'Honneur* listed in the Pantheon. A marble plaque inside the Champeaux Gate of the papal palace at Avignon reads "To the memory of Robert André-Michel, archiviste paléographe, member of the Ecole Française de Rome. The palace of the popes became the object of his most important works. Thirty years of age, he fell gloriously before the enemy on 13 October 1914." Six years after his death, the military decorations he had earned were added to his record with a citation: "An under-officer conscientious as well as courageous, who from the beginning of the campaign proved his heroism and his love of the Fatherland. Fallen gloriously on 13 October 1914 at Crouy. Croix de Guerre with bronze star. Médaille Militaire."

Les Villes Martyres de France

André Michel was inspired to an extraordinary effort by the sacrifice of his son and by his grief for suffering France. He used his prestige and his skills as an art historian in a hot and eloquent protest against the destruction of French cathedrals and other churches by German shells and bombs. His slide lectures were delivered in February 1915 and immediately printed in several languages for the effect they might have in persuading neutral opinion.[14] The booklet is a remarkable document in many ways, one being that it is entirely free of personal pathos, even where Michel salutes the soldiers in action:

> With an ardent moral telepathy, let us send to the men who are fighting the good fight out there thoughts of gratitude, encouragement, and admiration; and to those who, like our friend Max Doumic, have heroically fallen on the field of honor, and who rest today, within sight of Reims or of Soissons, in the sacred land that they have covered with their bodies and bathed with their generous blood, an homage and an invocation: may their dear spirits hear us, and help me.[15]

There were few in his audience who did not know that André Michel's only son lay dead in sight of Soissons, but he stuck to his subject, German barbarism against art, and specifically the deliberate targeting of ancient churches by the German artillery. He began his lecture on Reims by calling attention to the "doctrine, cynically boasted and cruelly applied, of terror against non-combatants."

An Alsatian who was overtaken by events in Germany and who, during the long delays that he had to endure in the rail stations in full mobilization, heard the conversations of hundreds of German officers, brought to me directly, well before its full effects became manifest, the revelation of that doctrine: "We will beat them by terror." My informant was a faithful witness and an indignant one, and he wrote down that watchword on the spot.[16]

Throughout these two lectures, André Michel avoided using the commonplace name "Gothic" to designate the late-medieval architectural style: it was always *opus francigenum*, "French work."[17] He showed a series of pictures of the cathedral of Reims before and after the German bombardment of September 1914.

Here you see the bare skeleton of the nave vault. It has valiantly resisted until now the assault of the shells, and it bears heroic witness to the scientific skill of its builders. "Until now," I say, because the bombardment continues to rage from time to time, and I learned a few days ago from the Commission of Historic Monuments that in the last volley a shell weighing more than fifty kilograms and containing many kilograms of melinite, according to our artillery officers, struck the transept vaults. Thank God, it didn't explode. . . . The vaults of the great nave of Reims remain intact. That is because the system of admirable crossed arches that shoulder them up, in spite of some hits, have not been seriously damaged by the shells. . . . But who knows what tomorrow holds for them?[18]

Turning from the architecture to the sculpture of Reims Cathedral, he denounced the theory that the French sculptors were inspired by German examples. It was the other way around, he insisted, and the German imitations are poor: he showed examples side by side.

The French smile, on crossing the frontier, has become a grimace; the flower is dried stiff in the German herbal book. This becomes more noticeable when you compare the *Synagogue* and the *Church* of Reims with their sisters at Bamberg. Truly, there is no comparing the copy to the model. See how the rhythm of the draperies coagulates and thickens, how the forms are dislocated, how the elusive beauty is dragged down and disappears in this ponderous design.[19]

It is easy to imagine the sorrowful hush in the hall as André Michel carried his lecture through to an end, alternating the transparencies that he had collected for his Louvre classes with recent photographs of the same priceless statues that he called by name, "this *before*, and this *after* the Germans." The next Friday, 25 February, he began with the latest chapter of the martyrdom

of Reims: "You have read the latest communiqués, and so you know that since our last meeting Reims has received a new barrage of shells and that the admirable vaults, whose robust construction I showed you and told you about their heroic resistance, have given way under this new assault."[20]

He constructed his lecture on "Senlis, Soissons, Arras" around his refutation of a propaganda article by Paul Clémen, the Germans' newly appointed administrator of historical monuments—"How to say this without shaking with rage?"—of Belgium and the north of France. Clémen was playing a variation on the "Manifesto of 93 German Intellectuals" with its rhythmically repeated denial, *Es ist nicht wahr*, of the obvious facts. Clémen's arguments were of a kind that became familiar in the succeeding century in the communiqués issued by belligerents powerful in the air: churches were not destroyed, well, perhaps damaged, but not badly, and only with the greatest regret by German forces confronting military necessity, because church towers were being used for observation and machine gun emplacements. "Was it, by chance," asked Michel, "because we had machine guns and 75's perched atop Notre-Dame de Paris that their *Tauben* came, turned methodically around the basilica, took aim, and dropped incendiary bombs?"[21]

To be completely accurate, the Germans did have military reasons for shelling churches with their heavy artillery, only not defensive reasons. While short-range field-artillery officers could observe the fall of their shots and adjust their aim and range accordingly, heavy-artillery commanders needed to hit targets a few miles away and usually hidden by intervening terrain. They became expert by practicing "map shooting," working out the direction by compass and the elevation of the gun by the distance between, and the relative altitudes of, the gun and the target. Church towers provided targets on which another officer with a high observation point and a telephone could note hits and correct misses. The destruction of churches of Reims, Arras, Senlis, and Soissons and many other towns went far beyond any imaginary defensive need and even beyond terrorism, and target practice was part of the reason.[22]

Within this slide lecture we find one of André Michel's set-piece demonstrations, his explanation of the ogival vault and pointed arch, a lovely offspring of French medieval architecture that was sired by the French stone-masons' genius upon the ponderous local limestone. He spoke of the structural problem faced by the builders of country churches in the region between Soissons, Senlis, Beauvais, and Noyon.

How to make these heavy stone vaults stay upon the two vertical walls, when according to the laws of gravity they tend to push apart their supports and

fall to the ground? . . . Some village masons in this part of France invented, and took the trouble to standardize, a new method of constructing the vaults: "Here I have a vault to build. Even over a low aisle or an ambulatory, placing those stones in balance isn't easy! Perhaps if I divide the problem I can get to the solution more handily." . . . So here is an arch, a round arch, supported from point to point on its heavy ribs. Throw one of those ribbed arches across another in each bay, the two arches crossing each other *diagonally*, and you create four independent compartments. . . . Those diagonal arches make the "ogive cross," the essential armature of the French vault. . . . You have the "stone carpentry" that holds up the vastest cathedrals and permits them to rise ever more boldly, almost doing without walls, multiplying and enlarging those sublime windows. . . . Here you see one of the earliest and most perfect masterpieces of the architectural style that would dominate Christendom: the south transept of the cathedral of Soissons. This is probably being destroyed by the Vandals while I am showing it to you on this screen.[23]

Over the ten years that remained of his life, how many times must André Michel have thought and dreamed of those tons of stone poised by French genius high above their church floors, safe for the ages until German artillery came within range to bring them thundering down?

Madame Robert André-Michel, Widow

Violet Ormond visited her daughter in Paris early in November. She wished to take her back to London, but she found Rose-Marie resolved to stay with Robert's family at 59 rue Claude-Bernard. Two weeks a widow, she wrote Guillaume on 25 October, "My great duty at present, which is my greatest comfort too, is to be to my poor parents in law, with whom I suffer so much, a son and a daughter altogether. Nobody in the world could approach to what Robert was, but in the wife of their son, they will find all the love I can give."[24]

With the help of her equally stricken *beau-père*, she worked to make Robert's last articles ready for the press, and eventually to prepare his transcriptions of Vatican Archives documents for publication, in service to future historians. In January 1915, when the German counterattack overran Crouy and Soissons, she was three weeks or more in bed with bronchitis, nursed by Robert's parents.[25] She used the days in copying excerpts of Robert's letters from the front for the use of André Hallays and Robert Burnand.

Rose-Marie's letters to her brother Guillaume in England, mostly written in her charming experimental English but plunging into French when she was profoundly moved, reveal Rose-Marie's doings and state of mind. She felt

that she could write frankly to Guillaume, who had spontaneously become Robert's friend, about her abiding union with Robert and the inspiration she took from his spirit and his example. "I will try through my poor life of which he is forever the great light, to continue his will and do, in my feebleness, what he would have done."[26] That included her volunteer work with the Red Cross, but whatever training she received there, and whatever work she found to do, it wasn't enough. She regretted the time lost from service while she was confined to bed, and her lack of training early in life for what she needed to do in wartime: "I never had thought enough on the duties I owe to others, to miserable people."[27] Always a generous giver of herself to her friends and family, she was full of "the pity of war, the pity war distilled,"[28] though she had none to spend on herself.

Late in her first summer as a widow she went for a holiday in Brittany with her parents, her brothers, Reine, and her Bonne-Maman. Photographs show her "trying to be glad" at the seaside, in mourning black. In one her father also appears, looking away; in the other Reine is bored, Rose-Marie grimly grasps a spar, and Guillaume shows the beginning of a mustache. We have to be grateful that Guillaume returned to London early, so that Rose-Marie had to record in a letter to him her lightning errand back to Paris.

24 August 1915, Grand Hotel de Provence & Angleterre, Dinard
I received Friday morning, a letter of my sister in law Madeleine [Vermeil] sending me a paper of the *Mairie* [of the 7th Arrondissement] saying that I could come as soon as I wanted to take possession of Robert's things (those which we are waiting for since over ten months). You understand I had not the patience to wait my return, especially for his *carnet de route* that I longed to know if it was destroyed or not. So the same evening on Friday I took the train for Paris, and Sunday morning I came back to S. Servan.[29] At last, I got those precious things of Robert. The *carnet de route* is ours now, and we have been able to follow, day by day, from his leaving of Montargis, to his death, all his impressions and doings. You can guess what an upsetting emotion it was. I will be happy to read it to you. Those lines, written among the tragic visions of dead soldiers, of burning towns and all horrors, are beautifully spiritual, and gay sometimes with the joy of feeling himself *plein possesseur de sa vie, d'une vie décuplée qu'il offre à l'idéal qu'il sert.* . . . Elsewhere I find too *Au-dessus de la vie, l'honneur, au-dessus du bonheur, le sacrifice.* . . . Impressions too of the beauty of two churches at Soissons, . . . and many other things. Hélas! He also writes several times his burning sorrow of seeing the coward-ness of some soldiers, of many officers. He speaks several times of that one who caused his death [Lt. Col. Duroux?]. . . . Two officers happily amongst his *compagnons* were brave and fine men.

Figure 6.2. The Ormond family summer holiday, Dinard 1915. Rose-Marie joined some of her family late in her first summer as a widow for a holiday in Brittany. Out sailing, Reine is bored, Rose-Marie grimly grasps a spar, and Guillaume shows resolve and the beginning of a mustache. Private collection.

Her last letter of that summer holiday reveals that she had already found her own answer to the question that had troubled her uncle John: how she would get through the next few years.

7 September 1915, Grand Hotel de Provence & Angleterre, Dinard
Before leaving this place, dearest, and so turning the last page of these summer holidays, I want to have a few last minutes with you, of silent recollection. . . .
Bonne-Maman . . . had suddenly took the decision to leave Dinard tomorrow morning at the same time as me. I am very glad to travel with her, and it will give her the advance of two days, which is not to be neglected, at Salies-de-

Béarn.[30] So, in three days I jump to Reuilly, with the will and resolution, that the first step of a new year's work gives one. One feels confident and blind, so full of unknown is tomorrow's future. But in the heads and hearts [she ends her letter in brave French] there is no slack and no indifference. Each one marches alertly toward a clear and definite goal, a goal that simply requires us to understand our responsibilities.

Reuilly

Robert's esteemed Saint Louis created the space where Rose-Marie found the cause that she served for the rest of her life. King Louis IX (1226–1270) was a champion in works of mercy, and his most sensational charity was his Hôpital des Quinze-Vingts. This was a hospital in the medieval sense, a hostel where the king provided bed and board to three hundred blind men (counted the Old French way as fifteen score). They had no need to beg for their living, and their only duties were to wear the king's badge on a white robe and to pray for his soul. Later kings permitted the foundation to decay, but on the eve of the Revolution, in 1779, Louis XVI transferred the blind pensioners to the barracks of the Black Musketeers in the Faubourg Saint-Antoine.[31] A clinic for the treatment of diseases of the eye was added to the original foundation, still under the old name of Quinze-Vingts, in 1880, when the relevant science and surgery had considerably improved. This was the kernel of the National Ophthalmological Institute.

When the War came, the Quinze-Vingts was quickly overwhelmed with blinded soldiers. Note that in the first months of the War, before gas was in use and before the French soldiers got helmets, men were blinded by bullets or shrapnel or blast, so they were often badly disfigured as well as blind. After their wounds had been treated and were healing, they had to be moved along, but there was nowhere to send them.

The Ministry of the Interior saw the approaching tidal wave of misery and got busy creating a rehabilitation annex to the Quinze-Vingts. They leased the buildings and grounds belonging to the convent and boarding school of the Catholic Sisters of Sainte-Clotilde at 99 rue de Reuilly. The site was perfect—an extensive parkland on elevated ground that shared a block with the military hospital of the Protestant *Diaconesses*: the block bounded by rues de Reuilly, Sergent Bauchat, Picpus, and Gare de Reuilly. The dilapidated buildings were repaired and rebuilt at urgent speed, and the first forty blind soldiers (just *deux vingts* to begin with) moved in on 29 March 1915, welcomed by the director, Paul Emard, by Pastor Marc Boegner and his corps of military orderlies, and by Mlle. Jeanne Lefebvre and her volunteer women

nurses.[32] Those *infirmières* performed the normal work of practical nursing, and they also helped teach the daily skills like washing, shaving, and eating that the men had to relearn by touch. They called each man by his family name. They read aloud in the workshops the daily newspapers and whatever prose and poetry the men chose to hear, and, in a lower voice, on a bench in the park, they would read a man the letters of his wife or sweetheart.

Beyond safe shelter, good nourishment, some home-like touches of women's voices, and nursing care, what could be done for these stricken men? In a bold experimental program volunteer instructors, organized by the Friends of the Blind Soldiers, would give training in basket- and brush-making and massage; printing, typewriting, stenography, and operating telephone switchboards. As soon as possible, Emard opened that path back to proud, manly independence.

> After a month the main work of rebuilding had so far progressed that I could take a dilapidated pavilion for a brush-making shop and put in a small work-bench and a knife for cutting brush fibres. I shall never forget my feelings on the day when the first pupil of Reuilly made his first brush. As I was passing through the dormitory in the evening, the man grasped my hands, kissed them, and cried: "Oh, sir, I am saved!" And at the same time all his comrades knew that they, too, were saved.[33]

Rescued from despair, they could begin to work rationally against the fear that had blighted their time of physical recovery, the fear of being dependent objects of pity rather than breadwinning husbands and fathers. The soldiers' habit of meeting disaster with comradeship helped immeasurably. They made their claim of independence together the first time a lecture was scheduled after the evening meal, before Reuilly was fully furnished with chairs. Marc Boegner asked the men to wait patiently while the attendants carried the chairs from the dining room to the lecture hall. "We'll each carry our own!" called one impatient hero, and so they did, with a few collisions and some, "Watch out, old man! Are you blind, or what?" As space became usable, the trades in the "School of Reuilly" proliferated: basket-making, chair-caning, cobblery, cooperage, fabrication of auto parts, the delicate grinding to fit tapered glass stoppers to perfume and chemical flasks, massage. There were classes for typewriting and reading Braille, individual instruction in hand-writing in a specially designed frame, and in instrumental and choral music. Most of the pensioners (as the staff called the residents) had been farmers before mobilization, and they practiced cultivating the gardens and orchards in the twelve-acre park.

The dramatist Eugène Brieux, who had made his way into the Acadé-mie Française in 1909 the hard way—by a flood of comedies blazing with indignation against social injustice—appointed himself big brother to the blind soldiers of Reuilly. He founded *Le Journal des Soldats Blessés aux Yeux* and published it monthly from November 1916 to June 1919. He attracted volunteer talent to teach at Reuilly and secured benefactions from his rich and titled circle. He was impresario for one memorable benefit evening at the Colisée, attended by the pensioners *en masse*, where the Folies Bergère stars Mistinguett and her young lover Maurice Chevalier performed, no doubt to shouts and applause from those who saw (and those who remembered seeing) her.[34] By the end of the war there were seventeen branches of the School of Reuilly throughout France. Brieux issued a bracing instruction on how to run them.[35] While he recognized pity as a valid part of the volunteers' good will, it was not something the wounded wanted given to them. He recommended that the visitors' entrance to such a school should have this notice in big capital letters: PITY IS NO CONSOLATION. His prime directive to the caretakers could be expressed this way: Love the men, surely, but don't try to have them love you; your job is to see that they go away home as soon as possible, free of your care and ready to forget you.

Visitors to Reuilly have given us their views of the work that was done there by and for the blind soldiers. An outstanding volunteer with the American Field Service, Nora Saltonstall, was surveying her opportunities for war service in Paris in November 1917. With eight braille watches to give away, she took half to *Le Phare de France*, a branch of the Boston-based Lighthouse, and then,

> I took the other four to a French military hospital for the reeducation of the blind at Reuilly. The wife of the director showed us around and she knew all the men by name and picked out the ones she considered the most appropriate. The first went to a little man who is learning to make glass stoppers for perfume bottles as a trade but who when we met him was on his way to a violin lesson. He loved it, especially as he is going to be married soon and this beautiful gold watch looks far better on the end of his chain than a knife which he had put there. The next two men were learning to be masseurs, a profession apparently particularly suited to the blind, and when they graduate from this school they are apt to go to the hospital of the mutilated and work on them. The last one was given to a very young Alsatian who enlisted with the French at the begin-ning of the war. All four of the men had face wounds and were pathetic to look at, although funnily enough we were so occupied with showing them how the watches worked, how to wind and set them, that we did not think of their awful disfigurement. We saw the men at this hospital making baskets, learning

to be mechanics, making barrels, etc. One man was also minus an arm but he had an arrangement with a hook and could make brushes almost as quick as the others; there was a semi-paralyzed man at work too. It is wonderful what they can learn to do![36]

Dorothy Canfield served at *Le Phare* when she first came to Paris, and she knew Reuilly well. Her story "Eyes for the Blind"[37] is set in a place more like Reuilly, with its extensive grounds and little lake, than like *Le Phare*; and the center of her story is the *Directrice*, who could easily have been modeled on Rose-Marie: a Frenchwoman from a wealthy family, widowed early in the War, a music lover and pianist, who could attend music performances only on Sundays, dedicated selflessly to her work for the blind regardless of the mind-deadening drudgery that it entailed.

Paul Renouard was the Daumier of his generation, a realist in his drawing technique and a penetrating judge of the scenes that he drew: he made his reputation at the turn of the century with his *Illustrations pour les défenseurs de la justice dans l'Affaire Dreyfus*. His etching *Ceux qui apprennent à être aveugles*, "Those Who Are Learning to Be Blind," shows a line of stricken soldiers, French and allied, surrounded by a white cloud of nurses, Catholic, Orthodox, Protestant, and secular. To make his preliminary sketches he visited Reuilly, "where he knew he would find the most moving models" of soldiers and volunteer nurses. In his etching we see Rose-Marie, one of the flock of ministering angels in white, shepherding the dark column of blind soldiers; her anxious care is for a Serbian officer who persists in trying to see his hand before his face.[38]

Rose-Marie joined the volunteer nurses, probably at the suggestion of Pastor Marc Boegner, soon after Reuilly opened its doors, some seven months after her last sight of her husband. In the brief year of her marriage Rose-Marie had come to know the Boegner family and had become best friends with Geneviève "Vivette" Boegner. In 1913 Vivette had taken on the direction of a corresponding society for chronically ill women, Les Coccinelles (Ladybirds), founded by a Swiss woman, Adèle Kamm (1885–1911), a few years earlier. The incurably tubercular Kamm had initiated the idea that shut-ins, frequently institutionalized and shunned by their family and friends, might join with each other, break out of their isolation and depression, and sustain their spirits by exchanging journal entries that ranged from the banal to theological discussions of the meaning and worth of their suffering. Vivette provided Rose-Marie an example as she took on the burden of confronting and allaying the despair of the newly blinded.

Color 1. Sargent, *Autumn on the River*, oil (1888). What began as a late-summer painting with the subject in a summer dress became a long, chilly ordeal for Violet until Sargent relented and covered Violet in fur and wool to complete his painting. Private collection.

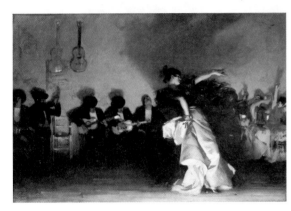

Color 2. Sargent, *El Jaleo*, oil (ca. 1880–1882). André Michel in *Le Parlement*, 8 June 1882: "She is contagious! After a quarter of an hour one feels the crazy desire to leap onto the banquettes, which would destroy a critic forever in the esteem of respectable folk." Courtesy of The Isabella Stewart Gardner Museum, Boston.

Color 3. Sargent, *Violet Sargent* (1890). At Nahant in August 1890, Sargent painted this picture of his sister Violet, shy but nevertheless singing, as a souvenir for her Boston hosts, the Fairchilds. Courtesy of The Isabella Stewart Gardner Museum, Boston.

Color 4. Sargent, *The Brook*, oil (1907). At Purtud in 1906 and 1907, Sargent posed his models in silken robes and veils as faux Turks in cool Alpine scenes. Here is Reine, chin on hand, and Rose-Marie, intent on the artist and viewer. Private collection.

Color 5. Sargent, *The Cashmere Shawl*, watercolor (ca. 1911). This spectacular watercolor shows Rose-Marie wrapped tightly in the signature cashmere shawl, turning her face away from a blustery wind. Photograph © 2014 Museum of Fine Arts, Boston.

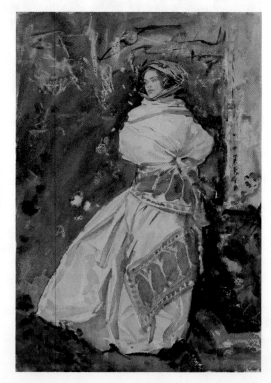

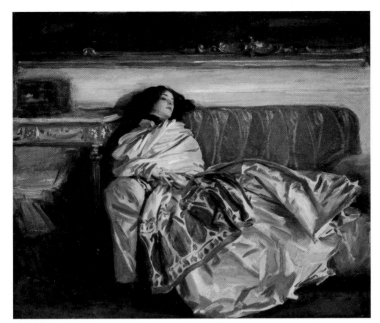

Color 6. Sargent, *Nonchaloir* or *Repose*, oil (1911). Sargent echoed Edouard Manet's portrait of Berthe Morisot in this evocative painting of Rose-Marie. She is extremely nonchalant about the huge painting hanging on the wall behind her. It's a Sargent. Open-access image courtesy of the National Gallery of Art, Washington, DC.

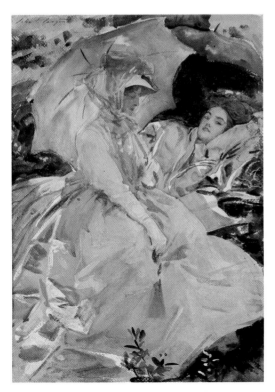

Color 7. Sargent, *Simplon Pass: Reading*, watercolor (1911). This was one of the watercolor masterpieces that Sargent produced for a show in New York and Boston with Edward Darley Boit. Dolly Barnard looks to her reading as if still unaware that she is being observed, but Rose-Marie looks up at us with an inviting glance. Photographs of the scene are figures 3.5 and 3.6. Photograph © 2014 Museum of Fine Arts, Boston.

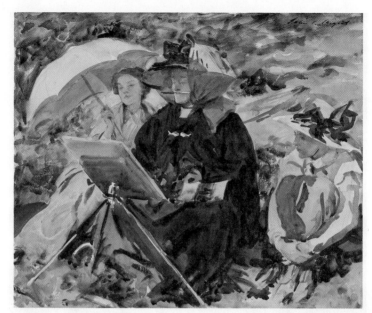

Color 8. Sargent, *Simplon Pass: The Lesson*, watercolor (1911). Sargent pictured Emily giving a painting lesson to her nieces Rose-Marie and Reine. Like her brother, Emily had been brought up drawing and painting, and she was an accomplished artist. Here Reine is unusually attentive. She would later study at the Slade School of Art. Rose-Marie holds the umbrella against the brilliant alpine light. Photograph © 2014 Museum of Fine Arts, Boston.

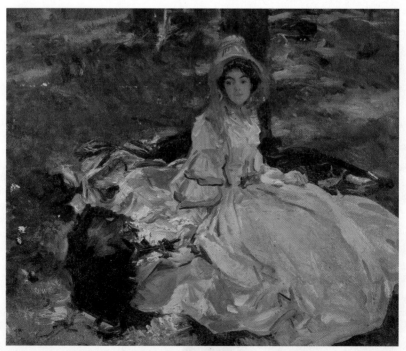

Color 9. Sargent, *The Pink Dress*, oil (1912). A pensive Rose-Marie at Abriès in the costume of a debutante from the crinoline 1860s. Private collection.

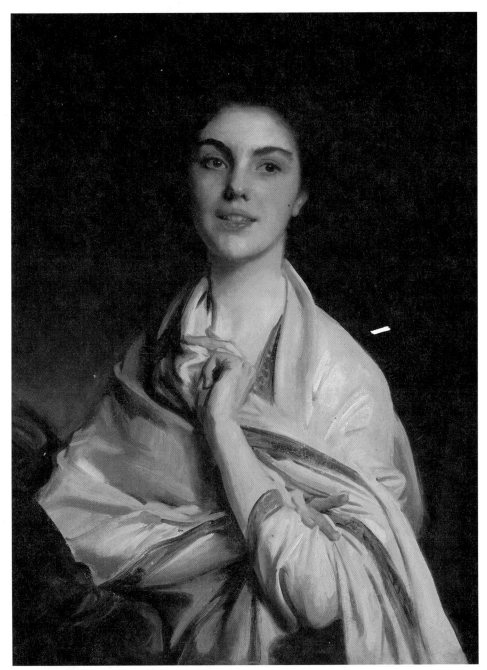

Color 10. Sargent, *Rose-Marie Ormond*, oil (1912). Of all Sargent's pictures of his beloved niece, this formal portrait is the only one that bears her name. She is posed like one of Sargent's society beauties of the 1890s, her own particular features delicately shown—her exquisite hands, her crown of chestnut hair. Her lovely face is alive with humor and happiness and candid charm. Private collection.

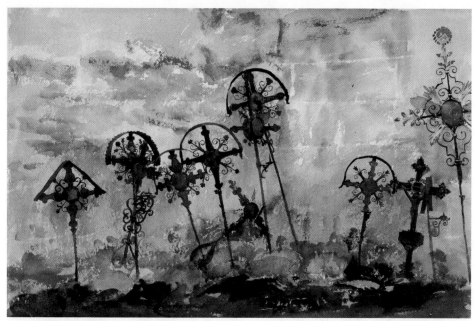

Color 11. Sargent, *Graveyard in the Tyrol*, watercolor (1914). Sargent produced this eerie image of antique metal grave markers in one of the mountain churches where he painted as the worries and realities of the War filtered through to him in infrequent and delayed letters. The markers emerge from a mist against a whitewashed wall evoking a looming dread. © Trustees of the British Museum.

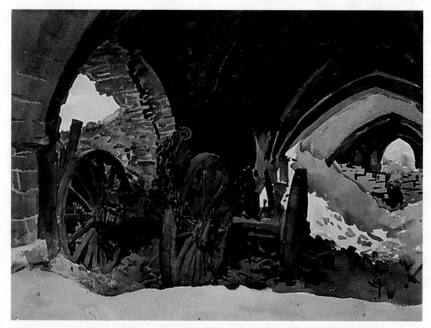

Color 12. Sargent, *Wheels in Vault*, watercolor (1918). Sargent's commission was to paint images of Anglo-American cooperation, but he did not find any such scenes. He was drawn to paint this ruined vault by his preoccupation with the fate of Rose-Marie. Open-access image, The Metropolitan Museum of Art, New York.

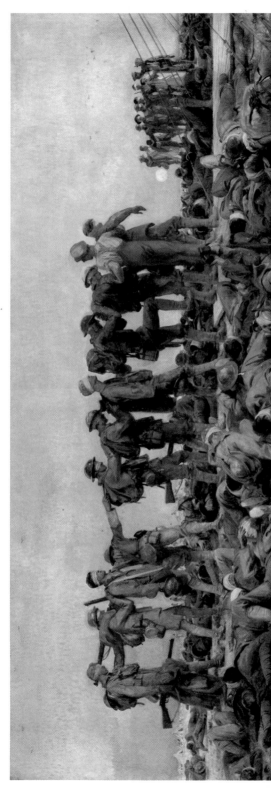

Color 13. Sargent, *Cassed*, oil (1918–1919). In the end Sargent fulfilled his War Memorials commission with an eloquent picture of blinded Tommies. Every detail of *Cassed* originated in the dozens of notes that the artist sketched on the Doullens Road before sunset, 21 August 1918: the lines of men with their bandaged eyes, their battledress, the orderlies, the airplanes, the footballers, the rising moon. © IWM (Imperial War Museum, London).

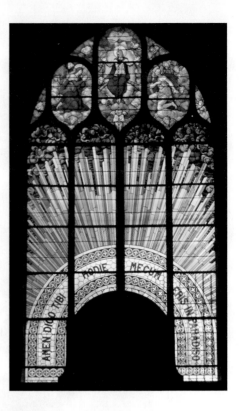

Color 14. Memorial chapel of Saint Gervais, stained glass window. The words of Jesus to the good thief are addressed to the dead of Good Friday 1918: "Verily I say unto thee, today thou shalt be with me in paradise" (Luke 23:43). Photograph by Karen Corsano.

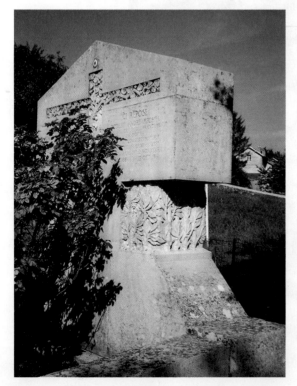

Color 15. The Tomb of Robert and Rose-Marie at Crouy. The cool iconography of the limestone monument built in 1922 is enhanced by the chiseled words of Robert and Rose-Marie expressing their love for each other and for France. When André Michel and Rose-Marie visited the original rough soldier's grave in 1917, she described in a letter to her brother the site, "half hidden by the invading greenery. . . . A few meters away there lies in ruins the house where his mortal remains stayed that night, and beyond that, a little higher on the plateau, the path is still visible where he was struck, under that grand sky of autumn, before that beautiful landscape of France that he loved and praised." Photograph by Karen Corsano.

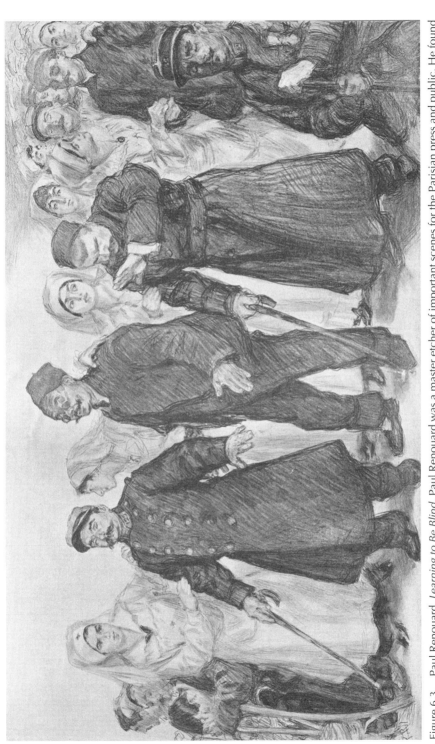

Figure 6.3. Paul Renouard, *Learning to Be Blind*. Paul Renouard was a master etcher of important scenes for the Parisian press and public. He found "the most moving models," including Rose-Marie (third nurse from the left), at the rehabilitation hospital for blinded soldiers at Reuilly. *L'Illustration*, 28 May 1915.

For her new life Rose-Marie wanted her own home where she could live alone with Robert's spirit, surrounded by the furniture and décor that she had shared with him. She was not abandoning her parents-in-law: their daughters Juliette and Madeleine Vermeil with her children were living at rue Claude-Bernard. Rose-Marie's new flat was just five minutes' walk away in a new Beaux-Arts building of white limestone with a swag of flowers and fruits above the street door, 7 rue Pierre-Nicole prolongée. André Michel may have suggested the place, Bonne-Maman probably paid for it, and Rose-Marie surely dined with the Michel family frequently, even daily. Her journey to work was simple and safe. She would put her letters in at the post office on the corner of rue Claude-Bernard and rue d'Ulm, then board the Q tram for Châtelet. André Michel might accompany her that far on his way to his office at the Louvre. At Châtelet she would take the Métro, direction Porte de Vincennes. The fifth stop was Reuilly (now Reuilly-Diderot), one long block from the hospital. Going and coming in her nurse's whites, she would be saluted by every French officer who passed her.[39]

Her journal shows her devotion to France and to Robert—really a religious fervor—as the cause that guided and nourished her. On the last day of 1915 she reflected on all the men, beloved as her Robert had been, who had died in battle.

> They all live no longer except through us, to whom they have confidently left the achievement of their thought and of their ideal. Our enthusiasm has been transformed through sorrow into will, and each day's suffering has made us those "who have much received," and who have learned to love much. Each sacrifice has made us realize better our debt toward France, I mean the subordination that we individuals owe her. She is accomplishing a labor that surpasses our fragmentary life. We cannot measure its scope, but we grasp its direction, we love it, we bring to it our powers and our entire being. We want the years 1914–1915 to be venerated in history for the valor that they brought to birth in individuals, and we join ourselves to that valor, we widows, we poor fragments, because a great love, a great veneration for our dead, exalts us and strengthens us.[40]

Rose-Marie's heart was firmly planted at Reuilly. She wrote to Guillaume on 21 December,

> I am wonderfully impatient to get to the 12 of January because I am to join you at home at that day for a week. It won't be long, but I could not leave my blind men for two weeks, and now a few days, even a few hours joy are a precious treasure to me, and are worth long, hard days. . . . I am always at Reuilly,

amongst many things, some awfully sad, others very fine, and when I will see you, I will have much to tell you.

Rose-Marie made her last visit to England between 12 and 18 January 1916. She visited Guillaume in his rooms in Exeter College, Oxford, delighted to be able to place her loving imagination of her brother's life into its actual scenes, and to meet some of his Oxford friends. They talked about Robert, of course, and Rose-Marie promised to copy passages from his *Carnet* and letters. She did so, and sent a sizable selection with a letter early in February. She hoped that Guillaume would visit Paris during his Easter vacation, when she could show him her "little home" and share more of Robert's written legacy. She promised Guillaume a full reading, with an explication of the difficult French passages, during their late-summer holiday together. Two weeks later, after that brief visit, she wrote, "I have just a few minutes before my lunch and Reuilly. . . . In two hours I shall be at Reuilly and am impatient to retake possession of my home of war time. Which is so dear to me." She was never able to visit England again, and she explained to Guillaume that the British Consulate was unwilling to grant visas for mere "heart reasons" or *raisons sentimentales*. But she probably did not ask urgently.

4 February 1916, Rose-Marie's Journal: The first words on these pages are, once again, an homage of loving emotion to our blind men. I want never to forget the name, the personality, the sublime nobility of soul, of one of them, Angot, who has truly the most beautiful and most touching character that I have met among the soldiers. Every time I meet a man made of such material, so eloquent, I tell myself again that France has a well guarded, solid altar. . . . Angot spoke to me today about the value of happiness—he has truly understood its fine, shining beauties—and he said to me, "Yes, isn't it true, we forget sorrows, but happiness remains." What profound intelligence has revealed to this man the truth that happiness, even if it lasts a short time, reveals the eternal Paradise where the greatest sufferings will find a power, a freshness, a nobility, a society, which is mixed into each hour of life once it has united itself with us?[41]

Her letter of 20 March was a long one, with the hardest and the best parts in French.

Yesterday I learned about the death of young Edmond Boegner, the brother of Robert's best friend Henri and of my best friend Vivette.[42] . . . He was killed at Bois des Corbeaux, and he had only been twelve days at the real front. . . . As our own people fall, our lives become more bitter and it becomes more difficult to live well, but more necessary too, as our responsibilities increase with all the posts of duty that need to be filled. This is perhaps the greatest grief that I

have had since Robert's death, and yet the mother and the sisters of that brave soldier are able to show how the best French hearts bear up.

Yesterday afternoon (before I got that news) I had been to hear the Requiem of Berlioz performed by an excellent orchestra, conductor, and chorus. This is the Requiem of the Last Judgment, and it is totally beautiful. I would have loved for you to be there.[43]

In her journal on 23 April 1916 Rose-Marie wrote:

Today is the day of the Resurrection! . . . Our souls began their Good Friday a year and a half ago, but few have succeeded in creating their Easter, their victorious and free resurrection, through their heavy pain. . . . The true generous gift is the simple, total offering of your sorrow to France. And then not to let yourself be killed by it, but to turn it toward life in active work where you really forget yourself.

September found Guillaume and Reine, in spite of the embattled Channel, with Rose-Marie near their Bonne-Maman's summer mansion at Crevin. The four met at Annemasse, where they occupied rooms in the Grand Hôtel Gay, and where the eldest brother joined them. At first Jean-Louis was not good company but morose and silent. He had been emotionally hardened, he later said, by his training for the Swiss Army, and he was preoccupied by who knows what personal problems—besides the business of Ormond Cigars, which was not prospering. Cigar production worldwide was threatened by the encroaching popularity of cigarettes, whose manufacture had been successfully automated before the turn of the century. The vogue of cigars and cheroots shifted to cigarettes; John Sargent, for example, had abandoned his habitual cigar for an addiction of fifty cigarettes a day. Marguerite Ormond, director of the firm since her husband died in 1901, insisted that Ormond Cigars *not* branch out into cigarette production, and the economic dislocation of the war and labor unrest had made the fate of the firm precarious.[44]

Rose-Marie had brought along Robert's *Carnet*, and Guillaume sat down to copy it on sheets of the hotel stationery. Jean-Louis took a turn, and between them they finished twelve sheets, Robert's journal from 20 to 26 September 1914.[45]

And they hiked—or walked, as they used to say.[46] From Annemasse it was four miles up to Monnetier, in the *piton* or saddle between the Grand and the Petit Salève, then up the short but steep mountain tracks to each of those peaks in turn. From Grand Salève they could look down on Crevin, the summer home of their childhood; and from Petit Salève, a panoramic sweep from Geneva on its lakeshore to the sunny side of Mont Blanc. Jean-Louis

began smiling, loosening up, his "scales of armor dropping off" in the clean alpine air and the congenial company. The cows were still up there in their summer pasture, the leaders' bells making the only sound besides fraternal conversation. There would be hot chocolate at a little *auberge* on the way back down. Four months later Rose-Marie looked back on those golden days: "Poor Monnetier, what a remembrance for ever. And aside from that, I like to think of some good hours, of some nice talks on the road of Monnetier (the chocolat direction)."

So why "poor Monnetier"? That would be on account of the typhoid.

Guillaume and Rose-Marie somehow ingested the *salmonella typhi* at the same time, in the last week of September. Guillaume went back to London very soon afterward, before the characteristic symptoms began: cough and headache, abdominal pain, rising temperature and slowing pulse, malaise.[47] He was at home in Emily's care when the delirious fever and abdominal pain and hemorrhage typical of the second and third weeks came on, and in his case the high fever and the lassitude of dehydration lasted longer than usual, partly because his diet was restricted even when his appetite was ravenous; he became frighteningly emaciated. Rose-Marie was prostrate with fever when the second anniversary of Robert's death came and went; but she promptly got more suitable care and recovered more quickly. Some weeks later her concerned Uncle John wrote her from Boston,

> I wrote quite a while ago to congratulate you on your recovery. . . . Judging from the letters which I have received from Emily and Violet, the most critical stage was right at the beginning and your condition soon ceased to give grounds for concern. . . . Poor Guillaume has not had such luck—only the most recent letters begin to be reassuring from his corner. Luckily the telegraph has kept me informed for some time that he is out of danger. But it remains to be seen if he will make a slow recovery from such a severe poisoning throughout his system, and he will experience highs and lows. . . . I was glad to learn that during the throes of your illness Madame Ormond was full of courage—I hope that she won't suffer any backlash from such worries and exhaustion. Please pass on to her a thousand best wishes on my behalf. I hope, my dear and charming Rose Marie, that you already feel almost renewed, as people tend to do when they recover from this abominable illness—it's the only good thing about it.[48]

At the onset of Rose-Marie's illness, her Bonne-Maman moved with her to a hotel in Geneva, where the best medical help would be at hand. By 19 October Rose-Marie was able to sit up and write her brother a note of loving concern for his condition and about her own, "I am better

every day and now most uninteresting." She would write him fifteen letters more before joyfully receiving one from him at the end of December. She optimistically chronicled her own recovery and rejoiced over each bulletin of his progress that came by post or telegram from Reine, or their mother, or Emily. Her *beau-père* André Michel came to visit and brought her best friend Vivette Boegner. On 25 October she reported, "I get up every day a little longer but my nice doctor is very severe about it because *flébites* are easily there." And she was not actually on her feet yet. She had shared with Guillaume a fondness for Rupert Brooke, so similar to her Robert in his heroic idealism and in his death in the War, and she sent some favorite passages translated into French prose.

"I had never such a clear complexion," she told her brother encouragingly on 29 October, "with no spots left whatever, and I love to think you are getting too at that pleasant state." She had Jean-Louis for company almost every day, and he was perfectly delightful, even "adorable," not the moody and silent conscript who had come to Annemasse back in September. When she was well enough to enjoy the views, she was moved to a sunnier room that looked out over chestnut trees to the Jura and Salève. As always, she pictured Guillaume's surroundings from his own current viewpoint, and at the end of October it was her dear Aunt Emily's drawing room in Carlyle Mansions, looking south over the Thames, that Rose-Marie remembered fondly.

> How lovely to think you are now in Aunt Emily's room, in the sweet rich light that gives the Thames, at any hour of the day. . . . I feel as if a new, warm, charming, infinitely full world was open to you. All things are lovable in her room, the inside and outside part of it. I can think what the view of the Thames can give you, judging through what it became to me, who is not its child like you. And all photos, all pictures and different *objets* of that room are most suggestive and helpful, I should think. I find perfectly adorable the little water colour of Mother's when she was a young girl by uncle John. And I think so fine uncle John's photo, of his youth's face, which is on her chimney. And over it Jesus' crucifixion, and so many beauties which I love but don't remember the details of. Don't you think one is bound to be softened and uplifted by the holy exquisite thoughts [she shifts to French] which float within these walls where she has lived so many years, and suffered like an angel when suffering came to her.

She advised against too much exertion too early: "Yesterday [30 October] I only went for an hour in Bonne-Maman's room and I felt so unwell after that, that I had to go to bed for the whole afternoon. Today it's all right again." Three days later, "I went out for the first time in moto with Bonne-

Maman and I thought it was nice and tiring." Some of Bonne-Maman's old Geneva friends were beginning to be tiring as well, in a different way. "I have always a lot of visits of all sort. Some are nice and give patience to bear the others."[49] One visitor was exceptional:

> I write today such a small card because I have only a few minutes, Marguerite being with us till this afternoon. She came here last Sunday in Jean-Louis's company and her little séjour with us was extremely precious to us, and to me. I really think her much better having so many interests in people and things round her. She asks very heartily about you and your typhoïd. Here she comes so I must stop with sending you my most loving wishes and kisses and cheering thoughts. Rose-Marie.[50]

In those days before typhoid was treated with anti-bacterial and fever-reducing medicines, transient acne and hair loss were common incidents of the disease that both Rose-Marie and Guillaume suffered. She was treated with a daily *cure d'abrutissement*, super-vigorous scalp massage by a specialist who was full of jokes and scary stories about bald people who never had her services. On 2 December: "My hair are growing in a prodigious lot under the performances of a dragonal massage. They are as thick and strong as a brush!" And on 15 December: "I was said they would get to their perfection in 3 years' time. Alas, I will perhaps have caught 3 desperate illnesses till then, and will never see the treasure that I hold over my brains." And she had another masseuse:

> Every morning Bonne-Maman's Russian masseuse is spending a full hour over my body, legs and tommy. I dare say it is very healthy and useful. She is an interesting creature, very cultivated and open on all subjects. She has read a great deal of philosophical works and of French literature, not speaking of Russian one. So we have ardent talks and discussions about them, and political and social ideas. . . . She speaks very splendidly on the miserable lives of *moujiks* and on so many changes that she dreams upon. She is wonderfully passionate and intelligent too.[51]

By 23 November Rose-Marie was able to go out of doors and be on her feet most of the day. Bonne-Maman was thinking of sunny Sanremo, but dubiously, because of the political situation.

> I have no idea about our leaving Geneva, which is lovely, because I am happy to stay as long as possible. Jean-Louis has been especially the great joy, and it will be a hard break to leave him. Here I have lost my beloved peace, because Bonne-Maman leads me to teas with old indifferent ladies to whom I must give

the dutiful smile and amiability. Tomorrow I am taking my first train to see Marguerite and am looking forward very hard to it.

Early in December, to get her away from the lakeshore mists, Rose-Marie was brought to another hotel, in Collonges on the very flank of Le Salève. In London, Guillaume took his first steps and began to receive visitors. "I am sure you enjoyed seeing the friends of home, whom I always think of with loving heart. Most of them are true parts of our lives, and are friends of the two generations, Mother's and ours. Aren't they tremendously different of the Genevese ones? 'Tis another concept of friendship altogether, and other personalities, thanks God."[52] As she recovered her strength Rose-Marie remembered how she relished the French style of emotional friendship, including what her Uncle John had transplanted to England. In contrast, the correct social circle of Geneva seemed cold and insipid, especially in wartime, when their neutrality seemed smug and cowardly.

By mid-December everything had shifted. Guillaume went to stay in the country with Sargent's old friend Mary Hunter. Rose-Marie had a growing conviction that she should be in Paris, not floating rootless in the alpine borderlands.

I am finishing this letter today, Tuesday morning [12 December], because yesterday evening I was half dead with the tremendous day I spent with Bonne-Maman! You know that suddenly three days ago, Bonne-Maman declared she was changing her plans concerning San Remo and not going there at all. The reasons are the pretty pessimistic views she catched in German victories of Roumania. So she sent telegrams all over the place, to *décommander* all the doings she had ordered. But as our present place has too beastly a climate, with damp, cold, snowy days and nights, Bonne-Maman is trying to think at a *séjour de montagne* which would not be too far from Jean-Louis. Consequently we went yesterday to different places over Vevey and we walked a lot in the frozen snow, and we wrapped our souls in the sadness of those great dead hotels, and I had all the time a tremendous desire to come down of such mournfull mountains. So we did, with no decisions at all about our departure. B.M. thinks of the Canton du Valais, which is the warmest part of Switzerland. I shall be lost as a dead leaf when away from Jean-Louis. He is day after day my best blessing. I do enjoy him so much.

[15 December] Finally our journey to San Remo is torn out of Bonne-Maman's plans, and our departure is reduced in very small proportions! We are finally going to Sierre, in Canton du Valais, and that will be, I think, not before 8 to 10 days. It's heavenly, to my taste, because we will be longer a time by Jean-Louis, and he is more and more to me, the bit of bright sun in weary days. I

think he is adorable now, and very different than last summer. He is no more
blindé dans une épaisse cuirasse.

She did not write Guillaume again until 28 December, and then she
overflowed with gratitude for the letter he had finally written to her, three
months after their *au revoir* at Annemasse. Then she revealed her wish to
rejoin her heart in Paris, and her firm plan to do so. These thoughts she had
to express in French.

I feel too radically distant from the people I see and with whom I speak. They
live, and they understand the war, with their reason, their cold logic; and in
general their hearts are very little engaged. Since all that reasoning can be
twisted and refashioned in a thousand ways, I clearly hear many, many hurtful
things that give me a desperate impatience for my return to Paris. Living a long
time here, I think it would be painfully hard to preserve a fervent idealism,
the soul is so starved and killed. I can't always define the reasons why I am so
unhappy in such company, but I feel it, I suffer from it, and this prevents the
heart from blooming in any healthful way at all.
On Christmas I went with Jean-Louis to an organ concert that Otto Barblan
gave at the cathedral of St. Pierre.[53] Some bits of Bach were infinitely beautiful
because Bach on the organ can't help transporting you, but truly Barblan was
good for nothing as far as emotion was concerned, and I felt always his frosty
lack of expression in his playing. It was like an extreme synthesis of the Ge-
neva spirit at its most depressing and least poetic. We also had a very beautiful
woman's voice singing some solos. She did not have energetic accents, but her
timbre was pure, full, and very supple, and it gave one a lively satisfaction—
even an emotion!
Many people here believe that peace is near, and the conversation about that
is tolerable, but inevitably they speak of it crudely, with sentiments entirely
different from those, mixed with a burning sorrow, that we French are feeling.
Besides, I am delighted to hear the Voice of Paris [broadcast from the Eiffel
Tower], which expresses the true beating heart of France. In spite of all, there
is still good, and evil; justice, and injustice. Here, for the most part, they have
little consciousness about it; they would like to spread the responsibility for the
war over all nations. That makes me boil. . . .
We are finally leaving this hotel and this country on Saturday [30 December],
because the fog is giving Bonne-Maman painful headaches and heart palpita-
tions. We will go to Sierre in the Valais, but our address will not change. I will
be only a few days there because I depart on 10 January for Paris.

And so early in 1917, she was immersed again in the life of Reuilly with
"my blind soldiers who are filling dearly my days." She complained that her

illnesses and periods of convalescence had kept her away from Reuilly too often and too long, and on 26 February she was dubious about Guillaume's coming Easter vacation from Oxford and whether she could share it, either in France or in London.

> I do wonder and hope about my Easter coming to England. I know not, yet, how it is practically possible, because at the *consulat* in Paris, they don't take as a valuable reason the want of seeing the family. War things exclude heart reasons. . . . and I wonder if Father will allow their departure in such dangerous seas. . . . Isn't that submarine *blocus* a diabolic murder. And at the list, every day published, of sunked ships, the revolt is greater against that incomprehensible Germany. Yesterday I read a most enchanting book which gave me more serene food than any other, since a long time. It is called "Out of the East" by Lafcadio Hearn. This man lived in Japan, as a professor, for a great many years, and was married there, with a Samurai, and wrote about that country better than anyone before.[54]

At the end of March, Rose-Marie was certain that she would get no visa for England, but her longing attention was elsewhere, at Crouy. The German army was drawing back for strategic advantages and French and British forces were advancing fast, far beyond the line of the Aisne. It was possible to hope that the war would be won soon. On 30 March she wrote to Guillaume in French, her language of emotional expression.

> You must have seen in the *Journal* that Crouy, the land where Robert rests, has been retaken by us.[55] How moving it is to think of those fields and villages, and above all their people, who were dying of want and who now come back into our great Fatherland. But we can never tell enough how the Germans have devastated everything in their retreat, burning houses one by one, vandalizing the marvels of art that are our pride, that our castles and our churches were keeping for us; destroying the fruits, the orchards, the roads; in short, everything that they could destroy in their devilish rage. I am overwhelmed with the pain of realizing all this. What will the last months of the war be like, and the fate of our prisoners?[56]

By June the battle line had moved north, beyond cannon range from Crouy. The American Field Service sent John Fisher there to set up a training camp for volunteer ambulance drivers. His gallant wife Dorothy Canfield went too, with their three children. She ran the camp's kitchen, driving daily to market in Noyon for provisions, and she took in a number of refugee orphans.[57] She made a short story, "The Permissionnaire," about the suffering in the villages that Rose-Marie lamented.

A local stone-mason and farmer, Sergeant Pierre Nidart, has a three-weeks leave from his regiment. "He found himself on the long, white road leading north [from Noyon]. It was the road down which once a week they had driven on market-days. Of all the double line of noble poplar-trees, not one was standing." All the villages in his district have been blown up and abandoned, the roads mined, the trees cut down. He finds his wife, Paulette, and his children in the ruins of their home. She has escaped being carried away to a German labor camp, as were all women except those with babies younger than three, because she took in the orphaned baby of a cousin. She tells him, "There wasn't much left inside the house when they finally blew it up. They had been taking everything little by little. No, they weren't bad to women . . . except when they were drunk. Their officers were awfully hard on them about about everything—*hard!* They treated them like dogs. *We were sorry for them sometimes.*" She tells how all their possessions were taken, first the metal: copper or brass: candlesticks, andirons, handles, knobs, pans and kettles, wire, then cloth, linen, wool, mattresses. At the very end special troops were brought in and completed the destruction of the area, cutting all the fruit trees down and blowing up the houses. Pierre, Paulette, and the children set to work to rebuild and prepare the ravaged field and garden for planting in the few days of the sergeant's leave. The asparagus and the peonies that they had planted together "when they were betrothed lovers" begin to come up. "What was in the ground alive they couldn't kill." At first they rejoice that their few pleached fruit trees and vines against the garden wall were spared. But when Pierre began to prune the vine

> it stirred oddly, with a disquieting lightness in his hand. The sensation was almost as though one of his own bones turned gratingly on nothing. . . . It had been severed from the root by a fine saw. . . . He went to the next, a peach tree, and to the next, a fine pleached pear. Everything, everything, had been neatly and dextrously murdered, and their corpses left hanging on the wall. . . . He felt something like an inward bleeding, as though that neat, fine saw had severed an artery in his own body. . . . "Paulette," he said, "I believe if we could get some grafting wax at once we might save those. Why couldn't we cover the stumps with wax to keep the roots from bleeding to death, til the tops make real buds, and then graft them to the stumps? It's too late to do it properly with dormant scions, but perhaps we might succeed. It would be quicker than starting over, The roots are there still.". . . [His three weeks up,] he started back to the trenches. He had gone but a few steps when he stopped short and came back hurriedly. The rake was still in his hand. He had forgotten his gun.[58]

Rose-Marie André-Michel, for whom Crouy was consecrated ground, finally got her chance to go there. Her letter of 26 June to Guillaume began

with the usual topics of their correspondence: he had finally passed the examination in Divinity that stood between him and his Oxford degree and a post as organist at Salisbury Cathedral; she was busier than ever at Reuilly because, as a veteran of the service, "I have to accomplish a lot of various labours *en plus de mes strictes fonctions*." Their mother and their sister Reine expected to be with her in Paris for eight to ten days in July, and then to join him in England. "And now," she continued in French,

I come to the subject which totally engages me, and which has greatly cheered me these last few days. Last Thursday [21 June] my *beau-père* came to my flat bearing in his hand the pass—requested three years ago—finally authorizing us to go to that dear grave at Crouy. We [Rose-Marie, André Michel, and Daniel Monod] left the next morning for Soissons, and on Saturday we made the pilgrimage which has left me unforgettable memories. It is a modest little grave, half hidden by the invading greenery and set in the midst of many others. A few meters away there lies in ruins the house where his mortal remains stayed that night, and beyond that, a little higher on the plateau, the path is still visible where he was struck, under that grand sky of autumn, before that beautiful landscape of France that he loved and praised. You can't imagine how completely all these sights became spiritual for me and clothed themselves in beauty! While there I constantly felt myself in dialogue with him, or at least, so enfolded by his spirit that it really was his noble, dear presence that I was receiving. And now every word of his letters and of his *carnet* comes back to me with new life. I have been there, where he loved the land of France fully and for the last time, to take it into my heart and venerate it and love it. . . . I have been to St. Jean des Vignes, I have gazed a long time at those statues that spoke to him their beautiful language, I have climbed the highest tower, that he surely stood upon many times. And there, as on the plateau of Crouy, I have truly found my Robert's inspiration in all its magnificent power. I am enclosing in this letter the photograph that my *beau-frère* [Daniel] Monod took of our little grave, and I've marked it with this sign \/ so you can find it. And I'm sending you the cloister of St. Jean des Vignes, the one Robert spoke about, where he meditated so heroically. I am sure you will love to have these images, so closely related to your brother and friend. We returned to Paris Sunday night, and it was a little hard to take up again without a pause my absorbing work in Paris: I was so far away in my beneficial and so brief respite! At Soissons I had all the impressions of war. The city is half destroyed, and over it the airplane fights are constant. Columns without end of troops, artillery, trucks plow the roads.

On 4 July Rose-Marie was still exalted by her pilgrimage to Robert's resting place.

On my part, I am always most busy and a bit more every day. I have to look after my men in different ways and nearly all my free time, out of Reuilly, is dedicated to some of them. What could I hope otherwise? My heart and thought is all plunged in Soissons' and Crouy's adorable visions. A new, beautiful treasure was given to me on that holy land [continuing in French:] where Robert completed his act of heroic faith by the gift of his youth, his joy, his strength. He had gained all the riches of the spirit by his total renunciation. Let us take inspiration from him.

Henry de Varigny saw Robert's grave later that year while on a tour of the former battle front with a group of journalists. Less spiritually inclined than Rose-Marie, he described the surrounding area still littered with shells, grenades, and bullets, the broken detritus of war materiel, gear, accoutrements, broken helmets, abandoned farm machinery, blood-stained water bottles, and everywhere the stench of decomposition.[59]

Rose-Marie had her last summer vacation in August 1917 at Sanremo and Crevin, where she felt alien and sad, even incapable of writing to Guillaume until 2 September, back home in Paris.

I always wish to have a spirit filled with good strong stuff. And apparently that hopeful state of mind never came across my way and so I stay poor and silent, with no reason ever to shake my passivity. . . . I went back to stay at Crevin for the first time without him. You can imagine it was hard to go through. And really, in those two months of August and October, so *tissés de souvenirs* [interwoven with memories], I wish to be alone and not disturbed by the continued presence of those strangers who take the name of friends. But I must say Bonne-Maman was very sweet in the last bit of my *séjour*. The beginning of it was different, and painfully stormy. . . . [She carries on in French] I find here, in spite of all my wandering, among the things that were ours, the dear recollection of our adorable past times. I have taken Reuilly up again. I have seen my dear parents in law and my little nephew [Guy] Vermeil.[60] And I spent today with my dear friend Vivette [Geneviève Boegner], who is my good angel, my joy and my example all at the same time.

Rose-Marie's Refuge in Music

Like the other inhabitants of Paris in 1917 Rose-Marie had need of dear recollections, dear relatives, and dear friends. The life of the city at war was more deprived and depressing week by week. Tickets for the ration of bread were distributed each month. Gas was rationed, too, and the City of Lights was a dim memory. Coal was scarce and of poor quality. Food of all kinds

Figure 6.4. Rose-Marie at Crevin, August 1917. Rose-Marie wrote to Guillaume: "I went back to stay at Crevin for the first time without him. You can imagine it was hard to go through." In widow's black, she leans over the stone coping of the reflecting pool where Robert had been photographed in the last month of their life together (see figure 4.6). Private collection.

was more and more expensive, though the family of André Michel was rich enough not to suffer real hunger. Aerial bombardments, at least, were in abeyance. The *Tauben* attacks had ended early in the War because those light and slow planes were no match for the French interceptors. There were only two Zeppelin attacks, in March 1915 and January 1916, killing twenty-four persons and wounding forty-one. After that, the French air defense prevented German incursions over Paris until early in 1918.[61]

Rose-Marie's refuge from the stresses of Reuilly and the general wretchedness of Paris was music. She shared the piano on rue Claude-Bernard with her father-in-law and her sister-in-law Juliette,[62] and she took whatever op-

portunities wartime Paris offered for professional performances. One of the charms of her location on rue Pierre-Nicole was the concert hall of the Schola Cantorum, around the corner at 269 rue Saint-Jacques, where she attended instrumental and choral concerts.[63] Rose-Marie's letters to her musician brother Guillaume were enthusiastic about the music she was hearing. Her diet of musical performance was limited by the fact that so many musicians had been casualties, or at least mobilized. Of the famous Paris orchestras, the Colonne and Lamoureux had to combine to make up a full orchestra, though the Pasdeloup continued to give its concerts in the Cirque d'Hiver, where Sargent had painted it in 1879. A year after her Berlioz, Rose-Marie was able to report, "Lately I heard a lot of music, I could not stand anymore without it. Yesterday I heard the *Passion selon S. Jean* of Bach, which gave me a spark of heaven.[64] Lately I went to an organ concert of César Franck compositions. The *Choral en la mineur* and the 3rd Beatitude were given. They are perfect beauties."[65] In an organ performance, Rose-Marie would not be distracted by the rather flat and pretentious verse and could meditate on the Sermon on the Mount as it played in her own memory, "Blessed are they that mourn, for they shall be comforted."[66]

On 10 May 1917 she wrote in French,

> I continue to hear a little music, and of the best quality. Last Thursday [3 May] and today I was at the Capet concert, where that marvelous violinist [Lucien] Capet is giving the whole series of Beethoven sonatas for piano and violin, and some of the trios. His playing is simply perfect, and its purity, its nobility, its diversity are prodigious. I don't know if you know those sonatas? The number 5, and the 7th, and the 8th too are admirable things. At the next concert and the last one [17 and 24 May] we will have the Kreuzer sonata [number 9].

Late in 1917, when Guillaume had finally passed his examinations at Oxford and thought of coming to Paris, Rose-Marie was overjoyed.[67]

> My dearest, I am in such a dream of hope and delight, since I red your dear letter, at mid-day, that I must come to you directly to have you sharing my joy. You know perhaps and anyhow cannot guess all the depths of it, that you would realize one of my old dreams most ardently wished in coming to work in Paris, in living at my little home. You would have all freedom, and would give me the too rare and so lovely gift of your company and good talks together, and fine things to see and hear on Sundays and free time. And through you my little home, which I often feel very dead and *glacé*, would have its first true birth of young warm life and of exquisite intimacy. My boy, since I have red your letter, I am stucked to that thought, and I combine the beautiful prospects, and I calculate when it will have a chance to take shape and life. Trying to see things out

of my own sisterly point of view, I do think it is almost necessary for you to have a touch with Widor at a time or another. And it must not be too late, because this fine, genius man is getting old and very much blinder. And perhaps are his years so short and precious. I do think he is a marvelous man. I shall never forget that time I heard his play at Notre-Dame de Paris. It is like nobody else's play, so large, and full, and manly. Gilly, my friend, don't let that prospect slip away.[68] I now live in that hope of having you staying with me and doing good nourishing work, and enlarging your youth with the learning of new things to you. Mother told me about your will of you and Conrad to work at some war business. I do feel like you and hope you will be accepted in some useful doings, or if impossible you will be quieter in your hearts. I do hate reading out [for the men in the Reuilly workshops] every morning the relation of air-raids over England. It is a too disgusting play on German part. Yes, I had heard about your nice time spent at the Bevary's and with Dt. Allen. I do hope you will gradually feel opened to a new energy, and dead to the awful depression of typhoid "sinks." Thanks heartily for your dear thought of this third anniversary coming through my life of sorrow to lift me to higher will and spirit. I greatly hoped you could be at Soissons by that time, but the answer to our wish was, it is impossible to do it now. We must try to be patient, that's all. Dearest Gilly, I send you my full heart of love and kisses. Your most loving Rose-Marie.

That dream did not come true, we don't know why, and we don't know why that was the last letter Guillaume received from his sister. He had joined the Coast Guard and put his acute ear and perfect pitch to work detecting submarines.[69] She may have written letters that German submarines sank or the French censor snuffed, and the first months of 1918 may have been so busy and depressing that the cheerful mood she preferred for writing didn't visit her. Her grief was always with her, though she sublimated it daily in hard-working mercy at Reuilly. Dying would have been a relief. Marc Boegner, who knew the state of her soul, said that she "had no fear of death. There were times in these last three years when she even hoped for it. But because she had learned to recognize in death an elevation to the perfect life, it seemed to her that death should only come for those who had made themselves worthy of it."[70] Emily Sargent remembered her saying (in French) just that: "We have to *deserve* death; and first we have to learn to suffer well in order to win that meeting."[71] Rose-Marie was fretted too with helpless worry for the fate of Paris and of France. 1918 brought to Paris new forms of death from above and the growing rumors, then the reality, of the desperate and deadly German spring offensive.

On a Wednesday night, 30 January, the alert sounded just as the theaters were letting out at 11:30. Sixteen Gothas, fast and heavily armed twin-

engine bombers, attacked Paris in two flights. When the all-clear siren sounded ninety minutes later there were 36 dead and 190 wounded, mostly women and children, and scattered damage to buildings. From her Q tram the next morning Rose-Marie could see the smoking ruins of the School of Mines down rue Saint-Michel on the edge of the Luxembourg Gardens.[72] Two bigger Gotha attacks got through to Paris early on the nights of 8 and 11 March, leaving some 50 dead and 120 wounded. On the 15th *Le Temps* reported, "The receipts of the theatres noticeably dropped off Tuesday evening, the day after the raid of the Gothas over Paris." The Ludendorff spring offensive began on the equinox, 21 March 1918. A desperate gamble in the guise of an unstoppable steamroller, it slashed away at the British and French forces for a week, until attrition, weariness, mud, and failing supplies brought it to a halt on the 29th, Good Friday.

While the allies were fighting their bloody retreat, the menacing news from the front was brutally brought home to Paris by a series of mysterious bomb explosions on Saturday, 23 March, scattered over the city and the near suburbs. Beginning shortly after dawn and spaced ten to twenty-five minutes apart, there were twenty-two strikes on Saturday, 29 on Palm Sunday, and 7 on Monday. Amid the damage to buildings, serious but local, there were 26 dead and some 80 wounded. The second shell on Saturday killed 7 and wounded 11 at the Metro station opposite the Gare de l'Est. One of the Sunday shells hit the church of Blanc-Mesnil during the Palm Sunday high mass, killing 4 and wounding 7.

The murderous sacrilege of it, the thought that now there was no sanctuary, no safe place, and no day of rest, made many Parisians thoughtful about faith and fate. Marthe Julliand, 26, was one. She was a student of the Schola Cantorum under Vincent d'Indy, who praised her remarkable talent. According to her mother, she was "a good Frenchwoman, a fervent Catholic, devoted to the great art of singing, she loved what was beautiful and practiced what was good." Marthe wrote a letter to her family that Palm Sunday evening, "We are to sing the Mass in D of Beethoven [*Missa Solemnis*] on Thursday. To die while singing that *Gloria*, now that would be beautiful. The good God would open the gates of His Paradise all the way, and we would end by singing His praises there on high."[73]

On Monday morning, *Le Matin* was able to declare that the shells had come from a monster gun an incredible 70 miles away in the forest of St. Gobain near Laon. "Alarm no. 3" was devised especially to warn that shells from the long-range gun were landing: each policeman on the street would beat a drum and blow his whistle. Decreed on Sunday, implemented on Monday and greeted with popular derision, Alarm no. 3 was not invoked

again. André Michel urged Rose-Marie to take an Easter vacation out of the bombarded town, but she said it was a bad time: she had a sore eye that was being treated in the Reuilly dispensary.[74] In fact she simply couldn't leave Paris, her dear parents-in-law, and her blind men at a time of crisis. The next three days of Holy Week were mysteriously but blissfully free of shells, air bombs, and alarms.

Rose-Marie's concerts were usually on Sunday afternoons, and she went to as many as she could, though we have no more bright notices of them to Guillaume. But there was great music through Holy Week of 1918. She attended that *Missa Solemnis* on Holy Thursday at the Schola Cantorum, and it did her good.[75] And she surely had bought her ticket to the concert announced in *Le Temps* for Easter Sunday: the combined Colonne and Lamoureux Orchestras were to play Berlioz's *Symphonie fantastique* in a benefit concert.[76] But first there was Good Friday.

> The Association of Singers of Saint Gervais, under the direction of their head, M. Léon Saint-Réquier, will perform, on Good Friday at 4:45, during the Office of Tenebrae, some motets and responsories of the sixteenth century in the Church of Saint Gervais. This ceremony will be given for the benefit of the wounded being treated in the unsubsidized hospital of Saint Gervais. Tickets at the church or at the offices of *Le Temps*.[77]

Saint Gervais

That Friday morning Rose-Marie read—and may have read aloud in one of the Reuilly workshops, to a chorus of groans and rude remarks—a note that appeared on the front page of *La Presse* and all the other dailies:

> Here is the exact text of the dispatch sent by the Kaiser to M. Krupp von Bohlen, director of the famous establishment at Essen, to congratulate him on his new cannon: "Your new cannon, which has bombarded Paris from a distance of more than 100 kilometers, has proven itself brilliantly. In building it you have added a glorious page to the history of the House of Krupp. I express to you my imperial recognition for this exploit of German science and labor."

Rose-Marie lunched with André and Hélène, wrote a letter or two, and set off for Saint Gervais in high spirits, even (what would have shocked Bonne-Maman) whistling.[78]

The parish church of Saints Gervais and Protais, martyrs, is deeply rooted in the history of the Hôtel de Ville quarter of Paris.[79] It is impressive rather than lovely on the outside with its flying buttresses and gargoyles fronted by

a seventeenth-century rococo façade. The Revolution took away much of the decoration of the interior, but to a modern eye, or a Protestant eye, the chaste nave that we see today, sixteenth-century Gothic, is an improvement over the Baroque stage where the Cardinal de Bourbon gathered the conspirators against Henry IV. The tall and bulky *banc d'oeuvre*, that once narrowed the nave and interrupted the long, cool vista of Gothic stone, was removed late in the twentieth century.[80] The stained glass, some by Nicolas Pinaigrier from about 1600, was highly prized. The best glass was taken down early in 1917 and replaced with oiled calico. The most valuable sculptures were also packed for storage; the last rescue crates went out of the church on 27 March 1918.

This was the church of the Couperin musical dynasty, though their organ, built by the cabinetmaker Jean Thury and given voice by François-Henri Clicquot, had not been kept in working condition; a smaller, earlier organ that had been moved into the short south transept served instead. The singers of Saint Gervais stood on a tribune or platform in the north transept opposite the organ, out of sight from most of the audience in the nave. That chorus, under the direction of the chapel master Léon Saint-Réquier, filled the eighty-foot-high nave with early music of such prestige that the great celebrations were attended every year by music lovers of all religions and of none—so many of them that it was a good idea to get tickets early because there were only about two hundred chairs.

The curate of Saint Gervais, Abbé Gauthier, designed the Good Friday ceremonies for 1918 with that mixed attendance in mind. There is no Mass on Good Friday. Instead, the clergy would perform in the morning, in Latin, the lessons and psalms of Matins and Lauds (the *Tenebrae* service properly so called) and, beginning at three in the afternoon, the solemn liturgy surrounding the veneration of the cross. The faithful of the parish would enter the church without tickets through the south door and listen to the Latin lessons and the Gregorian responsories by the small *schola cantorum*. Next would be the Passion chapters (18–19) of St. John's Gospel, not in the Bach polyphony that gave Rose-Marie her "spark of heaven" the previous Friday, but in dramatic monotone, different deacons chanting the roles of Evangelist, Jesus, Pilate, and the rest. Then, the long Prayer of the Faithful with litanies, followed by a silent pause. The last ticketed music lovers would enter by the west door, pay another franc to Mlle Jeanne Baheigne for a printed program of the music to come, and take their places in the chairs behind the worshippers.[81] The singers would file into the north transept. Then, while the parishioners went forward in a line to kiss the feet of the figure on the crucifix held by an acolyte, the rest of the day's music, this time polyphonic, would fill the darkened church, the *Improperia* of Palestrina and Victoria.[82]

~

The Paris Gun

A Triumph of German Engineering

In 1916, when the German trench line came within 56 miles of the center of Paris, ballistic engineers and artillery designers of the Krupp foundry at Essen had presented to Quartermaster General Ludendorff their finished, feasible plan for a cannon with a record range of 62 miles, a marvel of German science and industry.[1] That prophet of Total War readily approved the plan for a weapon that had no military value or function, but that should terrorize the Parisians into revolt against the Clémenceau government. But at the end of the year, when he was planning a strategic withdrawal from the Somme and the Aisne to the Siegfried Line, he raised his demand to 75 miles. That range could theoretically be achieved if the shell traveled most of the distance in the stratosphere, where air friction is practically nil; and that altitude could be achieved by a muzzle velocity approaching a mile per second.

The engineers calculated, the ordnance designers drafted, the Krupp works labored, and a sample gun was produced and began testing in July 1917. It was a monstrosity. A 15-inch naval gun was given a rifled steel lining that reduced its bore to 8¼ inches, and a smooth or unrifled extension was screwed onto that, making a cannon 112 feet long. Such a length, even of steel tube, had to be braced by a system of steel straps and turnbuckles like that of a suspension bridge in order to keep it from drooping. Once a suitable shell had been developed, the cannon was reproduced. Seven of these *Parisener Kannonen* or *Wilhelmgeschütz* were built.[2]

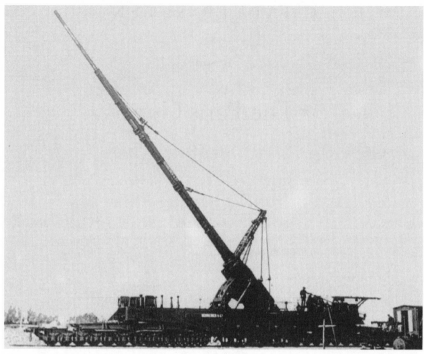

Figure 7.1. A Paris Gun on the testing range, late 1917. The Kaiser to Krupp von Bohlen: "Your new cannon, which has bombarded Paris from a distance of more than 100 kilometers, has proven itself brilliantly. In building it you have added a glorious page to the history of the House of Krupp. I express to you my imperial recognition for this exploit of German science and labor." (*La Presse*, 29 March 1918) Open-source photograph.

Three of the guns were put into the "Laon pocket," the bulge in the German line that brought it nearest to Paris. Spurs were diverted from the railway line just west of the station at Crépy-en-Laonnois to bring the guns into the forest of St. Gobain, and three were emplaced, using rail-borne transverse cranes, on the far slope of Mont de Joie. Gun number one was placed on a circular steel track that had been marked to aim the gun directly at the Parvis of Notre Dame. The other two guns had oblong timber and steel foundations pointing the same direction and similarly marked for aim. One by one the smooth extension barrels were screwed into the 210-mm rifled naval guns, and the support systems were attached. The carriages came into place on their solid foundations and received the guns. The crews of naval gunners and Krupp mechanics under the direction of Krupp engineers then adjusted the suspension rigs until the barrels were perfectly straight, and tested the hydraulic and electric machinery that operated the guns. Intense training went on daily in the loading and firing drill.

The shells specially cast and machined for the Paris Guns each weighed 265 pounds and carried an explosive charge of just 17 to 22 pounds divided between two chambers, each with its inertial fuse. The shells were about 19 inches long and were streamlined with an equally long conical sheet-metal fairing cap. The shell was grooved with spiral tracks precisely machined to match the rifling of the gun, and it had two copper bands designed to act like piston rings, keeping the explosive pressure behind the missile as long as it was in the gun.

On the ground as represented by a flat map, the distance between Mont de Joie and the Parvis Notre-Dame in Paris is 69.6 miles. For earlier weapons, that distance on the ground would be the cannon range; but the shortest distance between those two points is really a chord of the circular surface of the earth, a straight (subterranean) line measuring 69.2 miles. The propulsive powder charge was therefore calculated to carry the shell 69.2 miles. The powder went into the gun in two cylindrical silk bags and a brass cartridge that also contained the fuse. The baseline charge of powder was 431 pounds, but the first silk bag could take more or less powder because it was not sewn closed until just before loading. Unlike earlier weapons, this gun extended or shortened its range, not by elevating or depressing its firing angle (that was fixed at 50 degrees in order to get the shell rapidly into the near-vacuum of the stratosphere) but by increasing or decreasing the propulsive powder charge. The charge would have to be increased also as the extreme heat and pressure of firing eroded the bore. The pressure of each shot would tell how far along its path the shell had landed. The engineers of this gun had a novel and clever way of determining that pressure: a cylindrical pellet of copper of exactly known diameter and length was fitted into a steel jacket and placed in a recess drilled in the wall of the firing chamber. After each shot the copper pellet was measured with a micrometer, and the pressure of the shot was revealed by how much the copper had been compressed. The guns were aimed along a line that crossed the Parvis Notre-Dame in the center of Paris. Adjustment right or left would be made if there were a strong cross-wind, but this gun also needed an adjustment to the left (eastward) to compensate for the rotation of the earth during the three minutes of the shell's flight, just as a hunter's shotgun has to "lead" a flying goose.

The first shots were fired from gun number one on Saturday 23 March. The gunners on Mont de Joie knew from their pressure gauges that day that they were striking Paris, and they were encouraged by their success as they resumed firing on Palm Sunday, alternating guns one and three. The Kaiser was there, marveling and proud, for two shots. But as early as Saturday afternoon French military intelligence and the Paris Defense had concluded,

from the pattern of the strikes and from earlier aerial photographs of the railway spurs at Crépy, what kind of gun was shooting, and where it was. The Germans' Sunday lunch was disrupted by 6- and 12-inch shells from French railway guns falling between guns one and three. Monday brought more setbacks. Gun number one fired consistently short: it was rapidly wearing out. Gun number three, on its third turn to fire, blew up and killed five of its servers, a picked crew from Krupp's. Probably the shell had dropped out of the rifling when the gun was elevated, then stuck fast when the powder ignited. The commanders decided to retire both one and three, and the work of extracting them for shipment back to Essen occupied the crews while Paris enjoyed a three-day respite from the bombardment.

Good Friday 1918

But gun number two was ready for action on Good Friday afternoon, and its crew was well briefed with the lessons learned on Monday from number three. Two shots, at 3:27 and 3:52 pm, were shown by the gauges to be long: they fell harmlessly in the southeast suburbs. Half an hour later the gun was ready again. The shell was brought up from its bombproof shelter and wheeled to the breech on a carriage. The crew fitted the rammer to the base of the shell, slid it through the powder chamber and turned it by feel until its grooves clicked into the rifling, then rammed it home. Then came the first silk bag with its just-measured weight of powder, then the standard bag. The copper pressure gauges went into their sockets, then the brass cartridge followed the powder bags. The massive steel block was cranked into place and locked, closing the breech. Electric motors slowly raised the cannon to 50 degrees. From his command hut the gunnery officer telephoned the command to fire at 4:27, and the circuit was closed, impelling the firing pin into the cartridge fuse. As the Paris Gun roared and bucked and belched orange fire and smoke, several more normal 210-mm cannons in the area also fired, the usual aural camouflage.

The shell left the muzzle of the gun at 5,500 feet per second, and though its speed was reduced by friction with the air to 3,000 feet per second, in less than half a minute it was 12 miles high, well into the stratosphere. In 90 seconds it was at its apogee 24 miles up, and then it began its descent. As it entered the atmosphere again, air friction and gravity bent its flight more and more downward, and at 4:30 it struck almost vertically and exploded with a frightening crash at the top of the second nave pier from the west front of Saint Gervais, just where the pointed arch and two ogival cross-ribs carried the weight of two bays of the vault onto that pier.

There was a moment of stunned silence.[3] The worshippers and music-lovers who crowded the nave had been thinking all week about the random explosions that had brought death to the Gare de l'Est and to the church of Blanc-Mesnil. The quickest thinkers probably made the connection—Marthe Julliand surely did—but nobody could move quickly enough. The struck pier broke off at the clerestory window sill and toppled diagonally into the church with most of the massive pointed arch. The unsupported ogival ribs dropped, carrying down half of the second bay of the vault and most of the third, with its proud "Virgin's Crown" keystone. Some fifty tons of cut limestone blocks, mortar, and plaster showered down to and into the church floor, tearing and crushing the human beings. Powdered stone and plaster and the accumulated grimy dust of four centuries filled the air, and the only light came through the two broken window bays from the rainy afternoon outside.[4]

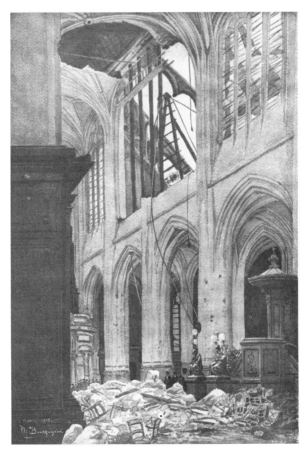

Figure 7.2. Maurice-Jean Bourguignon, *The Bombed Nave of Saint Gervais*. A watercolor made five days after the attack of Good Friday. *L'Illustration*, 17 August 1918.

One of the wounded was Countess Morand, who had come to Saint Gervais for the musical service with her daughter Marie-Thérèse and a cousin. The daughter gave an interview to *Le Petit Parisien*.

Everyone was seated in silence, waiting for the office to begin. In that moment of impressive contemplation, at about 4:30, something burst like a tremendous thunderclap! Then immediately chunks of plaster and stones fall from the vault, and acrid black smoke fills the church. We hear shouts, groans, cries of fear, but it is impossible to make anything out, the air is so full of dust and powder. I was blinded, and it was only after several minutes that I was able to see again. Then a heart-rending spectacle, all around us were sprawling bodies, ragged parts of corpses, the wounded dripping blood, a turmoil of wretched people searching for each other in all the sorrow, all the pain of their own catastrophes! We were recognized by some officers and soldiers, and my vision returned little by little as that horrible smoke dissipated, so I set about looking for my mother. I found her stretched on the ground under some chairs and under the inert body of a neighboring lady who had stumbled and fallen on her. My poor mother could not get free, and we had a thousand difficulties, my cousin and I, in carrying her out of the church. There we got her up into a taxi that she drenched with her blood, and had her brought to the hospital, then home, where she received treatment.

—Where were you seated in the church? Right in the center, near the pulpit. And what is extraordinary is that in that area some were killed, some injured, and some others, like us, got out unharmed! Isn't that surprising, inexplicable? But we are safe, after all, and I hope that my mother's condition will improve in spite of everything. Haven't we already had enough trials? Think of it, sir, one of our brothers killed at the front [5]

The next day Countess Morand, née Passant, age 49, died at home of her wounds, which included a shattered cervical vertebra.[6]

Within minutes of the blast help came, firemen and police, aided by soldiers and other volunteers. The American Ambulance[7] and Red Cross were there in strength—some volunteer nurses were among the dead, and more seem to have been in the rear of the church, just beyond the worst of the fall. The American Ambulance had their Model T cars ready in the parvis at the steps of the church by the time the first living victims on stretchers could be brought out. Within half an hour, sixty wounded were in the Hôtel-Dieu and other hospitals. An army major—it was Commandant Monpert of the anti-aircraft defense—was seen giving an injection to a dying woman pinned under the debris.[8] Men heaved the stones away to rescue the trapped wounded and to recover the corpses and fragments of bodies and lay them

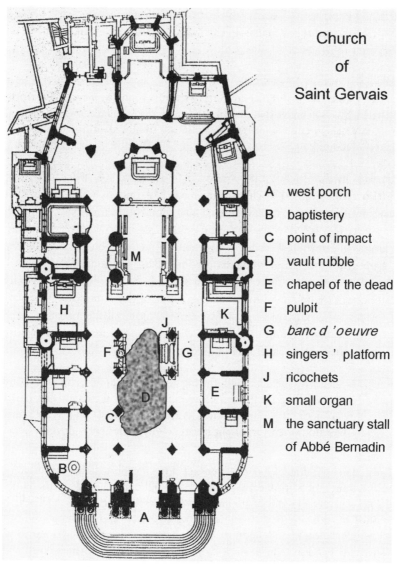

Figure 7.3. Marie-Thérèse Morand, interviewed for *Le Petit Parisien*, 31 March 1918: "Where were you seated in the church?" "Right in the center, near the pulpit. And what is extraordinary is that in that area some were killed, some injured, and some others, like us, got out unharmed! Isn't that surprising, inexplicable?" Plan, after André Devèche, *L'Eglise Saint-Gervais et Saint-Protais de Paris* (1974).

out in the baptistery. They piled the pitiful belongings—jackets, handbags, prayer books, umbrellas, hats—in the side chapels to be claimed by the owners or their relatives.

> Several of the worshippers who were assisting in the work of rescue had seen a friend seated some distance in front of them, a young woman only recently married. She was under the mass of debris and as the stone was cleared away, the only recognizable mark by which she was finally identified was her engraved wedding ring.[9]

That was an American, Lucy Speed, née Landon, 34, who had married a British officer in 1917. Her sister Ruth, like Lucy a volunteer with the American Ambulance, died with her; also their mother Mary.[10] A few other bodies were identified in the earliest casualty lists in *Le Matin* on Monday by the engraving in their wedding rings as the Morgue recorder had read them, and Rose-Marie was one: "Mme Robert, née Rose Ormond."[11]

Alice Snyder, who had come to Paris as a fashion columnist, was an active relief worker and a volunteer surgical clerk at the American Ambulance. Her letters to her husband in London show her journalist's instincts, her talent for exact observation, and her excellent connections. From her post in Neuilly she heard the Saint Gervais explosion.[12]

> Paris, March 29, 1918. . . . I think the big gun has begun firing again. At any rate, sounds of falling shells, at twenty-minute intervals, have been heard since three o'clock. No one pays any attention and life goes on just the same. . . . This morning when I went out it was pouring as it always does on Good Friday. . . .
>
> Paris, March 30, 1918. Of course you read of the terrible catastrophe yesterday to the church of Saint Gervais, how a bomb fell upon the side of the building on a vulnerable spot of the masonry, loosened a supporting pillar which crashed in, bringing down part of the vaulted arch and crushing to death seventy-five people and injuring ninety. Can you imagine anything more sadistically fiendish than to hit a church on Good Friday where women and children were praying for their loved ones at the front and reliving the agony of Christ on this, the anniversary of his death!
>
> Commandant Monpert, who was on the spot five minutes after the news of the accident reached the anti-aircraft headquarters, told me some of the things he had seen there. He said he picked up a little child's hand; a tiny arm clean severed from the trunk and broken just above the elbow; against a pillar he saw plastered a thick strand of blood-matted hair and on the stone floor something strange and dark which, when he stooped to pick it up, he

found was a face which in some curious manner had become detached from the rest of the head. He helped carry out about twenty dead bodies and, though unnerved by these horrors, remained until Clémenceau and Poincaré arrived with the rest of officialdom to take note of the casualties. The cannon boomed all afternoon but this was its most serious damage. All the lovely windows of Saint Gervais are shattered and the church is horribly wrecked. Monpert said the entire inside was a thick welter of blood and powdered plaster in which you walked ankle deep.[13]

None of the clergy of Saint Gervais, seated in the choir stalls of the sanctuary, was killed, but a guest was: Abbé Eugène-Charles Bernardin, 49, of the diocese of Nancy. He had been taken by the Germans as a hostage during the fighting for Longwy, interned in several prisons in Germany, finally exchanged and returned to France. He was seated in the third stall on the Epistle side (north or left side) of the sanctuary.[14] The instant that the shell exploded, it shot fragments of the arch ribs like shrapnel diagonally across the nave. Ten of those stones struck above the *banc d'oeuvre* and left jagged craters that are still to be seen in the clerestory wall, the window embrasure, and the pier at the corner of the transept. One of the missiles caromed back across the nave, struck Abbé Bernardin in the head, and killed him instantly.

The count of the dead of Saint Gervais in the newspapers increased over the next week as injured victims died in the Hôtel-Dieu or at home and as the pile of rubble was hoisted away, uncovering more corpses. The falling stones, the heaviest more than three quarters of a ton, had broken through the church pavement and uncovered the bones of old burials there. Those were cremated along with the debris of unclaimed personal effects, and the ashes were placed in the Chapel of the Dead, which is now the memorial of the Good Friday catastrophe.[15] A wooden trapdoor marks the spot.

Mourning for Rose-Marie

Saturday, 30 March, Henry de Varigny's Journal: I am just up this morning when the phone rings. It is André. He tells us that Rose-Marie went out yesterday, full of gaiety, to the chapel of Saint Gervais to hear some music; that she hasn't come back; that she isn't in any of the hospitals.[16] He and Hélène spent the whole night running around for information, without getting any. At the Morgue, they aren't letting anyone in.[17] We decide that Blanche and I should go and try to get into the Morgue, and so we do—as the cannon begins again. Right away, on the 10th or 12th bier, we recognize poor Rose-Marie, with her skull broken, more by her clothes than by her features—but those show no sign of pain. She must have been killed instantly by the falling stone. Verification is

provided by the jewelry found on her, rings and wedding ring: it is Rose-Marie for sure. André and Hélène arrive, M. de Bévotte and Rose-Marie's house-maids, and they confirm the identification. Some diamonds are missing from her ring, also her handbag with papers and money. We go home with Hélène and André to decide what to do for Marguerite Ormond and the parents—one in London, the other in Tunis. I stop at the Credit Lyonnais to get some money for André, then home for lunch. Afterward, back to Hélène's. They have de-cided to have the funeral on Tuesday and burial at Montmorency. Lamentable weather, pouring rain, cold, quite suited to the sadness of the day. This young couple cut down so early, and they had everything to hope for from life. What a sadness. Poor Rose-Marie, so noble, so open, so honest. The André Michels are devastated, and no wonder. She was the joy of their ravaged home. In the evening Blanche feels ill, mostly from the emotion and the cold.

André Hallays went to the Morgue, too, to carry a share of André's shock and grief. Hallays thought about the pledge of sacrifice that Rose-Marie had shared with Robert and that now she had also fulfilled. "That smile of hers, a smile of peace, of heroism, of love, still lit up her murdered face. Beyond their sacrifice, they had met again in the mysterious haven of rest and recompense."

1 April, Henry de Varigny's Journal: Weather slightly overcast but fair and mild. Telegram from Marguerite Ormond. She knows everything, and forgoes coming to Paris; we can only approve. André tells us that she will be placed in the coffin at 3; the funeral Wednesday at 2 at the Oratoire. Gatherings in that quarter are not recommended while the cannon is working. . . . At the Morgue at 3. She is placed in her coffin in our presence—Hélène, André, Blanche and me. Poor Rose-Marie's hands, folded and crushed. André and I bring her to the Oratoire.

Rose-Marie's grandmother later put into poetry her own story of Good Friday.

The Lilacs

Happy are they who can see the lilacs bloom
in springtime and not falter.
It was the hateful war of this century,
it was the time when atheists prayed,
it was the day of black Good Friday . . .

As sirens sounded before the shells
riddled the city, a child already widowed,
alone at home, refused to leave,
wishing to give an example of cool and calm.

That Friday, with her hand of a Madonna,
she wrote: "*Bonne-Maman*, so dear
and far away, enjoy the lilacs
frozen just yesterday! They are dressing in haste . . .
I want to see you before they are blown!
But at this hour, how to put the personal
before the fate that threatens France,
her Liberty, her ancestral spirit?
Was there ever a Good Friday more somber?
Or one more noble? What will we sacrifice?"

The letter ends, she's off to Evensong.
At that same hour beyond the borders,
a bunch of white lilacs was offered
to her grandmother: "Why come to me," she cried,
"you flowers for those who die in spring?". . .

In the sanctuary where the widow was uplifted
when the plainchant exalted Calvary,
when the priest in the pulpit recited
the act of faith of Jesus dying,
"Lord, into thy hands I commend my spirit,"
the bomb exploding split the air,
pierced the vault, spread darkness
over the cries, over the dying

Among the dead buried under the rubble
there appeared a face inspired,
the last reflection of the widow's soul
White lilacs covered her coffin.

Happy are they who can see the lilacs bloom
in springtime and not falter.[18]

André Michel put the unbearable news in a cablegram to Violet Ormond in London, who relayed it to Sargent in Boston. Observing the rules against transmitting any information that could help the enemy, Michel did not mention Saint Gervais. Emily wrote at length to Alice James, who replied with a flowery but honest expression of her sentiment.

A solemn and infinitely touching story of the passing of Rose Marie. . . . I loved her from the first moment—no one could look into her face and not love her. I shall never forget her, nor cease to be thankful that I knew her ever so briefly. It *feels* as if I had known her as one of my very own; for recognition does bring with it a dear if ever so modest sense of *belonging*. For blessed Rose Marie, I am

filled with solemn triumph. For you, and Violet, and her brothers, and Reine, my heart is heavy. It is a bewildering blow at the best, the first break in the family; and it will never become natural for Violet or the brothers & sister to miss her radiant presence.[19]

Rose-Marie's funeral service was held in the Oratoire du Louvre at 2 pm on Wednesday, 3 April. "Beautiful decoration of the church," wrote Henry de Varigny in his journal, "with a panoply of flags. The coffin is covered with a flag. A touching delegation of the blind from Reuilly. Representatives of the *Services sanitaires*, the Ministry of War, etc." Marc Boegner delivered an eloquent sermon for the time of the year and of the war that was also a loving eulogy of Rose-Marie and of Robert.[20] He began with reflections on the fears and losses suffered by so many French families during the German offensive, which was only then being contained, and then he drew the parallel between the brutal death of Jesus on Good Friday and the murder and destruction in the church of Saint Gervais. He gently hinted that there was an *union sacré* of Catholic and Protestant "on that day when all Christian souls unite in recollection and prayer," and when redemption was in sight. "Man learns, most often in sorrow, to pay no heed to himself, but to dedicate that sorrow to the wellbeing of his brothers in misery and suffering."

Certain human creatures have received the grace to be a revelation on earth of that divine life that grows richer by the gift it makes of itself. One of those was Madame Robert Michel. With that total absence of egotism that characterized her, she never supposed that those who knew and loved her would seek and receive some warmth and light from the sacred flame that God had kindled in her soul without her realizing it.

This is not to exalt the creature, but to bless God for permitting us to meet along our way a soul in whom all was purity and nobility. Although she was very severe with herself, she could never believe evil of another, and wherever she went she seemed to be sowing life abroad by handfuls, and a life so brilliant, so youthful, so intense, that others were fascinated by her at the first meeting. Life was singing in her already in those too-short days when, at the side of the man who was so completely worthy of her (though she never believed herself worthy of him) she knew a fullness of happiness that few hearts achieve here below. You all know how that happiness foundered. Beforehand, in her ardent patriotism, she had accepted the supreme sacrifice. She had consented to the unreserved gift that her husband granted to our country. He wished with all his soul for France to realize her whole destiny, for her whole genius to flourish. A few days before he fell he wrote, "France must emerge from this great test regenerated and ennobled. Otherwise it has been nothing but getting and giving bloody wounds."[21]

Only a few murdered hearts like hers could fathom the depth of her suffering. Nevertheless, she did not admit that an existence that had been transfigured as hers had been by so much beauty and love could ever languish in misery. God gave her the grace to draw from the memory of her happiness more strength than sorrow. She opened her great heart to the eternal realities, and she knew that the one she loved lived still beyond death. She planned to make his thoughts live on earth, to continue his work here, and in order to achieve that, she hoped to live ever more for others, and above all for those who suffer. I know that this ambition inspired her to come, almost three years ago, to offer herself as a nurse at the home for convalescence and reeducation of blind soldiers at Reuilly. Those who saw her at work in this home sometimes perceived what strength and what calm she found among the war-blind. But the men bore witness every day to the boundless devotion she brought to the service of her dear wounded ones. She made of them a family whose sufferings and hopes and joys she shared. And they bear witness to the attachment they had to her. Far from veiling the life that was in her, pain gave it a mysterious brilliance that shone into the soldiers' heart-breaking darkness. They loved her for everything she gave them of affection, of confidence in themselves and in life, and of the courage to accept daily their great trial. Permit me to pay homage to her, for them and for all those in that Home for blind soldiers who loved her from the first day, in recognition of her love. The tragic death that brings us here together makes that love still more vivid.

Madame Robert Michel had no dread of death. In the course of the last three years she sometimes even hoped for it. But because she had learned to greet death as an elevation to the perfect life, it seemed to her that death should only come to those who had made themselves worthy of it. The further she advanced, the more life appeared as a harmony. She felt that all the beauties sent by God in nature, in consciousness, in thought, in art, should come together to shape and enrich that harmony in us. In the music that she passionately loved, as in the other sources of the most noble emotions of the soul, she sought a higher understanding of life, of pain, and of death. It was that power and that inspiration that she had come to find on the afternoon of Good Friday, in the church that stands broken today. Her heart would not open any more to earthly song, but henceforth to the eternal harmonies for which it thirsted. If she had seen death coming, at the thought of the one she was going to meet again in the presence of God, she would have felt the holy thrill that no other words can better express than those of the apostle Paul, "for me to die is gain." But what a heartbreak for those who remain, and what a sudden darkness they feel enveloping their lives, those who, without her suspecting it, received from her each day such magnificent enlightenment! We who had a sense of the treasures of tenderness that she prodigally gave to those who lived closest to her heart, we embrace you with a sympathy whose intensity I am powerless to express to you. We think of her natural family, today scattered, and especially

of her grandmother, whose tenderness has never ceased to watch over her since her infancy. We think of her spiritual family, those to whom in these years of sorrow and hope she was revealed as an incomparable friend. And above all, we think of you, among whom she brought to life again the son and the brother whom you mourned along with her. She embodied in herself here on earth, until her last breath, in her courage, in her noble aspirations, in her filial and fraternal love, the qualities with which Robert Michel's heart never ceased to beat.

You mourn them both now, and today's suffering makes yesterday's wound bleed worse than before. But do not seek the living among the dead! To you also Easter Day reveals the splendors of eternal life. And don't you hear now, in the depth of your hearts, their beloved voices, calling out again in a tone even more urgent, what they said while on earth? She said, "Mourning must become a force, otherwise it betrays the one whose departure breaks the heart." He said, "True courage is not what immortalizes itself in an act of heroism; it is in the steady acceptance of the daily task, in steadfastness every hour."[22]

Henry de Varigny continued in his journal: "Her body passes from the church into the hearse between two ranks of soldiers presenting arms, a very moving ceremony. We go, Hélène, André, Poupette, Madeleine, Madame Massigli, Marguerite de Watteville, Blanche, and I, by car to Montmorency, to place the body in our vault.[23] Rain, bitter weather." There was one spot on earth where Rose-Marie had wanted her grave to be, and that was beside her Robert. But Crouy was again in the war zone.

There was a state occasion at the Oratoire at five that evening, the funeral of two other victims in Saint Gervais: Henri Stroehlin, counselor of the Swiss Legation, and his wife.[24] Killing him had caused the German government embarrassment because, when the United States declared war on Germany, the American Embassy had passed on to the Swiss the responsibility for German interests in France, and Stroehlin was the diplomat who bore that charge. Regrets were expressed.

Edouard Gruner, president of the Federation of Protestant Churches of France, wrote, "The horror of such a crime on this day, which every Christian worthy of the name is compelled to consecrate to humble prayer, rouses our conscience to indignation. We feel compelled to come and tell you, in the name of all the Protestants of France, how we share your sorrow." [25]

Israël Levi, grand rabbi of France, showed great erudition and great interreligious courtesy in his eloquent open letter to the archbishop:

Eminence, I make myself the speaker for all my French coreligionists in telling you how fully we share the grief which has stricken so many families, devas-

tated by a sacrilegious barbarity. Overwhelmed as we are in this moment by the same anxieties and the same hopes as our Christian brothers, we are also overwhelmed with pity and indignation at the spectacle of this hideous crime, which seems a deliberate insult to what humanity holds most sacred. Like the high priest Zacharias of old, murdered in the temple of the Lord, the innocent victims of the enemy's bloody cowardice, fallen in a house of prayer, cry out to heaven.[26]

On Rose-Marie's birthday in 1919, her grandmother raged in verse against her passing.

My Rose

Trample them down! chop them up! my gaudy gardens.
May the perfumes of all the flowers
expire on the ground! There is nothing that I want
except my rose, an immortal rose,
the one born of flesh and light,
the one crushed by an impious hand,
the one escaped across space,
the one perched upon the rosy clouds.[27]

~

Sargent's War, 1914–1919

War in the Tyrol, August–November 1914

For a decade Sargent had made the high passes of the Alps the jumping-off point for his summer and autumn painting expeditions. His 1914 campaign had a different tone from the beginning. Now Rose-Marie belonged to another family, and her husband was a working professional whose vacation time was limited. The Ormonds and Emily planned to meet the newlyweds for a short visit to the sea at Sotteville-sur-Mer, on the English Channel. Sargent declined to join the family group at the seaside, preferring to travel directly to the Alps to meet with a small group of painter friends. He was anxious to try out a new locale, this one at Seiseralp (7,028 feet) in the Austrian Tyrol, that he remembered visiting as a boy and that had been highly recommended as scenery in the high, clear air. But he would miss his usual family group, especially Emily, whom he planned to meet later in Venice.

The habits and hopes of peace died slowly in 1914. If Georges Gendarme de Bévotte had been able to put the alarming signs of impending war out of his mind while his son was in the active army, it was even more natural for Sargent, who notoriously ignored current political events, to be oblivious to the storm that gathered after the assassination of Archduke Franz Ferdinand of Austria on 28 June. Long before, Lucia Fairchild "heard him say that he thought it wrong for an artist to think of politics, and so on. He said the two influences can't live together."[1] Sargent, with his valet Nicola d'Inverno, hastened to meet his friends, the British landscape painter Adrian Stokes and his Austrian wife, Marianne, also a painter, who had been among his

traveling companions in the Simplon in 1910 and 1911. Marianne brought along her maid. The sixth member of their party was a retired British army medical officer and amateur watercolor artist, a neighbor of Emily's, Colonel Ernest Armstrong. No one in the party had a passport.

Sargent's party arrived in the Austrian Tyrol on 24 July. Austria declared war on Serbia on the 28th, and the domino alliances that the major powers of Europe had set up over the last decades fell into mobilization. In alliance with Austria, Germany mobilized on the Russian front and moved against France through Belgium and Luxemburg. Russia mobilized to fight the Austrian army in Serbia and to stop the German invasion. England and France declared war against Germany on 4 August as the German armies poured over the French borders. From the first, Sargent's party found it difficult to get transport and then lodging, as tourists cut short their holidays and the hotels shut down. It became impossible to travel by train without a passport. It was not immediately clear what was the best course for that party of foreigners.[2] They found an inn at Kolfuschg (Colfosco) and persuaded the owner that it was worth his while to keep it open for their party. At first they received no letters or newspapers from home, and they badly underestimated the scope of the conflict. Sargent was famous for making the best of the inconveniences of travel, and he did so from August to November. As always, he painted.

Emily and Violet were more concerned for John than he was for himself. A note appeared in The New York Times on 22 August that reflected the apprehension of his sisters and London friends: "London, August 21.— John S. Sargent, the painter, is somewhere in Austria, and his friends are worried. He was last heard from on Aug. 4. He had been painting in the Tyrol, and was accompanied by an Englishman, Maj. Armstrong. It is believed that they have probably been detained by the military authorities and are not permitted to return."[3]

In fact Sargent and the others were carrying on their painting campaign. An old acquaintance of Sargent from his youth, the Austrian painter Carl Maldoner, offered them the use of his country house in the lower elevations at Sankt Lorenzen (San Lorenzo, at 2723 feet, significantly below Kolfuschg at 4708 feet) when the weather became colder. At the end of August, Colonel Armstrong "tried to get home where he surely would be useful."[4] He was arrested and interned in the fortress of Trient (Trento). In late September, unaware of the Colonel's difficulty, the others moved down the valley of the Gardena to Sankt Lorenzen, 22 miles north.[5] But at the beginning of October Sargent got news of the arrest and was "for the first time, upset, and left no stone unturned in his effort to procure his freedom."[6] Sargent made a jour-

ney of some hours to Trient, where he and Carl Maldoner successfully made the case for Armstrong's release. Armstrong left for England while Sargent returned to Sankt Lorenzen. Sargent's first stack of paintings and his painting tools were temporarily confiscated. All five applied for passports from their respective embassies in Vienna. For weeks after the Stokes received their passports, Sargent's still had not arrived.

Sargent's friend, correspondent, and biographer Evan Charteris explains Sargent's response to the situation by his habitual ignorance and indifference to world affairs. "The war was outside his ken, and so involved with consequences and questions of which he was entirely ignorant, that he seemed merely conscious of being rather isolated. It was as if his imagination had suffered a complete breakdown."[7] Adrian Stokes, in his later account of the time, portrays Sargent as completely unperturbed by the events.[8] "He seemed to regard the whole grim affair simply as an example of human folly. . . . The war seemed to become real to him for the first time when he heard that the young French husband of a beautiful and favorite niece had been shot in the trenches." In his letters to Emily and Rose-Marie, Sargent took care not to alarm them about himself or even to reveal the extent of his worry about his family. But his lack of news from his sisters in the early weeks, and then the horrible news of Robert's death, clearly affected his painting. His anxiety, and then his realization that war had broken into the circle of his loved ones, is visible in the tone, palette, and subjects of his work.

The mountain scenes from these months do not have the bright openness of the Simplon or even the dappled shade of Purtud. *The Master and His Pupils* shows Adrian Stokes, deep in an almost sunless glen, doing a painting demonstration for three ladies (Marianne Stokes's maid in three different costumes and poses).[9] Hot sun beats on a rock-strewn stream bed in the foreground, dry and lifeless in that season.

The *Tyrolese Interior* is said to show the blessing before the midday meal of peasants.[10] The faces of the women and old men, at home with no news of their young soldiers, reflect quiet anxiety. The scene is set in a farmhouse that had been built as a castle. The thick dark walls crowded with religious images are made all the darker in contrast with the bright light that streams through the high windows. A deeply shadowed shrine is dominated by a looming wooden crucifix that soars into the ceiling gloom. It is flanked by two wooden statues of saints attired in baroque billowing robes that stand on little supports over a draped shelf where a small figure of the Madonna catches some of the window light. Saint Roch, the figure to the viewer's left of the crucifix, is recognizable as he raises his smock to reveal the pestilential sore on his thigh. His was one of the major cults of Venice and the Italian and Austrian hinterland,

and traditional believers would have appealed to him for aid against epidemics and in aid of invalids, surgeons, and gravediggers.

That was only one of several crucifixes painted by Sargent during those weeks of work and waiting. The oil painting A Tyrolese Crucifix,[11] in fact, depicts two: a large one, perhaps half life-size, under the eaves of a stone peasant home and another held by the man on the outdoor stairs. The large one is of the Man of Sorrows type, showing hundreds of cuts and blows all over the body of the dead Christ. The other one is about as long as the forearm of the man engaged in repairing it or readying it to be displayed. With both hands engaged, he holds a hammer in his teeth ready for the next step in his work. A little girl with a kerchief solemnly peers out at the viewer and wraps her arms around two of the balusters like a Magdalen at the foot of the cross. A watercolor of a rustic outdoor shrine, Tyrolese Crucifix depicts a large wooden cross under a protective pitched roof attached to a tree.[12] The body of Christ is painted dead white while his wounds drip red blood. The tree shows where branches were sawed off to accommodate the shrine. The spindly twigs that straggle down beyond the shrine are bare, as lifeless as the Christ. Crucifix in the Tyrol (figure 8.1) in oil is disquieting and elegiac.[13] The large crucifix dominates a white interior wall and overhangs a deep window or door embrasure through which bright autumn light shines on clean drying linen. The cross and corpus are hung with votive symbols of fruitfulness and hope, now desiccated: an uneven string of pomegranate seeds like the blood-red beads of a rosary, dried corncobs and pomegranates, last Palm Sunday's withered olive branches, a mass of dried hydrangeas.

A series of cemetery scenes are studies of death made visible at home. The oil painting Cemetery in the Tyrol shows a sunny graveyard being tended by a peasant couple.[14] The low-walled enclosure is filled with wrought-iron crosses on high poles marking the graves. A half-dozen more complex markers include the body of the dead Christ. A couple of small wooden replicas of the tree shrine of the Tyrolese Crucifix modestly rise up from the grass. In the watercolor Graveyard in the Tyrol (Color 11), Sargent depicted the same sort of metal grave markers crowded against a white stone wall, eerily obscured by mist.[15] And Sargent filled pages of his notebooks with sketches of crucifixions or of the crucified Christ or details of his crucified body. Considering the amount of study and effort that Sargent had spent on the major sculpted crucifix that was the focus of his Dogma of the Redemption (installed in the Boston Public Library eleven years before) his compulsion to revisit and reemphasize the subject in his work tells us how he was dwelling on death and suffering in those days. The biographer William Howe Downes, who knew Sargent, wrote, "When the exile returned in due time to London, he brought

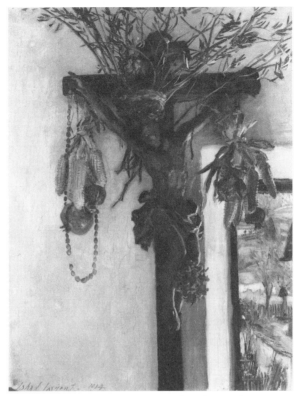

Figure 8.1. Sargent, *Crucifix in the Tyrol* or *Still Life with Crucifix* (1914). A crucifix floats in the uncertain light of a whitewashed interior, laden with withered symbols of fertility and hope. Private collection.

with him some of the strangest looking pictures he had ever painted. Strangest of these were the *Tyrolese Crucifix* and the *Tyrolese Graveyard*."[16] They were the journal of an autumn of excruciating worry.

While the out-of-the-way mountain valleys where Sargent found himself marooned were strongly Catholic in tradition, Sargent's choice of religious subjects in these weeks must also have been influenced by his companions in the tiny closed society they shared in those days. Both Marianne and Adrian Stokes were devout Catholics. Marianne was known for her paintings of the Madonna and genre pictures with religious themes. Adrian Stokes remembered that Sargent accompanied Marianne to paint at a certain church, and it was perhaps that outing that provided Sargent's material for the graveyard studies.

It is the ensemble of his pictures that are his diary, where he recorded his shock. And it must truly have been a shock that his Europe had broken

into two armed and lethal camps. This was the fine, civilized world that he knew so well and had traveled, oblivious of borders and with native ease, in an international society of artists and patrons, musicians and writers. Now it had suddenly gone homicidal. He was five years old when the American Civil War began, old enough to witness his father's fervent patriotism for the Union. When he was older, he understood from FitzWilliam that this was a war that the Union fought from moral necessity.[17] Neither necessity nor morality could be seen in the beginning of this conflict. The normality of rest in the hospitality of an old friend whose country was hostile to England and France made the madness of the politicians and generals even more mysterious to him. Not knowing when or if he would be able to return to London, he instructed Emily to insure his Fulham Road studios and to pay Nicola's wages direct to his mother.[18]

On 3 November *The New York Times* had received a special cable and headlined a two-sentence item on page one: "London, Nov. 2—John S. Sargent was painting in the Austrian Tyrol when the war broke out and according to the Manchester Guardian, there was anxiety among his friends, despite his American citizenship. That anxiety has now been relieved by news that Mr. Sargent's work has not been interrupted in any way, and that he proposed to return to London next month."[19] The source of the *Times* report must have been among Sargent's close friends, a person in contact with his sisters; Sargent had not bothered them with accounts of his inconveniences. Three weeks later, on 21 November, as Sargent finally set off from Sankt Lorenzen to confront officials in Vienna over his delayed passport, *The New York Times* reported that Sargent had been awarded a gold medal in recognition of his work as "America's foremost painter" by the American Academy of Arts and Letters and the National Institute of Arts and Letters. "He is at present in Paris, and the medal will be forwarded to him there."[20] So while his friends were in the dark about the exact circumstances of Sargent's travels and travails, they knew that his return to England would be by way of Paris.

The World at War, Sargent at Work, 1915–1917

Sargent came back into the family circle in London, after his visit of condolence to Rose-Marie and the Michel family in Paris, to find his sisters already busy on the "home front," organizing charity funds and rolling strips of old, clean, linty bed linen into standard bandages. His English friends were involved in war activities, and many of his younger acquaintances were already in uniform. Everyone knew about the cultural destruction and the mass killings of hostage civilians in Belgium and France and the "Manifesto

of 93 German Intellectuals" that denied those facts *and* simultaneously justi-
fied them as military necessity in defense of *Kultur*. In January 1915 Sargent
sought to return a decoration he had received from the German government
and to resign from the Prussian and Bavarian Academies, using American
diplomatic channels. "Sargent makes no criticism of the German govern-
ment or German societies," wrote the London Consulate, "but merely resigns
because he is no longer in sympathy with German aims." Even that soft word-
ing proved too belligerent for the insistently neutral US State Department,
and his request was rejected. He was billed for the telegram telling him so.[21]

What Sargent could do about the war was not apparent to him or to anyone
close to him. He was fifty-seven, and unlike Charles Gleyre at the beginning
of the Franco-Prussian War, he realistically understood that he would be use-
less in any military role. But there were fund-raising activities for the civilians
widowed, orphaned, or displaced by the war. Sargent contributed pictures to
charity auctions and publications. The charcoals ("mugs" as he called them)
that he still did instead of oil "paughtraits" were now frequently of young men
in their new uniforms. He felt useless and out of place amid the activity of his
sisters and close friends and the reports of the ongoing horrors in France.

He turned his attention back to the Boston Public Library murals. From
1895, when he knew that he had the wall space of the entire hall to work
with, he aimed to illustrate the "progress of religion," not as a temporal nar-
rative, but more challengingly, in representations of ideas of the spiritual, in
symbols that would evoke the nature of historic pagan, Jewish, and Christian
relations to the divine. He planned to end with a conception of religion
that surpassed the ritual, laws, and dogma of the Judeo-Christian past in a
personal and internalized morality and spirituality to which God is a loved
and loving father and the acts of religion are charity and compassion. He
intended to illustrate that culmination with the Sermon on the Mount, a
distillation of the essence of the Christian message from before there was a
Church, preached by a Jew who had moved beyond the confines of the Jew-
ish law. In short, he would illustrate the ideas of Ernest Renan.[22]

But in 1914 there remained the six ceiling lunettes to be installed along
each of the two long walls of the room and the Marian arch covering the wall
panels and ceiling section immediately flanking the *Dogma of the Redemption*
wall. Sargent returned to this old project as the war engaged all of society
around him. He had already finished some parts, probably the *Mysteries of
the Rosary* and surely the *Lady of Sorrows*, with seven swords piercing her
heart: that was shown in London in 1912.[23] Sargent completed this phase of
his program, to the extent possible in his London studio, over the course of
1915 and the winter of 1916.

The war continued its disruptions. Sargent decided to sell *Madame X* to the Metropolitan Museum of Art in New York City because it was on exhibition in San Francisco and shipping it back to England was too risky. In April he contributed two charcoal portraits that he would create for the highest bidders to benefit the Red Cross and realized 1,340 guineas.[24] In the summer of 1915 Sargent was asked by Edith Wharton for a contribution to the volume she was producing, *The Book of the Homeless*, to raise funds for the American Hostel for Refugees Committee and Children of Flanders Rescue Committee. He agreed, together with Beerbohm, Renoir, Rodin, Monet, and Bakst, among others. His pen contribution, *Two Heads*, itself brought $220 at sale.[25] Henry James was actively arguing for the United States to enter the war, and in July, disgusted by what seemed a blindly pro-German American public opinion and governmental policy, he renounced his American citizenship for British. James could not understand why Sargent would not do likewise, and a breach opened in their thirty-year friendship. Fortunately, there was a rapprochement before James died in February 1916.

Sargent sailed to America in March of 1916. *The New York Times* published the following hasty preview:

> John S. Sargent is expected in Boston next week to direct the installation in the third story hall of the Boston Public Library of the paintings which complete the mural decorations depicting "The Triumph of Religion.". . . As to the date when the new decorations will be visible, that is not yet known. . . . Mr. Sargent evidently considers these mural paintings his greatest work. . . . William Howe Downes, an art critic, hazards a supposition that the central motive of the new paintings is the Sermon on the Mount. The general title of the subject of the entire series is sometimes given as "The Pageant of Religion." The new paintings are to occupy the long East wall, over the staircase.[26]

In Boston Sargent moved into his usual hotel, the Vendome, and rented studio space. He began the work of readying and installing the paintings he had prepared in London. For this installation Sargent also was sculpting and overseeing installation of the cornices and moldings for the lunettes and the ceiling ornament. Sargent worked closely and harmoniously on those details with his congenial architectural liaison, Thomas Fox. As Sargent's stay in Boston dragged on, he was frequently Fox's guest at the St. Botolph's Club, and the two were often dinner and social companions.[27]

The wall panels and ceiling abutting the *Dogma of the Redemption* wall were devoted to Marian imagery. The *Lady of Sorrows* occupied the lower panel of the wall opposite the staircase and echoed the depiction of *Astarte* diagonally across the hall. Opposite the *Lady of Sorrows* was the panel *The*

Handmaid of the Lord, a seated Madonna with Child. The two images were joined above and across the ceiling with depictions of the *Joyful, Sorrowful and Glorious Mysteries* of the rosary.

The three lunettes above the east staircase depict, from left to right, an eerie *Gog and Magog*, the enemies of Israel, defeated figures tumbling headlong into nothingness. The central lunette depicts God, a completely shrouded figure, revealing his word on a long scroll to Israel, a young boy sheltered within God's protective cloak. In the border of this lunette Sargent painted in Hebrew characters the blessing on reading the Torah in Synagogue, words that a boy learns in preparation for his Bar Mitzvah.[28] The right-hand lunette, next to the *Dogma of the Redemption* wall, shows a more mature boy who strides forth from a gate forced open by four figures, leading his parents by the hand into a land of peace and plenty: the *Messianic Era* (figure 9.3). The opposite ceiling's three lunettes draw on familiar iconography. The central lunette depicts the judgment of souls in a scale held by the archangel Michael. The damned proceed into the right lunette to be devoured by a monstrous green devil, while on our left the saved, holding hands, ascend into heaven escorted by a choir of angels with harps.[29]

When Sargent had finished preparing the new works and handed his moulding sculptures and canvases over to Thomas Fox for installation, he followed his lifelong custom and sought respite from the summer city heat in the mountains, this time the Rockies. His itinerary was inspired by Denman Ross, a wealthy artist and lecturer and friend of Isabella Stewart Gardner; and Sargent promised Mrs. Gardner a painting from the expedition.[30] He was probably also encouraged by stories from Peter Harrison about Dos Palmer's palatial home in Colorado Springs, but his destination was much further north, to Glacier National Park in Montana and then into British Columbia and the Yoho National Park, about 5,000 feet above sea level on the western slopes of the Rockies—full of spectacular waterfalls, snow-covered peaks, and glacial lakes.[31] Roughing it in tents in muddy terrain, rain, and snow, Sargent got a different taste of mountain travel than he had ever had in the Alps. He wrote ruefully to his old friend Mrs. Ralph Curtis on Canadian Pacific Railway stationary, "I will never forget . . . painting in the Rockies in generally arctic temperatures much of the time snowed up."[32] He came back with watercolors and oils of the dramatic scenery and the everyday pictures of his experience—tents and camp scenes. It was his only venture into the North American mountain wilderness and his last mountain holiday.

Returning to Boston in October, "he worked daily on the scaffolding in the library, modeling and gilding every least bit of ornament, repainting whole passages of his panels, attaching them to many yards of ribbed

corduroy, so applied so as to make the diffusion of light more interesting than from flat surfaces. . . . He was reluctant to let the public see the work at Christmas time; he would gladly have spent another year over its installation."[33] Only the prodding of his patrons made him finally stop tinkering with the details of his work on the moldings and murals. The installation was unveiled for the public just before Christmas of 1916. The early expectations of a Sermon on the Mount were disappointed, but the Marian arch and the six lunettes, like the work that had gone before, garnered him almost universal praise, and Sargent himself admitted that he was pleased with his work. He wrote to his friend Evan Charteris, "The whole architectural and ornamental scheme seems to work out on the large scale, and it has been a great satisfaction not to have to make any changes. Whether or not it is another of the palpable signs that I am getting old, I am rather revelling in the appearance this white elephant of mine is taking on of amounting to something, after all these years."[34]

The east wall still awaited the Sermon on the Mount. At least as early as October 1915, Sargent had decided to use only the middle third of the wall for that culminating scene, and to flank it with allegorical figures of Synagogue and Church.[35] He placed frames in the form of architectural "shrines" in each of those flanking spaces and covered them with curtains of his own design: a repeating pattern of cherubim and menorahs on the north "Jewish" side and of St. John's eagles and harts-at-the-spring on the "Christian" south side.[36]

In November he had begun discussions with the Boston Museum of Fine Arts for mural decorations over the rotunda at the top of their grand entrance stairs. Sargent took up the new project with enthusiasm and began planning it in his Boston studio. Thomas Fox was engaged again to deal with the architectural components of the project, which proved to be even more challenging than at the Library. Sargent's original commission was just to paint the lunettes over the doors leading from the rotunda. Sargent countered with a proposal to paint the rotunda itself; this required replacing the original coffered interior of the dome (something like that of the Pantheon in Rome) with surfaces that could be painted. The project he devised included bas relief and plaster casts as well as murals.[37] Later, when Fox was preparing an essay on the Library and Museum projects, Sargent insisted on how important Fox's help had been in these projects, "Woodbury has brought me your essay which he will take back to you. I think it is first rate, though I think you have been over modest in keeping your own share in the work so entirely out of sight. I feel I ought to add a postscript to do justice to

your advice and help. . . . Now I think if you substituted the word 'talent' for the word 'genius,' it would be less hard to swallow."[38]

Sargent needed to be busy and occupied with thoughts of his art rather than his family and the War. The news from London and Paris got worse every week, and he was once again an exile, poorly informed and powerless to help or comfort. He wanted to get back to England or for his sisters to come to America—he knew that Rose-Marie would not budge; but the unrestricted warfare of German submarines against Atlantic merchant shipping made the voyage in either direction hazardous.

In the spring of 1917 he undertook the portrait of the elderly capitalist John D. Rockefeller, his fee to be donated to the Red Cross. His need for distraction and the tropical scenes of Florida's Atlantic coast persuaded Sargent to break again his "no more paughtraits" rule. Sargent's friends, the businessmen and art collectors Charles and James Deering, invited Sargent to extend his Florida vacation with them. So Sargent spent much of the spring of 1917 enjoying and painting different and exotic surroundings—alligators, palmettos, and swamps. On stationary imprinted "On board the Houseboat NEPENTHE" he wrote to Fox a typically humorous account of his puritan conscience's struggle with his own frank enjoyment of the time, shadowed as always by the fact of the war.

> April 18th. The days and weeks fly by—it is disgraceful—and I am still down here—I think I mentioned before that I was induced to go on a fishing cruise of a week—here we are in the Gulf of Mexico and still outward bound. Fishing is hard work, but the rest of the time it is very lazy and monotonous. The principal event is that I caught a Tarpon over six feet long, and weighing 149 pounds . . . my arms ache with pulling in various and heavy fish—but only one Tarpon—I lost the others. Not a periscope so far—but some risk of being sniped at by patrols on viaducts.[39]

To Sargent's surprise the sittings with Rockefeller were so congenial that a second portrait was planned, and he painted it in June at Rockefeller's wooded estate at Pocantico, 25 miles north of Manhattan.

The War Comes to Sargent in America, Winter 1917–1918

On 7 May 1915 a German submarine had sunk the British passenger liner *Lusitania*. Among the 1,195 deaths (out of a total of 1,959 passengers and crew) was Sir Hugh Lane, an illustrious Irish art collector and the founder of the Hugh Lane Municipal Gallery in Dublin. Lane had pledged to donate

£10,000 to the Red Cross when Sargent painted a portrait of a personage to be named later. When the United States declared war on Germany at the beginning of April 1917 the trustee of the scheme, the National Gallery of Ireland, chose President Wilson to be the sitter. This task loomed over Sargent while he continued work on his ideas for the Boston Museum of Fine Arts and the president was preoccupied by the direction of the war effort. Finally in October Mrs. Wilson identified some time for the sittings, and Sargent dutifully went to Washington for the task. The painter and the president found a common interest in the subject of camouflage, and the undertaking of this portrait too ended by proving agreeable.[40]

The winter of 1917–1918 brought constantly worse news from Europe. Sargent, with his loved ones so far away and the mail irregular, began paying attention to the newspapers. German raids on London and Paris were headlined in the *Boston Globe* along with the progress of the war and accounts of the American Expeditionary Force that was just beginning to see action. On 30 January the headline told of "47 Killed, 169 Hurt in [Zeppelin] Raid on London."[41] Two days later came the news of the great Gotha raid on Paris. [42]

> The alarm was given at 11:30. Bombs were thrown at various points in Paris and the suburbs. It was the first aerial attack since July 27 last. Construction of new German high-flying, speedy airplanes led to the resumption of the raids. . . . Thousands of persons mounted to the rooftops and watched the sparkling signal lights and flashing of machine guns in the amazing midnight battles in the air. . . . As to the psychology of the German attacks . . . the common opinion was that they would serve as a tonic to the fighting spirit of the Frenchmen, rather than depressing in their effect.

By the next day's paper the toll had risen to 45 dead and 207 wounded. London was under Zeppelin attack and Sargent felt he should return to share the danger with his sisters. There was a fresh offer of £10,000 for another Red Cross benefit portrait, and late in February Sargent inquired whether he would be able to go to England and return with his present passport.[43]

Raids had continued irregularly through the winter on the two cities where his loved ones lived, each one memorable for its particular horrors of dead and wounded. On 25 March the *Boston Globe* introduced Sargent to "Germany's Big Guns. Stunning Surprize. Range 76 miles. Beyond Wildest Expectations," and in smaller print, "Maj. Gen. Wood and Other Officers Doubt Monster's Existence." But the facts in the article and the information about the gun and its range were accurate and soon confirmed by dispatches from Berlin. The report went on, "the damage in Paris from an all-day bombardment was insignificant. . . . If the Germans counted upon terrorizing the

populace, there has not been a line from Paris to indicate that they have attained success in that direction."[44] *The New York Times* on 27 March printed a cable giving more details of the Palm Sunday bombings.

> Paris will not forget Palm Sunday, 1918, when with monotonous regularity for six hours the Germans dropped flying shells upon the French capital. . . .Today Paris knew that it was being bombarded from a distance of 75 miles. . . .The results of the first two days' work of the German tool of war were negligible. . . . If the Germans thought the new invention would hurt the morale of the French people they are wrong. I have just come from a spot where one of the flying shells fell. It tore a hole 3 feet in diameter in the pavement and wrecked the fronts of buildings for a half a block, killing several people and injuring some, but it was not a large damage for a 10 inch shell. . . . Today the Ritz Salon was crowded and the streets were filled with promenaders. The Madeleine was crowded for services this morning while shells were knocking regularly in many parts of the city.[45]

When the *Boston Globe* brought the news of the Good Friday calamity to Sargent on Saturday, he would have feared, but did not know, that it was news of Rose-Marie: "Shell Kills 54 Women at Worship in Paris."

> Rescue parties at work in a church which was struck yesterday by a shell from a German long range gun have found more bodies. It is known that 54 women were killed. The shells struck the North side of the church, bringing down part of the roof and opening a breach 12 feet high and 20 feet wide. Nearly all of the debris fell inward upon the heads of the worshippers, 60 feet below. The edifice is now a heart-rending sight. The enormous mass of stone, crumbled into all shapes and sizes, lies in the middle of the nave, and piled to about the same height as the high altar which was damaged. The aisles are littered with the less cumbersome wreckage and the pavement is covered with dust. All the stained glass windows, some of which were of historical interest, are shattered. The church although begun in the Middle Ages, was remodeled in the epoch of the Renaissance. The beauty of its musical services which were sung unaccompanied, attracted many music lovers. In addition to M. Stroehlin, counsellor of the Swiss Legation in Paris, who was killed, it is feared that his wife also is a victim, although searchers have not yet found her body in the debris. Among the injured are Countess Morand, Viscount Molitor and ex-senator Louis Gautteron.[46]

As days passed the Paris church bombing continued to reverberate in the *Globe*, with higher casualty numbers but no lists of names. On 2 April the *Globe* headlined a Paris dispatch, "Church Slaughter Recalls the Lusitania. Victims' Blood Splattered Floor of Edifice. Two New York Women

among Victims. Paris Again Bombarded."[47] That article could have relieved Sargent's apprehension when it said that the victims had been kneeling in a Catholic service of worship, as Rose-Marie would never do. But almost immediately a cable from André Michel, relayed by Violet from London, brought him the horrible fact. He wrote back to her:

> Hotel Vendome, Commonwealth Ave Boston, April 3d [1918].
> My dear Vi, I have just got [lined out: your] the terrible cablegram of Rose Marie's death, and I can't tell you how sorry I am for you, and you all, and how I feel the loss of the most charming girl who ever lived. And what a death—I hope it was instantaneous. It makes me feel all the more that I ought to be with you instead of over here, as I wrote you lately. You will be wanting to go to Paris, but I dare say it is not possible at such short notice. I am so sorry for Reine and the boys, and for Emily who must be uninformed. I leave you, my poor dear Vi, to write to her. Your loving brother, John S. Sargent[48]

The terse cable of André Michel had surely included an expression of condolence, but no more information: he knew the censorship rules. Thomas Fox remembered being at the St. Botolph Club that evening,

> when Sargent was to dine out of town. There was a call to the telephone about eight o'clock. "I have just had bad news from Paris," said he. "My niece has been killed, and I think I won't go out to dinner. I'll come around to the Club." This he did. There were no details, only a cable from England giving the bare fact. "It was Rose-Marie," said he. "Her husband was killed at the beginning of the war. She was very young and one of the most beautiful and attractive women I ever knew." And this meant much from him.

Another member of the St. Botolph came in that evening, the Bavarian-born painter Ignaz Gaugengigl, "who," the censorious Fox tells us, "had been and still was, in the minds of many, more anti-ally than even his birth would justify."[49] Sargent's deep-rooted *noblesse* prevented all awkwardness.

> Dinner was ordered with the hope on my part that nothing would happen to intensify the blow. Before the meal was ready, however, who should come in but the "painter in question." "Have you dined?" asked he. "No," said Sargent. "Won't you dine with us?" And while the painter in question had gone to the desk to order, Sargent said, "I don't think I'll tell him what has happened."[50]

From maddeningly sparse data Sargent was compelled to construct, by reason, imagination, his memories of his beloved niece, and his recollections of Paris, the reality of Rose-Marie crushed to death under a falling

church vault. Two days later Sargent shared his burden with his friend Isabella Stewart Gardner, writing on a Hotel Vendome note card that he posted at Back Bay Station, "Hotel Vendome, Commonwealth Ave Boston, Friday [5 April]. Dear Mrs. Gardner, Imagine the horrible news I got night before last—my charming widowed niece Rose Marie was killed in the bombardment of Paris. I have no details—they are probably dreadful. Yours sincerely, John S. Sargent"[51]

Had he tried to close himself off from more details and reminders, it would have been difficult. There were memorial services for the dead held at St. Patrick's Cathedral in New York, continuing bulletins about the American victims, more bombardments of Paris. With such hateful images in his mind, Sargent immediately booked passage from New York to Southampton on the White Star liner RMS *Baltic*.[52] Clearing out the Boston studio after two full years of occupation, and packing for the journey, had to be done without Nicola d'Inverno, who had caused a scene at the Vendome and left Sargent's service. Thomas Fox came to help.

> The time for packing was exceedingly short and I gave what assistance was possible to help a self-contained man. Among other things there was a vast accumulation of boxes, papers, and letters to be sorted, and for the most part destroyed, and as we were beginning Sargent said, "There's one letter I must find." He went over the few which had been apparently been kept more carefully than the rest and then began to search among the others. He was evidently much disturbed but finally said, "Here it is, and I am much relieved it's found." The envelope had a black border and the letter was written in French. He didn't say so but it must have been the last that came from Rose-Marie.[53]

But then Sargent's departure was delayed a month because the *Baltic* was under orders as a troop carrier and also had to wait to join an escorted convoy.

> Hotel Vendome, Commonwealth Ave Boston, private April 14th 1918. My dear Vi, On the chance of catching a mail, this hurried line is to say that my steamer the "Baltic" which was to sail on the 1st of May is postponed for a week—dates are of course very vague, but this is the latest probability. I have a stateroom engaged [—with] next to a friend Mr. Charles King, with a bathroom between. His people live at Bath, Americans. I wonder whether you have yet heard details of dear Rose Marie's death in Paris—whether it was in that church, or where. I hope it was instantaneous. There will be a letter for me to your care from M. André Michel. Keep it—I wrote to him and asked him how it happened. Give my love to the children and to Em. I wrote to her the other day. Your loving brother John S. Sargent

P. S. I suppose you will have got my letter of ten days ago or more saying that I was coming over, but asking you to keep it dark from Emily who would worry. I am sorry to worry you too and long beforehand.

Germany's submarine warfare had been unrestricted for a full year, with frequent sinkings of merchant ships and passenger liners. Sargent recognized the possibility that he might go down with the *Baltic*, and so he made his will on 20 April.[54] The document is short and formal, but telling: it shows that Sargent's original antipathy to his brother-in-law Francis Ormond had not waned with the passage of time. The executors, a Boston attorney and a Grays Inn solicitor, got "full power of sale and management," a measure of the testator's faith in their ability and probity. There were only two cash legacies: £ 5,000 "to my friend Alice Barnard" and £ 200 to Nicola d'Inverno. Emily was to have half the remainder, and half was to be for Violet, in trust. She was to receive the income of the property during her life "without power of anticipation or assignment and not subject to be reached by any creditor of hers," and at her death the balance was to be distributed "to and among her issue." Nothing for Francis, then, and he had no standing to interfere with the estate.

Painting the War, July–October 1918

Before he left Boston, Sargent was contacted by the British Department of Information, War Memorials Committee, about a commission to go to the front in France and to paint the War. The project was led by Alfred Yockney, a former editor of *Art News*, and designed "to preserve an official collective memory of the War." From the inception of the scheme in 1916, more than ninety artists of all stylistic schools had been commissioned, including Muirhead Bone, William Orpen, William Rothenstein, Sir John Lavery, and Paul Nash.[55] Yockney aimed high with his request to Sargent, "the foremost American artist." He or the committee thought to make the request more appealing by proposing that the subject of Sargent's commission should "suggest the fusion of British and American forces."[56]

Sargent was back in London on 7 May. He no longer thought of taking his sisters away across the dangerous Atlantic to safety in Boston. As he wrote to Isabella Stuart Gardner, "the married one won't leave because her boys are enlisting and the other one does not feel that she can leave her—and my New England conscience dictates that I must chance at least a dozen raids with them."[57] He busied himself with his new Red Cross portrait, *Mrs. Percival Duxbury and Her Daughter*,[58] and pondered whether to accept Yockney's

offer. He asked Fox in Boston to send him precise measurements of the two shrine frames in the Boston Public Library, in case he had time in London to paint *Synagogue* and *Church*.[59]

In mid-May Yockney's offer of the War commission was seconded by a letter from the prime minister himself, Lloyd George: "I support the suggestion . . . that you should execute one of these large paintings, the subject being, I understand, one in which British and American troops are engaged in unison."[60] Sargent had found two things that he needed: a way to get across the Channel in wartime, and a wartime task that he was uniquely qualified to perform. His agreement was likely made easier by the fact that his good friend, the painter Henry Tonks, had also been chosen. In June the two artists were attached to the Guards Division, and on 2 July, in British officers' uniforms without badges of rank, they crossed together to France on a troop ship.

Tonks had entered Sargent's circle years before. A teacher at the Slade School of Art in London, he was a neighbor and then a close friend of Mary Sargent and then of Emily at Carlyle Mansions. Besides his serious painting he was a clever caricaturist, often poking fun at those in his close circle of friends. Tonks was a member of the Alpine painting party in 1910 and then Sargent's companion as he descended to Siena, Bologna, and Florence.[61]

Tonks had already seen service in the War.[62] Originally trained as a doctor, he had volunteered as an orderly in a hospital for prisoners of war, then at one for wounded officers. By 1915 he was in France as a Red Cross orderly. In 1916 he joined the army with a lieutenant's commission and was assigned to various medical duties at Aldershot. There he began an organized effort to record the details of facial wounds, as a scientific aid to the developing field of reconstructive surgery. Tonks's pastels captured the "skin tones, mass, shape and color" that were "beyond the reach of the camera" and served as an integral part of the medical record of a surgery.[63] He wrote revealingly to his and Sargent's good friend, the critic and curator D. S. MacColl,

> I am doing a number of heads of wounded soldiers who have gotten their faces knocked about. A very good surgeon called Gillies . . . is undertaking what is known as the plastic surgery necessary. . . . One I did the other day of a young fellow with a rather classical face was exactly like a living damaged Greek head as his nose had been cut clean off. Another I have just finished with an enormous hole in his cheek through which you can see the tongue working, rather reminds me of Philip IV as the obstruction to the lymphatics has made his face very blobby.[64]

Tonks left the army at the end of 1916, but he was soon asked by the Department of Information to join the war artists. Because of the graphic nature

of his work, however, it was not clear to the Department or to himself what would be the best use of his talents. Finally, in April 1918 the request came for him to paint a "hospital dressing station" and Tonks accepted.

As the two artists sailed together for France, it must have been comforting to Sargent that he would be with his old friend. On the other hand, Sargent must have been familiar with Tonks's depictions of the horribly maimed and worried about his own response to seeing war close up. In 1916 he had joked in a letter that he might "be tempted to go out and have a look at it. . . . But would I have the nerve to look, not to speak of painting? I have never seen anything the least horrible—outside my studio."[65] He also had no idea of what he could paint that would depict the subject of his commission: the cooperation of British and American troops. With the arrival of the fresh American armies, the war had only recently begun to turn definitively in the Allies' favor. "They had no battle memories to haunt them. Their thoughts were not of the past, not of defeat. Their thoughts were all of victory. They were in line for the first time and they were to be victorious."[66]

Upon landing in France, Tonks was sent to the medical headquarters at Bercelaire while Sargent was brought to General Haig's headquarters at Boulogne, where he was welcomed by Haig's aide de camp, Sir Philip Sassoon. Sargent had painted Sassoon's mother Aline, née Rothschild, in 1907, and he became a great friend of the entire family, including the children, Philip and Sybil, who were similar in age to his own nieces and nephews. Sassoon, a notorious aesthete and a great art lover and patron, had written that Sargent "must do something of D. H. (Douglas Haig). He is *the* only artist—now that Velasquez has died."[67]

> General Haig reported tersely: "Mr. Sargent, the painter, came to dinner and stayed the night." . . . The following morning was the 4th of July—a suitable date for the Americans to receive their baptism of fire, and together with the Australians, acquitted themselves nobly. The attack was completely successful. The British line was advanced on a front of four miles to a distance of a mile and a half. The village of Hamel and the ridge to the east of it were captured. Over 1500 prisoners were taken and 103 machine guns, 12 trench mortars and 77 field guns.[68]

Sargent did not paint that instance of Anglo-American cooperation. Philip Sassoon made a comical record of Sargent's arrival:

> I had had two delightful days with Sargent. . . . He arrived in the most faultless Khaki, Sam Brown belt under his armpits, puttees, etc. and saratoga trunk upon trunk filled with his trousseau. He and D. H. were amusing together.

Both are inarticulate. D. H. can begin his sentence very well but can't always end it, as his mind goes so much more quickly than his tongue. Sargent on the other hand can't begin it, but when he does it goes with a rush to the end at such a pace that you don't know what he said. Between the two I was quite at sea. I asked D. H. what he thought of Sargent & he replied "He doesn't look as if he took much exercise. He'll burst one of these days." . . . He went for a ride in a Tank and enjoyed it like a child. . . . He said to me "Shall I paint what I want or what I must?" I said "What you want," & I left him painting cows in an orchard, which he might just as well be doing in Worcestershire.[69]

Sargent also painted camps, tents, and tanks; Tommies bathing, resting, sleeping, and stealing fruit—and destroyed sugar refineries.

Sargent gave every impression of ignorance of all things military. Later Tonks wrote,

I don't think he (Sargent) ever grasped much about the military campaign in actual being, which is curious as he . . . had read with deep interest many books on Napoleon's campaigns. I could never make him understand differences in rank, no, not the most obvious, so I gave up trying. Things that seemed the commonplaces of war surprised him as when he said . . . "I suppose there is no fighting on Sundays." Sometimes I wonder if he knew how dangerous a shell might be, as he never showed the least sign of fear."[70]

It is also told about Tonks, the experienced war-worker, that "when a terrific shell burst Tonks did no more than rise from his stool. 'So that's what they look like.'"[71] Although Sargent was a novice in this world of violence, he did know what shells could do. As always, he kept his sentiments and anxieties to himself. As always, he painted, this time with a commission to fulfill. And this time his grief helped him to choose his subjects.

From Boulogne, Sassoon took Sargent to Bavincourt, and on 13 July he was taken up to the line of battle, where Tonks joined him a few days later. Tonks wrote about his own work, "I have gone about much and seen much. . . . We live in the middle of a terrible din of artillery. The other day I motored to the battle front and saw what I wanted of the wounded. . . . I find work very difficult and only seem to be collecting notes."[72] They went on together to Arras, one of André Michel's *villes martyres*, where they spent two or three weeks. Sargent described the scene to Fox.

I have been in France for the last 6 weeks or so—moving about from one place to the other, with another artist friend on the same mission. We are doing what we can in the way of sketching and collecting materials for work. I am now in a ruined tower, comfortably lodged in a big empty house without a

whole pane of glass in any window, shaken to its foundations night and day by guns going off within a few yards—the air full of whistlings and whinings and hummings, but on the whole pleasanter than the mud of the trenches we have come from. . . . Remember me to the fellows.[73]

Tonks painted scenes of domestic upheaval: houses with their front walls blown away, a French woman in the ruins of her home.[74] Back in England, he assembled his sketches from the field to create *An Advanced Dressing Station, France, 1918*. His crowded canvas is a mass of vignettes of wounded men being treated or transported or waiting, against a backdrop of desolation and shellfire. This was not a single scene that Tonks had witnessed, but rather a conflation of many notes of the wounded and of dressing stations that he had sought out over his months at the front.

Sargent produced pictures of the destruction that had come from above, arches and vaults blown apart. The nave of the *Ruined Cathedral, Arras* (figure 8.2) stands open to the sun.[75] A clear blue sky shines behind the remaining standing arch. The cathedral vault litters the floor. *Wheels in Vault* (Color 12) shows abandoned caissons or a broken cart in the rubble that fills the space below the pointed arches of a cloister or a crypt.[76] *Ruined Cellar at Arras* shows a simple interior with arches still intact, but windows and walls broken to reveal the daylight outside.[77] *A Street in Arras* shows the long street wall of a fine home with a hole smashed into the section on the left closest to the viewer, revealing an old carriage still upright under the collapsed stones and timbers. Blasé Scots Guards, who have seen it all, relax along the wall.[78] On 20 August, Sassoon, who knew Sargent well as an artist, reported that he "has been doing lovely things of Tommies stealing apples – a broken down coupe in a ruin, Arras cathedral etc.—but he has not attempted to embark as yet upon his big picture or even make studies for it. How he wishes he had never been sent out to do it. It hangs over him like a sword of Damocles."[79]

The very next day Sargent found his big picture, and it was not a scene of Yanks and Tommies cooperating, but of blinded soldiers (Color 13). Nature set the scene perfectly: the weather on Wednesday 21 August was "magnificent and hot."[80] The moon was full, and so it rose shortly before the sun set at about 8 pm. Tonks remembered:

After tea we heard that on the Doullens Road at the Corps dressing station at Le Bac-du-Sud there were a good many gassed cases, so we went there. The dressing station was situated on the road and consisted of a number of huts and a few tents. Gassed cases kept coming in, led along in parties of about six . . . by an orderly. They sat or lay down on the grass, there must have been several hundred, evidently suffering a great deal, chiefly I fancy from their eyes which

Figure 8.2. Sargent, *Ruined Cathedral, Arras* (1918). The bright sun of a midsummer day pours into the ruined church, its vault a heap of rubble on the floor. Private collection.

were covered up by a piece of lint. . . . Sargent was very struck by the scene and immediately made a lot of notes.[81]

A little later he asked me if I would mind his making this essentially medical subject his, and I told him I did not in the least mind. He worked hard and made a number of pencil and pen sketches which formed the basis of the oil painting known as *Gassed* now in the war museum.[82]

Sargent described the scene to Charteris as "a harrowing sight, a field full of gassed and blindfolded men"[83] This was the scene that became the masterpiece of Sargent's campaign; it moved him more than any other in his war experience. He filled pages with studies of the blindfolded men, notes of their postures and motions and kit, details of that summer evening in the open French countryside. These blinded soldiers were his models, visually recreating for him the splendid, heroic types, the *soldats aveugles* about whom Rose-Marie had written, and to whom she had dedicated the last years of her life.

Nine days later, on 30 August, the British troops pushed as far as Bailleul as the Germans pulled back from the Lys salient. From there Sargent was transferred to the New York Division, the 27th Infantry under General John

F. O'Ryan, who had come up to fight beside the British at Vierstraat Ridge on what was called the East Poperinghe Line south of Ypres.[84] It was during the few days that Sargent spent with the New York Division that he was observed by Major Tristram Tupper, the Division adjutant.

> Headquarters had been pushed forward to the dizzy shell-shocked edge of the Allies' world. Flanders. August. Then, like a giant mushroom springing unheralded overnight out of the mud and the mire of things there appeared a huge white umbrella—just an inoffensive sit-by-the-sea, green lined white umbrella. Everything else was warlike, everything else was camouflaged, everything was hard, serious, tense, and determined for this was at battle headquarters, on a hill overhanging the lines. . . . Its owner was with the division commander. . . . He was tall. He was large and grizzly. He sat there in the hut over which the shells passed with a staccato shriek, a whistle and a roar. He wore a British uniform. But he was an American, and though his years were many his honors were more. His long unusual hand was steady as it guided a crayon over white drawing paper. The man was John S. Sargent. The position was under close observation from Mont Kemmel and was subjected to observed artillery fire by day and continued fire by night, inflicting daily casualties.[85]

In one encounter Tupper asked Sargent why he wasn't painting and "the reason was obvious—all the paintings of the great galleries of the world can give no adequate impression of war. It is indescribable." But something reminiscent of the battle for Vierstraat Ridge would appear later in Harvard's Widener Library.

> The attack on Vierstraat Ridge, 31 August to 2 September, forced the Germans to retreat from Mont Kemmel, as well as from its territory to the south. The enemy was found to be withdrawing his main force to Wytschaete Ridge, but leaving his machine gun crews to hold the ground as long as possible, and keeping the whole terrain covered with artillery fire. . . . As a result of the three days' fighting, the 27th captured Vierstraat Ridge, Rossignol Wood, Petit Bois, and Plateau Farm. Many prisoners were taken and a new line established on favorable ground in place of the old line, which for months had suffered under direct enemy observation."[86]

Tupper later described his last meeting with Sargent in a dangerous situation in Ypres.

> As he sat among the ruins of the cathedral of Ypres, painting an arch under which a broken timber had jammed, he talked of art after the war: Artists would arise to take the place of those who had been killed, and as he talked a

pigeon perched high on the broken walls that were once the tower of the cathedral of Ypres. Sargent pointed with a paint brush to the pigeon. "It's in the heart of every living thing," he said. "The thing that has brought the pigeon back to the cathedral tower where it used to live will bring men back to these ruined towns and cities. They will build again. Home has irresistible power. Man and beast always return."[87]

The Americans withdrew from the line, and Sargent returned to the British forces. He wrote to Charteris on 11 September that he was in the "neighborhood of Ypres . . . but will probably go to Cassel where the hotel is still open." The pace and difficulties of war painting were telling on Sargent. His reflections to Tupper give the impression of weariness. He had found the scene of the blinded soldiers that would be his homage to Rose-Marie's men and his *tombeau* for her.

He despaired of finding the right picture to fulfill his commission. To Fox he now called it "the damned portion that is expected of me."[88] Sargent described his difficulty in a classical metaphor to Charteris.

The programme of "British and American troops working together," has weighed heavily upon me for though historically and sentimentally the thing happens, the naked eye cannot catch it in the act, nor have I, so far, forged the Vulcan's net in which the act can be imprisoned and gaily looked upon. How can there be anything flagrant enough for a picture when Mars and Venus are miles apart whether in camps or in front trenches. And the farther forward one goes the more scattered and meager everything is. The nearer to danger the fewer and more hidden the men—the more dramatic the situation the more it becomes an empty landscape.[89]

But Sargent's Puritan heritage forced him to keep looking. On 24 September he arrived at the site of the British IV Army's Transit Cage near Péronne where prisoners were held before being sent to the rear. He saw hundreds of German prisoners and even entered the cage to draw them. The influenza that the French called *la grippe espagnole* and the Americans "the Spanish flu" was rampant in the German army, and two days later it struck Sargent down. The emotional strain and the pressure of worry and work for eleven weeks in France, constantly hearing shell-fire, no doubt contributed to his susceptibility. He was taken to the 41st Clearing Station at Roisel and put into a hospital tent "with the accompaniment of groans of wounded and the choking and coughing of gassed men, which was a nightmare. It was always strange on opening one's eyes to see the level cots and the dimly lit long tent looking so calm, when one was dozing in pandemonium."[90] He was confined

to bed for a week, and then, although he still had intestinal symptoms, Sargent returned to his work.

On 10 October, he saw a scene that—at the time—seemed to answer the requirements of his commission. In a letter to Mrs. Hunter, "I have wasted lots of time going to the front trenches. There is nothing to paint there—it is ugly and meager and cramped, & one only sees one or two men. In this Somme country, I have seen what I wanted, roads crammed with troops on the march. It is the finest spectacle the war affords, as far as I can make out."[91] He may have written that even while knowing that the scene would not be up to his artistic standards. A month earlier he had written to Charteris mentioning that "the best thing" for the subject of the commission would be "a big road encumbered with troops and traffic . . . combining English and Americans . . . if it can be prevented from looking like going to the Derby."[92] But in October it was the excuse that he needed to release himself from further searching.

That is the last we know of Sargent's painting expedition in France, but he was not home in London until the end of October: two weeks of his life are completely unrecorded because he was on a personal errand. We are sure that he visited André Michel in Paris to express his deep sympathy; it was always Sargent's way to stand in person by his grief-stricken friends. As Mrs. Abbey had known, "Being Sargent, he could not fail to come." It would have been utterly unlike him to be just a few hours by rail from Paris and not to visit the Michels and Rose-Marie's tomb at Montmorency. He was in the situation that Catullus described in one of his best poems, the one that ends "hail and farewell." On military service in the east when his brother died, the poet returned home long after the funeral to do the traditional sad duty of a wreath of flowers.[93]

Sargent and Michel had known each other for forty years, but they had not met since that hurried visit of Sargent's in 1914 to mourn Robert's death with his parents and his widow. And now they were mourning the lovely, charming young woman who had been a special joy to each of them. They both had changed in four years. Sargent had grown noticeably stouter, but not stronger. The months of painting at the front, anxieties, and hard travel had worn him down, and the effects of influenza lingered. André Michel had aged and withered with the years. Two of his nephews had followed Abel and Robert, *morts pour la France*, further heavy blows to his frail heart.[94] He had worked through the war years, steadily but without much joy, on the last volumes of the *Histoire de l'Art* and on propaganda for the cause of the cultural patrimony of France.

They had much to talk about. Michel would want to tell Sargent about Rose-Marie's bravery and kindness and her work at Reuilly; perhaps they visited the hospital. Sargent would finally hear the details of the catastrophe of Good Friday. They could have visited Saint Gervais, which was being rebuilt. Its damaged section was filled with scaffolding and barricaded, but the crossing, sanctuary, and apse, everything from the pulpit eastward, had just been reopened for worship and was always crowded with pilgrims. André Michel's position as conservator of sculpture at the Louvre would have allowed them access to the damaged nave if Sargent had wanted to see for himself the scene that he had imagined and reimagined as he set on paper and canvas the shattered ruins of northern France. If Sargent showed some of his sketches, André Michel would have understood better than anyone else the deep sadness that drove Sargent to detail again and again the bombed-out arches, the vaults piled in rubble on church floors, and the noble heads of blinded, blindfolded soldiers.

André Michel would have shown Sargent his own account of the cultural devastation of Germany's terror campaign, his call to the defense of French civilization, *Les villes martyres*. They must have visited the Varigny family crypt at Montmorency, where Rose-Marie lay, and André would have talked about his plan to bring her remains to the grave of Robert at Crouy and his plan to build a monument to the noble couple there, where Robert died. He returned the letters Sargent had written to Rose-Marie, and Sargent gave him that last letter he had received from her in Boston, still in its black-bordered envelope.

Michel had seen Sargent's first two installations at the Boston Public Library, *Judaism Oppressed* and *Dogma of the Redemption*, in 1903. He would have asked about the "Progress of Religion." Sargent would tell about his 1916 installation, the Marian arch and the sets of lunettes, and the curtained frames that awaited *Church* and *Synagogue*. Michel would have shown his pre-war photographs of those symbolic figures at Strasbourg and Reims. The destruction of Reims Cathedral was already being repaired; Paul Vitry's monumental work *La cathédrale de Reims*, with photographs of the whole brave story, was in proofs on Michel's desk. One photo shows the serene stone face of the Reims *Church*, which had been found miraculously whole in the rubble, a symbol of the survival of French culture.[95] Sargent and Michel could find some consolation in their common sorrow in conversation on art and civilization.

Sargent was back in London on 28 October, eager to finish his War Memorials commission.[96] After the months of fretting about finding the kind of scene he had been commissioned to paint, he decided that the

picture of the blinded soldiers would be the one that he would complete for the British War Memorials Committee. It was readily accepted. In its original mandate, the Department of Information hoped that the commissioned works would be "something more than mere renderings of scenes and events; rather should they be considered as the direct and personal impressions of men who have come into close contact with the realities of war, its emotions, its horrors, and its flood of human activity, and have given expression to them through the medium of their art."[97] In principle, then, the Committee did not press the official War Artists to produce according to a program; they were allowed to represent the front as they saw it. The artistically alert commissioners were quick to recognize a masterpiece when they saw one, even from the sketched preliminaries. Fictitious compositions were not wanted. Tonks, who witnessed the actual scenes of the gassed on the Doullens Road declared that "it is a good representation of what we saw, as it gives a sense of the surrounding peace."[98]

The scale and proportions of the space that the picture would fill were panoramic: 7.5 by 20 feet. Sargent got to work, as he always worked, alone with no assistants. He organized his notes and sketches into a compelling composition that depicts two lines of soldiers who had been blinded by gas, their eyes bandaged, moving slowly toward the field dressing station whose taut guy ropes stretch in from the right side of the frame. The point of view is low, and the upper quarter of the canvas is empty except for the late afternoon light and a few airplanes and exploding shells far off in the serene expanse of sky. A line of ten soldiers and an orderly coming from the left of the frame are the focus of the picture, their khaki battledress glorified by the ruddy gold sunset behind the artist. Each man has his hand on the backpack or shoulder of the one in front of him. The third man from the right has just stubbed his left foot on the duckboard. He has not yet "learned to be blind" and cannot tell (by how much the pack of the man ahead rose) how high the obstacle is, so he exaggerates the height of his step to be sure. The fourth man from the left turns away to retch. From the right hand rear of the picture another eight blindfolded soldiers and two surgeons approach the tent. In the eastern distance the rising moon, which turned full that night of 21–22 August, hangs milky and featureless.

In the background, visible between the legs of the blinded, men in blue and red colors are playing football; one on the right has just launched a long kick; to their left a man leans slightly forward, hands at his hips in a goalkeeper's stance. Sargent was alluding to A. E. Housman's poem "Is My Team Ploughing," an elegy as well known to the English public as Thomas Gray's.[99]

A dead man questions his living friend about the things he loved when alive. Their second exchange goes

> Is football playing
> Along the river shore,
> With lads to chase the leather,
> Now I stand up no more?"
> Ay, the ball is flying,
> The lads play heart and soul;
> The goal stands up, the keeper
> Stands up to keep the goal.[100]

Sargent had sketched the football players on the Doullens Road; those drawings are in the Imperial War Museum. In the drawings the goalkeeper is in an expectant crouch; but Sargent made sure that his finished painting caught the ball flying and the goalkeeper standing up. That tiny detail, the soldier footballers, would have recalled for the British public the whole poem, with its stab of regret for a young man's pleasures of work, play, and love cut short—and life going on without him.[101]

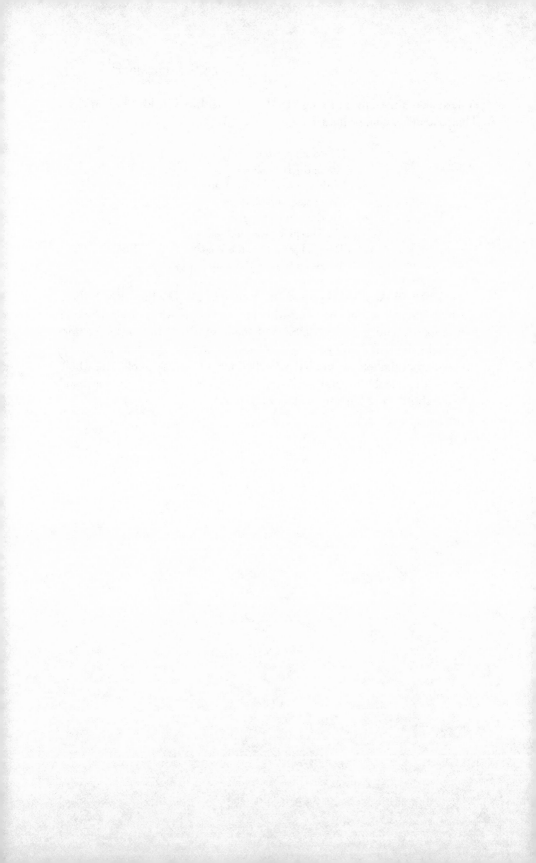

CHAPTER NINE

~

The End of *The Triumph of Religion*

When *Gassed* was finished, Sargent dutifully undertook one more War Memorials service, the group portrait *General Officers of the Great War*, a frieze of uniformed warriors now in the National Portrait Gallery, London.[1] In between the sittings of the generals in Tite Street, he worked into the spring of 1919 to finish his Boston Public Library task, energized by a new purpose.

Most of Sargent's biographers skim past that long project of public decoration, or regret it as ill-conceived and a waste of his talent and energy. A new assessment of Sargent's Boston decorations now prevails. Sally M. Promey's excellent 1999 study, *Painting Religion in Public*, John Singer Sargent's Triumph of Religion *at the Boston Public Library*, turned the spotlight of respectful criticism on the murals and is indispensable for a thorough understanding of Sargent's artistic and intellectual inspirations and the larger context of their production and reception. The final volume of *John Singer Sargent: Complete Paintings* will be a definitive study by Mary Crawford Volk of all three mural programs, Boston Public Library; Museum of Fine Arts, Boston; and Widener Library (at Harvard University, Cambridge, MA).

Sargent himself ranked public decoration as the highest task to which a painter could aspire. He wanted to crown his artistic achievement with something grand, challenging, and monumental, and so he was ready to take on the Boston projects and to enlarge and continue them over three decades. They were not just jobs of embellishment. Fox wrote that Sargent considered portraiture "a comparatively low form of the art of painting—making homely people handsome to please their family, he often expressed it. Next in

ascending scale he placed figure composition and landscapes, and above them, at the top, the work of decoration."[2] Looking back in 1903, just before the unveiling of the *Dogma of the Redemption* wall, a popular assessment guessed that he had been chosen for the work because "some people thought they detected in Sargent rare artistic possibilities aside from mere portraiture."[3]

Images and Inspirations

Sargent was looking to the mural genre to stretch his artistic talents for a work that would be public and monumental; and he was seeking a subject, a great theme that would stretch his intellect and invention. What greater theme than mankind's quest for the spiritual? For this great project he read, studied, and traveled to find and develop the ideas and images that would be worthy of the topic that he had boldly adopted in 1890, "The Triumph of Religion." Once he had the commission, Sargent organized a program of exotic travel to gather understanding, background, and color for the Library work. For him, the depiction of the ideas that he intended to convey needed to be based on first-hand observation of the sights and the human context where those ideas first came into existence. This was the work that he felt would be his lasting artistic legacy.

Sargent's ideas for the murals were shaped by a variety of inspirations. One of these inspirations was artistic: the vast historic repository of western art in which he had been immersed all his life and that he knew as only a professional artist can know it. Western art had been in the service of religion since the earliest antiquity. Depiction of religious scenes and the glorification of religious ideals through the ancient, classical, medieval, Renaissance, and baroque eras were the highest artistic expression of each of those civilizations. Young John and Emily Sargent, guided by their mother through the artistic treasures of Europe—the temples, cathedrals, and museums of sculpture and painting, had absorbed the history of western civilization through its art, so much of that art in service to the religions that flourished as empires and kingdoms rose and fell. So for Sargent the history of religion as a theme for the decoration of a secular public building did not present a conflict; instead, he knew the development of religion as integral to the pageant of civilization.

His own attitude toward religion guided his program. His parents had brought him up as an Episcopalian, versed in stories from the Bible and understanding "sin" and "salvation" pretty clearly, but not burdened with any rote catechism.[4] He had grown up in countries where the native population almost always was of a different religion than his family's. He was no bigoted

sectarian. He simply remained an Episcopalian as he remained an American. From the time he was a young adult and a member of modern artistic and literary circles, he was most often among friends who were freethinkers rather than adherents of any religious confession. His friend Evan Charteris summed up his understanding of Sargent's personal involvement with his Boston Public Library subject:

> To Sargent the evolution of religion was a subject which could be viewed with detachment; he approached it without bias or preference. He was no mystic drawing near to some sacred shrine, no devout enthusiast working by the light of an inward revelation, but a painter aware that here was a subject with a significance lending itself to interpretation in decorative pictorial designs. His imagination was fired, but as when he was told he had revealed the moral qualities of the sitter he said, "No, I do not judge, I only chronicle," so in his Boston decorations he must be understood as treating objectively and dispassionately the images suggested by his theme.[5]

Renan's *Life of Jesus*

Lucia Fairchild confided to her diary long accounts of occasions when she was with Sargent, their conversations, and her reactions to him. She paid attention to his religious behavior and ideas, and she drew him out with intellectual flirtations that they both seem to have enjoyed. In November 1890 she wrote that at Dennis Bunker's wedding "Sargent was there. At prayers in the ceremony he prayed though many men didn't."[6] A conversation with Sargent that she recorded at the beginning of his Boston Public Library project tells us much of what we know about Sargent's own attitudes toward the history of religion. In August of 1891 they visited St. Mary's Church in Fairford, the little town where Abbey had set up the vast studio where he and Sargent would complete their first Library murals. St. Mary's has a fine series of stained and painted glass windows from the first years of the sixteenth century that illustrate Old and New Testament scenes, evangelists, apostles, prophets, and martyrs. Sargent was looking particularly for ideas on the depiction of the prophets.[7]

> About stained glass at Fairford church, he said the windows of the prophets would not help him very much as the clothes they wore were too "extravagant and various" to be allowed and he didn't think any of them characteristic "except perhaps Jeremiah—you might tell *Jeremiah* by his expression." I asked "Was he a plaintive person?" "Oh yes, very," said Sargent. And then, when I mulled over a lot more, "How happens it that you don't know about them?" I

said that I had never read the Bible, neither Old nor New Testament. Sargent, "What do you mean? Extraordinary. Do you mean literally that you have never read the Bible? You can't." "No, isn't it awful? I never recognise any allusions." Sarg: "Why, but you ought to—it's *tremendous*—You would enjoy it more than anything. I mean to say it's as exciting as Cellini's escape out of prison.[8] Why if you care for stories of adventure perfectly plainly told, with no reflection you couldn't get anything better—You ought to read it certainly.

"All the 3rd book of Samuel is very fine—All about David and Saul—Kings—Chieftains of tribes I should think—like the Indian tribes. It's all tremendously picturesque. You ought to read the New Testament too. It's beautiful. I mean just from a literary point of view you ought to read it.

"Have you ever read Renan's 'Life of Christ'? Oh that you ought to read—that's a fine book—That is to say," he added suddenly—then looking at me. "Yes I should think that you might read it, but it is a book that most young people are not allowed to see. It's considered awfully sacrilegious and so on. But after all since you haven't any of that conventional feeling to start with—Still of course if a man were known to have recommended that to a girl—Dear me what would people think? —Raising doubts taking away the young creature's faith etc. etc.

"I know the bored feeling one has just at the mention of the Bible—on account of the hushed voice that people use, and all that. But it really isn't so at all. It is splendid. You must certainly read it."

That is the gist. . . . I asked him if he had been brought up very much on the Bible." Yes." He said with his rather doubtful intonation. . . . "That is—not so very much—we always went to church and all that."

In the afternoon I asked him about the Sermon on the Mount. Whether he thought if one saw that kind of person. . . "Blessed are the poor in spirit" whether one would really admire them. "What do you mean," said he, "But you think that it isn't practicable?" "No, not that," said I, "But practically do you think that one would admire it?" "Yes, I do, certainly," said he. "That is to say, of course if it was a saintly person and not just a weak character."

I said "Yes, that is true." And a moment later he said "I think my sister Emily is very like all that, don't you?" I said I had just been thinking of her. "Yes she is." "Very beautiful, all that sermon," he went on. "I haven't read it for years. But I remember it as awfully lovely. Didn't you find it so?" Then he said I should find Epistles etc. awfully tiresome, just like an ordinary kind of sermon.[9]

The ideas of Ernest Renan were congenial to Sargent in many ways. Renan dedicated his best-known book, *La vie de Jésus*, to his older sister Henriette, who had been his special protector as he grew up and the financial support of a family mired in poverty and debt after their father's death when Ernest was five.[10] Later she continued to support him through his spiritual and intellectual struggles and development, and she experienced first the

religious doubts that led them away from institutional Catholicism. In 1861 Renan, by then a recognized expert in Semitic languages, headed a scientific mission to the Near East. Observing with his sister the scenes of the Bible, Renan was inspired to write the book that Sargent recommended to Lucia. The dedication read:

> To the Pure Soul of my sister Henriette who died at Byblos, 24 September 1861. Do you remember, from the bosom of the Lord where you repose, those long days at Ghazir where, alone with you, I wrote these pages inspired by the places we had visited together? Silent beside me, you reread each page and recopied it as soon as it was written, while the sea, the villages, the ravines, the mountains spread out before us. When the oppressive sun replaced the countless array of the stars, your keen and delicate questions, your discrete doubts, led me to the sublime object of our identical thoughts. You told me one day that you would love this book, first because it had been written with you, and also because it so pleased you. If sometimes you feared the narrow judgments of the frivolous against it, you were always persuaded that the truly religious souls would in the end be pleased with it. In the midst of these sweet meditations, Death touched both of us with his wing; fevered sleep took hold of us in the same hour; I alone awoke! . . . You are still asleep in the land of Adonis, near holy Byblos and the sacred waters where the women of the ancient mysteries mixed in their tears. Tell me, good spirit, reveal to me, whom you loved, the truths which conquer death, and keep it from being fearsome, yes, make it almost beloved.[11]

The human tragedy of Renan's beloved sister's death, just at the genesis of his controversial book, surely recommended the author to Sargent, whose closest lifelong friend and supporter was his own sister Emily.

Renan revered Jesus as "the one who has caused his fellow men to make the greatest step toward the divine. . . . Jesus is the highest of these pillars which show to man whence he comes, and whither he ought to tend. In him was condensed all that was good and elevated in our nature. . . . All the ages will proclaim that among the sons of men there is none born who is greater than Jesus."[12] And yet he was entirely human, not divine. This thesis was more than enough to earn Renan's work a place on the Vatican's *Index* of prohibited books.

Just as upsetting to religious authority was Renan's repeated insistence that the message of Jesus had been warped and degraded by his followers and their institutions. Even the Gospel of John, according to Renan, veered away from the pure simplicity of Jesus's message: "Gnosticism has already commenced. . . . We enter on the barrenness of metaphysics, into the darkness of abstract dogma."[13]

Jesus was not a founder of dogmas, or a maker of creeds; he infused into the world a new spirit. The least Christian of men were, on the one hand, the doctors of the Greek Church, who, beginning from the fourth century entangled Christianity in a path of puerile metaphysical discussions, and on the other, the scholastics of the Latin Middle Ages, who wished to draw from the Gospel the thousands of articles of a colossal system.[14]

It was only at the beginning of the third century, when Christianity had fallen into the hands of the reasoning races, mad for dialectics and metaphysics, that the fever for definitions commenced that made the history of the Church but the history of one immense controversy.[15]

For ages the Bishops have been princes and the Pope has been a king. The pretended empire of souls has shown itself at various times as a frightful tyranny, employing the rack and the stake in order to maintain itself. But the day will come when the separation [of church and state] will bear its fruits, when the domain of things spiritual will cease to be called a "power," that it may be called a "liberty."[16]

It is clear from Sargent's comments to Lucia that he found Renan's ideas compelling. Other aspects of *La vie de Jésus* would have hugely pleased Sargent the observer. Renan had discovered in Palestine how varied the landscapes were, and how beautiful. He explained his need to write his book: "The personality of the great Founder had risen very clearly to my mind as I perused the Gospels in Galilee itself."[17] Again and again in the text, Renan sets the person of Jesus in the context of his surroundings with word-pictures that evoke the delight that he and his sister shared in their discovery of the Holy Land. He tied the personality and development of Jesus to the beauty and mildness of his early surroundings.

A beautiful external nature tended to produce a much less austere spirit [than Jerusalem's]. . . . Galilee was a very green, shady, smiling district, the true home of the Song of Songs, and the songs of the well-beloved. During the two months of March and April the country forms a carpet of flowers of an incomparable variety of colors. The animals are small and exceedingly gentle—delicate and lively turtle-doves, blue-birds so light that they rest on a blade of grass without bending it. . . . In no country do the mountains spread themselves out with more harmony or inspire higher thoughts. Jesus seems to have had a peculiar love for them.[18]

The distillation of Renan's thought is this: "Whatever may be the transformations of dogma, Jesus will ever be the creator of the pure spirit of religion; the Sermon on the Mount will never be surpassed."[19] Early in his proj-

ect Sargent identified that moment as the climax of his cycle. Renan gave him a scene: "The God that Jesus found in the desert was not his God. It was rather the God of Job, severe and terrible, accountable to no one. Sometimes Satan came to tempt him. He returned, then, into his beloved Galilee, and found again his heavenly Father in the midst of the green hills and the clear fountains—and among the crowds of women and children, who, with joyous soul and the song of angels in their hearts, awaited the salvation of Israel."[20] This was the picture that Sargent had in mind for the Sermon on the Mount on the long east wall over the Boston Public Library stairs.

When Sargent visited the Holy Land in 1906 in preparation for his further work on his Library cycle, he was following in the footsteps of Renan. Visiting when he did, from November to January, he did not find quite the artistic inspiration he was searching for, prompted by Renan's almost ecstatic springtime descriptions. And his visit was cut short by the news of his mother's death. Sargent must have felt another kinship with Renan, who lost his beloved sister in that very land.

The Installations of 1895, 1903, 1916

When *The Israelites Oppressed* was previewed at the Royal Academy, the London reception was puzzled but favorable. Charteris understood why.

> It is a daring composition. Figures and symbols are crowded into the design, but the artist has maintained an astonishing coherence and mastery in the handling of his highly complex scheme. A fine solemnity is apparent in the design, and the figures, oppressors and oppressed alike, are keyed up to a pitch of dramatic intensity. . . . The academy public were very puzzled as to what it all meant. . . . There was no one to explain, and it certainly did not explain itself. Of this Sargent was well aware, and he wrote to Lady Lewis: "You seem to me really to like my decoration and not to look upon it as a hopeless conundrum as most people do. I was delighted to find that you got some pleasure out of it through your eyes and were not fidgetting about the obscurity of those old symbols. What a tiresome thing a perfectly clear symbol would be."[21]

When the wall was unveiled in Boston it gained immediate and almost universal praise.

> Out of the darkness of antiquity came the struggling Jewish religion through the prophets with the great lawgiver Moses in the center down to the advent of the Christian era. People said the artist must be a deeply religious man, others said only a poet could conceive of such a picture, and the balance of the

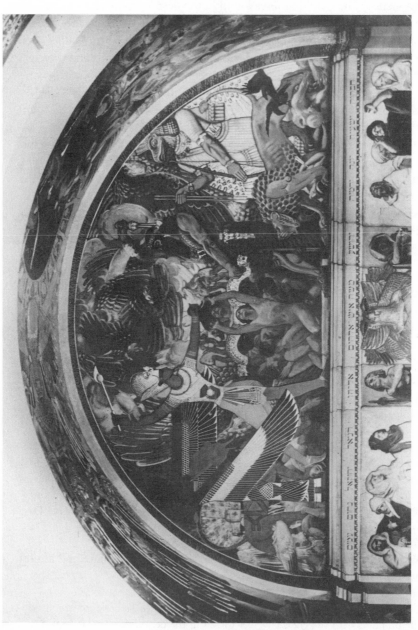

Figure 9.1. Sargent, *Israelites Oppressed*, Boston Public Library (installed 1895). The Jewish people suffers under the yoke of slavery, but mighty divine arms reach down to stay the deadly blows of the (archeologically correct) Egyptian and Assyrian oppressors. Below is the central panel of the *Frieze of the Prophets*; left to right we see: Amos, Nahum, Ezechiel, Daniel, Elijah, Moses, Joshua, Jeremiah, Jonah, Isaiah, Habakkuk. Courtesy of the Trustees of the Boston Public Library / Rare Books.

world just stood and admired the work. Sargent had risen far out of the realms of portrait painting: he had soared into the heights of splendid composition, of giving a vast idea picturesque expression in form and color.[22]

In critical and popular opinion Sargent's first installation was the success he had hoped for. He had earned a reputation as a serious artist and not a mere portraitist. *Israelites Oppressed*, without a narrative and without picturing a specific event, did suggest its meaning with multiple symbols that rewarded the observer's continued attention to all the details. For example, on first—or even on multiple—viewings of the lunette, it is not at all obvious, amid the exotic and evocative and archaeologically informed figures, that the hands of God reach out from the cloud of cherubim to stay the blows of the Egyptian and Assyrian oppressors on the people of Israel. Likewise the depiction of each of the prophets can be examined, on the human and the Biblical level, to understand his message of rage or promise. And the Biblical message can be read in a purely Old Testament sense, or as a foreshadowing of the New. So this wall can be satisfactorily viewed, according to the interests of the viewer, with a range of meanings or as an entirely decorative endeavor. And Bostonians and the wider critical world were inclined in 1895 to take both religious and artistic satisfaction from it on many different levels of personal understanding.

The second installation, in 1903, was the *Dogma of the Redemption* on the south wall of the hall, the wall that confronts the viewer at the top of the stairs. This work added acclaim to acclaim for Sargent. The immediate reaction to this section of the cycle was that "the new painting is pronounced very beautiful by art connoisseurs, but perhaps it will not appeal to the popular taste as much as the other paintings did. His motive is deep and symbolism plays an important part in it." In fact the Library provided leaflets for visitors (as they still do today) describing "what the artist sought to reveal."[23] But this section actually did not require the aids that some critics predicted. The depiction of the crucified Christ, below a triune God and above the angels carrying the symbols of Christ's sufferings, was understandable for the great majority of viewers, whether Christian or culturally educated. Although some details may have been unfamiliar, the whole could be understood as a rendering of Christian beliefs in symbols from a bygone era. For example, Charteris traces the motif of Adam and Eve collecting the blood dripping from the nailed hands of Christ to mentions of that rare trope in Emile Mâle's *Religious Art in France*, a book that was in Sargent's library when he died.[24]

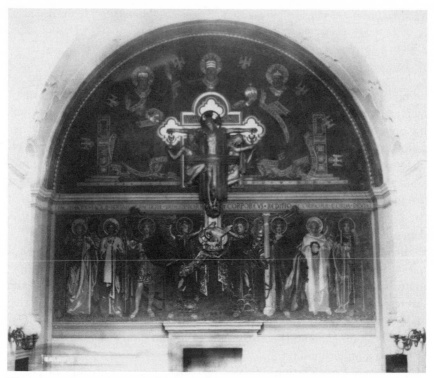

Figure 9.2. Sargent, *Dogma of the Redemption*, Boston Public Library (installed 1903). The God of medieval Christian dogma is portrayed as three identical persons wearing three different crowns, above a depiction of the crucifixion, the redeeming sacrifice. Adam and Eve collect Christ's blood and the pelican pierces her breast to feed her young. Below, a frieze of eight angels carrying the instruments of the passion. Courtesy of the Trustees of the Boston Public Library / Rare Books

Some liberal Protestants among his wide audience might have noted that this wall could be read as strongly critical of the medieval church, although that was not the general reception. The very name used by Sargent for the lunette, *Dogma of the Redemption* recalled Renan's critique of the institutional, theological smothering of Christ's pure message by *dogma* in the years and centuries after the crucifixion. Sargent used metaphorical images developed in the Middle Ages, but his choices out of the many possibilities reveal his own point of view.

The triune God appears in the form of three royal personages swathed in a single chasuble. God the Father wears the three-tiered "triregnum," the crown adopted by the papacy during the Babylonian Captivity (1308–1378) when the Popes lived far from Rome in Avignon. This was the period (Robert André-Michel's specialty) in which the papal secular government

excelled in fiscal acumen with advanced methods of taxation, while their political interests undermined their spiritual authority. The three tiers of this crown boasted sovereignty over secular princes, spiritual authority over all Christians, and temporal authority over the Papal States. The second person of the Trinity, the Son, on the Father's right hand, wears the Iron Crown of Lombardy that marked emperors-elect; and the Holy Spirit on the Father's left wears the crown of the later Holy Roman Empire, which was still the crown of the emperor of Austria when Sargent painted it. The identification of the Godhead with secular imperial government and with the least spiritual aspects of the Papacy illustrates Renan's point that the Church corrupted Christ's message by becoming a political power itself. Sargent was a teenager before the Popes had their last political dominion stripped forcibly from them by the nascent Italian state, and the coronation of a new pope was still a vivid reminder of papal political aspirations. Until 1929 the popes considered themselves "prisoners of the Vatican," rejecting the reality that they had indeed ceased to rule over a state.[25]

The very depiction of the three persons of the Trinity would have reminded the more free-thinking viewers of Renan's contention that the followers of Jesus had soon created "thousands of articles of a colossal system" that did not spring from his simple message, but rather confused, distorted, and encumbered it. They developed the details of their system in myriad symbols. Images of Adam and Eve collecting the blood of Christ and the pelican piercing her breast to nourish her young were parts of that system, benign and poetic as those images may have been. The angels who bear the instruments of the Passion of Jesus appeared first in paintings of the Last Judgment, carrying into that heavenly court the physical evidence of that murder to make the case against humanity. The Christian wall was as little an endorsement of a spiritual ideal as *Israelites Oppressed* was. It was, however, much more familiar and, like the Jewish wall, it lent itself to many readings. Was it an expression of the artist's own creed? A thoughtful writer to *The New York Times* tried to settle that question.

> I was much interested . . . about the amusing discussion held in a Swedenborgian convention concerning John S. Sargent's mural painting. . . . If the criticism . . . had resulted from a sincere attempt to understand the purpose of the artist, it would have been wholly praiseworthy. The appearances, however seem to indicate that, strangely enough, the liberal theology of these gentlemen has stood in the way of any sincere attempt to reach a disinterested judgment of the picture.
>
> Plainly Sargent has not attempted to paint a genre picture. He has painted a dogma, "the Dogma of the Atonement" as its title frankly proclaims. He has

detached himself in a remarkable way from his ordinary portraitist's manner, and has painted figures not of flesh and blood, but of pure idea. Sargent may be a Unitarian for aught I know, but that fact should not prevent him from painting such a picture as the "Dogma of Atonement" any more than the accident of Christianity should have prevented Michael Angelo and Raphael and their contemporaries and successors from going to Greek mythology for subject matter. The fact seems to be that Sargent has withdrawn himself to a wholly disinterested point of view, appropriating his material exactly as he found it, very much as a historian uses the materials of past ages, without bias and without distortion.

Certainly the Jesus of Sargent's picture is not the Nazarene of the New Testament but, let us repeat, Sargent is not painting Jesus: he is painting an idea which Mediaeval Christians formed about Jesus, which is distinctly another matter. In order to complete his series we may safely predict that the painter will give these hypercritical gentlemen an interpretation of the real Jesus of the lakes and fields. If the work which follows is as well done and as interesting as the "Dogma of Atonement" and its companion piece upon the opposite wall we shall have in the complete series a notable addition to mural and sacred art.[26]

Of course, Michelangelo's and Raphael's public included no Greek or Roman pagans, but Sargent's work was open to the judgment and criticism of all kinds of Christians—and Jews.

Thirteen years went by before Sargent returned to Boston with the third of his installations, which many well-informed observers expected to be his last. Instead, in 1916, as the War raged in Europe while the United States still remained neutral, Sargent installed the six ceiling lunettes and the Marian arch adjacent to the *Dogma* wall. They were greeted with general enthusiasm. The three lunettes of the weighing of souls and souls being sent off to heaven and hell were familiar, clear, and uncomplicated. The three lunettes across from them suggested the idea of Israel, pictured as a young child, receiving the Law from God, flanked on the left by the fall of *Gog and Magog*, and to the right by the *Messianic Era*. Each of these required the viewer, whether expert or amateur, to reach for the Library leaflet for help in understanding Sargent's original and idiosyncratic iconography. His representations of the Virgin Mary could have been found in any Catholic church in Boston; they were surely and sympathetically understood by the wider Christian community. Any Protestants who rejected the Catholic cult of saints to the point of being offended at the multiple representations of the Virgin could assign this strip to the category "of historical interest only."

Figure 9.3. Sargent, *Messianic Era*, Boston Public Library (installed 1916). In 1916 Sargent brought the canvases of the Marian arch and the six ceiling lunettes to Boston. In *Messianic Era* Sargent painted the prophecies of Isaiah, showing the Messiah as a youth, the prince of peace, who strides out, leading humankind into the new paradise of peace and plenty. A wolf plays with a lamb, lower left, while to the right a little child pulls on a lion's mane. Symbols of fruitfulness—pomegranates, vines, fig leaves, gourds—frame the scene. Courtesy of the Trustees of the Boston Public Library / Rare Books.

After the unveiling of the 1916 installations, *The New York Times* featured a long appreciation in its arts pages, concluding with unstinting praise:

> This is the chief characteristic of the series of decorations now presented to public view: fitness of the parts to the defined scheme and fitness of the scheme to convey noble thought. The various sections of the decoration yield to nothing in America in actual artistic beauty, and their appropriateness to the emotional state to be expressed gives to the whole a distinction and style and depth of feeling unsurpassed in modern work.[27]

Sargent's biographer William Howe Downes was there as a critic for the unveiling of the last installations. He surveyed the informed contemporary opinion and made his own perceptive summation:

> The pronounced originality of the decoration was recognized by all observers. In no respect was it more remarkable than in the fertility of invention. Old ideas were invested with new forms. They were composed, related, and combined in a thrilling ensemble. The final impression was of a work of prodigious ability and scholarship. The ancient traditions and doctrines were presented with a new note of eloquence, an accent preëminently personal and modern, but with more scientific and literary elegance and philosophical assent than naïveté. Wrought with all the resources of a great and shining talent, the tremendous scheme was carried out with an intellectual and aesthetic grasp of the highest order, with richness and splendor and unity. If it lacked the impassioned conviction and the ingenious simplicity of the age of faith which gave birth to the mural paintings of the Renaissance, this was not to be imputed to the painter as a fault; he was, as always, himself, sincere, unassuming, genuine; and all one could do was to accept gratefully what he had to give.[28]

Synagogue and *Church*, 1919

Sargent had put up his Library decorations of 1916 and rested, as he had done after each of his installations. He had, however, already done preliminary sketches of his plan for the final large east wall over the stairs. His original idea, that the Sermon on the Mount would cover the entire expanse, had given way to a modification, in which a narrower Sermon would be flanked by two framed pictures, on the north and south ends of the wall, that would bring the metaphorical narrative to a conclusion by representing the two traditions that Jesus surpassed with his sublime teaching.

Sargent had originally included personifications of Church and Synagogue, a common medieval trope, among the symbols that adorned the ceiling molding. When he reduced the wall space that he would devote

to the Sermon on the Mount to the central section of the stair wall, he identified *Church* and *Synagogue* as the allegorical pendants that he wanted to flank that space. He announced to Fox that he would be returning to Boston with those images, "We expect to sail on the 'Olympic' about the 12th or 15th of April. . . . I have been working lately at two designs for the two shrines at the Library and will bring them over and see how they look of a Sunday morning."[29] Accompanied by Emily and his niece Reine, Sargent arrived in Boston with the panels, possibly not in their final state; it was only in October that they were unveiled in the frames that Sargent had prepared for them. The two paintings are subdued, almost grisaille, in contrast with the bright colors and gold highlights of the other murals. *Synagogue* is portrayed as a powerful old woman, blindfolded, collapsed in the ruins of the Temple. The symbols of Synagogue's power are destroyed. Her emblematic crown, the crenellated city wall of Jerusalem, is tumbling off, and she clutches to her bosom her broken staff and the tablets of the Law. To the viewer's right, *Church* is a heavily mantled young woman seated in majestic solemnity on a cosmatesque cathedra. She holds the host and the chalice, her hands correctly shrouded with an altar cloth so as not to touch the sacred vessels. The allegorical figures and names of the evangelists surround her as she stares impassively forward. The body of the dead Christ is supported between her knees.

Sargent was familiar with many medieval representations of the pair, and he probably discussed the iconographical tradition with André Michel, a profound expert who had taken particular note of the *Eglise* and *Synagogue* in the cathedral of Reims. Emile Mâle's *L'art religieux du XIIIe siècle en France*, in Sargent's own library, provided a plentiful background.

By His death Jesus not only founded the Church, but abolished the authority of the Synagogue. At the very hour when He gave up His spirit on Calvary, the Jewish church with her sacrifices of blood which were symbols and with the Bible whose meaning she did not understand, faded away before the newly created church of Christ. . . . The defeat of the Synagogue and the victory of the Church at the foot of the Cross had been too often celebrated by theology for the thirteenth-century artists . . . to fail to include them in their representations of the Crucifixion. To the right [hand] of the Cross they placed the Church, to the left the Synagogue. On the one side the Church, crowned and wearing a nimbus and with a triumphal standard in her hand, receives in a chalice the water and blood that flow from the Savior's side. On the other side the Synagogue with blindfolded eyes, her crown falling from her head, still grasps in one hand the broken staff of her standard, and lets fall from the other the tables of the Law. The attributes given to the Synagogue were taken from

a passage in Jeremiah which was applied to her by the Middle Ages: "Woe to us," said the prophet, "for we have sinned, *our eyes are covered with darkness, our heart has become sad, and the crown has fallen from our head*." . . . In the eyes of the theologians Mary is not only the mother of Jesus but is also the personification of the Church. . . . Mary, they taught, symbolized the Church in almost all the circumstances of her life, but especially at the moment when she stood at the foot of the Cross. . . . A miniature in the *Hortus deliciarum* represents the Crucifixion in all its symbolic detail. To the right of the Cross are seen the centurion, the Virgin Mary, the penitent thief and lastly the Church, figured as a woman riding a hybrid animal in whose four heads the emblems of the evangelists can be recognized. To the left are the man with the sponge, St. John, the impenitent thief and lastly the Synagogue mounted on an ass, that obstinate beast which when it should go forward draws back. The general meaning is given by the rent veil of the Temple placed at the top of the composition, clearly showing that the subject is the substitution of the New for the Old Law.[30]

In the very rough sketches that we have from Sargent's first thoughts on the subject, it is possible to see that he was trying out different representations of the two allegorical figures: sometimes young, sometimes old, sometimes seated, sometimes mounted, enthroned, overthrown. In the sketches, Synagogue is identifiable by her toppling crown and bandaged eyes. Sargent's ideas for Church and Synagogue remained unfixed until he took up work on them again when he was finishing *Gassed*. For him, bandaged eyes had come to suggest blinded soldiers and Rose-Marie at Reuilly, and the medieval significance of that image, the failure of the Jews to recognize the Messiah when he came, receded to the background of his thinking. Sargent engaged with this next step of his mural project with the personal need, born of sorrow, that had been the impetus of *Gassed*. As with the earlier Library images, what he would paint now layered many sources and ideas—but tangled with the art-historical and intellectual, there is a new thread, Good Friday 1918, woven through the two paintings.

Synagogue is shown at the moment on Good Friday when Christ died, according to Matthew 27:51–52: "And, behold, the veil of the temple was rent in twain from the top to the bottom; and the earth did quake, and the rocks rent; and the graves were opened." It is the veil of Solomon's Temple, as Sargent had designed and hung it to curtain the *Synagogue* frame in 1916, and as it was described in *Chronicles* 3:14: "And he made the veil of blue, and purple, and crimson, and fine linen, and wrought cherubim thereon."[31] The heavy embroidered material is torn and a great fold of it wraps the slumped figure of Synagogue.

Figure 9.4. *Synagogue* and *Eglise*, Reims Cathedral (13th century). In medieval Christian art, these allegorical women stood for the new and old queens of the Chosen People of God. Church with her staff stands erect, her crown stable, the chalice of redemption in her hand. Synagogue was sometimes treated sympathetically, as here at Reims, but her reign has ended: her crown is falling, her staff broken, her eyes blindfolded, meaning that she did not recognize Jesus as the Messiah. Paul Vitry, *La cathédrale de Reims*, vol. 2 (1919), plate LIV.

The stones of the temple roof, rent by the earthquake that Matthew describes, have fallen onto the floor around her. It is the scene of Saint Gervais on that other Good Friday.

Promey connects Sargent's *Synagogue* artistically with Michelangelo's *Cumaean Sibyl* in the Sistine Chapel; the noble, knowing profile and the muscular arms of that seer are unmistakable.[32] The Cumaean Sibyl, in Virgil's *Fourth Eclogue*, predicts the dawn of a golden age associated with the coming of a boy, just such as Sargent had painted in *Messianic Era* (figure 9.3), and whom medieval Christian writers had identified as Jesus. More broadly, Virgil's Cumaean Sybil foresees an age of peace and prosperity, of advancing

Figure 9.5. Sargent, *Synagogue*, Boston Public Library (installed 1919). Sargent's *Synagogue* has her medieval attributes: the blindfold, tumbling crown, broken staff, and tablets of the Law. But she has the keen face and the powerful arm of a seer, Michelangelo's *Cumaean Sibyl*. It is the first Good Friday, and she is falling in the ruins of the Temple in Jerusalem. Courtesy of the Trustees of the Boston Public Library / Rare Books.

civilization, of man and nature in harmony.[33] That message had resonated in Sargent's lifetime but had been drowned out by the Great War. The collapsed figure of the Synagogue in the guise of the Cumaean Sibyl marks the end of human progress, the collapse of the European civilization that Sargent had loved and had seen crushed in Saint Gervais.

Church also tells a story beyond what her medieval attributes suggest. The usual medieval figure of Church was a noble young woman, standing crowned and holding a banner. But Sargent's *Church* is also a Pietà. In the usual Pietà, the body of Christ lies across the lap of Mary,[34] but here the dead Christ slumps between Church's knees, his lifeless arms hanging over her

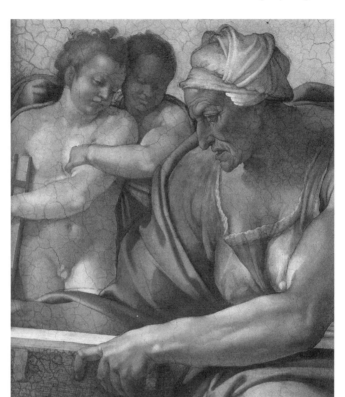

Figure 9.6. Michelangelo, Sistine Chapel *Cumaean Sybil*, detail. The prophecy of the Sybil of Cuma is found in Virgil's *Fourth Eclogue*: she foresaw the dawn of a golden age associated with the coming of a boy like the one Sargent painted in *Messianic Era*. Medieval Christian theologians identified Virgil's Boy as the Messiah, Jesus. Open-source image.

thighs. Sargent had an authoritative source for this iconographic variant. In 1902 Isabella Stuart Gardner, who discussed with Sargent his ideas for the murals, had acquired one of her great treasures, a drawing by Michelangelo portraying Mary with the dead Christ in very much the pose that Sargent used. As Mâle had pointed out, the person of Mary is a type of the Church; but in Christian allegory, Church is the "bride of Christ."[35] Sargent's figure may be seen simultaneously as Mary the mother of Jesus and as Church the spouse (and here, the widow) of Christ. Just as *Synagogue's* artistic antecedent, the Sistine *Cumaean Sybil*, referred to a deeper meaning in Virgil's *Fourth Eclogue*, so a text is associated with Michelangelo's *Pietà* that Sargent echoes so clearly in his *Church*. In the Gardner Michelangelo *Pietà*, the upright beam of the cross bears the words from Dante's Paradiso, *Non vi si pensa quanto sangue costa*: "There they don't think of how much blood it costs."[36]

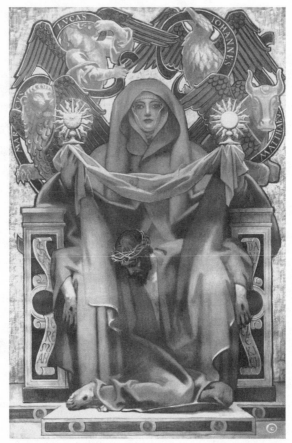

Figure 9.7. Sargent, *Church*, Boston Public Library (installed 1919). Sargent portrayed Church as an enthroned Pietà, holding the host and chalice aloft and supporting the dead Christ between her knees. The photograph, taken at the time of the installation, shows the names of the evangelists Matthew and Luke reversed. Sargent was preoccupied with other concerns when he made that mistake. Courtesy of the Trustees of the Boston Public Library / Rare Books.

Promey identifies the solemn features of the young woman as those of Rose-Marie. Perhaps so, but a Rose-Marie stylized out of recognition. Church stares forward solemnly, her mouth as still and expressionless as that other one of Reims. And Rose-Marie's face was always so lively with charm and humor, smiling or about to smile. Sargent would have considered it pathetic and tasteless to portray anyone he knew recognizably on that wall, and much more so his beloved niece. But whether or not Sargent was recalling his Rose-Marie with a stylized image, he referred to her clearly by attributes in the dress of *Church*. The figure is swathed in a great mantle,

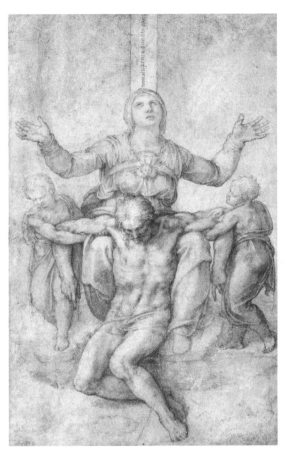

Figure 9.8. Michelangelo, *Pietà*, black chalk on paper. This Michelangelo drawing was a particular treasure in Isabella Stewart Gardner's collection. The quote from Dante in the upright of the cross reads, "Down below they do not know how much blood it costs." Sargent adopted this pose of Mary, with her raised arms and the dead Christ slumped between her knees, for his depiction of *Church* on the Boston Public Library wall. Courtesy of The Isabella Stewart Gardner Museum, Boston.

but below, that her face is framed with a wimple, the medieval headcloth still seen on some traditionally garbed nuns and at that time also worn by some nurses, and by the *diaconesses* of Reuilly. And below that we see the broad lapels of a grey army greatcoat, the hand-me-down winter gear of a nurse in the Great War.[37] The figure is Church, it is Pietà, and it is also Rose-Marie, martyr's widow and military nurse. In a preparatory sketch for *Church*,[38] Sargent left the garment under her mantle hard to identify, but it could be a Red Cross–style cape with button closures in front. In the sketch the torso of the corpus is clothed in a shirt with a high military collar, the

Figure 9.9. Sargent, sketch for *Church*, 1918. Sargent was musing about a war-memorial Pietà, with a soldier dead of wounds instead of Jesus taken down from the cross. The figure of the dead man wears a soldier's uniform shirt with its standing collar and breast-pocket flap, sleeves rolled up. There are no nail wounds, and there is a bandage instead of the crown of thorns. Photograph © 2014 Museum of Fine Arts, Boston.

sleeves rolled up to the elbows, the head bandaged, no crown of thorns, no marks on the hands. This was not the crucified Christ taken down from the cross, but a soldier dead of wounds. Sargent wanted a seated Church rather than the more usual standing one because he wanted his Church also to be a Pietà, a war memorial, his *tombeau* for his own dear Rose-Marie and her own dear Robert, the victims of the War for whom he grieved. On further thought, of course, he knew that he could not put that vision up on the wall of the Boston Public Library because it was too nonce, personal, and pathetic, and his aim was timeless monumentality.

But all this was below the surface, Sargent's private thread in the tapestry of artistic allusions. The earliest descriptions of the new panels gave a benign account of the pieces, one guessing that *Synagogue* was "in the ruins of the

temple in Jerusalem after the Romans under Titus had destroyed the city and taken the people into bondage. All that was left the Jews at the moment was that intangible but dominating spirit of their religion that was imbedded in the Ten Commandments."[39] Many Jewish leaders, however, found the painting offensive to modern Jews and their synagogues. A controversy erupted, beginning with rabbis in Detroit who declared that the murals were an affront to their religion.

> The crux of the controversy lies in a difference of opinion as to whether Sargent's picture is an adequate, impartial and acceptable representation of the theme. . . . Jewish critics declare that the powerful form of the aged woman, in the first place, does not represent fitly the synagogue, and that the figure employed preferably should be a man with a flowing beard. In the second place they deny that the condition set forth in the painting is indicative of the position of the synagogue in Jewish life.[40]

The controversy spread. An angry citizen threw ink at the *Synagogue* panel. Christian pastors took the side of their offended Jewish counterparts, and politicians followed. The sound and fury reached a crescendo when the Massachusetts state legislature actually passed a bill requiring that the painting of the Synagogue be taken down. In all of this Sargent remained silent, after pointing out to a Jewish delegation that his symbolism was that of the medieval representations of the theme as seen in "Rheims, Notre Dame, Strasburg and other cathedrals."[41] Those three were just the cathedrals that André Michel had identified in *Les villes martyres* as having the loveliest examples of the symbolic sisters *Eglise* and *Synagogue*. Sargent's paintings resemble none of those sculptures except in the bandaged eyes and falling crown of his *Synagogue*. But Sargent never answered criticism of his work. He would certainly not engage in this dispute.

Liberated from Theology

As the Synagogue controversy carried fruitlessly on, Sargent's position among the socially and artistically prominent strata of Boston was not harmed or even reduced. His surviving letters note a constant round of lunch and dinner engagements, of visits, concerts, and theater. He and his sister Emily often occupied the seats of the ailing Isabella Stewart Gardner in Symphony Hall.[42] They must have been immediately recognizable: the stout, grizzled six-footer gently squiring his petite, bowed sister. Sargent frequently laments the need to turn down an invitation because he had already been booked elsewhere, for instance a dinner in Ignaz Gaugengigl's studio.[43] Nor had Sargent's status as an

artist suffered. He was finding more work, and work that he relished: his murals for the Museum of Fine Arts. In fact his Museum commission was enlarged to include more panels around the staircase. According to Fox,

[U]ndoubtedly one of the reasons why Sargent became more and more interested in decoration as time went on was the fact that it offered much more diversion than mere painting, for such work afforded a much broader field of activity than that of portrait or landscape. Even in the first installment of his work in the BPL he introduced the element of relief and as time went on he employed this expression more and more until in his later work, it became almost, if not quite, as important as the use of mere painted surfaces.[44]

For five years the Museum work was a constant pleasure to him, and it shows. He relished the tests that he set for himself in perspective—figures on curved or flat surfaces, directly or diagonally over the viewer's head—and in nude figures, an aspect of his art that he had never before sufficiently explored. With a straight face he could top the allegories of Puvis with such panels as *Architecture, Painting, and Sculpture Protected by Athena from the Ravages of Time*.[45] The Greco-Roman pantheon had been absent from his representations of paganism in the Boston Public Library, but those gods and goddesses and minor immortals totally populate the murals in the Museum of Fine Arts. And there was nothing for him to explain or defend about their symbolism: that had been one of the major jobs of Western literature for most of two millennia. Among the four painted, plaster, bas-relief panels that are like delicately enlarged cameos, we find not one, but two, of the Three Graces. Another muralist might have captioned them with the lines from two different Odes of Horace, "The lovely Graces tread the ground, each foot in time," and "Grace with her twin sister nymphs dares to lead the dances nude."[46] Sargent in 1921, liberated from *all* theology, said, "Oh, they're three blokes dancing."[47]

In 1920 he was offered yet another mural commission, this one for two panels in Harvard's Widener Library to commemorate the war effort of Harvard men, and he readily accepted. The Harvard panels, completed in 1922, have been unkindly disparaged as YMCA posters. They certainly are crowded with patriotic symbols. The right-hand panel depicts the massed marching soldiers that Sargent had found inspiring in France in early October of 1918. Under a huge waving Stars and Stripes and a screaming American Eagle, the clean, young, American doughboys (still wearing the floppy tropical campaign hats of the Spanish-American War and Black Jack Pershing's Mexican Expedition) cascade down the canvas from the blue sea that

carried them "over there," giving helping hands to three allegorical ladies: grey, gaunt Marianne in her Liberty cap clutching her orphan babe and her fallen husband's bayonet;[48] moribund Belgique with her broken sword; and helmeted Britannia, robed in khaki. The left-hand mural shows an American soldier striding forward on the battlefield, embracing Victory in his right arm and in his left, Death, who drags at his neck. Victory has the wings of the emblematic American Eagle, and she brings a martyr's palm and a victor's laurel crown. Trumpeters above herald the triumph, one in khaki kilt and wreathed in the banderole "Victory and Death." Dead soldiers, including the German machine gunner whom the Harvard lad has killed with his unmounted bayonet, sprawl underfoot. It is an idealized image of Vierstraat Ridge. The two paintings have captions that Sargent worked out with President Lowell of Harvard:

> They crossed the sea crusaders keen to help
> The nations battling in righteous cause.
> Happy those who with that glowing faith
> In one embrace clasped death and victory.[49]

The Boston Public Library controversy died down. The bill to remove the Synagogue panel was quietly repealed. But for Sargent, after *Church* and *Synagogue*, the rest is silence. The great grey wall between the two allegories remained and remains blank. The Jewish controversy had made it impossible for Sargent to finish his program as he had planned, with the Christian "triumph" of the Sermon on the Mount, but perhaps that was a relief to him. Perhaps he no longer believed in the progress that was to have reached a climax on that panel, and now he did not have to paint it, for reasons beyond his control. Although he had not fulfilled his last commission, and did not take his fee for it, he considered his Library work at an end.[50] In London in 1925, when the last Museum of Fine Arts panels were ready to ship, he said to Adrian Stokes, "with a gay smile," "Now the American things are done; and so, I suppose, I may die when I like."[51]

CHAPTER TEN

~

Epilogues

Saint Gervais Rebuilds and Remembers

Because it is an historic monument, the fabric of the church of Saint Gervais belonged, and belongs, to the Ville de Paris. Just as Reims had done, Paris undertook the complete restoration of her treasure without waiting for peace. At the direction of Jacques-René Hermant, chief architect of the city,[1] carpenters shored up the lintel plate of the broken wall with a row of pine poles, replaced the broken and dislodged timbers of the *forêt*, and built a wooden barrier to separate the undamaged east end, between the pulpit and *banc d'oeuvre* and the apse, from the damaged western bays of the nave. Payment of 70,000 francs was approved for those works on 20 August 1918.[2] On Saturday 5 October the east end was reopened, not only for the parish but for the civilized world. "Everyone who passes through Paris comes to visit Saint Gervais and prays in union with the victims of the murderous bomb."[3] Hermant pressed on with the rebuilding of the vault. The best stained glass, which had been taken down for safety early in 1917, was restored and replaced; that work was finished and the bill of 371,000 francs paid on 27 April 1920. When the 500th anniversary of the church came in October 1922, the reconstruction was complete, and it was seamless. Visitors today will spot the new stonework only if they know precisely where to look, and if they look patiently.

A memorial in the church for the victims of Good Friday 1918 was proposed and approved on 28 May 1919. The second chapel from the west end on the south aisle, already the memorial chapel of the dead, was the

appropriate place. Some incinerated relics of the bombing had already been placed under the floor of that chapel. Over the chapel altar, where the crucifix is placed by custom, there is an original marble sculpture: as a procession of faithful women approaches from the left to venerate the crucified one, a swirling cloud of victims, women and children, rises from stone debris on the right and Jesus extends his arms in welcome. The altar is crowned by a brilliant stained-glass window unshaded from the midday sun (Color 14). Surrounding the marble sculpture there is an arc of white glass bordered by ninety-two linked yellow roundels, each containing a white cross on a red field. The violet legend within the arc reads AMEN DICO TIBI HODIE MECVM ERIS IN PARADISO,[4] the words of Jesus to the penitent thief crucified with him, "Verily I say unto thee, today thou shalt be with me in paradise." Above this is a gold and yellow sunburst that reaches to the clouds crowded with cherubs. In the three panels that fill the point of the arch are Christ in majesty, his mother on his right hand, and on his left that penitent thief himself (named Dismas in legend). Marble panels to the left and right of the altar give the names of ninety-two victims in alphabetical order.

André Michel at Montmorency, 12 October 1925

André Michel's losses in the War broke his heart. When it was over he took up the interrupted *Histoire de l'art* and continued his critical articles and his lectures in the Ecole du Louvre, then became professor of the Collège de France, but his friends noted that the liveliness was gone from his conversation and his writing. He had felt himself possessed by sorrow from the time of his son's death, as he wrote to Paul Vitry, "Every morning one must climb again onto the machine, and every day the burden of pain is heavier."[5] In 1920 his profile was taken in bronze by Paul-Marcel Dammann: one would guess that he was eighty, not sixty-seven.[6] His sixteen-year-old grandson Max Vermeil died suddenly in February 1922, a new sorrow for the war-ravaged family. After the second funeral of his cherished Rose-Marie that November, "when he came back from Montmorency, he was an old man."[7] He wrote no more for *Gazette des Beaux-Arts*, resigned his professorship, and withdrew into the family, then into himself.

As the sun, setting in the Alps, puts into shadow first the valley, then the hillside, then the glacier, and seems to pause before snuffing out on the rocky peak, our friend's shining intelligence declined and he gradually gave up his

vibrant public teaching, then the work of his study, the customs of home life, familiar friends, and his dearest loves, and then paused at the summit of memory, the cradle. "My mother is waiting," he said, and slept.[8]

He was seventy-two, and it was the anniversary of Robert's birth and death. The family tomb of André and Hélène Michel is number 169 in the Cimetière des Champeaux, rue Galliéni, Montmorency. It is a speckled grey and black granite witness to the firm and loving ties that kept their three elder daughters within the family circle and that embraced their husbands, the Michels' *beaux-fils*, Vermeil, Leenhardt, and Monod.

<div align="center">

ANDRE MICHEL
1853 – 1925
MEMBRE DE L'INSTITUT
PROFESSEUR AU COLLÈGE DE FRANCE
CONSERVATEUR HONORAIRE DES MUSEES NATIONAUX
OFFICIER DE LA LEGION D'HONNEUR

—

MAX VERMEIL
7-11-1905 – 21-2-1922
(Ps. 130 v. 6)[9]

—

HELENE ANDRE MICHEL
NEE CROSNIER DE VARIGNY
25 SEPTEMBRE 1858 – 4 DECEMBRE 1936

—

EDMOND VERMEIL
29-5-1878 – 14-4-1964

—

MADELEINE VERMEIL
NEE MICHEL
28-10-1882 – 9-6-1974

—

MAURICE LEENHARDT ET JEANNE NEE MICHEL
1878 – 1954 1881 – 1970

—

PASTEUR DANIEL MONOD ET SON EPOUSE MARTHE MICHEL
1885 – 1955 1886 – 1974

</div>

Marguerite Ormond at La Tour-de-Peilz, 11 February 1925

The person closest to Rose-Marie throughout her brief life was the domineering grandmother who had brought her up from infancy. With Louis Ormond's death in 1901, Marguerite became the matriarch of the family and the fortune. She ruled her little family with a stern sense of decorum and of her undisputed primacy.

Her granddaughters Marguerite and Rose-Marie were her joy and the fairy princesses of her palaces and gardens until they outgrew those fancies and departed, one to the asylum and the other to marriage and Paris. Their youngest sister Reine had her turn under Bonne-Maman's wing. In the poem "Royauté," dedicated "to a little girl named Reine," she is told that her given name obliges her to seek a diadem, but that each jewel will have to be won by her good deeds. Early in 1924, Reine's future husband, Hugo Pitman, called at the avenue du Bois to ask Madame Ormond for permission to court Reine. He was shown in to Madame senior rather than to the other Madame Ormond in residence, the one he had in mind, Violet. And when Bonne-Maman heard the reason for the call, she did not include Violet in the discussion, but made her own decision, based on his soft Scottish accent, a reminder of the Auld Alliance that trumped her usual anti-British biases.[10]

As Madame Ormond senior aged and grieved her losses, she took refuge in a fairyland like the ones she had encouraged her grandchildren to imagine when they were little. She realized just what she was doing.

> Prologue, 5 May 1922
> That I may induce you to believe in the power
> of fairy dreams, born of the wind in the reeds,
> know that the hour when I write this fable
> marks on the sundial my seventy-five years,
> and if I keep my youthful spirits,
> it is because I relish the secrets of the little animals,
> I wander about with the elves,
> I sleep between the earth and fairyland.[11]

She died in 1925 and was buried beside her husband in the cemetery of La Tour-de-Peilz. Their granite and limestone monument is in the form of a miniature open neoclassical temple with six columns supporting a coffered ceiling and pitched leaded roof. The architrave is decorated with alternating cherub heads and skulls. Louis Ormond's inscription is carved in square capitals on the west face of the tomb:

MICHEL LOVIS
ORMOND
NE A VEVEY
LE 14 IANVIER 1828
MORT A PARIS
LE 14 AVRIL 1901

His epitaphs, also in French, are on the south face in two panels with his LO monogram between them: "You see in me what you will become, reduced to dust; I can do nothing; therefore beware and live wisely." "All flesh is as grass, and all the glory of man as the flower of the field." (Isaiah 40.6). Louis Ormond's last word is his motto, IAMAIS ARRIERE, "Never behind."

Marguerite's inscription is on the east side,

MARIE MARGVERITE
ORMOND RENET
NEE A VERSAILLES
LE 5 MAI 1847
DECEDEE
LE 11 FEVRIER 1925

It is followed by that of the only grandchild who had stayed near her:

ET SON PETIT-FILS
JEAN-LOVIS ORMOND
NE A SAN REMO
LE 22 NOVEMBRE 1894
DECEDE A CORSEAUX
LE 29 OCTOBRE 1986

The north face of the monument is marked with her monogram MO and bears the epitaphs "Be ye kind to one another, tenderhearted, forgiving one another (Ephesians 4.32)" and "Mark the perfect man, and behold the upright: for the end of that man is peace (Psalm 37.37)." Then her motto PENSEZ FORT, "Think strongly!" reminds us of the intellectual power that she admired in her mother and wished her own princesses to have in their own lives.

John S. Sargent in Brookwood Cemetery,
Woking, 15 April 1925

"Now the American things are done," said John Singer Sargent to his colleague Adrian Stokes, "and so, I suppose, I may die when I like."[12] He may have put a stress on the "I" if he was remembering the dying anxiety of Edwin Austin Abbey that his Pennsylvania Capitol Building mural, hanging on the scaffold in London, should be properly finished.[13] And the senior member of that painting triumvirate of the Boston Public Library, Pierre Puvis de Chavannes, had written, "I am dreaming of the day when I shall have finished my Pantheon series. It seems to me that then I shall have nothing to do but to lay me down and sleep."[14] And luckily enough, Puvis did supervise the last touches to *La veillée de Sainte Geneviève* before locking up his Neuilly studio and going home to die on 24 October 1898.

For Sargent too, his monumental public commissions were always in his consciousness and on his conscience until they came to their end, and then he was ready to rest. Overexerting his heart by taking an energetic hand in the labor, he crated up at Fulham Road the last mural paintings for the Museum of Fine Arts, and loaded and consigned them for shipment to Boston. On 14 April 1925 Emily gave a bon-voyage dinner at Carlyle Mansions for her brother, their sister, and a few select friends, and John died that night in his sleep at Tite Street.[15]

His sisters buried him in a private ceremony at Brookwood Cemetery near Woking. Then, as a member of the Royal Academy and the honored center of many circles of friends, professional colleagues, and a still "Sargentolatrous" public, he received a full-dress memorial at Westminster Abbey.[16] The Brookwood grave is marked with a plain, timeless stele and an inscription that cannot be improved:

<div align="center">

LABORARE EST ORARE
JOHN S. SARGENT R.A.
BORN IN FLORENCE
JAN 12th 1856
DIED IN LONDON
APRIL 15th 1925
ALSO HIS SISTER
EMILY SARGENT
BORN JAN 29TH 1857
DIED MAY 22ND 1936
HE GIVETH HIS BELOVED SLEEP

</div>

Whoever chose it, that motto of the Benedictines, "to work is to pray" is the perfect epitaph for Sargent. Thomas Fox, the professional colleague closest to him in his last years, considered hard work the keynote of Sargent's character and the foundation of his success. Fox's memorial essay ended with a similar epitaph: "John S. Sargent, 1856–1925: creator, draughtsman, painter; in the truest sense of the word, a gentleman; but finally above all (and I firmly believe he himself would like best to be known) a master workman." [17]

The Tomb of the Spouses at Crouy

Rose-Marie's second funeral, like her first, was on a day of rain and bitter cold, 3 November 1922. André Michel and Edmond Vermeil escorted the sealed casket with Rose-Marie's remains by road from Montmorency to Soissons. There they met the other mourners, who had come on the 8:50 train from Gare du Nord: Robert's mother Hélène, her sister Pauline Franckfort and her brother Henry de Varigny with his wife Blanche, Robert's sister Juliette with her husband René Bouvier, Daniel and Marthe Monod, Georges Gendarme de Bévotte, Marguerite Massigli and her sons Jacques and René, Violet Ormond with Reine and Conrad, and a blind instructor from the Reuilly hospital, Mme Villard, with her husband. The cortège climbed Montagne Neuve to the farm called Le Meunier Noir and there placed Rose-Marie beside Robert in the soldier's grave some 330 yards from the spot where he had been killed eight years before. Pastor Monod offered a prayer.[18]

The mourners drew comfort from the monument, movingly modest and poetic, that André Michel had put in place there (Color 15). His Institute colleague Emmanuel Pontremoli designed and sculpted it, and it had been installed, surely with the cash support of Marguerite Ormond, early in October.[19] Built of blocks of the coarse golden limestone that is quarried in the nearby hills, the monument stands above the double grave, which is surrounded by a low coping of the same stone and planted with a flourishing rose bush. The inscriptions and the symbolic images were devised by André Michel, and they are cool and noble, deeply touching memorial poetry. The only religious symbol is the outline of a cross on the front, and this is filled with two twining limbs of ivy with their leaves and berries (meaning faithful love) in flat relief. The roots of the two ivy plants hang below them, uprooted. Below the arm of the cross on the visitor's left is the inscription,

ICI REPOSE
ROSE-MARIE R. A. MICHEL
NEE ORMOND

INFIRMIERE VOLONTAIRE DES
AVEVGLES DE GVERRE
TVEE LE VENDREDI St A L'EGLISE St GERVAIS
BOMBARDEE PAR LES ALLEMANDS
5 NOV 1893 – 29 MARS 1918

Below that inscription, a funeral offering is carved on the front, side, and back of the stone block: the branches of a rosebush crowded with blooms.

To the right we read,

ICI REPOSE
ROBERT ANDRE-MICHEL
MEMBRE DE L'ECOLE FRANÇAISE
DE ROME
SERGENT AV 204. Rt D'INFANTERIE
MEDAILLE MILITAIRE – CROIX DE GVERRE
MORT AV CHAMP D'HONNEVR
12 OCT 1884 – 13 OCT 1914

And below that, a block carved with boughs of laurel. The back of the monument is inscribed with quotations from Robert's *Carnet* and from Rose-Marie's last letter to him.

The *Tombe des Epoux* stands beside the road that leads to the farm called Meunier Noir on Montagne Neuve. To the west the ground falls off in a thick wood, but north and east the vista widens onto open fields stretching out to the high ground of Hill 132 in the distance. Now the trenches west, north, and east of the road, where Robert was leading his men, have all grown over, but traces of the war—shelter dugouts and bomb craters—remain in the tangle of trees and undergrowth, and in the old quarry caves that were sometimes shelters and sometimes traps to the men of the 55th Division. A little investigation will uncover barbed wire, cartridges, bomb fragments, buttons, bullets, and shrapnel balls.

The grave is maintained by the Commune of Crouy, and on a day before Armistice Day each year a procession of the citizens goes there to lay a wreath and remember the noble story of Robert and Rose-Marie. Veterans of subsequent wars with their medals, caps, and white gloves carry regimental flags. Men of the 1914–1918 historical society Eperon 132 in horizon blue uniforms present arms, dip flags, and blow the *sonnerie aux morts*. All sing the first verse and chorus of *La Marseillaise*.

~

Notes

1. The Painter and the Critic: John Sargent and André Michel

1. Sargent has been the subject of several biographies. The Boston art critic William Howe Downes put his personal acquaintance and fresh recollections into his *John S. Sargent: His Life and Works* (1925). Evan Charteris, artist and author, was a personal friend; his *John Sargent* (1927) is candid and well informed on the artist and the art. *John Singer Sargent: A Biography* (1955) by the pseudonymous Charles Merrill Mount has entertaining gossip and fictional scenes, also the best documentary research; but it is rendered dubious by the author's criminal conviction in 1989 for the theft of documents from the Library of Congress and National Archives. Stanley Olson, *John Singer Sargent: His Portrait* (1986), builds on his predecessors and creates the fullest history of the artist's life in a pleasant, driving, occasionally malaprop prose style, but he offers a lot of unverifiable psychosocial analysis of Sargent, his relatives, and his sitters. Richard Ormond, *John Singer Sargent: Paintings, Drawings, Watercolors* (1970); Carter Ratcliffe, *John Singer Sargent* (1982); and Trevor Fairbrother, *John Singer Sargent* (1994) are excellent picture galleries, each accompanied by a running biography. Today every serious study of Sargent must include *John Singer Sargent: Complete Paintings* (1998–) edited by Richard Ormond and Elaine Kilmurray.

2. See her memoir, "J. S. S. in Memoriam," in Charteris, 233–55.

3. JSS:CP 1, no. 20, Philadelphia Museum of Art.

4. Geneviève Bresc-Bautier, his successor as conservator of sculpture in the Louvre, wrote the professional biography, "André Michel," in *Dictionnaire critique des historiens de l'art* (2010). Precious information on his personal life was collected in typescript and photocopy by Christine Boisson, Stephanie Genan, and Jeanne Susplugas, *André Michel: Monographie de muséologie* (1996). Memorial articles at the time of his

death in 1925 were written by his friends and collaborators: Max Leclerc in *Histoire de l'Art* 8, part 3 (1925), 922–32; Paul Vitry, "André Michel (1853–1925)," *Gazette des Beaux-Arts* 12 (1925) 316–32; and André Hallays, "André Michel," *Journal des Débats*, 27 December 1925.

5. *Rehearsal of the Pasdeloup Orchestra at the Cirque d'Hiver* in two versions, JSS:CP 4, no. 723, on loan to The Art Institute of Chicago from a private collection; and no. 724, Museum of Fine Arts, Boston.

6. On Sunday, 8 February 1880 *Le Figaro* announced a 2 pm popular concert at the Cirque d'Hiver starring the young pianist Anna Essipoff, who had recently made a hit touring in the United States. She played Mozart's Quintet in E-flat Major with oboe, clarinet, horn, and bassoon from the Pasdeloup Orchestra. The Suite for Orchestra that André Michel escaped was Jules Massenet's 5th, *Scènes Napolitaines* (1874) in its Pasdeloup premiere.

7. Gabriel Monod (1844–1912) trained under Georg Waitz in the German method of medieval history based on archival sources; he founded the *Revue historique* in 1875. A cousin of his in the next generation married André Michel's daughter. Arthur Giry (1848–1899) wrote the benchmark *Manuel de diplomatique* (1894). Hippolyte Taine's great historical work, *Origines de la France contemporaine*, was already in progress; its six volumes, covering the *ancien régime*, *Revolution*, and *régime moderne*, appeared from 1876 to 1894.

8. Henri Dubief and Jacques Poujol, eds., *La France protestante: Histoire et lieux de mémoire* (1992), 349.

9. A fine survey of the moment, calm, careful, and complete, is Frederick Brown, *For the Soul of France: Culture Wars in the Age of Dreyfus* (2010).

10. All eighty-three companies of French Forty-Niners failed, usually because of fraud; but the dishonest organizers did not travel to California: Henry Blumenthal, "The California Societies in France, 1849–1855," *Pacific Historical Review* 25 (1956), 251–60.

11. The authors are indebted to Henri-Abel Vermeil, who provided the authors with a typescript of the unpublished *Mes souvenirs: Journal de Madame Charles de Varigny née Louise Constantin*, his great-great grandmother. The authors are also indebted to her great-great-grandson Yves Antuszewicz, for a digital edition.

12. Constantin, *Souvenirs*. Louise studied French, literature, history, geography, cosmography, English, chemistry, physics, arithmetic, dance, and piano.

13. The authors thank Renée Chapeville for her accounts of her grandmother's childhood memories, sent by e-mail on 30 March 2012.

14. Charles Victor Crosnier de Varigny, *Quatorze ans aux îles Sandwich* (1871); *Ella Wilson, Parley Pratt, Kiana* (1878); *Louis Riel et l'insurrection canadienne* (1885); *Emma, reine des îles Havai* (1885); *L'océan Pacifique* (1888); *Les grandes fortunes aux Etats-Unis et en Angleterre* (1889); *La femme aux Etats-Unis* (1893).

15. Charles Victor Crosnier de Varigny, *Fourteen Years in the Sandwich Islands*, trans. Alfons Kron (1981), 190. President Barack Obama attended Punahou School on a scholarship from 1971 to 1979.

16. de Varigny, *La femme aux Etats-Unis* (1893), 5 and 15–16.

17. Dufaure died in 1881; Ribot was then Republican member of the Chamber of Deputies for Boulogne, 1878–1885, and later four times prime minister of France.

18. Leclerc, "André Michel et l'*Histoire de l'art*," 925.

19. Gérard-Georges Lemaire, *Histoire du Salon de peinture* (Paris, 2004), especially 211–34.

20. JSS:CP 1, no. 20, Philadelphia Museum of Art.

21. JSS:CP 4, no. 670, Corcoran Gallery of Art, Washington, DC.

22. JSS:CP 1, no. 21, Clark Institute, Williamstown, MA.

23. JSS:CP 4, no. 702, Museum of Fine Arts, Boston, MA.

24. JSS:CP 4, no. 789, Clark Art Institute, Williamstown, MA.

25. JSS:CP 1, no. 25, Corcoran Gallery of Art, Washington, DC.

26. JSS:CP 1, no. 24, Musée d'Orsay, Paris.

27. JSS:CP 1, no. 41, private collection.

28. Interview with André Michel's granddaughter Stella Corbin in Paris, 1996: Boisson et al., *Monographie*.

29. Quoted by Max Leclerc, "André Michel et l'*Histoire de l'art*," 926.

30. Quoted by Max Leclerc, "André Michel et l'*Histoire de l'art*," 926.

31. André Michel, "Le Salon de 1880, X," *Le Parlement*, 2 June 1880.

32. André Michel, "Le Salon de 1880, X," JSS:CP 1, no. 41, private collection.

33. André Michel, "Le Salon, onzième article," *Le Parlement*, 9 June 1881.

34. Color 2; JSS:CP 4, no. 772, Isabella Stewart Gardner Museum, Boston, MA.

35. JSS:CP 1, no. 55, Metropolitan Museum of Art, New York.

36. The reference is to Alfred Roll's painting *Le 14. Juillet 1880*.

37. Prosper Mérimée's novella of 1845 has the title *Carmen*, but its gypsy heroine is often called by the affectionate diminutive.

38. André Michel, "Le Salon de 1882, VIII," *Le Parlement*, 8 June 1882.

39. André Michel, *Puvis de Chavannes* (1912), 35–36 and plate XIX. *Espérance, vestida,* is now in The Walters Art Gallery, Baltimore, MD, and the Musée d'Orsay has a smaller version, *desnuda*.

40. André Michel, "Le Salon de 1882, X," *Le Parlement*, 18 June 1882.

41. JSS:CP 1, no. 114, Metropolitan Museum of Art. An entertaining and well-researched study of the background is Deborah Davis, *Strapless: John Singer Sargent and the Fall of Madame X* (2003).

42. Louis de Fourcaud, "Le Salon de 1884, VI," *Gazette des Beaux-Arts* 29 (1884) 465, 482–84 Trevor J. Fairbrother, "The Shock of John Singer Sargent's 'Madame Gautreau'," *Arts Magazine* 55 (January 1981), 90–97.

43. André Michel, "Le Salon de 1884," *L'Art* 10, no. 1 (1884), 161–65, 181–86, 201–13, 227–37; and 10, no. 2 (1884), 9–16 for the portraits; the quotation from pp. 13–14.

44. Michel was echoing and answering the observations of the senior critic Paul Arène, "Promenade au Salon," *La Nouvelle Revue* 23, no. 3 (1 June 1884), 603: "A century from now, our great-grand-nephews will picture to themselves a worldly

woman in the year of grace 1884 in no other way. And, I don't know by what extravagant association of ideas, the bizarre and arresting portrait of Mme *** makes me think of the *Mme Récamier* of old David. By these two portraits one can make judgments of the two epochs."

45. André Michel, "Le Salon de 1884," *L'Art* 10, no. 2 (1884), 13–14.

46. Now in the Musée des Beaux-Arts, Rennes.

47. Now in the Musée d'Orsay, Paris

48. André Michel, "Le Salon de 1884," *L'Art* 10, no. 2 (1884), 13–14.

49. JSS:CP 1, no. 129, Sheffield City Art Galleries, UK; and no. 132, Virginia Museum of Fine Arts, Richmond.

50. André Michel, "The Salon of 1885," *Gazette des Beaux-Arts* 32, no. 2 (July 1885), 5–20, at 16–17.

51. JSS:CP 1, no. 140, private collection.

52. JSS:CP 1, no. 127, private collection.

53. Claude Phillipps, "Expositions de la Royal Academy et de la Grosvenor Gallery," *Gazette des Beaux-Arts* 32 (1885), 90–96, at 92.

54. *Journal des Débats politiques et littéraires*, 1886: the editor's note on 30 April.

55. *Journal des Débats politiques et littéraires*, 1886: André Michel's reviews on 30 April; 2, 6, 9, 18, 22, 28 May; and 3, 6, 11, 17, 19 June.

56. *Journal des Débats politiques et littéraires*, 28 May 1886.

57. Bresc-Bautier, "André Michel." Hélène joined her husband André in London on 15 August 1887: de Varigny, *Journal*.

58. JSS:CP 1, no. 175, private collection.

59. JSS:CP 5, no. 871, Tate Britain, London.

60. André Michel, "Le Salon de 1888," *Gazette des Beaux-Arts* (June 1888), 454; translation from JSS:CP 1, pp. 181–2.

61. JSS:CP 3, no. 523, Galleria degli Uffizi, Florence.

62. "Settlement Building: Artists and Chelsea," in *A History of Middlesex* vol.12: *Chelsea*, ed. Patricia E. C. Croot (2004), 102–6.

63. Wilde made the remark to W. Graham Robertson, according to the latter's memoir *Life Was Worth Living* (1931), 233. Sargent painted Robertson in a slim black overcoat in 1894: JSS:CP 2, no. 306, Tate Britain, London.

64. JSS:CP 3, fig. 122, p. 214.

65. Mount, 149.

66. JSS:CP 1, no. 200, Bowdoin College, Brunswick, ME.

67. Sally was a beauty painted several times by Sargent; Lucia gives us precious reports, sometimes verbatim, of his conversations during his visit to Boston in October 1890 and hers to Paris the next spring and to Fairford in August: Lucia Miller, "John Singer Sargent in the Diaries of Lucia Fairchild, 1890 and 1891," *Archives of American Art Journal* 26, no. 4 (1986), 2–16.

68. Hanover, New Hampshire, Dartmouth College Library, MS. 152: Lucia Fairchild Fuller Papers, Box 2, folder 14.

69. JSS:CP 5, no. 907, private collection.

70. Eyebrows and nose in one looping line, dots for eyes, as in his caricature *Self-Portrait*, JSS:CP 2, no. 271.

71. Verses by Paul Robiquet, set to music by Jules Massenet in 1878.

72. An Occitan *Cansouneto* translated into French by Jean Pierre Claris de Florian (1755–1794) for his *Estelle et Némorin*; setting by Benjamin Louis Paul Godard (1849–1895). For source information, the Occitan original, the French translation, and an online performance, see http://www.recmusic.org/lieder/get_text .html?TextId=5680&RF=1.

73. A joke about her hearty appetite. A 35-ton 12-inch muzzle-loaded cannon built at Woolwich Arsenal, ironically nicknamed "Infant," notoriously burst when a double charge was accidentally loaded: *The Illustrated London News*, June 27, 1874.

74. *A Morning Walk*, JSS:CP 5, no. 888, pp. 158–9, private collection.

75. A souvenir paperback, *Carmencita, the Pearl of Seville* was for sale at fifty cents at the music hall. Written and printed by "Professor" James Ramirez, it is a melodramatic delight, from the chaste girl's capture by the Bandit Chief of Spain, through the attempted seduction by Count Marco Durazzi, an abduction, the death of the Count in a gambling fight, and the suicide of the disappointed suitor Viscount Armand, to her New York triumph, complete with mendacious name-dropping and mention of her portrait by Sargent (JSS:CP 2, no. 234, Musée d'Orsay, Paris). In the last thirty pages Ramirez gave a more conventional biography and declared that the dancer was born Carmen Dauset in 1868 in Almeria near Seville. Dancing in the costume that Sargent painted, she was filmed in three seven-second clips at Thomas Edison's Black Maria Studio in 1894.

76. Mount, 168–72; Garnett McCoy, "Visits, Parties, and Cats in the Hall: The Tenth Street Studio Building and Its Inmates in the Nineteenth Century," *Archives of American Art Journal* 6 (1966), 1–8.

77. JSS:CP 2, no. 243, Carnegie Institute, Pittsburgh, PA.

78. JSS:CP 2, no. 233, private collection.

79. JSS:CP 2, no. 272, The Players, New York.

80. Charles Moore, *The Life and Times of Charles Follen McKim* (1929), 63, quoted in Carol Troyen, "American Mural Painting, the Boston Public Library, and Sargent's Triumph of Religion," in Narayan Khandekar, Gianfranco Pocobene, and Kate Smith, eds., *John Singer Sargent's* Triumph of Religion" *at the Boston Public Library: Creation and Restoration* (2009), 26.

81. Teri Hensick et al., "Puvis de Chavannes's Allegorical Murals in the Boston Public Library: History, Technique, and Conservation," *Journal of the American Institute for Conservation* 36 (1997), 59–81.

82. Color 3; JSS:CP 2, no. 269, p. 50, Isabella Stewart Gardner Museum, Boston, MA. The picture had belonged to Lucia Fairchild.

83. Benjamin McArthur, *The Man Who Was Rip van Winkle: Joseph Jefferson and Nineteenth-Century American Theatre* (2007), 314. The house was largely destroyed by fire in 1893 but immediately rebuilt to Jefferson's designs, this time in stone.

84. The windmill now serves as gift shop of the Aptucxet Trading Post owned by the Bourne Historical Society. The authors thank Joanne Corsano, docent at the site.

85. JSS:CP 2, nos. 273 and 274, The Players, New York, and a private collection.

86. JSS:CP 5, p. 141 and fig. 73, Fine Arts Museums, San Francisco. Any paintings or drawings that Sargent gave or sold to Jefferson, an avid collector, would have been lost in the fire that destroyed the first Crows' Nest in 1893.

87. 1. From the beginnings of Christian Art to the end of the Roman Period; 2. Formation, expansion, and evolution of Gothic Art; 3. Realism; the beginnings of the Renaissance; 4. The Renaissance; 5. The Renaissance in Northern Europe; formation of modern classic art; 6. Art in Europe in the 17th century; 7. Art in Europe in the 18th century. The three volumes of tome 8 were posthumously edited by Paul Vitry, but their title pages read "Publiée sous la direction de ANDRE MICHEL": 8. Art in Europe and in America in the 19th century and the beginning of the 20th. The general index was added in 1929. For the inside story, see Max Leclerc, "André Michel et l'*Histoire de l'art*," 923–32.

88. *Boston Daily Globe*, 27 September and 3 November 1903; *New York Times* 17 and 19 November 1903.

89. *Wellesley College News*, 11 November 1903. The authors thank Wellesley College Archivist Ian Graham for his help.

90. *Smith College Monthly*, December 1903. The authors thank Smith College Archivist Deborah Richards for her help.

91. André Michel, "Causerie artistique: musées américains," *Journal des Débats*, 8 December 1903.

92. Autograph letter signed, from John Singer Sargent to D. S. MacColl, Hotel Saint-Romain, 5 & 7 rue St. Roch, Paris: Glasgow University Library, MS MacColl S52. Donald Sutherland MacColl was a well-regarded watercolorist and a champion of the French Impressionists, art critic for *The Saturday Review* from 1896 to 1906, keeper of the Tate Gallery 1906–1911 and of the Wallace Collection 1911–1924.

2. The Ormonds and the Sargents

1. In the 1920s Marguerite Ormond jotted down notes for a "Genealogical History of the Griolet Family" and a "Biography of Michel-Louis Ormond Dedicated to His Grandchildren." These unpublished reminiscences, in a private collection, are the basis of the following paragraphs and the French source of the quotations, cited as Ormond Notes.

2. About twenty-five miles north of Vevey, the castle had been constructed in 1275 and was long a defensible and palatial residence of the bishops of Lausanne. It was enlarged in 1580, when it had passed into the control of the cantonal administration.

3. Marguerite identified this as the Clos des Vignes de Relliet, near the stream of Ognonnaz above La Tour-de-Peilz. The vineyard has since been built over, and the Ognonnaz canalized and sent underground.

4. Madeleine Denisart and Jacqueline Surchat, *Le cigare et les fourmis: Aperçu sur l'histoire des ouvrières vaudoises: L'exemple de Vevey et Nyon* (1987), 26–29.

5. Charteris, 111.

6. Club Alpin Français, *Annuaire* 12 (1886), 355; and *The Silent Worker* 32, no. 2 (1919), 34. In 1845 Ernest married the daughter of a Swedish Baron de Geer, adding the baron's title to his name. The baron, who had an "alliance with a Genevan lady," had required, as a condition of his daughter's marriage, that the couple make their home in Geneva.

7. In little more than the decade 1824–1835 he had opened factories in Paris, Reims, Sommières, and the Oise, employing over fifteen hundred workers, producing high quality woolens and fine fabrics of a mix of wool and silk; he was named chevalier of the Legion of Honor: Edward Foucaud, *The Book of Illustrious Mechanics of Europe and America*, tr. John Frost (1846), 285.

8. Ormond Notes.

9. Ormond Notes.

10. Karl Baedeker, *Switzerland*, 23rd ed. (1909), 298–301.

11. Among Francis's idiosyncrasies, as related to the authors by Richard Ormond, was his refusal, to the end of his long adventurous life, ever to subject himself to the services or advice of doctors or dentists.

12. *The Silent Worker* 9, no. 6 (1897), 93.

13. Charles Gleyre (1806–1874) was born near Vevey. Orphaned at nine and brought up by an uncle, he persuaded his guardian to allow him to study art in Paris. He followed his years of study with travels in Italy, Greece, and North Africa. On his return to Paris, he produced paintings in an academic, classical style inspired by his travels and his study of antiquity. His work began to be widely known in the 1840s, and for twenty years starting in 1843 his free atelier was a mecca for students, notably the later Impressionists Monet, Renoir, Sisley, and Whistler: Catherine Lepdor, ed., *Charles Gleyre: Le génie de l'invention* (2006); also Jane Turner, *The Grove Dictionary of Art from Monet to Cézanne: The Late Nineteenth Century* (2000), 210–12.

14. *Dandies and Dandies* (1896); both portraits are in the Musée Jenisch, Vevey.

15. According to Marguerite he was 1.85m (6'1") tall with narrow shoulders, dull complexion, a long face, nose, and neck; thin, well-formed lips; and curly, chestnut hair.

16. Lepdor, 24–25. Bocion had studied in the atelier of Charles Gleyre. According to Mme Ormond's memoir, he was a frequent guest in the Villa at Clarens in the summer and the Villa Ormond at Sanremo in the spring, and he recorded those sites in numerous paintings. Anker's oil portrait, now in the Kunstmuseum at Solothurn in northern Switzerland, shows Marguerite in pensive mourning for her mother's recent death, dressed in deep black relieved only by a large belt buckle and a show of lace at the wrists and the severe, high neckline. In her hair is a single fresh daisy, a *marguerite*.

17. Marguerite Ormond's notes.

18. Club Alpin Français, *Annuaire* 12 (1886), 355.

19. *The Silent Worker* 32, no. 2 (1919), 34; and *Annales de la Société historique et archéologique de Château Thierry* (Château-Thierry, 1901), p. iii: "Griolet de Geer, numismate"; p. 38: "M. Griolet, retenu à Londres au Congrès des Sourds-Muets"; p. 19: Griolet de Geer donated to the Society a lacquer box given to him by the ruler of Persia, sabers given to him in Japan, and wooden statues from Tonkin.

20. This stately eighteenth-century country home, still with its old, low-curbed fishpond, is now the clubhouse for an internationally known golf course. Marguerite would be pleased to know that no jeans are allowed on the greens.

21. Giulia Zoccai, *Dal 1875 a San Remo: La famiglia Ormond, la villa, il parco* (1998). The villa was acquired by the Commune of Sanremo in 1930, and since 1987 it has been the seat of the International Institute of Humanitarian Law. Louis Ormond received the Order of San Maurizio e Lazzaro from the king of Italy for his organizational and monetary aid to the victims of the earthquake of 23 February 1887. Francis Ormond, then 21, received a citation for his "philanthropy in aid of the endangered population" of the medieval hilltop village of Bussana a few miles southeast of Sanremo, where more than two thousand were killed.

22. Olson, 170–71.

23. The bust was one of Carriès's first pieces in lost wax (May 1884), cast by Pierre Bingen. The original is in a private collection, but copies in patinated plaster are in the Musée du Petit Palais, Paris (PPS 00598), and in the Collection Guédon, Ville de Pouilly-sur-Loire. See Elisabeth Lebon, "Carriès et Bingen: La collaboration exemplaire d'un sculpteur et d'un fondeur," in *Jean Carriès ou la terre viscérale* (2007), 91–99 and plate XV; and Patrice Bellanger, "Bingen/Carriès: La renouveau de la fonte à la cire perdue," in *Jean Carriès (1855–1894): La matière de l'étrange* (2007), 59–67, 207, and Fig. 5.

24. De Varigny Journal, 21 January 1888.

25. Richard Ormond, "I giovani Ormond," in Giulia Zoccai, ed., *Villa Ormond: I giochi, le favole, le fate* (1998), 6.

26. JSS:CP 5, p. 145. Dennis Bunker recovered from his infatuation with Violet and married Eleanora Hardy in Boston in October 1890, just three months before his premature death from cerebrospinal meningitis.

27. JSS:CP 5, no. 891, p. 162, in a private collection.

28. The City Museum of Sanremo preserves a map of rental properties of the city in 1880. The four Castillo properties are located in the block just southwest of the Rondò Giuseppe Garibaldi, a leisurely ten- or fifteen-minute walk from the Villa Ormond.

29. Sargent was charmed by the exotic Javanese dancers and by the Spanish dancer Carmencita, whom he would encounter again the next year in New York. JSS:CP 5, pp. 168, 171.

30. John's letter to Vernon Lee, 10 February 1883, quoted in JSS:CP 5, p. 74: "My people are all well except poor Baby [Violet Sargent, age thirteen] who has been in bed with a bad cold."

31. Sally M. Promey, *Painting Religion in Public* (1999), 36–39.

32. Olson, 168–69.

33. JSS:CP 5, no. 932, pp. 230–31. This was a painting that Sargent liked enough to show at the New English Art Club that year and at the World Columbian Exhibition in Chicago in 1893; now in a private collection, on loan to the Art Institute of Chicago.

34. Musée Cantonal des Beaux Arts, Lausanne, painted 1867.

35. It is (barely) possible that Sargent at age fourteen encountered Gleyre when they were both in Clarens in September 1870. Gleyre was still an influential presence in Paris when Sargent arrived, ten years after Gleyre had closed his atelier and just a few months after his death. Sargent became close friends with one of Gleyre's last students, the young Swiss-American painter Charles Edouard Du Bois (1847–1885). Sargent shared a studio with a much older Gleyre alumnus, Auguste Alexandre Hirsch (1833–1912), at 73 rue Notre-Dame des Champs, from 1879 to 1883: JSS:CP 4, pp. 177 and 387.

36. Olson, 169.

37. Lucia Miller, "John Singer Sargent in the Diaries of Lucia Fairchild," *Archives of American Art Journal* 26, no. 4 (1986), 12–13.

38. MS in a private collection.

39. Hanover, NH, Dartmouth College Library, MS. 152: Lucia Fairchild Fuller Papers, Box 2, Folder 15.

40. Metropolitan Museum of Art, New York (accession 50.130.153), gift of Mrs. Francis Ormond, 1950. This was perhaps a study for an oil portrait: there is a faint receding row of columns in the background. Some time later, a picture of Marguerite was wanted by or for Francis, and Sargent made it in pencil from the Metropolitan drawing: the dress, hairdo, and pose are the same, though the pensive left hand is omitted, the head is slightly tilted, and the face seems careworn, older by a decade. This second drawing (in a private collection) is inscribed "A mon ami," and as an afterthought, "Francis." Sargent's friendship with his brother-in-law was a purely formal one.

41. Peter Gunn, *Vernon Lee, Violet Paget, 1856–1935* (1964), 26.

42. Olson, *John Singer Sargent: His Portrait* (1986), 171.

43. In the new (1886) cathedral church at 23 avenue de l'Alma (now avenue George V), not the one on rue Bayard where John and Emily had been confirmed during John's first year with Carolus-Duran: Promey, 28.

44. Boston Athenaeum, Sargent / Fox Papers 3.14–15.

45. JSS:CP 5, p. 268.

46. Warren Adelson, *Sargent's Venice* (2004), 211.

47. Olson, 178 and 189.

48. Letter from Sargent at Fairford to McKim, 9 December 1895 or 1896, in Boston Athenaeum, Fox / Sargent Papers, 1, 50. The letter discusses details of the moldings, the built-out plinths, exact measurements of the pilasters, and the like.

49. Ormond, *Villa Ormond*, 4.

50. They posed for Otto Wegener, a fashionable photographer in the place de l'Odéon frequented by Proust and patronized by Sarah Bernhardt.

51. The information and quotations in this account of the Ormonds come from the unpublished *Memoir of Rose-Marie* by her nephew Richard Ormond.

3. Rose-Marie Ormond

1. Downes, *John S. Sargent*, 52. See figure 9.2.

2. Promey, *Painting Religion in Public*, 42: "In official correspondence dated as early at 1893 . . . and as late as 1918, the artist maintained that Sermon on the Mount was essential to his conception of *Triumph of Religion*."

3. Quoted in Donelson F. Hoopes, *The Private World of John Singer Sargent* (1964), facing figure 145.

4. L. V. Bertarelli, *Italie* Vol. 1: *Des Alpes à Rome* (1922), 68. A complete survey of the scene and the pictures is "Purtud, Val d'Aosta, Italy 1906–1907," in JSS:CP 7, 279–323.

5. "After 1900, watercolor became a seasonal event . . . resulting in an inventory of his travels and chronology of his life. The pictures were not only personal statements, gifts to himself; they were his resolution of outdoor painting. They were his spontaneous, snapshot vision. They represent his powers as an observer able to render quickly those effects of light and color that fell in his field of vision, without regard for composition or traditional balance. They were the free field for his eye in which he could run to paint as he saw it, life as it was before him. Friends if he chose to, and above all, color and the effect of light on it." Warren Adelson, "John Singer Sargent and the 'New Painting'," in Olson, Adelson, and Ormond, *Sargent at Broadway* (1986), 60.

6. This detail comes from the Port of New York Passenger Records online at ellisisland.org.

7. Breuil and Giomein are at 6,600 feet, and were reached by a mule track: Bertarelli, *Italie* Vol. 1: *Des Alpes à Rome*, 66. See Elaine Kilmurray and Richard Ormond, *John Singer Sargent* (1998), 276.

8. Elaine Kilmurray, "Traveling Companions," in Warren Adelson et al., *Sargent Abroad: Figures and Landscapes* (1997), 55–61 for biographical sketches of Sargent's companions in his Alpine summers.

9. Letter of John Singer Sargent to Mrs. Ralph Curtis, 25 January 1905, from Grand New Hotel A & J Morcos, Jerusalem, in Boston Athenaeum, Sargent / Fox Papers 1.6.

10. Peter Gunn, *Vernon Lee*, 33.

11. Adelson, "John Singer Sargent and the 'New Painting'," 211.

12. Reminiscence of Guillaume Ormond in Boston Athenaeum, Sargent / Fox Papers, A1.

13. Kilmurray and Ormond, *John Singer Sargent*, 246.

14. Ilene Susan Fort, "Dressing Up: Subterfuge and Sublimation in the Alpine Paintings," in Bruce Robertson, *Sargent and Italy*, (2003), 141–61.

15. Fort, "Dressing Up," in Robertson, ed., *Sargent and Italy*, 142. *Zuleika* was the name given to a 1906 watercolor of a veiled and costumed model (JSS:CP 7, no. 1403, Brooklyn Museum), and Richard Ormond calls the costumed series the Zuleika pictures. Zuleika was the heroine of Byron's *Bride of Abydos*, and Sargent may have known that, in Jewish and Moslem traditions of the story of Joseph in Egypt, Zuleika was the name of Potiphar's predatory and mendacious wife. Sargent's friend Max Beerbohm published his Oxford fantasy *Zuleika Dobson* later, in 1911.

16. Hoopes, *Private World*, opposite figure 150.

17. Kilmurray and Ormond, *John Singer Sargent*, 246. In the spring of 1908 Sargent made a final use of the dotted robe that had clothed many of his summer models, using it as a part of the costume in which he painted Almina Wertheimer, the daughter of Asher Wertheimer, the art dealer and his great patron. This was the last of twelve portraits of that family and one of the last formal portraits he willingly took on as a commission after his pledge of "no more paughtraits."

18. Edythe Humphrey, "Calgary 90-Year-Old Modelled for Sargent," *Calgary Herald* (1966), reproduced without date in the online *JSS Virtual Gallery*. Margaret O'Regan (later Beaton) worked for Mary Sargent and then for Emily from late 1905 to 1907.

19. Color 4; JSS:CP 7, no. 1398, in a private collection.

20. According to Richard Ormond, Conrad's son.

21. Reminiscences of Guillaume Ormond in Boston Athenaeum, Sargent / Fox Papers, A1; and reminiscences of Nicola d'Inverno, "John Singer Sargent as His Valet Saw Him," *Boston Sunday Advertiser*, 7 February 1926.

22. See Fort, "Dressing Up," 145–7.

23. Richard Ormond, *John Singer Sargent: Paintings, Drawings, Watercolors* (1970), plate 105 and p. 255; in a private collection.

24. Richard Ormond, "In the Alps," in Adelson et al., *Sargent Abroad* (1997), 68–73.

25. Fort, "Dressing Up," 142–43 calls attention to the dated style of the gowns. "The garden dresses used by Sargent in the Intertwingles and some of the Siesta pictures were not quite contemporary: they dated from an earlier period, the 1850s and 1860s, as indicated by the voluminous skirts (a style that was abandoned in the 1870s). Sargent's historicizing of costume suggests that he may have wanted to present his models outside the boundaries of time."

26. Ormond, "In the Alps," 97.

27. Color 5; Erica E. Hirshler and Teresa A. Carbone, *John Singer Sargent Watercolors* (2012), cat. 52, Museum of Fine Arts, Boston.

28. Color 6; National Gallery of Art, Washington; to appear in JSS:CP 8.

29. Now in the Rhode Island School of Design, Providence.

30. Richard Ormond, *Memoir of Rose-Marie*.

31. Quoted in Downes, *John S. Sargent*, 237. George Meredith had recently died. His works, particularly *The Egoist* (1879), sympathetically explore women's states of

mind and Edwardian women's experiences under Victorian conventions. Meredith had inscribed a copy of his *The Tale of Chloe* to Sargent: Christie, Manson & Woods, *Catalogue* (1925), no. 71.

32. Walter Sickert, "Sargentolatry," *New Age* 4, no. 23 (19 May 1910), 56–57.

33. Mary Abbey, *Concerning Edwin A. Abbey's Last Work* (1926), a pamphlet in the Boston Athenaeum. Mrs. Abbey was concerned that critics had inflated Sargent's role in Abbey's last work: Sargent had limited himself to the supervision of Abbey's painting assistant, William Simmonds, in scrupulously carrying out Abbey's last instructions, "slight modifications, mostly of small passages of light and shade which would add depth to the composition." Then he reported the work to Abbey to allay his dying friend's anxieties.

34. Ormond, "In the Alps," 70.

35. The few stereoscopic pairs in a private collection include some from the marble quarries of Carrara, where Sargent painted in 1911.

36. Sargent's works in their earlier show (1908) had been snapped up by the Brooklyn Museum; the 1911 batch was bought in advance by the Museum of Fine Arts, Boston. Hirshler and Carbone, *John Singer Sargent Watercolors*, is the catalogue of the 2013 show of the united collections: *The Tease*, cat. 58; *Reading*, cat. 56; *The Lesson*, cat. 57.

37. Kilmurray, "Traveling Companions," in Adelson et al., *Sargent Abroad*, 59.

38. Richard Ormond, *Memoir of Rose-Marie*.

39. Copies of these casts exist in a private collection and in some museums, e.g., the Museum of Fine Arts, Boston (accession number 37.53), a gift of Violet Ormond.

40. Color 10; JSS:CP 3, no. 561, p. 223, in a private collection.

41. At the Châtelet that same evening Ida Rubinstein was performing Oscar Wilde's scandalous *Salomé* with dances by Fokine and costumes by Bakst. Paul Felix von Weingartner, Austrian by birth, was Kappelmeister of Hamburg and conductor of the Vienna Philharmonic at the time. Guest conductor of the Boston Opera Company until 1914, he was to be known for his early phonograph recordings.

42. Yves Carton, *Henry de Varigny, darwinien convaincu, médecin, chercheur et journaliste (1855–1934)*, (2008).

43. Now part of The Queyras Regional Park (Hautes Alpes).

44. Private collection.

45. Color 9; private collection; see Adelson et al., *Sargent Abroad*, no. 61.

46. Now in the Cincinnati Art Museum.

47. *Louise*, music and libretto by Gustave Charpentier, at the Opéra Comique, where it had premiered in 1900. In this production Louise was sung by Geneviève Vix in her last season with the Comique before launching her international career: *Le Figaro*, 20 November 1912.

48. Henry de Varigny was Robert André-Michel's maternal uncle, most noted as the French translator and popularizer of Darwin. In 2008, in the attic of a cousin's home, his great-grandson Yves Antuszewicz discovered an old trunk that had gone

unopened for decades. They forced the lock and found a series of diaries that Henry de Varigny had kept from 1885 to his death. M. Antuszewicz provided us copies of those diaries and the *Souvenirs* of Henry's mother Louise Constantin.

49. The Sunday promenade is in the de Varigny Journal; Rose-Marie wrote her eight-page letter to Guillaume on 24 June 1913 in Bonne-Maman's apartment, 42 avenue du Bois de Boulogne.

50. Richard Ormond, *Memoir of Rose-Marie.*

51. From a private collection.

52. Emile Boutroux (1845–1921), professor of Philosophy at the Sorbonne, elected to the French Academy in 1912. Former student of Helmholz at Heidelberg, he and William James exchanged book-length appreciations and critiques. His wife was Aline Poincaré.

53. Charles Massigli, professor of law, Robert's uncle, married to André Michel's sister Marguerite.

54. Henry de Varigny, Robert's maternal uncle, professor of natural history and writer on Charles Darwin, married to Marguerite Ormond's second cousin Blanche Meyrueis.

55. "Foulc Library Sold by Morgan," *New York Times*, 14 May 1914, 5: When the collection of some 600 books was put up for sale by J. P. Morgan, Jr., "Edmond Foulc lived in a hotel at 4 rue de Magdebourg, Paris. Here he brought together marbles, precious stones, paintings, enamels, and works in wood, iron, and bronze. At the same time he picked up, whenever occasion offered, books dealing with these subjects." J. P. Morgan, Sr. had bought the library in 1910.

56. Boston Athenaeum, Sargent / Fox Papers 1.9, letter from Emily Sargent to Mrs. Curtis, 18 August 1913, "Violet . . . is almost crippled with rheumatism which has brought on eczema."

57. The international Banque Hottinguer, founded in Paris in 1786.

58. Madame Ormond's second cousin Blanche Meyrueis, the wife of Robert's uncle Henry de Varigny.

59. Pasteur Charles Wagner, 1852–1918, an influential preacher, author of *The Simple Life* and other books favored by Theodore Roosevelt.

60. Rose-Marie and Robert probably went on their honeymoon to his family's beach cottage at Berck-sur-Mer, but Emily went with the Ormond family to Combloux on the French side of Mont Blanc. There bad weather aggravated Violet's rheumatism, and she went with Emily to Aix-les-Bains to take a cure: Boston Athenaeum, Sargent / Fox Papers 1.1.9, letter of Sargent to Mrs. Curtis, 18 August 1913. Sargent instead went to spend some time in the Austrian Tyrol in preparation for a longer trip in 1914.

61. This was Robert's niece Jacqueline Vermeil, eight years old.

62. Letter of Conrad Ormond to Susie Zileri, 8 August 1913, typescript copy in a private collection.

4. Robert André-Michel

1. This chapter depends heavily on the brief biography given by André Hallays in the Introduction to his edition of Robert's articles, *Avignon: Les fresques du Palais des Papes; Le procès des Visconti* (1920), ix–xiv.

2. De Varigny Journal. After Louise and Charles died Henry and Hélène kept the house as a vacation home and rental property, but finally sold it in 1914.

3. Archives de Paris, D4R1 1264.

4. Matricule de recrutement no. 806, classe de mobilisation 1902, Archives de Paris.

5. *L'Illustration*, 3 October 1914: "The new garb of the infantry. In spite of questions of sentiment that have contributed to keeping them, the red trousers have been abandoned for the infantry." The changeover was to be made gradually, as the old uniforms wore out. *Garance* is French for madder, the plant whose roots gave the red dye.

6. Georges de Bévotte, *Notre fils* (1916), 370–73.

7. de Bévotte, *Notre fils*, 368–74. For information about the uniform, weapons, and equipment of an infantry soldier, and indeed for a thorough introduction to the realities of life in the army and of the campaign on the Aisne in 1914, we are indebted to M. Mille of Crouy, president of the local military historical society Eperon 132.

8. In the Zola trial, Meyer was asked if he was a German Jew, and he replied with the points of his French Catholic biography: born in Paris of French parents, baptized at Notre-Dame, First Communion and Confirmation at St. Sulpice. Because he was indifferent to religious distinctions, he scorned to deny publicly that he was a Jew. Dorothy Canfield, who sat in his romance philology class in the Ecole des Chartes in 1899, recounts a scene in which his lecture was actually invaded by students shouting, "Dirty Jew, who paid you?" while Meyer placidly waited, chalk in hand, for the noise to go away. She assumed that he was Jewish, and she revered him: Dorothy Canfield, "Professor Paul Meyer," in *Raw Material* (1923), 127–41.

9. Our thanks to Juliette's daughter Renée Chapeville and her niece Martine Bosshardt for the information and photograph (figure 4.2).

10. Henri Boegner turned away from his liberal heritage after the war. He became a teacher of Classics and Philosophy, converted to Catholicism, and founded the *Cercle Fustel de Coulanges*, which sought to turn the French school system away from its ideals of equal access to education for all. The *Cercle* and its parent *Action Française* insisted that intelligence and democracy are incompatible: Eugen Joseph Weber, *Action Française: Royalism and Reaction in Twentieth-Century France* (1962), 264.

11. We thank Henri Marcel and his mother for their memories of the Alfred Boegner family.

12. "Comptes-rendus des séances," *Académie des Inscriptions et Belles-Lettres* [annual report], 54 (1910), 678.

13. "The French Revolution as It Appeared to Enthusiasts at Its Commencement" (first published 1809), lines 4 and 5.

14. Joseph de Loye, *Les archives de la Chambre apostolique au XIVe siècle* part 1: *Inventaire*. Bibliothèque des Ecoles françaises d'Athènes et de Rome, no. 80 (1899), 119–79.

15. The article "Le développement des villes dans le Comtat-Venaissin" was prepared by Robert's widow and his father, with their unsigned preface, for *Revue historique* 118 (1915). In that study (p. 294) Robert expressed surprise that a certain census of Avignon, the *Liber divisionis*, showed so many resident non-natives in the town in 1376, when the Plague had so recently struck and Gregory XI with his court had already departed for Italy. Robert's instinct was correct. The document bears no year date; an early editor, Louis Duchesne, had guessed 1376, but the true date is 1371, when Gregory's recent election had revived the commercial life of Avignon. Daniel Williman, *Letters of Pierre de Cros, Chamberlain to Pope Gregory XI (1371–1378)* (2009), 48–49.

16. James Clifford, *Person and Myth: Maurice Leenhardt in the Melanesian World* (1982), 7.

17. de Varigny, *La femme aux Etats-Unis*, 15.

18. James Clifford, *Person and Myth* supplies most of what we know of Jeanne Michel.

19. Alfred Boegner, father of the eight children with whom the Michels were so close, was also the uncle of Pastor Marc Boegner, later the president of the Federation of French Protestant Churches, a leader in the Christian ecumenical movement.

20. Pastor Alexandre Westphal's discourse at the funeral of André Michel (a mimeograph copy addressed to Paul Vitry), in Boisson, *André Michel: Monographie de muséologie*.

21. Katja Marmetschke, *Feindbeobachtung und Verständigung: Der Germanist Edmond Vermeil (1878–1964) in den deutsch-französischen Beziehungen* (2008), especially p. 109 and notes. Henri Vallette (1877–1962), who grew up in Montpellier, was the son of a pastor of Basel. He regularly showed his portraits and his animal figures in bronze and marble in the Paris Salon.

22. An earlier Vermeil, Pastor Antoine of Nîmes had inspired and fostered the work of Caroline Malvesin in founding the Diaconnesses de Reuilly, a fervent Protestant sisterhood dedicated, without vows, to hospital work: Gustave Lagny, *Le réveil de 1830 à Paris et les origines des Diaconesses de Reuilly* (1958).

23. Letter of Daniel Monod's niece Rose-Mai Langlois-Berthelot to the authors, 5 October 2012; also W. D. Halls, *Politics, Society and Christianity in Vichy France* (1995), 141.

24. de Bévotte, *Notre fils*, 318. Abel's father thought that his brokenhearted memorial "can interest no one but our family and some friends. It is at their request that I have decided to print it. It should never go beyond our intimate circle or be shared with strangers." But alas, as André Hallays wrote in reference to the letters of Robert and Rose-Marie, these are nobody's secrets now.

25. At the Paris Opéra on Saturday 23 March 1907, as noticed in *Le Figaro*.

26. de Bévotte, *Notre fils*, 166.

27. de Bévotte, *Notre fils*, 229–30. His father went on to imagine "the bitter disillusionment, the pain he would have suffered, if he had witnessed the frightful crimes committed by the German army, and if he had seen the compatriots of Kant and Goethe become the rivals of the Vandals and the Huns."

28. Hallays, *Avignon*, v.

29. Gustave Charpentier, *Louise*, act 3: "Depuis le jour où je me suis donnée, toute fleurie semble ma destinée."

30. de Bévotte, *Notre fils*, 388–89.

31. de Varigny Journal, 15 January 1914.

32. Raymond Sabouraud, dermatologist, painter, and sculptor, had an x-ray clinic especially for the treatment of scalp ringworm. From 1909 to 1922, the star dermatologist Ferdinand-Jean Darier was head of the clinical department of the Hôpital Saint-Louis and a friend of the families de Varigny and Michel.

33. Letter of John Singer Sargent to Violet Ormond, n.d. January 1914.

34. Letter of Rose-Marie André-Michel to Guillaume Ormond on his eighteenth birthday, 25 January 1914, from 68 rue de Bellechasse, Paris.

35. Letter of Rose-Marie André-Michel to Guillaume Ormond, 17 May 1914, from 68 rue de Bellechasse, Paris.

36. Hallays, "Introduction" to Robert André-Michel, *Avignon: Les fresques du Palais des Papes; Le procès des Visconti* (1920), xi.

37. André Michel was already a contributor to this Protestant fortnightly and probably recommended his son for the commission. Mistral, although not a Protestant, had expressed sympathy for the Huguenots, referring to Aigues-Mortes, "where forty Protestant women and girls were imprisoned after the dragonnades under Louis XIV and rotted there until the end of his reign, forgotten and condemned to misery for some forty years." Frédéric Mistral, *The Memoirs of Frédéric Mistral* [*Moun espelido*, 1906], tr. George Wickes (1986), 200.

38. Robert André-Michel, "Au pays de Mistral," *Foi et Vie*, 16 April 1914, 203–212 at 212.

39. Letter of Rose-Marie André-Michel to Guillaume Ormond, 17 May 1914.

40. An offprint of the article published in *Gazette des Beaux-Arts* was offered to the society by André Michel in 1916: *Bulletin de la Société nationale des antiquaires de France* (1916), 290–91.

41. de Bévotte, *Notre fils*, 392.

42. The manuscript letters of Sargent to Rose-Marie are transcribed from a private collection.

43. Sotteville-sur-Mer, on the coast of Normandy near Dieppe. The steam ferry from Newhaven to Dieppe took three hours.

44. We owe our knowledge of Daniel Monod's service in both World Wars to Rose-Mai Langlois-Berthelot, his niece.

5. Robert's War, 1914

1. Barbara W. Tuchman, *The Guns of August* (1962) offers a thorough and engaging survey of the war from its proximate causes through the Battle of the Marne. This masterpiece of popular history is solidly based on firsthand sources, which are carefully cited in the notes. We take it as our background study without hesitation.

2. By an ultimatum of 31 July the German government demanded the neutrality of France if Germany went to war with Russia, and, as a guarantee of that neutrality, the surrender of Toul and Verdun for the duration of the war: Tuchman, *Guns of August*, 76.

3. Abel Gendarme de Bévotte to Juliette Michel, in Georges de Bévotte, *Notre Fils* (1916), 398.

4. de Bévotte, *Notre fils*, 393–403; JMO, 102e RI, 10 August 1914.

5. de Bévotte, *Notre fils*, 402–03. In 1921 Juliette married the industrialist and author René Bouvier, widowed father of five children; she gave him two more, and named them Robert and Renée for her lost siblings.

6. de Bévotte, *Souvenirs d'un universitaire* (1938), 231.

7. Every unit of command, from General Headquarters down to each regiment, kept its own record in such a *Journal des marches et operations* (JMO), a blank book sold by a military publisher such as Chapelot of Paris, noting daily the orders received and how they were executed, and all marches, actions, and casualties. On the first pages were printed the regulations governing such record keeping. These precious historical sources can all be found online at memoiredeshommes.sga.defense.gouv.fr.

8. The reserve regiments were set up as adjuncts of the active regiments; each one bore the number of the parent regiment plus 200. The active regiment provided a "cadre" of officers and subofficers to train and eventually to lead the adjunct regiment.

9. Alsace and Lorraine, lost in the Franco-Prussian War of 1870.

10. Letter of Robert André-Michel to Rose-Marie André-Michel, 7 August 1914, in Hallays, "Introduction" (1920), xv.

11. JMO, 169th RI.

12. An officer or sergeant normally kept a daily record of his movements and the discharge of his duties and orders in a blank book sold by one of the military publishers with the title *Carnet de route*. The passages of Robert's *Carnet* quoted in this chapter come from transcriptions by Rose-Marie into her own notebook; or from the verbatim copy of the portion from 20 to 26 September 1914 made by Rose-Marie's brothers Guillaume and Jean-Louis Ormond in September–October 1916, in a private collection; or from André Hallays, "Introduction" in *Avignon: Les fresques du Palais des Papes; Le procès des Visconti* (1920) xiv-xxi; or from Robert Burnand, "Robert André-Michel," *Foi et Vie* 22 (1 March 1919), 67–70; or from Ecole nationale des chartes, Paris, *L'Ecole des Chartes et la guerre (1914–1918): Livre d'Or* (1921), 138–40.

13. Sargent was referring to sea mines, which he called *torpilles*, thinking of the stationary torpedoes of the American Civil War, such as the ones famously damned by Commodore Farragut at the Battle of Mobile Bay.

14. Letter of John Singer Sargent to Rose-Marie Ormond, 24 September 1914, sent from S. Lorenzen, MS in a private collection.

15. La Flèche, in the Loire region, where Robert took military training exercises at the Prytanée National Militaire; Beighede is a Basque name.

16. The first news of the bombardment and burning of Reims Cathedral appeared in *Le Temps* and in the *Bulletin des Armées de la République* dated 23 September but issued the day before.

17. G. F. Nicolai, *The Biology of War*, tr. Constance A. Grande and Julian Grande (1919) provides text and commentary.

18. Almost a platoon, which would normally be headed by a lieutenant.

19. The *apaches* were violent street gangsters of Paris in the decade after 1900. *Dolman* was the short, sky-blue uniform jacket of a heavy-cavalry trooper or *hussard*.

20. The *chasseurs forestiers*, irregular units of military scouts and riflemen in the 1870 war, had been regularized in May 1914 and attached to army units as expert guides.

21. The reserve regiments were gathered in reserve divisions, and those divisions were distributed in groups among the armies. At mobilization on 2 August 1914, France put five armies into her defense under Field Marshal Joffre. The Third Army, commanded by General Ruffey, comprised the IV, V, and VI Corps plus the 3rd Group of Divisions of Reserve (GDR) under General Paul Durand: the 54th, 55th, and 56th Divisions.

22. Theoretically, in the reserves,

each regiment of 1920 troops was commanded by a colonel or lieutenant colonel;
each battalion of 960 troops had a commandant (major);
each company of 240 troops was commanded by a captain;
each platoon of 120 troops was headed by a lieutenant or sublieutenant;
each section of 60 troops was led by a lieutenant, sublieutenant, or adjudant;
a half-section of 30 troops should have a sergeant;
and a squad of 15 troops should have a corporal.

23. Tuchman, *Guns of August*, 353.

24. The 55th Reserve Division consisted of six reserve regiments in two brigades. The 109th Brigade (General Arrivet) comprised the 204th, 282nd, and 289th Regiments; and in the 110th Brigade (General de Mainbray) were the 231st, 276th, and 246th. Two squadrons of dragoons were also attached to the division, and three groups of 75-mm field artillery, a regiment of engineers, and a radio section. Two machine-gun sections were normally attached to each regiment.

25. These accounts are translated from the online articles "Sambre-Marne-Yser, Août–Novembre 1914" and "55e Division de réserve s'immole sur le plateau de Barcy."

26. The 204th RI was under the temporary command of Commandant Hasen-winkel of the 5th Battalion until 27 September, when Lieutenant Colonel Duroux took command.

27. This was the case until 1917, when the German forces fell back to another deadly defensive line on the Chemin des Dames. Our map is based on one in the JMO of the 246th RI.

28. General Quiquandon's 90th Brigade, on loan from the 45th Division, comprised the 2nd Zouave Regiment and the 2nd Moroccan Rifle Regiment.

29. JMO, 109th Brigade of Infantry and JMO, 55th Division of Reserve.

30. Letter of Robert André-Michel to André and Hélène Michel, 5 September 1914, quoted by Robert Burnand, "Robert André-Michel," *Foi et Vie* 22 (1 March 1919) 69.

31. Solitude, où je trouve une douceur secrète / Lieux que j'aimais toujours: Jean La Fontaine, Fable : "Le songe d'un habitant de Mogol," in *Fables* Vol. 11.

32. 23 September, JMO, 55th DR.

33. Paul Tuffrau, *1914–1918, Quatre années sur le front: Carnets d'un combattant* (1998) 52–53 for 6 October 1914.

34. John Denton Pinkstone French, Earl of Ypres, *1914* (1919), 145–53, 171, 186–88.

35. Joseph Joffre, *The Personal Memoirs of Joffre*, tr. Colonel T. Bentley Mott (1932) vol. 1, at the given dates.

36. Letter of Robert André-Michel to André and Hélène Michel, 4 October, quoted by Robert Burnand, "Robert André-Michel," *Foi et Vie* 22 (1 March 1919) 69.

37. From the copy by Rose-Marie (in a private collection), where the entry is misdated 9 October.

38. Letter of Rose-Marie André-Michel to Robert André-Michel, 12 October 1914, quoted in Hallays, "Préface," vi.

39. Tuffrau, *1914–1918*, 55–56 for 11 October 1914.

40. Letter of André Michel to Robert André-Michel, quoted by Pastor Westphal in his funeral address for André Michel, 15 October 1925: Boisson, *Monographie*, piece 14.

41. Tuffrau, *1914–1918*, 56–57 for 12 October 1914.

42. Letter of Rose-Marie André-Michel to Robert André-Michel, 14 October 1914, quoted in Hallays, "Préface," vi.

6. Rose-Marie's War, 1914–1918

1. Sargent wrote *Rose-Croix* for *Croix Rouge* by mistake or in jest; Rose-Marie certainly had nothing to do with the 18th degree of Freemasonry, or with the gnostics called Rosicrucians.

2. Letters of John Singer Sargent to Rose-Marie André-Michel, 14 and 18 October 1914, MS in a private collection.

3. Letter of John Singer Sargent to Rose-Marie André-Michel, 20 October 1914, MS in a private collection.

4. Letter of John Singer Sargent to Emily Sargent, 25 October 1914, MS in a private collection.

5. The Château de Crevin was not used by Madame Ormond early in the war: possibly it had been commandeered for military purposes, being on the French side of the frontier.

6. Letter of John Singer Sargent to Rose-Marie André-Michel, 29 October 1914, MS in a private collection. The letter was written on a light-letter form, folded in four and sealed with three Austrian stamps totaling 25 Heller, addressed in black ink, in a scrupulously legible hand—"Madame Robert André Michel, 9e Hotel des Bergues, Genève, Schweiz"—with the pencil addition "Absender J. S. Sargent, St. Lorenzen, Pusterthal." The postmark of origin is illegible; but the Geneva arrival postmark is dated 5 XI 1914.

7. This account of the return journey is reconstructed from Mount, *John Singer Sargent*, 322, and from Mount's article "The Rabbit and the Boa Constrictor: John Singer Sargent at the White House," *Records of the Columbia Historical Society* (Washington, DC) 71/72 (1971–1972), 618–56. Mount's researches in the State Department archives turned up some precious details, including a copy of Sargent's passport photograph taken at Le Havre: Mount, "The Rabbit," 652.

8. Quoted in Hallays, "Introduction," xxi; and in Ecole nationale des chartes, *L'Ecole des chartes et la guerre*, 139.

9. Letter of Henry James to Edith Wharton, 20 October 1914, in James, in Henry James, *Letters*, vol. 4 (1984), 723. Letters on pages 721–24 are all of interest.

10. Letter of Henry James to Margaret Mary James, 23 October 1914, in James, *Letters* vol. 4, 726. Letters on pages 724–27 are all of interest.

11. Henri Stein, "Robert Michel," *Bibliothèque de l'Ecole des chartes* 75 (1914), 451–53.

12. *Bibliothèque de l'Ecole des chartes* 76 (1915), 602.

13. *Bibliothèque de l'Ecole des chartes* 76 (1915), 465.

14. André Michel, *Les villes martyres: Reims, Soissons, Senlis, Arras* (1915). This pamphlet of 95 pages contains three lectures, published in French and eleven other languages, to spread the word of German atrocities, human and cultural. André Michel gave "Reims" (pp. 7–22) on Friday, 19 February 1915 and "Soissons, Senlis, Arras" (pp. 27–46) on Thursday, 25 February as slide-illustrated lectures. A cheap wartime production, on poor acid paper that is now browned and fragile, the French version was priced 26 centimes and the English twopence halfpenny or five cents American. The copies in Harvard Library belonged to the president of the university, Lawrence Lowell. The English translator was not a native speaker of the language, and so the text is a little stilted; quotations here are our own version of the French.

15. Michel, *Les villes martyres*, 11. Max Doumic, an architect and Catholic religious writer, was mobilized at age 52 with the 118th Territorial Infantry and was killed before Reims on 11 November 1914.

16. Michel, *Les villes martyres*, 33. The witness probably heard *Wir werden sie beim Schrecken haben!*

17. Michel's *Histoire de l'art*, volume II part I, *Formation et expansion de l'art gothique* (1906) had made many of these points of architectural history. Michel's Introduction explained "gothic" as a disdainful Renaissance reference to Europe's poor attempts at building after the Germanic barbarians overwhelmed classical culture. Chapter 1 (pp. 5–195) by Camille Enlart treats the gothic architecture of the 13th century.

18. Michel, *Les villes martyres*, 14.

19. Michel, *Les villes martyres*, 19.

20. Michel, *Les villes martyres*, 27.

21. Michel, *Les villes martyres*, 28–33, The *Taube*, "dove," was a light single-wing airplane. Two bombs struck Notre-Dame and one broke through the roof and exploded, but the fire was quickly extinguished. That terror raid happened at 3 am, 12 October 1914, Robert's birthday, and was reported in *Le Temps* and *Le Matin* on the 13th, the day he died.

22. *L'Illustration* of 28 April 1917 showed photographs that had been recovered from a German observation post at Crouy: naked-eye and telescopic views of Soissons and its cathedral.

23. Michel, *Les villes martyres*, 37–40.

24. Letters in this chapter of Rose-Marie André-Michel to her brother Guillaume Ormond, as dated, MSS in a private collection.

25. Rose-Marie's letters of 22 and 28 January 1915.

26. Rose-Marie's letter of 25 October 1914.

27. Rose-Marie's letter of 9 February 1915.

28. Wilfred Owen, "Strange Meeting" (1918), line 25.

29. The fortress port of St. Malo straddles the wide mouth of the river Rance. Dinard is to the west of St. Malo and St. Servan to the east.

30. A spa town in the Pyrénées-Atlantiques.

31. Paul Emard, *Toiling through the Dark* (1919), 20.

32. *Le Petit Parisien*, 28 and 30 March 1915; and see Marc Boegner's preface to Lagny, *Le réveil de 1830 à Paris*.

33. Emard, *Toiling through the Dark*, 22. There is a series of striking and revealing postcards from Reuilly in the online archives of the Perkins School for the Blind: www.flickr.com/photos/perkinsarchive/9237704251.

34. *Journal des soldats blessés aux yeux*, July 1917, 5.

35. Eugène Brieux, *Nos soldats aveugles* (1917).

36. Nora Saltonstall, *"Out Here at the Front": The World War I Letters of Nora Saltonstall*, ed. Judith S. Graham (2004), 52–53. Saltonstall soon found her role as a heroic driver for a privately funded *autochir* or mobile surgical hospital.

37. In the collection Dorothy Canfield Fisher, *Home Fires in France* (1918), 173–93.

38. The etching was printed across the centerfold of *L'Illustration* for 28 May 1915, 518–19, accompanied by an essay of Lucien Descaves, "Un voile sur les yeux,"

511; also in Noël Clément-Janin, *Les estampes, images et affiches de la guerre* (1919), 15–16, which is quoted here. J. J. Weerts, a pupil of Renouard, painted his portrait, now in the Château de Blois collection, with this favorite drawing displayed behind his shoulder.

39. Karl Baedeker, *Paris and Its Environs* (Leipzig, 1907).

40. Rose-Marie André-Michel, personal journal, 31 December 1915, MS in a private collection. The excerpts translated here were made by Emily Sargent after Rose-Marie's death.

41. Rose-Marie André-Michel, personal journal, 4 February 1916, MS in a private collection. By the end of the year, with material help from the Amis des Soldats Aveugles, Alphonse Angot was in business as a brushmaker at 15 rue Paul-Marion, Le Havre: *Journal des soldats blessés* 2 (December 1916), inside front cover.

42. Georges Edmond Boegner, médecin auxiliaire of the 53rd Regiment of Artillery, was killed at Montzéville (Meuse) on 16 March 1916.

43. *Le Temps*, 19 Mars 1916, "LES GRANDES CONCERTS." The performance was by 250 players and singers directed by Victor Charpentier at the Théâtre des Champs-Elysées, in memory of the soldiers who had died for their country.

44. Denisart and Surchat, *Le cigare et les fourmis*, 26–33. In 1931 Ormond cigars merged with another Vevey cigar company and became Rinsoz & Ormond Holding SA, which in the last quarter of the twentieth century branched out into food products, finally sold off its tobacco production, was renamed Orior SA, and continues activity in the supply of food products to hotels and restaurants.

45. Guillaume's hand is upright or even slightly left leaning, and he used a broad nib and black ink suitable for copying music; Jean-Louis's hand is rounder and right leaning, his pen finer, and his ink lighter. Both fell into English spellings of words, notably *cannonade* for the French *canonnade*.

46. Baedeker, *Switzerland*, 23d ed. (1909), 288.

47. "Typhoid Fever," *Encyclopedia Britannica*, 11th ed. (1911) vol. 27, 503–8.

48. Sargent's letter is dated Hotel Vendome, Boston, 11 November 1916.

49. The excerpts here are from letters of 31 October and 15 November.

50. 15 November 1916.

51. 19 November 1916.

52. 7 December 1916.

53. Otto Barblan (1860–1943), organist of St. Pierre cathedral since 1887, gave his grand organ concerts on Good Friday, Reformation Sunday, and Christmas from 1907 to 1927.

54. Lafcadio Hearn, *Out of the East; Reveries and Studies in New Japan* (Leipzig: Bernhard Tauchnitz, 1910).

55. "HAM ET CHAUNY SONT PRIS; SOISSONS EST COMPLÈTEMENT DÉGAGÉ," *Le Petit Parisien*, 20 March 1917.

56. *L'Illustration* for 28 April 1917, 406, told how orchards and vineyards were systematically cut down or girdled by the retreating Germans, and gave advice, with pictures, on how to save a fruit tree by bridge grafting. Dorothy Canfield's story "The

Permissionaire," *Home Fires in France*, 27–59, set in or near Crouy, recreates the experience. See also Maurice Thiéry, *La guerre en 1917* (1918), especially for Noyon and Coucy-le-Château.

57. Elizabeth Yates, *Pebble in a Pool* (1958), 131–32. Dorothy Canfield's stories in the collection *Home Fires in France* describe Crouy and its people, both under the German occupation and in the process of rebuilding and restoring their devastated fields, gardens, and orchards in 1917. Returning to Crouy in 1918, she used the expository trick of conversations with various young American soldiers to account for that wonderful old town and its way of life: "Notes from a French Village in the War Zone," in Canfield, *Home Fires in France*, 1–26.

58. Canfield, *Home Fires in France*, 27–59.

59. De Varigny Journal, 31 October and 1 November 1917.

60. Guy Vermeil, younger son of her sister-in-law Madeleine.

61. Maurice Thiéry, *Paris bombardé par Zeppelins, Gothas et Berthas* (1921), 1–129; Jules Poirier, *Les bombardements de Paris (1914–1918): Avions - Gothas - Zeppelins - Berthas* (1930), 1–203.

62. Rose-Marie's letter to Guillaume, 24 January 1916: "By the way, could you tell me the name of César Franck four hands that we played because Poupette would like to play them with me."

63. The Schola Cantorum was founded in 1896. The director from 1900 until his death in 1931 was Vincent d'Indy. Teachers and students have included Albeniz, Canteloube, Casadesus, Landowska, Messiaen, Milhaud, Roussel, Satie, and Turina. The concert hall of the Schola is in the church built by Louis XIV for a convent of exiled English Benedictine monks, where King James II in exile lived, died, and was buried.

64. 30 March 1917, Friday of Passion Week, at the Schola Cantorum. The St. John Passion calls for considerable forces, orchestra, chorus, and soloists.

65. The *Chorale in A minor* was one of three organ chorales published in 1890. *Les béatitudes* is an oratorio for soloists, chorus and orchestra, with a French text that paraphrases and extends the Sermon on the Mount, first performed in 1891, after Franck's death. Stephen Eddins wrote, "The music has a relentless Wagnerian intensity and earnest weightiness that are too rarely leavened by moments of textural and emotional transparency. Those moments, such as the closing to the Third Béatitude, are all the more lovely for the contrast they provide." ("Helmuth Rilling, César Franck: Les Béatitudes," Review by Stephen Eddins, online at allmusic.com).

66. Franck set this Béatitude third in his oratorio, although it is the second in the Gospel of Matthew 5:4.

67. 4 October 1917. In a black bordered envelope, franked 25 centimes, postmarked rue Claude-Bernard, [Friday] 5.10.1917, 12h, addressed "Monsieur Guillaume Ormond, 94 Cheyne Walk, Chelsea, Londres S.W." and on the flap "Exp: Mme Robert André-Michel, 7 rue Pierre Nicole prolongée, Paris."

68. Charles-Marie Widor succeeded César Franck as organ professor at the Paris Conservatoire; Albert Schweitzer was one of his many distinguished students. Widor

was 73 in 1917, but he continued as organist at Saint-Sulpice until 1933, so Rose-Marie's urgency was premature and, as she hinted, self-interested.

69. According to Richard Ormond.

70. Marc Boegner's address at the funeral of Rose-Marie, 3 April 1918, MS in a private collection.

71. Emily Sargent's copies and notes on Rose-Marie's journal and letters: "Il faut *mériter* la mort; et d'abord apprendre à bien souffrir, afin d'acquerir le revoir."

72. Alice Ziska Snyder and Milton Valentine Snyder, *Paris Days and London Nights* (1921), 4: Alice wrote from Paris to her husband in London, "The Ecole des Mines near the Luxembourg was destroyed. The theory is that the Huns were aiming at the Senate to avenge their friend Cailloux [a condemned spy]. An airplane fell in flames in the Luxembourg Gardens." Full accounts with statistics are in Jules Poirier, *Les bombardements de Paris*; and, more immediate and passionate, Maurice Thiéry, *Paris bombardé par Zeppelins, Gothas et Berthas*.

73. Pierre de Coubertin, *Le livre d'or des victimes du bombardement de l'église Saint-Gervais* (1922), 73.

74. De Varigny Journal, 30 March 1918.

75. According to Hallays, "Préface," vii, quoting André Michel.

76. *Le Temps*, 5 March 1918: The concert was for the benefit of the mobilized members of the combined orchestras, their prisoners of war, and their widows. The venue was Salle Gaveau, 45 rue La Boétie. The meager remnants of those orchestras gallantly offered Berlioz, *Symphonie fantastique*; Saint-Saëns, *Septet* for piano, trumpet, 2 violins, viola, cello and double bass; and Beethoven, Symphony no. 5.

77. *Le Temps*, 28 March 1918: the early music was to begin at 4:45 Summer Time. That energy-saving system was called "l'heure Honnorat" after the deputy who had introduced the change in 1916. In 1918, Summer Time began on 9 March.

78. De Varigny Journal, quoting André Michel.

79. These descriptions depend on F. Martin-Ginouvier and Albert Savine, *La Passion de Saint-Gervais* (1919).

80. The *banc d'oeuvre* is an enclosed bench reserved for the distinguished lay members of the parish council, traditionally the major donors to the *oeuvre*, the building and maintenance of the church. In 1918 and until quite recently, the tall and ornate walnut *banc* of Saint Gervais stood directly across the nave from the pulpit.

81. Jeanne Baheigne, 20 years old, a typist, came as in previous years to sell the programs for the benefit of the parish *ambulance*. If she had survived Good Friday, she would have married a week later: de Coubertin, *Le livre d'or*, 21.

82. The *Improperia* were short "reproaches" addressed as if by Jesus during his suffering to the People of Israel, beginning "My people, what have I done to you, or how have I saddened you? Answer me!" The texts are based on two medieval Christian dogmatic presumptions: that Jesus was One God with the God who had tenderly fostered the Jews under the Old Covenant, and that the Jewish People was collectively guilty of the death of Jesus. Giovanni Pierluigi da Palestrina (1525–1594) wrote and directed *Improperia* for the Sistine Chapel in 1560; Tomás Luis de Victoria (1548–

1611), who may have been Palestrina's student, composed his in Rome in 1585. The Latin texts can be found in the *Graduale romanum* (1961) 225–231; several videos of the settings by Palestrina and Victoria are online.

7. The Paris Gun

1. The entire story of the Paris Gun, technical and tactical, social and human, is best told and illustrated in Christophe Dutrône's splendid new work *Feu sur Paris!* (2012). The technical descriptions in this chapter are taken from Henry W. Miller, *The Paris Gun: The Bombardment of Paris by the German Long Range Guns and the Great German Offensives of 1918* (1930) unless otherwise noted. Miller, a lieutenant colonel of the US Ordnance Corps, had access to German technical information, military logs, and witnesses immediately after the Armistice, and his expertise as an ordnance officer enabled him to give finely detailed accounts, sometimes minute-by-minute, of the mounting and operation of the guns. Miller also used Poirier, *Les bombardements de Paris*, 205–74, sometimes in direct translation but without citation. Heinz Eisgruber, *So schossen wir nach Paris* (1934) took illustrations with attribution, and text without, from Miller, and he translated passages from Poirier without citation; his book is a reliable source for early-Nazi revanchism, but not for its ostensible subject. Thiéry, *Paris bombardé*, 112–87, has some details of the experience of Paris to supplement Poirier and Miller.

2. The Parisians called the monster "Grosse Bertha," a name originally given by the makers at Krupp to a 17-inch siege mortar that had pounded the fortifications of Liège in 1914.

3. The following descriptions were assembled from Miller, *The Paris Gun*, 59–60; *Le Matin*, 30 March–4 April 1918; The *New York Times* for the same dates, partially derived from *Le Matin*; Thiéry, *Paris Bombardé*, 130–39; Poirier, *Les bombardements de Paris*, 228–31; Martin-Ginouvier, *La passion de Saint-Gervais*, especially 23–29. Articles, photographs, and drawings are in *L'Illustration* for April 1918. Our plan is after André Devèche, *L'église Saint-Gervais et Saint-Protais de Paris* (1974).

4. *L'illustration*, 17 August 1918, the colored engraving on p. 159 and the anonymous article "L'église Saint-Gervais" on p. 158.

5. 31 March 1918.

6. de Coubertin, *Le livre d'or*, 113. Baron Pierre de Coubertin, best known as a founder of the modern Olympics, lost his sister-in-law in Saint Gervais.

7. *Ambulance* was the French term for a field hospital, such as the successful and popular one operated by American volunteers, in tents on an acre of borrowed ground, during the Franco-Prussian War of 1870: Thomas Wiltberger Evans, Edward Augustus Crane, John Swinburne, and William Edwin Johnston, *History of the American Ambulance Established in Paris during the Siege of 1870–71* (1873), especially chapter 1. The American Ambulance was revived in 1910 at Neuilly and served there and in several field hospitals throughout the 1914–1918 War.

8. de Coubertin, *Le livre d'or*, 10.

9. Miller, *The Paris Gun*, 60, without attribution.

10. de Coubertin, *Le livre d'or*, 79; and *New York Times* for 3 and 15 April 1918.

11. The couple clipped their names to fit into the ring, "Rose Ormond—Robert Michel," and the recorder mistook Robert's *nom* for his *prénom*. The legal record of deaths and inheritances gives "Ormond Rose [age] 24 rue Pierre-Nicole prolongée, 29 [March] à l'église S. Gervais. [Veuve] Michel." A cryptic addendum, "Oct. 19—197 coffre fort," refers to an official permission, 19 October 1922, to open the de Varigny family vault and move Rose-Marie's remains to a sealed casket for transfer to Robert's grave at Crouy. Archives de Paris, DQ8 2325: Table des Successions et Absences, lettre O, 1907–1934, opening 95: Mars 1918, no. 7.

12. Milton Valentine Snyder was the foreign correspondent of *The Sun* (New York). Transferred from Paris to the London desk early in 1918, he left his wife Alice Ziska Snyder to her war work in Paris. They corresponded copiously and informatively through the last year of the War.

13. Alice Ziska Snyder and Milton Valentine Snyder, *Paris Days and London Nights* (1921), 61–91. Long-range guns continued firing from the forest of Saint-Gobain through April. They never again matched their achievement of Good Friday, though one shell did hit a *crèche* or maternity hospital in boulevard Port-Royal on 11 April, killing or wounding four babies, seven nursing mothers, and three midwives.

14. de Coubertin, *Le livre d'or*, 29.

15. de Coubertin, *Le livre d'or*, 7–13.

16. Most of the living victims had been taken to the Hôtel-Dieu on the Ile de la Cité, a short walk down the *quai* and across the Pont de l'Arcole. Rose-Marie was not in the wards or in the *chapelle ardente* of candles and flowers that the nurses had arranged there for the dead-on-arrival.

17. At the Morgue, on the upriver tip of the island, the quai de l'Archevêché, the identification of the anonymous corpses was being managed as it had been for a century: they were laid out on marble or copper tables behind a glass wall to be scanned by grieving relatives and the curious public. But it was after hours, and the street gate of the Morgue was locked.

18. Marie-Marguerite Ormond, "On the Third Anniversary of the Death of Rose-Marie, 23 March 1921." This text and the one that ends this chapter were added in manuscript to a copy of her *Résonnances* (1919) in the Library of the University of Wisconsin at Madison.

19. An excerpt in Emily's copybook devoted to Rose-Marie, in a private collection.

20. The following account of Marc Boegner's sermon is an abridged translation of the holograph copy, sent to Violet Ormond and kept in a private collection.

21. There is a footnote: "Lettre de 12e octobre 1914": Robert's birthday, and the day before he died.

22. An excerpt in Emily's copybook devoted to Rose-Marie, in a private collection.

23. Number 1000 in the *ancien cimetière* in rue Galliéni, where Charles de Varigny was buried; thanks to Yves Antuszewicz for this note.

24. *Le Matin*, 4 April 1918.

25. *Le Petit Parisien*, 2 April 1918.

26. "Une lettre du grand rabbin à l'archevêque de Paris," *Le Matin*, 30 March 1918, 2. The high priest Zacharias does not appear in the Old Testament, only in the Christian Gospels. In the Gospel of John, chapter 1, he is the father of John the Baptist; Matthew 23:35 has Jesus calling down on the heads of the Scribes and Pharisees, "all the righteous blood shed upon the earth, . . . unto the blood of Zacharias son of Barachias, whom ye slew between the temple and the altar."

27. Marie-Marguerite Ormond, "On the Anniversary of Her Birth, 5 November 1919," MS addition to *Résonnances* (1919).

8. Sargent's War, 1914–1919

1. Lucia Miller, "John Singer Sargent in the Diaries of Lucia Fairchild, 1890 and 1891," *Archives of American Art Journal* 26, no. 4 (1986), 5.

2. The Stokeses chose to stay until Sargent had obtained his temporary pass in mid-November. After Sargent's departure they expected to wait at the Austrian border until they could return to their apartment in Munich. Only at the border, when they were ordered to proceed directly to Switzerland, did they understand that their world had capsized. Magdalen Evans, *Utmost Fidelity* (2009), 128–31.

3. Special cable to *The New York Times*, 22 August 1914.

4. Adrian Stokes, "John Singer Sargent," *The Old Water-Colour Society's Club 1925–1926 Third Annual Volume* ed. Randall Davies, F.S.A. (1926), 57.

5. Evans, *Utmost Fidelity*, 131.

6. Stokes, "John Singer Sargent," 57.

7. Charteris, *John Sargent*, 203.

8. Stokes, "John Singer Sargent," 58–59.

9. Museum of Fine Arts, Boston. Stokes, "John Singer Sargent," 58: "No model was available except my wife's servant who, though admirable in every other way, was stiff as a poker." The maid was probably the Josephine Worka of Graz, Austria, whom Stokes in his will in 1935 remembered handsomely for "many years of devoted and unselfish service": Evans, *Utmost Fidelity*, 149.

10. The Metropolitan Museum of Art, New York.

11. Private collection.

12. The Metropolitan Museum of Art, New York.

13. Private collection.

14. Private Collection.

15. The British Museum, London.

16. Downes, *John S. Sargent*, 66.

17. FitzWilliam Sargent, *England, the United States, and the Southern Confederacy.* 2nd ed. revised and amended (1864).

18. Olson, *John Singer Sargent*, 246.

19. *New York Times*, 3 November 1914.

20. *New York Times*, 22 November 1914.

21. Mount, *John Singer Sargent*, 326–27.

22. Sally M. Promey's *Painting Religion in Public* points out the influence of Renan in the tendency of modern religion away from institutional forms toward subjectivity, and she discusses that tendency chiefly in her first chapter.

23. *New York Times*, 30 June 1912; Mary Crawford Volk, "Sargent: Boston Public Library Murals" in *Sargent/Sorolla*, 171, assumes that these mural sections were in progress already in 1908 when the Spanish painter Joaquín *Sorolla* y Bastida visited Sargent's studio and was reportedly critical of Sargent's turning to Raphael and Michelangelo as models.

24. Mount, *John Singer Sargent*, 324.

25. Olson, *John Singer Sargent*, 247 and *New York Times*, 21 January 1916.

26. "Sargent Paintings Ready. He Will Soon Install Them in the Boston Public Library," *New York Times*, 24 March 1916.

27. The St. Botolph Club was then located at 2 Newbury Street, just across Arlington Street from the Public Garden. Thomas Fox (1864–1946) was an important Boston architect whose work was known and sought after all over the Northeast United States. He worked closely and enthusiastically with Sargent on projects that they both felt were important public monuments meant for posterity. After Sargent's death, Fox worked with Sargent's sisters in the distribution of sketches and drawings to appropriate museums and collections. He worked to catalogue Sargent's works and lectured and wrote about Sargent and his art. His nephew John Fox, in a private conversation, remembers that Thomas Fox was known to his businessmen siblings as eccentric and impractical; they felt that Sargent had taken advantage of his good will. He lived at the St. Botolph Club in Boston until late in life, when dementia and failing health made it impossible for that institution to care for him.

28. The authors thank Ellen Gurman Bard for placing the text in its association with Jewish families. See Mary Crawford Volk, "Sargent: Boston Public Library Murals" in *Sargent/Sorolla* (2006), 182, note 61.

29. The Boston Public Library's own description of the murals after the installation of these panels is found on the website www.bpl.org/central/sargentmurals.htm.

30. Alan Chong, ed., *Eye of the Beholder, Masterpieces from the Isabella Stewart Gardner Museum* (2003), 207.

31. Trevor Fairbrother, *John Singer Sargent, The Sensualist* (2000), 137.

32. Letter of Sargent to Mrs. Curtis, postmarked September 19, 1916, Boston Athenaeum, Sargent / Fox Papers 1.1.10.

33. Downes, *John S. Sargent*, 67–68.

34. Letter of Sargent to Evan Charteris, 25 July, 1916 in Charteris, *John Sargent*, 207.

35. See Mary Crawford Volk's captions for chapter 5, "The Murals," in Kilmurray and Ormond, *John Singer Sargent* (1998), 177–207, particularly 205.

36. Promey, *Painting Religion in Public*, 64–65 and notes.

37. Carol Troyen, *Sargent's Murals in the Museum of Fine Arts, Boston* (1999), 13.

38. Letter of Sargent at Tite Street, London, to Thomas Fox, 27 January n.y., Boston Athenaeum, Fox / Sargent Papers 1.42.

39. Letter of Sargent to Fox, 18 April 1917, Boston Athenaeum, Fox / Sargent Papers 1.45. Sargent had been lured by the Deering brothers to join them on their boat for a fishing expedition. James Deering's palatial property, Villa Vizcaya, based partially on the Venetian Ca' Rezzonico, was still being built.

40. Olson, *John Singer Sargent*, 254–55. The portrait is now in National Gallery of Ireland. For the painter's and the sitter's interest in camouflage see Mount, *John Singer Sargent*, 347–48.

41. *Boston Globe*, 30 January 1918.

42. *Boston Globe*, 1 February 1918.

43. Boston Athenaeum, Fox / Sargent Papers, folder 63.

44. *Boston Globe*, 25 March 1918.

45. *New York Times*, 27 March 1918.

46. *Boston Globe*, 30 March 1918.

47. *Boston Globe*, 2 April 1918.

48. MS in a private collection.

49. Ignaz Marcel Gaugengigl, born in Bavaria in 1855, immigrated to Boston in 1878 and became "court painter to the Back Bay." From the beginning of the war, as vice president of the *Bostoner-deutscher Gesellschaft*, he took a leading role in charities to benefit German war widows and orphans (*Boston Globe*, 22 December 1914 and 6 May 1915). Within a month of this April evening, the St. Botolph Club unanimously adopted a resolution to ask the resignation of any member who did not support the United States and its allies in the war, and Gaugengigl was on the list.

50. This quotation of Thomas Fox, and the one immediately above, are from "Fox 4 Newbury St.": three pages of typescript numbered 24–26, Boston Athenaeum, Fox / Sargent Papers 1.1.

51. Letter of John Singer Sargent to Isabella Stewart Gardner, 5 April 1918, Isabella Stewart Gardner Museum Archives, letters to Isabella Stewart Gardner, item 112.

52. The *Baltic* had been the first ship to radio an iceberg warning to her sister *Titanic* in April 1910 and was one of the ships that participated in the rescue of survivors.

53. "Fox 4 Newbury St.": typescript reminiscences of Fox, 26, Boston Athenaeum, Fox / Sargent Papers 1.1.

54. Letterpress copy in a private collection.

55. Clare Bowen, "Paul Nash and the First World War Official War Artists Scheme," *CERCLES: Revue Pluridisciplinaire du Monde Anglophone* 1 (2000), 21–31, especially 21–24 for the genesis and development of the War Artists Scheme. By the end of the war the project had commissioned over twelve hundred works.

56. Letter of Alfred Yockney to Sargent, 26 April 1918, in Olson, *John Singer Sargent*, 258.

57. Letter from Sargent to Isabella Stewart Gardner, 31 May 1918, in Olson, *John Singer Sargent*, 257.

58. *Mrs. Percival Duxbury and Her Daughter*, no. 581, City Art Galleries, Manchester, JSS:CP 3, no. 581, 246–47.

59. Boston Athenaeum, Sargent / Fox Papers, folder 11.

60. Letter of David Lloyd George to Sargent, 16 May 1918, in Mount, *John Singer Sargent*, 354.

61. Kilmurray and Ormond, *John Singer Sargent*, 276.

62. Joseph Hone, *The Life of Henry Tonks* (1939), 142.

63. Julian Freeman, "Professor Tonks: War Artist," *The Burlington Magazine* 127 (May 1985) 284–93.

64. Hone, *Henry Tonks*, 127, quoted in Freeman, "Professor Tonks: War Artist," 286. Tonks was probably referring to the portrait of the late King Philip IV of Spain, now in the National Gallery.

65. Charteris, *John Sargent*, 207.

66. Major Tristram Tupper, quoted in "Sargent's Studio of Shellfire," *New York Times*, 23 March 1919.

67. Peter Stansky, *Sassoon: The Worlds of Philip and Sybil* (2003), 76, quoting from a letter from Sir Philip Sassoon to Viscount Reginald Esher.

68. Duff Cooper, *Haig* (1936), 2, 317. In fact a regiment of the American First Infantry Division had the AEF's first offensive victory, capturing and holding Cantigny, on 28 May. But that was in the French sector.

69. Stansky, *Sassoon*, 77, quoting from Sassoon's diary.

70. Charteris, *John Sargent*, 211.

71. Hone, *Henry Tonks*, 143, quoting a former Slade School pupil, Thomas Lowinsky, then in the Scots Guards, whom Tonks took sketching with him.

72. Hone, *Henry Tonks*, 143.

73. Letter of Sargent to Thomas Fox, 9 August 1918, Boston Athenaeum, Sargent / Fox Papers, folder 15.

74. Hone, *Henry Tonks*, 144.

75. Private collection.

76. The Metropolitan Museum of Art, New York.

77. The Metropolitan Museum of Art, New York.

78. Imperial War Museum, London.

79. Stansky, *Sassoon*, 77.

80. Quoting the Journal of Henry de Varigny, who spent the day on the beach at Onival 50 miles to the west.

81. Letter of Tonks to Yockney, 19 March 1920, on the Imperial War Museum website. The site includes audio descriptions of mustard gas by veterans, including J. C. Hill, a British officer who served as a chemical adviser with Special Gas Company, Royal Engineers, from 1916 to 1918. He described the effect of mustard gas: "They were blind, the men, they couldn't see at all, they were choking, and in thousands they had to leave the line. Fortunately, one or two of the shells had not exploded and I got one of these and nursed it on my knees all the way back to the

research station. But it took our best chemists some weeks to find out what this new substance was—dichlorethyl sulphide. It was an oily liquid which evaporated very slowly and because it had such a faint smell the troops tended to take no notice of it. And when they did feel their eyes smarting, they were too late. It was a dreadful substance: if they got it on the soles of their boots, it would go through and burn their feet; if they went with some on their boots into a dugout and slept there, they would gas everyone in the dugout."

82. Charteris, *John Sargent*, 212, quoting Tonks. *Gassed* (Color 13), Imperial War Museum, London; to appear in JSS:CP 8.

83. Letter of 11 September 1918 in Charteris, *John Sargent*, 214.

84. Mount, *John Singer Sargent*, 358.

85. *New York Times*, 23 March 1918. Tristram Tupper served in both World Wars, rising to the rank of brigadier general, and later wrote screenplays and novels.

86. Lieutenant Leslie Kincaid, Judge Advocate, 27th Division, "The 27th New York's Guard Division that Broke German Line," *New York Times*, 9 March 1919.

87. Tupper, "Sargent's Studio of Shellfire," *New York Times*, 23 March 1918.

88. Sargent to Fox in Boston, 22 September 1918, Boston Athenaeum, Fox / Sargent Papers 1.49.

89. Letter of Sargent to Charteris, 11 September 1918, in Charteris, *John Sargent*, 214.

90. Letter of Sargent to Isabella Stuart Gardner, n.d., in Charteris, *John Sargent*, 216.

91. Letter of Sargent to Mrs. Hunter, 10 October 1918, in Olson, *John Singer Sargent*, 260–61. Péronne was the station where the main railway line crossed the Somme, 90 miles north of Paris.

92. Letter of Sargent to Charteris, 11 September 1914, in Charteris, *John Sargent*, 214.

93. Catullus, 101, "Multas per gentes"

94. Jean Philippe Jacques Massigli, son of André's sister Marguerite and her husband Charles Massigli, aspirant in the 239th RI, died of wounds near Givenchy (Pas de Calais) 1 October 1915. His name appears on the tablet of *Morts pour la France* in the Temple de l'Oratoire. Maurice Michel, son of André's older brother Félix, lieutenant in the 122nd Territorial RI, died of wounds at Clermont-en-Argonne (Meuse) 9 December 1915.

95. Paul Vitry, *La cathédrale de Reims, architecture et sculpture*, 2 vols. (1919), 1, 8.

96. His niece Reine wrote Guillaume on Friday 25 October that Sargent was returning "on Monday": letter in a private collection.

97. Bowen, "Paul Nash and the First World War," 22.

98. Quoted in Charteris, *John Sargent*, 212.

99. "Is My Team Ploughing" appeared in *A Shropshire Lad* (1896), and it was one of three Housman poems anthologized by Arthur Quiller-Couch in *The Oxford Book of English Verse* (1900).

100. Paul Fussell, *The Great War and Modern Memory* (1975), 161, quotes a soldier's letter full of echoes of the English Poets and comments, "To write like that you

have to read all the time, and reading the national literature is what the British did a great deal of in the line." Paul Fussell, *The Great War*, 164: "Everyone read Housman too. . . . *The Oxford Book of English Verse* was sufficient to satisfy the general appetite for poetry." Paul Fussell, *The Great War*, 282: "It is remarkable the way *A Shropshire Lad* . . . anticipates, and in my view even helps determine, the imaginative means by which the war was conceived. 'One feels Housman foresaw the Somme,' says Robert Lowell."

101. Imperial War Museum, 16162, 12. The authors wish to thank Senior Curator Jennifer Wood for taking the time to show us the preliminary sketches for *Gassed* and the other war paintings by Sargent in the collection.

9. The End of *The Triumph of Religion*

1. JSS:CP 3, no. 587, and pp. 252–263.

2. "John S. Sargent 1856–1925: The Man and Something of His Work," Boston Athenaeum, Fox / Sargent Papers 4.12; and an unpaginated essay about the Museum of Fine Arts decorations, 4.13.

3. "Sargent, the Artist," *Boston Globe*, 1 February 1903, 29.

4. Letter of FitzWilliam Sargent to his parents, quoted at length in Charteris, *John Sargent*, 5.

5. Charteris, *John Sargent*, 107.

6. Miller, "John Singer Sargent in the Diaries of Lucia Fairchild," 4.

7. "The new Fairford Parish Church, built in a late Perpendicular Gothic style, was consecrated . . . in 1497. . . . It must have been complete by 1520, when King Henry VIII stayed in Fairford and heard Mass in the church. The medieval glass that is the glory of the church was made in 1500–1517 by the King's glazier, Barnard Flower, working out of his workshops at Westminster. Many of the glaziers and glass painters who worked on the project were Dutch, which shows in the styling of the windows." From the website sacred-destinations.com.

8. William Dean Howells and Thomas Sergeant Perry, eds., "Benvenuto Cellini's Escape from Prison," in *Library of Universal Adventure by Sea and Land* (New York: Harper & Brothers, Franklin Square, 1888), 442–48.

9. Miller, "John Singer Sargent in the Diaries of Lucia Fairchild,"13–15.

10. Ernest Renan, *La vie de Jésus* (1864) translated as *The Life of Jesus* (1864), 9; Ernest and Henriette Renan. *Brother and Sister: A Memoir and the Letters of Ernest and Henriette Renan*, tr. Mary Loyd (1896), 5–68.

11. Renan, "Dedication," *La vie de Jésus* (1864), authors' translation.

12. Renan, *Life of Jesus*, 226–27.

13. Renan, *Life of Jesus*, 13.

14. Renan, *Life of Jesus*, 220.

15. Renan, *Life of Jesus*, 34.

16. Renan, *Life of Jesus*, 218. The book was written and published in the last days of the Papal States in Italy, after Garibaldi and King Vittorio Emmanuele had joined

their forces in the creation of the Italian state (1860). What remained of the Papal States was actually propped up for the decade of the 1860s by the French Army.

17. Renan, *Brother and Sister*, 46.

18. Renan, *Life of Jesus*, 56.

19. Renan, *Life of Jesus*, 221.

20. Renan, *Life of Jesus*, 58.

21. Charteris, *John Sargent*, 143–44.

22. "Sargent, the Artist," *Boston Globe*, 1 February 1903, 29.

23. "Sargent's Beautiful Painting Now on Exhibition," *Boston Globe*, 17 February 1903, 14: Source for both quotations in this paragraph.

24. Charteris, *John Sargent*, note to p. 167.

25. It was only in 1963 that Pope Paul VI stopped wearing the crown in ceremonies; Pope John Paul I's refusal to be crowned at all (1978) was a symbolic renunciation of secular authority.

26. John G. Davidson, writing to the editor, *New York Times Book Review*, 18 June 1905.

27. *New York Times*, 24 December 1916.

28. Downes, *John S. Sargent*, 67–68.

29. Letter of Sargent to Fox, 24 March 1919, Boston Athenaeum, Fox / Sargent Papers 1.17a.

30. Emile Mâle, *Religious Art in France, XIII Century; A Study in Mediaeval Iconography and Its Sources of Inspiration*, translated from the 3rd ed. by Dora Nussey (1913), 188–193. Sargent owned that third French edition (1910): Christie, Manson & Woods, *Catalogue* (1925), no. 161. Note that this work of Mâle's had shared the Gobert Prize in 1910 with Robert André-Michel's *Administration royale*. See also André Michel's *Histoire de l'art* vol. 1, part 2, 784–5 and fig. 419, and 832 and fig. 445 for analogous groups.

31. The veil of the Temple of Solomon was directly modeled on the veil of the tabernacle in the Sinai desert, as described in Exodus 26:31 "And thou shalt make a veil of blue, and purple, and scarlet, and fine twined linen of cunning work: with cherubim shall it be made." The veil of the Temple of Herod, which stood in Jesus's time, was only mentioned in the apocryphal 1 Maccabees 4:51,"They set the loaves upon the table and hung up the veils and finished all the works that they had begun to make." However Josephus in *The Wars of the Jews* 5.5.4 confirms that the tradition was continued: "It was a Babylonian curtain, embroidered with blue, and fine linen, and scarlet and purple. . . . This curtain had also embroidered upon it all that was mystical in the heavens."

32. Promey, *Painting Religion in Public*, 229–34.

33. Here is the *Fourth Eclogue*, lines 4–30, our translation with a medieval Christian slant: "Now comes the last age of the Cumaean song: a whole great series of centuries begins. A Virgin returns, and a peaceable kingdom. A Son is newly sent down from heaven. With the Boy just born, wars will cease for the first time, and a precious People will arise throughout the world. . . . He will reign over a world pacified by his

Father's power. For you, oh Boy, the earth will bring forth her gifts without a farmer's labor. . . . The goats will come home by themselves, their udders full of milk, and the flocks will not fear great lions. . . . The plain will grow yellow with waves of grain, and on untended vines the reddening grapes will hang."

34. Most famously, Michelangelo's sculpted marble *Pietà* in the Vatican.

35. Ephesians 5:23–33; 2 Corinthians 11:2; Revelation 19:7–9 and 21:2–9.

36. James M. Saslow, "Pietà," in Chong, *Eye of the Beholder*, 81: "Like much of Michelangelo's work, the drawing is deeply autobiographical. The key to its meanings, both public and private, lies in the verse from Dante's *Paradiso* inscribed on the (now partly-cropped) cross: 'There they don't think of how much blood it costs' (Non vi si pensa quanto sangue costa). Michelangelo, who knew much of Dante by heart, was quoting canto 29, where Beatrice deplores how few on earth appreciate the sacrifices martyrs make to spread the divine gospel down there, or how pleasing to God are those who cling to it."

37. Sargent knew the British greatcoat; this one is similar to the coat of Field Marshall French in *General Officers of the Great War*: JSS:CP 3, nos. 587 and 601, also fig. 143, a pencil sketch of the greatcoat, which was modeled separately.

38. Kilmurray and Ormond, *John Singer Sargent*, 205–7, fig. 98. The drawing is now in the Museum of Fine Arts, Boston.

39. "Two Sargent Panels Unveiled at Library," *Boston Globe*, 6 October 1919, 5.

40. "New Painting at Public Library Stirs Jews to Vigorous Protest," *Boston Globe*, 9 November 1919, 48.

41. Letter of Sargent to Charteris, 24 October 1919, in Olson, *John Singer Sargent*, 252.

42. See Sargent's letters to Isabella Stewart Gardner between New Year's and May of 1920 when Emily returned to England, in the Isabella Stewart Gardner Museum's Archives. The authors thank the Isabella Stewart Gardner Museum's archivists, Lisa Feldmann and Shana MacKenna, for expediting our survey of those letters.

43. Sargent letters to Isabella Stewart Gardner, 147, Isabella Stewart Gardner Archives.

44. "John S. Sargent 1856–1925: The Man and Something of His Work," 58, Boston Athenaeum, Fox / Sargent Papers 4.12.

45. Carol Troyen, *Sargent's Murals in the Museum of Fine Arts, Boston*, 29, note 16 sees a possible last tribute to Rose-Marie in the face of the allegorical figure of Painting.

46. *Gratiae decentes alterno terram quatiunt pede* (Horace, *Carmina* 1.4.5–6) and *Gratia cum nymphis geminisque sororibus audet ducere nuda choros* (Horace, *Carminas* 4.7.5).

47. Sargent's words were reported by an "assistant director" of the Museum, quoted in Downes, *John S. Sargent*, 80.

48. It is an American bayonet; Sargent had no example of the French one.

49. Captions for Sargent's *Death and Victory*, 1922, and *Entering the War*, 1922, Widener Library, Harvard University, Cambridge, MA.

50. Fox, who knew Sargent's mind better than anyone else in those days, could only report that "the placing of the canvases in the frames in the two end panels of the staircase wall, unveiled in Oct. 1919, completed this work, although a composition to fill the centre panel had until then been under definite consideration. But in the end Sargent unquestionably felt—and so expressed himself—that all things considered, the hall would look best as it is rather than if the centre panel were filled with a composition as originally intended and of which indications but not much more, can be seen in several studies." Typescript of an essay by Fox, 10, Boston Athenaeum, Fox / Sargent Papers 4.18.

51. Stokes, "John Singer Sargent," 52.

10. Epilogues

1. A graduate and later professor of the Ecole des Beaux-Arts; his Société Générale building (1907) shows that he could be trusted with glass walls.

2. "Suppléments, édifices du culte (1840–1920): Eglise Saint-Gervais, réparation des dégâts causés par le bombardement du 29 mars 1918," Archives de Paris VM 32–37, 14.

3. Baron Pierre de Coubertin, *Le livre d'or des victimes du bombardement de l'église Saint-Gervais le Vendredi Saint 29 Mars 1918* (1922) was sold for two francs in the sacristy, for the benefit of the church. Preface by the curé, abbé Gauthier, p. 15.

4. Luke 23:43

5. Letter of André Michel to Paul Vitry, 20 June 1915, in Paul Vitry, "André Michel (1853–1925)," *Gazette des Beaux-Arts* 16 (1925) 329.

6. This plaque, shown in Vitry, "André Michel (1853-1925)," 331, may have been mounted on a column at the south end of the Luxembourg Garden, near the headquarters of the publisher Armand Colin. André Michel's granddaughter Stella Leenhardt Corbin mentioned a plaque in his memory there, but we have not been able to find it. Interview of Stella Leenhardt Corbin with Christine Boisson et al., 12 January 1996, Christine Boisson et al., *Monographie.*

7. "Discours du pasteur [Alfred] Westphal aux obsèques d'André Michel au Temple de l'Oratoire, 15 Octobre 1925," Paul Vitry's typescript copy, reproduced in Boisson et al., *Monographie.*

8. "Discours du pasteur [Alfred] Westphal," reproduced in Boisson et al., *Monographie.*

9. In the Geneva Bible of 1669, "Mon âme s'attend au Seigneur plus soigneusement que les guettes du matin, qui aguettent la venue du matin." In the King James Bible, "My soul waiteth for the Lord more than they that watch for the morning: I say, more than they that watch for the morning."

10. Private conversation of the authors with Richard Ormond.

11. Marie-Marguerite Ormond, "Chimère," MS addition to *Résonnances* (Geneva: privately printed, 1919).

12. Stokes, "John Singer Sargent," 52.

13. Mary Abbey, *Concerning Edwin A. Abbey's Last Work* (1926), a pamphlet in the Boston Athenaeum.

14. André Michel, *Puvis de Chavannes* (1912), 93–94.

15. Charteris, *John Sargent*, 231–2; Olson, *John Singer Sargent*, 268–69.

16. The picture of Sargent's funeral by Fred Roe is in the Guildhall Art Gallery in the City of London (no. 1291).

17. "John S. Sargent 1856–1925: The Man and Something of His Work," Boston Athenaeum, Fox /Sargent Papers 4.12.

18. de Varigny Journal, 3 November 1922. Two missing mourners, John Sargent and his sister Emily, were in America, where Sargent's just-finished memorial to the young Harvard war dead was due to be unveiled the next day. "Sargent's Paintings Unveiled at Harvard Widener Library," *Boston Globe,* 4 November 1922, 16.

19. Henry de Varigny, "In Memoriam," *Journal des Débats*, 15 October 1922. Emmanuel Pontremoli (1865–1956) was born in Nice, son of a rabbi; elected to the Académie des Beaux-Arts in 1922.

~

Bibliography

Short Citations

Boston Athenaeum, Fox / Sargent Papers = MS .L614: Thomas A. Fox and John Singer Sargent Collection, 1882–1934.

Boston Athenaeum, Sargent / Fox Papers = MS .L324: Papers of John Singer Sargent and Thomas A. Fox, 1882–1932.

Constantin, *Souvenirs* = *Mes souvenirs: Journal de Madame Charles de Varigny née Louise Constantin* (1827–1870), typescript and electronic file provided by her great-great-grandsons Henri-Abel Vermeil and Yves Antuszewicz, respectively.

JMO = *Journal des marches et opérations* (followed by unit name and number), found in the French Ministry of Defense website Mémoire des Hommes.

JSS:CP = Ormond, Richard and Elaine Kilmurray. *John Singer Sargent: Complete Paintings* (followed by volume, serial number, and pages [where applicable]).

Ormond Notes = Marguerite Ormond's notes for a "Genealogical History of the Griolet Family" and a "Biography of Michel-Louis Ormond Dedicated to His Grandchildren."

de Varigny Journal = Journal (1885–1895, 1898–1934) of Henry de Varigny, the original manuscript provided in digital form and typescript by his great-grandson Yves Antuszewicz.

Historic Newspapers and Journals

L'Art: Revue Hebdomadaire Illustrée (Paris, 1875–1907)
Le Figaro (Paris, 1826–)
Gazette des Beaux-Arts (Paris, 1859–)

L'Illustration (Paris, 1843–)
Journal des Débats Politiques et Littéraires (Paris, 1815–1944)
Journal des Soldats Blessés aux Yeux (Paris, 1916–1919)
Le Matin (Paris, 1844–1944)
La Nouvelle Revue (Paris, 1879–)
Le Parlement: Journal de la République Libérale (Paris, October 1878–December 1883)
Le Petit Parisien (1876–1944)
Revue Historique (Paris, 1876–)
The Silent Worker (Trenton, NJ, 1888–1929)
Le Temps (Paris, 1861–1942)

Bibliography

Abbaye de Solesmes. *Graduale romanum* (Paris: Desclée & Socii, 1961).

Abbey, Mary. *Concerning Edwin A. Abbey's Last Work* (1926). A pamphlet in the Boston Athenaeum.

Adelson, Warren, "John Singer Sargent and the 'New Painting,'" in Stanley Olson, Warren Adelson, and Richard Ormond, *Sargent at Broadway: The Impressionist Years*, s.v.

Adelson, Warren, Donna Janis, Elaine Kilmurray, Richard Ormond, and Elizabeth Oustinoff. *Sargent Abroad: Figures and Landscapes* (New York: Abbeville Press, 1997).

Adelson, Warren. *Sargent's Venice* (New Haven, CT: Yale University Press, 2004).

Baedeker, Karl. *Paris and Its Environs*, 16th ed. (Leipzig: Karl Baedeker, 1907).

Baedeker, Karl. *Switzerland*, 23rd ed. (Leipzig: Karl Baedeker, 1909).

Bellanger, Patrice, "Bingen/Carriès: La renouveau de la fonte à la cire perdue," in *Jean Carriès (1855–1894): La matière de l'étrange* (Paris: Petit Palais, Musée des beaux-arts de la ville de Paris; N. Chaudun: Paris-Musées, 2007).

Bertarelli, L. V. *Italie*. vol. 1, *Des Alpes à Rome*. Les Guides Bleus, Touring Club Italien (Paris: Hachette, 1922).

de Bévotte, Georges Gendarme. *Notre fils: Vie d'Abel Gendarme de Bévotte, mort pour la France le 10 Août 1914: Mémoire de la vie de notre fils et de la nôtre au cours de 23 ans.* (Chartres: Durand, 1916). Privately printed in 220 copies.

de Bévotte, Georges Gendarme. *Souvenirs d'un universitaire* (Paris: Librairie Académique Perrin, 1938).

Blumenthal, Henry, "The California Societies in France, 1849–1855," *Pacific Historical Review* 25 (1956) 251–60.

Boisson, Christine, Stephanie Genan, and Jeanne Susplugas. *André Michel: Monographie de muséologie*, under the direction of Geneviève Bresc-Bautier (1996). Typescript copy consulted in the Département des Sculptures, Musée du Louvre.

Bowen, Clare, "Paul Nash and the First World War Official War Artists Scheme," *CERCLES: Revue pluridisciplinaire du monde Anglophone* 1 (2000) 21–31.

Bresc-Bautier, Geneviève, "André Michel," in *Dictionnaire critique des historiens de l'art*, Institut national d'histoire de l'art (Paris: Institut national d'histoire de l'art, 2010).

Brieux, Eugène. *Nos soldats aveugles: Note pour les directeurs des écoles de rééducation professionelle*, 2nd ed. (Paris: Delagrave, 1917).

Brown, Frederick. *For the Soul of France: Culture Wars in the Age of Dreyfus* (New York: Alfred A. Knopf, 2010).

Burnand, Robert, "Robert André-Michel," *Foi et Vie* 22 (1 March 1919) 64–70.

Canfield Fisher, Dorothy. *Home Fires in France* (New York: H. Holt and Company, 1918).

Canfield Fisher, Dorothy. *Raw Material* (New York: Harcourt, Brace and Company, 1923).

Carton, Yves. *Henry de Varigny, darwinien convaincu: Médecin, chercheur et journaliste (1855–1934)* (Paris: Hermann, 2008).

Charteris, Evan Edward. *John Sargent* (New York: C. Scribner's Sons, 1927).

Chong, Alan, ed. *Eye of the Beholder, Masterpieces from the Isabella Stewart Gardner Museum* (Boston, MA: Isabella Stewart Gardner Museum, in association with Beacon Press, 2003).

Christie, Manson & Woods, London July 29, 1925. *Catalogue of the Library of the late John Singer Sargent, R.A., DCL., LL.D.*

Clément-Janin, Noël. *Les estampes, images et affiches de la guerre* (Paris: Gazette des Beaux-Arts, 1919).

Clifford, James. *Person and Myth: Maurice Leenhardt in the Melanesian World* (Berkeley: University of California Press, 1982).

Cooper, Duff. *Haig* (Garden City, NY: Doubleday, Doran, 1936).

de Coubertin, Pierre, Baron. *Le livre d'or des victimes du bombardement de l'église Saint-Gervais le Vendredi Saint, 29 Mars 1918* (Paris: J. Mersch, 1922).

Croot, Patricia E. C., ed. *A History of the County of Middlesex*. vol. 12, *Chelsea* (London and New York: Oxford University Press, 2004).

Davis, Deborah. *Strapless: John Singer Sargent and the Fall of Madame X* (New York: Jeremy P. Tarcher/Penguin, 2003).

Denisart, Madeleine, and Jacqueline Surchat. *Le cigare et les fourmis: Aperçu sur l'histoire des ouvrières vaudoises: L'exemple de Vevey et Nyon* (Lausanne: Editions d'en bas, 1987).

Descaves, Lucien, "Un voile sur les yeux," *L'illustration*. 28 May 1915, 511.

Devèche, André. *L'Eglise Saint-Gervais et Saint-Protais de Paris* (Paris: Editions de la Tourelle, Librairie de la nouvelle faculté, 1974).

Downes, William Howe. *John S. Sargent, His Life and Work* (Boston, MA: Little, Brown and Company, 1925).

Dubief, Henri, and Jacques Poujol, eds. *La France protestante: Histoire et lieux de mémoire* (Montpellier: Max Chaleil, 1992).

Dutrône, Christophe. *Feu sur Paris! L'histoire vraie de la Grosse Bertha* (Paris: Editions Pierre de Taillac, 2012).

Ecole nationale des chartes, Paris. *L'Ecole des chartes et la guerre (1914–1918): Livre d'or* (Paris: Ecole nationale des chartes, 1921).

Eisgruber, Heinz. *So schossen wir nach Paris: die Geschichte des Schusses nach Paris über 128 km: der Roman einer historischen Wirklichkeit* (Berlin: Vorhut Verlag Otto Schlegel, 1934).

Emard, Paul. *Toiling through the Dark: A Treatise on the Re-education of Blinded Soldiers*, with a Preface by Eugène Brieux (Baltimore: Red Cross Institute for the Blind, [1919]).

Evans, Magdalen. *Utmost Fidelity: The Painting Lives of Marianne and Adrian Stokes* (Bristol, UK: Sansom & Company, 2009).

Evans, Thomas Wiltberger, and Edward Augustus Crane, John Swinburne, William Edwin Johnston. *History of the American Ambulance Established in Paris during the Siege of 1870–71, Together with the Details of Its Methods and Its Work* (London: S. Low, Marston, Low, and Searle, 1873).

Fairbrother, Trevor. *John Singer Sargent* (New York: Abrams, 1994).

Fairbrother, Trevor. *John Singer Sargent, the Sensualist* (Seattle, WA: Seattle Art Museum; New Haven, CT: Yale University Press, 2000).

Fairbrother, Trevor, "The Shock of John Singer Sargent's 'Madame Gautreau'," *Arts Magazine* 55 (January 1981) 90–97.

Fort, Ilene Susan, "Dressing Up: Subterfuge and Sublimation in the Alpine Paintings," in Bruce Robertson, ed., *Sargent and Italy*, s.v., 141–61.

Foucaud, Edward. *The Book of Illustrious Mechanics of Europe and America*, tr. John Frost (New York: D. Appleton, 1846).

Freeman, Julian, "Professor Tonks: War Artist," *The Burlington Magazine* 127 (May 1985) 284–93.

French, John Denton Pinkstone, Earl of Ypres. *1914* (London: Constable and Company Ltd., 1919).

Fussell, Paul. *The Great War and Modern Memory* (New York and London: Oxford University Press, 1975).

Gunn, Peter. *Vernon Lee: Violet Paget 1856–1935* (London and New York: Oxford University Press, 1964).

Hallays, André, "André Michel," *Journal des Débats*, 27 December 1925.

Hallays, André, "Préface" and "Introduction," in Robert André-Michel, *Avignon: Les fresques du Palais des Papes; Le procès des Visconti* (Paris: Armand Colin, 1920).

Halls, W. D. *Politics, Society and Christianity in Vichy France* (Oxford and Providence, RI: Berg, 1995).

Hensick, Teri, Kate Olivier, and Gianfranco Pocobene, "Puvis de Chavannes's Allegorical Murals in the Boston Public Library: History, Technique, and Conservation," *Journal of the American Institute for Conservation* 36 (1997) 59–81.

Hirshler, Erica E., and Teresa A. Carbone, eds. *John Singer Sargent: Watercolors* (Boston, MA: Museum of Fine Arts; Brooklyn, NY: Brooklyn Museum, 2012).

Hone, Joseph. *The Life of Henry Tonks* (London: W. Heinemann Ltd., 1939).

Hoopes, Donelson F. *The Private World of John Singer Sargent* (Washington, DC: The Corcoran Gallery of Art, 1964).

James, Henry. *Letters*, ed. Leon Edel. 4 vols. (Cambridge, MA: Belknap Press of Harvard University Press, 1974–1984).

Joffre, Joseph Jacques Césaire. *The Personal Memoirs of Joffre, Field Marshal of the French Army*, tr. Colonel T. Bentley Mott, appendices by Colonel S. J. Lowe. 2 vols. (New York and London: Harper & Brothers, 1932).

Khandekar, Narayan, Gianfranco Pocobene, and Kate Smith, eds. *John Singer Sargent's* Triumph of Religion *at the Boston Public Library: Creation and Restoration* (Cambridge, MA: Harvard Art Museum; New Haven, CT: Yale University Press, 2009).

Kilmurray, Elaine, and Richard Ormond, eds. *John Singer Sargent* (Princeton, NJ: Princeton University Press, 1998).

Kilmurray, Elaine, "Traveling Companions," in Warren Adelson et al., *Sargent Abroad*, q.v., 55–61.

Lagny, Gustave. *Le réveil de 1830 à Paris et les origines des Diaconesses de Reuilly*. Préface du pasteur Marc Boegner (Paris: Association des diaconesses, 1958).

Lebon, Elisabeth, "Carriès et Bingen: La collaboration exemplaire d'un sculpteur et d'un fondeur," in *Jean Carriès ou la terre viscérale* (Auxerre, FR: Musées d'art et d'histoire; Saint-Amand-en-Puisaye, FR: Association des Amis du Musée du Grès, 2007) 91–99 and plate XV.

Leclerc, Max, "André Michel et l'*Histoire de l'art*," in André Michel, *Histoire de l'art*, s.v. vol. 8 part 3, 922–32.

Lemaire, Gérard-Georges. *Histoire du Salon de peinture* (Paris: Klincksieck, 2004).

Lepdor, Catherine, ed. *Charles Gleyre: Le génie de l'invention* (Lausanne: Musée cantonal des Beaux-Arts, 2006).

de Loye, Joseph. *Les archives de la Chambre apostolique au XIVe siècle*. Part 1, *Inventaire*. (Bibliothèque des Ecoles françaises d'Athènes et de Rome, fasc. 80). (Paris: Fontemoing, 1899).

Mâle, Emile. *L'art religieux du XIIIe siècle en France: Étude sur l'iconographie du moyen âge et sur ses sources d'inspiration*. 3rd ed. revised and augmented (Paris: Armand Colin, 1910).

Mâle, Emile. *Religious Art in France, XIII century: A Study in Mediaeval Iconography and Its Sources of Inspiration*, tr. from the 3rd ed. by Dora Nussey (London: J. M. Dent & Sons, Ltd.; New York: E. P. Dutton & Co., 1913).

Marmetschke, Katja. *Feindbeobachtung und Verständigung: Der Germanist Edmond Vermeil (1878–1964) in den deutsch-französischen Beziehungen* (Köln: Böhlau Verlag, 2008).

Martin-Ginouvier, F., and Albert Savine. *La passion de Saint-Gervais: Récit du bombardement du Vendredi Saint 1918* (Paris: R. Tricot, 1918).

McArthur, Benjamin. *The Man Who Was Rip van Winkle: Joseph Jefferson and Nineteenth-Century American Theatre* (New Haven, CT: Yale University Press, 2007).

McCoy, Garnett, "Visits, Parties, and Cats in the Hall: The Tenth Street Studio Building and Its Inmates in the Nineteenth Century," *Archives of American Art Journal* 6 (1966) 1–8.

Michel, André. *Histoire de l'art depuis les premiers temps chrétiens jusqu'à nos jours*. 12 vols. (Paris: Armand Colin, 1905–1929).

Michel, André. *Puvis de Chavannes*, with notes by J. Laren (Philadelphia, PA: J. B. Lippincott Company; London: W. Heinemann, 1912).

Michel, André. *Les villes martyres: Reims, Soissons, Senlis, Arras*, [et] *Louvain par Mgr. Baudrillart* (Paris: Plon-Nourrit, 1915).

Michel, Robert. *L'administration royale dans la sénéchausée de Beaucaire au temps de saint Louis*. Mémoires et documents publiés par la Société de l'Ecole des Chartes, 9 (Paris: A. Picard et fils, 1910).

Miller, Henry W. *The Paris Gun: The Bombardment of Paris by the German Long Range Guns and the Great German Offensives of 1918* (New York: J. Cape & H. Smith, 1930).

Miller, Lucia, "John Singer Sargent in the Diaries of Lucia Fairchild, 1890 and 1891," *Archives of American Art Journal* 26 (1986) 2–16.

Mistral, Frédéric. *The Memoirs of Frédéric Mistral* [*Moun espelido*, 1906], tr. George Wickes (New York: New Directions Publishing Corporation, 1986).

Mount, Charles Merrill. *John Singer Sargent: A Biography*. 1st ed. (New York: W. W. Norton, 1955).

Mount, Charles Merrill, "The Rabbit and the Boa Constrictor: John Singer Sargent at the White House," *Records of the Columbia Historical Society* (Washington, DC) 71/72 (1971–1972) 618–56.

Nicolai, Georg Friedrich. *The Biology of War*, tr. Constance A. Grande and Julian Grande (New York: Century, 1919).

Olson, Stanley. *John Singer Sargent: His Portrait* (New York: St. Martin's Press, 1986).

Olson, Stanley, Warren Adelson, and Richard Ormond. *Sargent at Broadway: The Impressionist Years*. (New York: Universe/Coe Kerr Gallery; London: J. Murray, 1986).

Ormond, Marie-Marguerite. *Résonnances* (Genève: Imprimerie "Atar," 1919).

Ormond, Richard, "In the Alps," in Warren Adelson et al., *Sargent Abroad*, q.v., 63–113.

Ormond, Richard. *John Singer Sargent: Paintings, Drawings, Watercolors* (New York: Harper & Row, 1970).

Ormond, Richard and Elaine Kilmurray. *John Singer Sargent: Complete Paintings*. (New Haven, CT: Yale University Press, 1998–). Cited as JSS:CP.

1. *The Early Portraits* [1874–1889] (1998)
2. *Portraits of the 1890's* (2002)
3. *The Later Portraits* [1900–1925] (2003)
4. *Figures and Landscapes, 1874–1882* (2006)
5. *Figures and Landscapes, 1883–1899* (2010)

6. *Venetian Figures and Landscapes, 1898–1913* (2009)
7. *Figures and Landscapes, 1900–1907* (2012)
8. *Figures and Landscapes, 1908–1913* (in preparation)
9. *Figures and Landscapes, 1914–1925* (in preparation)
10. Boston murals: Boston Public Library, Museum of Fine Arts, Widener Library (in preparation)

Ormond, Richard, *Memoir of Rose-Marie* (unpublished).

Poirier, Jules, *Les bombardements de Paris (1914–1918): Avions - Gothas - Zeppelins - Berthas*, préface du général Niessel (Paris: Payot, 1930).

Promey, Sally M. *Painting Religion in Public: John Singer Sargent's Triumph of Religion at the Boston Public Library* (Princeton, NJ: Princeton University Press, 1999).

Ratcliff, Carter. *John Singer Sargent* 1st ed. (New York: Abbeville Press, 1982).

Renan, Ernest. *La vie de Jésus* (Paris: Michel Lévy, 1864); *The Life of Jesus* (London: Trübner, 1864).

Renan, Ernest and Henriette. *Brother and Sister: A Memoir and the Letters of Ernest and Henriette Renan*, tr. Mary Loyd (New York and London: Macmillan and Co., 1896).

Robertson, Bruce, ed. *Sargent and Italy* (Los Angeles, CA: Los Angeles County Museum of Art and Princeton, NJ: Princeton University Press, 2003).

Robertson, W. Graham. *Life Was Worth Living: The Reminiscences of W. Graham Robertson*, with a foreword by Sir Johnston Forbes-Robertson (New York: Harper and Brothers, 1931).

Saltonstall, Nora. *"Out Here at the Front": The World War I Letters of Nora Saltonstall*, ed. Judith S. Graham (Boston, MA: Northeastern University Press, 2004).

Sargent, FitzWilliam. *England, the United States, and the Southern Confederacy.* 2nd ed. revised and amended (London: Hamilton, Adams, and Co., 1864).

Snyder, Alice Ziska, and Milton Valentine Snyder. *Paris Days and London Nights* (New York: E. P. Dutton & Company, 1921).

Stansky, Peter. *Sassoon: The Worlds of Philip and Sybil* (New Haven, CT: Yale University Press, 2003).

Stein, Henri, "Robert Michel," *Bibliothèque de l'Ecole des chartes* 75 (1914) 451–53.

Stokes, Adrian, "John Singer Sargent, R.A., R.W.S.," in *The Old Water-Colour Society's Club 1925–1926 Third Annual Volume*, ed. Randall Davies, F.S.A. (London: The Club, 1926) 51–65.

Thiéry, Maurice. *La guerre en 1917, les crimes allemands dans la Picardie dévastée.* Preface by S. Pichon. (Paris: E. de Boccard, 1918).

Thiéry, Maurice. *Paris bombardé par Zeppelins, Gothas et Berthas* (Paris: E. de Boccard, 1921).

Troyen, Carol. *Sargent's Murals in the Museum of Fine Arts, Boston* with notes on the restoration by Pamela Hatchfield and Lydia Vagts (Boston, MA: Museum of Fine Arts, 1999).

Tuchman, Barbara W. *The Guns of August* (New York: Macmillan, 1962).

Tuffrau, Paul. *1914–1918, Quatre années sur le front: Carnets d'un combattant.* Foreword by Françoise Cambon; preface by Stéphane Audoin-Rouzeau (Paris: Imago, 1998).

Turner, Jane. *The Grove Dictionary of Art from Monet to Cézanne: Late Nineteenth Century* (New York: St. Martin's Press, 2000).

de Varigny, Charles Victor Crosnier. *La femme aux Etats-Unis* (Paris: Armand Colin, 1893).

de Varigny, Charles Victor Crosnier. *Fourteen Years in the Sandwich Islands*, tr. Alfons Kron (Honolulu: University Press of Hawaii, 1981).

Vitry, Paul, "André Michel (1853–1925)," *Gazette des Beaux-Arts* 16 (1925) 317–32.

Vitry, Paul. *La cathédrale de Reims, architecture et sculpture.* 2 vols. (Paris: Librairie centrale des beaux-arts, 1919).

Volk, Mary Crawford. "The Murals," chapter 5 of Kilmurray and Ormond, *John Singer Sargent* (1998), 177–207.

Volk, Mary Crawford, "Sargent: Boston Public Library Murals," in Tomàs Llorens, curator, *Sargent/Sorolla*: Madrid, 3 October 2006–7 January 2007, Museo Thyssen-Bornemisza, Fundación Caja Madrid; Paris, 14 February–13 May 2007, Petit Palais—Musée des Beaux-Arts de la Ville de Paris (Madrid: Fundación Colección Thyssen-Bornemisza, 2006), 171–182.

Volk, Mary Crawford, "Sargent in Public: On the Boston Murals," in Kilmurray and Ormond, *John Singer Sargent*, q.v., 45–58.

Weber, Eugen Joseph. *Action Française: Royalism and Reaction in Twentieth-Century France.* (Stanford, CA: Stanford University Press, 1962).

Williman, Daniel. *Letters of Pierre de Cros, Chamberlain to Pope Gregory XI (1371–1378)* (Tempe: Arizona Center for Medieval and Renaissance Studies, 2009).

Yates, Elizabeth. *Pebble in a Pool, the Widening Circles of Dorothy Canfield Fisher's Life.* (New York: Dutton, 1958).

Zoccai, Giulia. *Dal 1875 a San Remo: La famiglia Ormond, la villa, il parco* (Sanremo, IT: Art & Stampa, 1998).

Zoccai, Giulia, ed. *Villa Ormond: I giochi, le favole, le fate* (Sanremo, IT: Art & Stampa, 1998).

Index of Persons and Places

Abbey, Edwin Austin (1852–1911), American artist, 23–24, 28, 43, 46–47, 54, 61, 209, 238, 252n33, 276n13

Abbey, Mary, wife of Edwin, 43, 46, 61, 202, 252n33, 276n13

Abdul Azis Khan (1830–1876), sultan of Turkey, 35

Abriès, Hautes-Alpes, France, 69

Agadir, sw Morocco, 94

Aigues-Mortes, Gard, France, 256n37

Aix-en-Provence, Bouches-du-Rhône, France, 5

Aix-les-Bains, Savoie, France, 253n60

Albéniz, Isaac (1860–1909), Spanish composer, 263n63

Alexander II (1818–1881), czar of Russia, 35

Alexandria, Egypt, 41

Alma-Tadema, Lawrence (1836–1912), Dutch-English painter, 13

André-Michel, Robert (1884–1914), French historian and archivist, husband of Rose-Marie Ormond: *passim*

Angot, Alphonse, French soldier, pensioner of Reuilly, 145, 262n41

Anker, Albert (1831–1910), Swiss painter, 34, 36, 247n16

Annemasse, Haute-Savoie, France, 146, 148, 151

Arène, Paul (1843–1896), French writer, 243n44

Armstrong, Ernest, British colonel, 180–81

Arras, Pas-de-Calais, France, 135, 197–98

Arrivet, French brigadier general, 111, 258n24

Aswan, Egypt, 41

Athens, Greece, 42

Auger, French captain, 109

Avignon, Vaucluse, France, 7–8, 32, 62, 87–89, 94, 97–99, 133, 216, 255n15

Bac-du-Sud, Pas-de-Calais, France, 198

Bach, Johann Sebastian (1685–1750), German composer, 72, 151, 157, 161

Bagge, French sergeant, 105–6

Baheigne, Jeanne, victim of St-Gervais, 161, 264n81

Bailleul, Nord, France, 199

Bakst, Léon (1866–1924), Russian costume and scene designer, 186, 252n41

Bamberg, Germany, 134

Barblan, Otto (1860–1943), German organist and composer, 151, 262n53

Barcelona, Spain, 45

Barcy, Seine-et-Marne, France, 108–9, 258n25

Barnard, Alice, 19, 54, 58, 194

Barnard, Dorothy or "Dolly," 19, 54, 58–59, 61, 64

Barnard, Frederick, 19, 54

Barnard, Geoffrey, 20, 54

Barnard, Margaret or "Polly," 19, 54, 58–59, 61, 65

Barrett, Lawrence (1838–1891) American actor, 23

Barton, Thomas, 24

Basel, Switzerland, 98, 255n21

Bath, Somerset, England, 193

Bavincourt, Pas-de-Calais, France, 197

Beaucaire, Gard, France, 79

Beaumont, Hélène de, friend of Rose-Marie Ormond, 70

Beauvais, Oise, France, 135

Beerbohm, Max (1872–1956), English essayist and caricaturist, 18, 36, 186, 251n15

Beethoven, Ludwig van (1770–1827), German composer, 72, 91, 93, 157, 159, 264n76

Beighede, French sub-officer, 105, 258n15

Bercelaire near Ypres, Belgium, 196

Berck-sur-Mer, Pas-de-Calais, France, 84–85, 95, 253n60

Bercy, Paris, France, 33, 35

Berlioz, Hector (1803–1869), French composer, 93, 146, 157, 160, 264n76

Bernardin, Abbé Eugène-Charles, French priest, victim of St-Gervais, 171

Biarritz, Pyrénées-Atlantiques, France, 2

Bigoudot, French army captain, 109

Billy-sous-Mangiennes, Meuse, France, 102

Bingen, Pierre (1842–1903), French founder in lost wax, 248n23

Biskra, Algeria, 38

Blanc-Mesnil, Seine-Saint-Denis, France, 159, 167

Bocion, François (1828–1890), Swiss painter, 36, 247n16

Boegner, Alfred (1851–1912), French Protestant pastor, 85, 91, 254n11, 255n19

Boegner, Edmond (d. 1916), brother of Geneviève, 145, 262n42

Boegner, Geneviève, "Vivette" (1888–1974), friend of Rose-Marie Ormond, 85, 142, 145, 148, 155

Boegner, Henri (1896–1960), 85, 254n10

Boegner, Marc (1881–1970), French Protestant pastor, 139–40, 142, 158, 174, 255n19, 261n32, 264n70, 266n20

Bois des Corbeaux, Le, near Verdun, 145

Bois-Roger, Aisne, France, 110, 123–24

Boissonnas, Frédéric (1858–1946), Swiss photographer, 45–46, 68

Boit, Edward Darly (1842–1916), American painter, 61

Bologna, Italy, 195

Bone, Muirhead (1876–1953), Scottish etcher, 194

Bonnet, Alexandre Léon, French army major, 117

Bonpas, Vaucluse, France, 89

Booth, Edwin (1833–1893), American actor, 23, 25

Bossey-sous-Salève, Haute-Savoie, France, 38

Boston, Massachusetts, 18–19, 22–24, 47, 61, 63, 141, 147, 173, 186–88, 193–95, 203, 207, 209, 213, 215, 218, 221, 229, 238, 244n67, 248n26, 252n41, 268n27, 269n49; Museum of Fine Arts, 24, 188, 190, 207, 230–31, 238, 252n36, 272n2, 274n47; Public Library, 23–24, 28, 41, 46–47, 52, 54–55, 61, 182, 185–88, 195, 203, 230–31, 238

Boulogne, Pas-de-Calais, France, 16, 196–97, 243n17

Bourbon, Charles de (1523–1590), French cardinal, 161

Bourget, Le, Seine-Saint-Denis, France, 105

Bournemouth, England, 19, 21, 55

Boutroux, Emile (1845–1921), French philosopher, 74–75, 253n52

Bouvier, René, husband of Juliette Michel, 239, 257n5

Bouvier, Renée, daughter of René, 257n5

Bouvier, Robert, 257n5

Brahms, Johannes (1833–1897), German composer, 72

Brault, French army colonel, 102–3

Braye near Crouy, Aisne, France, 121

Breuil-Cervinia, Valle d'Aosta, Italy, 54, 250n7

Brieux, Eugène (1858–1932), French dramatist, 141

Broadway, Worcestershire, England, 19–20, 22–23, 46, 54–55, 59

Brooke, Rupert (1887–1915), English poet, 148

Budapest, Hungary, 5

Buffalo, NY, 29

Bunker, Dennis Miller (1861–1890), American painter, 19–20, 39–40, 209, 248n26

Burckhardt, Charlotte Louise (1862–1892), "Lady with the Rose," 13–14, 17

Burnand, Robert (1882–1953), friend of Robert André-Michel, 80, 136

Bussana, Liguria, Italy, 248n21

Buzzards Bay, Massachusetts, 25

Byblos, Lebanon, 211

Byron, George Gordon lord (1788–1824), English poet, 251n15

Café, French army lieutenant, 121–22, 130

Cairo, Egypt, 41

Calcot, Gloucestershire, England, 19–20

Cambridge, Massachusetts, 27; Widener Library of Harvard University, 207

Camprodón, Catalonia, Spain, 45

Canfield Fisher, Dorothy, Mrs. John Fisher (1879–1958), American author, 142, 152, 254n8, 262nn56–57

Canteloube, Marie-Joseph (1879–1957), French composer, 263n63

Cantigny, Somme, France, 270n68

Capet, Lucien (1873–1928), French violinist, 157

Carivenc, French army sublieutenant, 112

Carmencita (Carmen Dauset Moreno, 1868–1910), Spanish dancer and singer, 23, 32, 245n75, 248n29

Carolus-Duran (Charles Auguste Émile Durand, 1837–1917), French painter, 1, 4–5, 13–14, 25, 249n43

Carpaccio, Vittore (1455–1526?), Venetian painter, 24

Carracci, Annibale (1560–1609), Italian painter, 24

Carriès, Jean-Joseph (1855–1894), French sculptor, 38, 248n23

Casadesus, Gaby (1901–1999), French pianist, 263n63

Cassel, Nord, France, 201

Catullus, Quintus Valerius (ca. 84–54 BCE), Roman poet, 202

Cavallier, Bartholomé (fl. 1360), French sculptor, 89

Cellini, Benvenuto (1500–1571), Florentine sculptor, 210

Cervantes, Miguel de (1547–1616), Spanish novelist, 41

Cézanne, Paul (1839–1906), French painter, 4

Chalet, French army captain, 111–12

Chamonix-Mont-Blanc, Haute-Savoie, France, 98

Chantilly, Oise, France, 98

Chapeville, Renée, 242n13, 254n9

Charidan, Victor, 106–7

Charleroi, Hainaut, Belgium, 106

Charles XV (1826–1859), king of Sweden, 35

Charpentier, Gustave (1860–1956), French composer, 252n47, 256n29

Charpentier, Victor, 262n43

Chartres, Eure-et-Loire, France, 81

Chase, William Merritt (1849–1916), American artist, 23

Chasseriau, Théodore (1819–1856), French painter, 28

Chelsea, SW London, 17–18, 20, 47, 55, 98, 131

Chemin des Dames, Aisne, France, 259n27

Chenier, André (1762–1794), French poet, 7

Chevalier, Maurice (1888–1972), French singer and entertainer, 141

Clarens, Vaud, Switzerland, 35–36, 44, 247n16, 249n35

Clemen, Paul (1866–1947), German art historian, 135

Clémenceau, Georges (1841–1929), French prime minister, 163, 171

Clemens, Samuel Langhorne (Mark Twain, 1835–1910), 23

Clément, Charles (1821–1887), French art historian, 17

Clicquot, François-Henri (1732–1790), French organ builder, 161

Coli, Giovanni (1636–1691), Italian painter, 24

Colin, Auguste Armand (fl. 1870), French publisher, 26, 91, 275n6

Collonges-sous-Salève, Haute-Savoie, France, 150

Combloux, Haute-Savoie, France, 75, 253n60

Constantin, Louise. See Varigny, Louise de

Corot, Camille (1796–1875), French painter, 4, 27, 36

Coubertin, Baron Pierre de (1863–1937), French educator, 265n6

Coucy-le-Château, Aisne, France, 132, 262n56

Couperin family (fl. 17th–18th c.), French musicians, 161

Courajod, Louis (1841–1896), French art historian and curator, 11, 26

Courbet, Gustave (1819–1877), French painter, 4, 27

Courmayeur, Valle d'Aosta, Italy, 53–54

Courtin, French lieutenant colonel, 109

Crépy-en-Laonnois, Aisne, France, 164, 166

Crevin, Château de, Bossey-sous-Salève, Haute-Savoie, France, 38, 45, 49–50, 61, 66, 69–70, 72, 98–99, 128, 146, 155–56, 260n5

Crouy, Aisne, France, 109, 119, 121, 123, 133, 136, 152–55, 176, 203, 239–40, 254n7, 261n22, 262n56, 263n57, 266n11

Cuffies near Crouy, Aisne, France, 111–12, 118–20, 123

Curtis, Ariana, "Dogaressa," wife of Daniel Curtis, 131, 253n56, n60, 258n32

Curtis, Lisa, wife of Ralph Curtis, 55, 187, 250n9

Dammann, Paul-Marcel (1885–1939), French medal sculptor and engraver, 234
Dammartin-en-Goële, Seine-et-Marne, France, 108
Darier, Ferdinand-Jean (1856–1938), French physician, 94–95, 97, 256n32
Darwin, Charles (1809–1882), English naturalist, 252n48, 253n54
Daubigny, Charles-François (1817–1878), French painter, 27
Daumier, Honoré (1808–1879), French sculptor, 142
David, Jacques-Louis (1748–1825), French painter, 27, 243n44
Dechizelle, French colonel, 117
Deering, Charles (1852–1927) and James (1859–1925), American businessmen and collectors, 189, 269n39
Degas, Edgar (1834–1917), French painter and sculptor, 4
Deigaux, French army adjudant, 105
Del Castillo, Ben, friend of John Singer Sargent, 3, 39, 42–43, 70
Delacroix, Eugène (1898–1963), French painter, 27
Delphi, Greece, 42
Demay, French army lieutenant, 109
Dieppe, Seine-Maritime, France, 256n43
Dijon, Côte-d'Or, France, 130
Dinard, Ille-et-Vilaine, France, 137–38, 261n29
Doumic, Max (1863–1914), French architect and writer, 133, 260n15
Downes, William Howe (1854–1941), American journalist and art critic, 182, 186, 220, 241n1
Dresden, Germany, 2

Dreyfus, Alfred (1859–1935), French army officer, 83–84, 92–93, 142
Drumont, Edouard (1844–1917), French journalist, 84
Du Bois, Charles Edouard (1847–1885), Swiss painter, 249n35
Duchesne, Louis (1843–1922), French priest and historian, 255
Ducros, French lieutenant colonel, 109
Dufaure, Jules (1798–1881), French statesman, 10, 243n17
Dujardin, French soldier, 105
Dumas, Alexandre *fils* (1824–1895), French writer, 37
Duroux, French lieutenant colonel, 118, 124, 137, 259n26
Dvorak, Antonin (1841–1904), Czech composer, 72

Edinburgh, Scotland, 91
Edison, Thomas Alva (1847–1931), American inventor, 245n75
Edward, prince of Wales, later Edward VII, king of England (1841–1910), 35
El Fayoum, Egypt, 42
Emard, Paul, French writer, 139–40
Esher, Reginald (1852–1930), English historian and politician, 270n67
Essen, Germany, 160, 163, 166
Essipoff, Anna (1851–1914), Russian musician, 242n6
Eugénie de Montijo (1826–1920), wife of Emperor Napoleon III, 35
Evian-les-Bains, Haute-Savoie, France, 98

Fabiani, French army captain, 111–12
Fairchild, Blair, son of Charles and Elizabeth, 43
Fairchild, Charles, 19
Fairchild, Elizabeth or "Lily," wife of Charles, 19, 23, 45, 47

Fairchild, Lucia, daughter of Charles and Elizabeth, 19, 39–40, 42–43, 71, 179, 209, 244n67, 245n82
Fairchild, Neil, son of Charles and Elizabeth, 20, 43
Fairchild, Sally, daughter of Charles and Elizabeth, 19, 244n67
Fairchild family, 18, 22, 25, 42
Fairford, Gloucestershire, England, 45–47, 54, 209, 244n67, 249n48, 272n7
Farragut, David (1801–1870?), American commodore, 258n13
Ferté, Marie Coche de la, Mme Gérard de Watteville, 67, 69
Finhaut, Valais, Switzerland, 98
Fisher, John, husband of Dorothy Canfield, 152
Fladbury, Worcestershire, England, 46
La Flèche, Sarthe, France, 105, 258n15
Florence, Italy, 1–2, 4, 195, 238
Flower, Barnard (d. 1517), glazier to Henry VII and VIII, 272n7
Fokine, Michel (1880–1942), Russian choreographer and dancer, 252n41
Fontainebleau, Seine-et-Marne, France, 27, 92
Foulc, Edmond (1828–1916), French businessman and collector, 74, 253n55
Fourcaud, Louis de (1851–1914), French art critic, 15
Fox, Thomas (1864–1946), Boston architect, 47, 186, 187–89, 192–93, 195, 197, 201, 207, 221, 230, 239, 268n27, 275n50
Franchet d'Esperey, Louis (1856–1942), French general, 119
Franck, César (1822–1890), French composer, 157, 263n62, 263nn65–66, 263n68
Franckfort, Pauline, 7–9, 239
Franz Ferdinand (1875–1914), archduke of Austria, 179

Franz-Joseph I (1830–1916), emperor of Austria, 35
Frederick (1831–1888), crown prince of Prussia, then Emperor Frederick III, 35
French, John Denton Pinkstone (1852–1925), British field marshal, 119

Gardner, Isabella Stewart, "Mrs. Jack" (1840–1924), Boston art collector, 18, 23, 39, 41, 187, 193–94, 225, 227, 229
Garibaldi, Giuseppe (1807–1882), Italian revolutionary commander, 272n16
Gaugengigl, Ignaz Marcel (1853–1932), German painter, 192, 229, 269n49
Gaulle, Charles de (1890–1970), French general and statesman, 91
Gauthier, Abbé, curé of Saint Gervais, 161, 275n3
Gautteron, Louis, victim of St. Gervais, 191
Gendarme de Bévotte, Abel (1891–1914), fiancé of Juliette Michel, 81–83, 92–96, 98–103, 105, 121, 202
Gendarme de Bévotte, Cécile (d. 1939), mother of Abel, 81, 92–93, 102
Gendarme de Bévotte, Georges (1867–1938), French educator, father of Abel, 81, 92, 93, 102, 172, 179, 239, 255n24, 256n27
Geneva, Switzerland, 2, 8, 33, 37–38, 44–46, 49, 68, 98, 128–30, 146–47, 149–51, 247n6, 260n6
Ghazir, Lebanon, 211
Gibert, French artillery lieutenant, 123
Giomein, Italy, 54, 250n7
Giotto di Bondone (1267–1337), Italian painter, 90
Giovanetti, Matteo (1322–1368), Italian painter, 90

Giry, Arthur (1848–1899), French historian, 5, 84, 242n7

Givenchy, Pas de Calais, France, 271n94

Glacier National Park, Montana, 187

Glehn, Jane Emmett de (1873–1961), American painter, wife of Wilfred de Glehn, 54, 57–59

Glehn, Wilfrid de (1870–1951), English painter, 54, 58

Gleyre, Charles (1806–1874), Swiss painter, 36, 41, 185, 247n13, n16, 249n35

Goethe, Johann Wolfgang von (1749–1832), German writer, 256n27

Gosset, French army sublieutenant, 112

Göttingen, Germany, 91

Goya, Francisco (1746–1828), Spanish painter, 13

Grainger, Percy (1882–1961), pianist and composer, 62

Granville, Manche, France, 72

Gregory IX, pope 1227–1241, 87

Gregory XI, pope 1371–1378, 255n15

Grieg, Edvard (1843–1907), Norwegian composer, 72

Griolet, Eugene, 33

Griolet, Jeanne-Julie. See Renet, Jeanne-Julie

Griolet de Geer, Ernest, Swiss alpinist and explorer, 33, 36–37, 248n19

Gruner, Edouard, French engineer, president of the Protestant Federation, 176

Guy, French lieutenant colonel, 109, 118

Hallays, André (1859–1930), French writer, 97, 136, 172, 254n1, 255n24

Hamburg, Germany, 252n41

Hamel, Le, Somme, France, 196

Hammamet, Tunisia, 45

Hardy, Eleanora, 248n26

Harrison, Lawrence or "Peter," 54, 58, 187

Harrison, Leonard or "Ginx," 54, 58

Harvard University. See Cambridge, Massachusetts

Hasenwinkel, French army major, 118, 259n26

Havre, Le, Seine-Maritime, France, 7, 130, 260n7, 262n41

Hawaii, 7–10, 67, 90,

Haÿ-des-Roses, Val-de-Marne, France, 73

Hearn, Lafcadio (1850–1904), international writer, 152

Helleu, Paul (1859–1927), French painter, 19–21, 47

Helmholz, Hermann von (1821–1894), German physicist, 253n52

Henri IV (1553–1610), king of France, 6, 80, 119, 161

Hensz, French army sublieutenant, 112

Héricourt, Jules (1850–1938), French physician, 38

Hermant, Jacques-René (1855–1930), French architect, 233

Higginson, Henry Lee (1834–1919), American philanthropist, 22

Hill, J. C., British engineer officer, 270n81

Hirsch, Auguste Alexandre (1833–1912), French painter, 249n35

Honolulu, Hawaii, 8, 16

Hortsmann, Geneviève, née de Varigny, 9, 70

Housman, Alfred Edward (1859–1936), English classicist and poet, 204, 271n99, n100

Hunter, Mary, 18, 150, 202,

Hyde, James Hazen (1876–1959), American businessman, 27

d'Indy, Vincent (1851–1931), French composer and teacher, 159, 263n63

Ingres, Jean Auguste Dominique (1780–1867), French painter, 27
d'Inverno, Nicola, factotum to John Singer Sargent, 46, 58, 130, 179, 184, 193–94
Istanbul, Turkey, 42
Iverny, Seine-et-Maritime, France, 108

Jaluzot, French army lieutenant, 109
James, Alice Howe Gibbens, wife of William James, 131, 173
James, Henry (1843–1916), American-English writer, 16, 19–20, 60, 131, 186
James, Margaret Mary, niece of Henry James, 131
James, William (1842–1910), American philosopher, brother of Henry James, 253n52
James II (1633–1701), king of England, 263n63
Jefferson, Joseph (1829–1905), American actor, 23, 25, 245n83, 246n86
Jerusalem, 55, 212, 221, 224, 229
Joan of Arc, saint (1412–1431), 79, 109, 119
Joffre, Joseph (1852–1931), French marshal, 108, 119, 258n21
John Paul I, pope 1978, 273n25
John XXII, pope 1316–1334, 88–89
Joussot, French army lieutenant, 109
Julliand, Marthe (1890–1918), Schola Cantorum student singer, 159, 167
Jusserand, Jean Jules (1855–1932), French ambassador to the United States, 27

Kamehameha IV (1834–1863), king of Hawaii, 7
Kamehameha V (1830–1872), king of Hawaii, 7
Kamm, Adèle (1885–1911), Swiss Huguenot writer, 142

Kant, Immanuel (1724–1804), German philosopher, 256n27
King, Charles, 193
Kluck, Alexander von (1846–1934), German general, 108
Kolfushg (Colfosco), South Tyrol, Austria (now Italy), 104, 180
Krupp von Bohlen, Gustav (1870–1950), German industrialist, 160, 163, 164, 166, 265n2

Lafontaine, Jean de (1621–1695), French fabulist, 116
Lamartine, Alphonse de (1790–1869), French writer, 7
Lambé, French army corporal, 105
Landon, Mary, 170
Landon, Ruth, 170
Landowska, Wanda (1879–1959), Polish harpsichordist, 263n63
Lane, Hugh, Irish collector, 189
Laon, Aisne, France, 159, 164
Lavery, John (1856–1941), Irish painter, 194
Leclerc, Max (1864–1932), French educator, 27, 241n4
Leenhardt, Maurice (1878–1954), French pastor and ethnologist, 85, 90–91, 235
Leenhardt, Max (1853–1941), French painter, 12, 17, 90
Lefebvre, Jeanne, head nurse at Reuilly, 139
Leguay, Louis, French general, 108, 110, 116–17
Leopold II (1835–1909), king of the Belgians, 35
Leroy, Paul (1860–1942), French artist and critic, 16
Levi, Israël (1856–1939), grand rabbi of France, 176
Lloyd George, David (1863–1945), British prime minister, 195

London, England, 2, 11, 16–18, 29,
46–47, 50, 53, 55, 60–62, 72, 75, 91,
99, 104, 128, 130, 136–37, 147, 150,
152, 170, 172–73, 180, 182, 184–86,
189–90, 192, 194, 195, 202, 203,
207, 213, 231, 238, 244n57, 264n72,
266n12
Longpont, Aisne, France, 106
Longwy, Meurthe-et-Moselle, France,
171
Louis IX, king of France 1226–1270,
saint, 80, 84, 119, 139
Louis XIV, king of France 1643–1715,
6, 10, 256n37, 263n63
Louis XVI, king of France 1774–1791,
139
Louis-Philippe, king of the French
1830–1848, 33
Louvain, Flemish Brabant, Belgium,
106
Lowell, A. Lawrence (1856–1943),
president of Harvard University
1909–1933, 231, 260n14
Lowinsky, Thomas (1892–1947),
English painter, 270n71
Loye, Joseph de (fl. 1870), French
historian, 88
Lucens, Vaud, Switzerland, 32
Ludendorff, Erich (1865–1937),
German general, 159, 163
Luxor, Egypt, 41

MacColl, Donald Sutherland (1859–
1948), Scottish watercolorist, critic,
and curator, 29, 195, 246n92
Madrid, Spain, 14
Mainbray, French brigadier general,
116–17, 258n24
Majorca, Balearic Islands, Spain, 45
Maldoner, Carl, Austrian friend of
Sargent, 130, 180–81
Mâle, Emile (1862–1954), French art
historian, 86, 215, 221, 225, 273n30

Malvesin, Caroline (1806–1889),
founder of the Diaconesses de
Reuilly, 255n22
Manet, Edouard (1832–1883), French
painter, 13, 60
Martin, French army lieutenant, 114
Martini, Simone (1284–1344), Sienese
painter in Avignon, 90
Massawa, Eritrea, 38
Massenet, Jules (1842–1912), French
composer, 242n6, 245n71
Massigli, Charles, professor of law,
74–75, 253n53, 271n94
Massigli, Jacques, 84–85, 239
Massigli, Jean-Philippe, 100, 271n94
Massigli, Marguerite, sister of André
Michel, 84, 176, 239, 253n53,
271n94
Massigli, René, 239
Mathé, French army sublieutenant,
112
Mauna Kea mountain, Hawaii, 8
Maunoury, Michel-Joseph (1847–1923),
French general, 108, 111
McKim, Charles Follen (1847–1909),
American architect, 23–25, 47
Mead, William Rutherford (1846–
1928), American architect, 23
Meissonier, Ernest (1815–1891), French
painter, 28
Mellor, Lillian, 54
Mendelssohn, Felix (1809–1847),
German composer, 72
Mercin-et-Vaux, Aisne, France, 110
Meredith, George (1828–1909), English
novelist, 61, 251n31
Mérimée, Prosper (1803–1870), French
writer, 13, 243n37
Messiaen, Olivier (1908–1992), French
composer, 263n63
Metternich, Klemens Wenzel,
prince von (1773–1859), German
diplomat, 35

Meyer, Paul (1840–1917), French philologist, 84, 254n8

Meyerbeer, Giacomo (1791–1864), Prussian opera composer, 93

Meyrueis, Blanche. *See* Varigny, Blanche Meyrueis de

Meyrueis, Marguerite. *See* Watteville, Virginie Marguerite de

Michel, André, 4–6, 9–18, 26–29, 32, 37, 67, 72, 74–75, 79–80, 84, 90–94, 100, 128, 130–31, 133–36, 144, 148, 154, 156, 160, 171–73, 176, 184, 192–93, 197, 202–3, 221, 229, 234–35, 239, 242n6, n7, 243n44, 255n20, 256n37, 256n40, 259n40, 260n14, 261n17, 275n6

Michel, Félix, brother of André Michel, 271n94

Michel, Hélène, *née* de Varigny, Mme André Michel, 6–10, 16, 67, 69, 72, 74–75, 80, 84, 90–93, 100, 130, 144, 160, 171–72, 176, 184, 202, 235, 244n57, 254n2

Michel, Honoré, Protestant pastor, 6, 79

Michel, Jeanne, Mme Maurice Leenhardt, 9, 10, 16, 74, 85, 90–91, 235, 255n18

Michel, Juliette, "Poupette," daughter of André Michel, Mme René Bouvier, 10, 84–85, 92–94, 96, 101, 156, 176, 263n62

Michel, Madeleine, daughter of André Michel, Mme Edmond Vermeil, 9, 10, 16, 74, 76, 91, 137, 144, 176, 235

Michel, Marguerite, sister of André Michel. *See* Massigli, Marguerite

Michel, Marthe, daughter of André Michel, Mme Daniel Monod (1876–1966), 10, 74, 91, 235

Michel, Maurice, nephew of André Michel, 271n94

Michel, Renée, daughter of André Michel, 10

Michel, Robert, later Robert André-Michel: *passim*

Michel, Théophile, 4–5

Michelangelo Buonarroti (1475–1564), Italian painter and sculptor, 86, 218, 223–25, 227, 268n23, 274n34, n36

Michelet, Jules (1798–1874), French historian, 7

Milan, Lombardy, Italy, 88, 130

Milhaud, Darius (1892–1974), French composer, 263n63

Millet, Elizabeth or "Lily," wife of Frank Millet, 19–20, 22

Millet, Frank (1848–1912), American painter, 19–20

Millet, Jean-François (1814–1875), French painter, 4, 27

Mistinguett (stage name of Jeanne Florentine Bourgeois, 1875–1956), French actress and singer, 141

Mistral, Frédéric (1830–1914) Occitan writer, 97, 256n37

Molière (stage name of Jean-Baptiste Poquelin, 1622–1673), French dramatist, 15

Molinier, Auguste (1851–1904), French historian, 84, 89

Molitor, Viscount, victim of St. Gervais, 191

Moltke, Helmuth von sr. (1800–1891), German field marshal, 35

Monet, Claude (1840–1926), French painter, 4, 186, 247n13

Monnetier, Haute-Savoie, France, 146–47

Monod, Daniel, Protestant pastor, husband of Marthe Michel, 67, 91–92, 100, 154, 235, 239, 256n44

Monod, Gabriel *alias* Pierre Molé (1844–1912), French historian, 5, 26, 79, 87, 92–93, 242n7

Monpert, French army commandant, 168, 170–71

Mont Blanc, Haute-Savoie, France and Valle d'Aosta, Italy, 8, 53, 98, 146, 253n60

Mont de Joie, hill in the forest of Saint Gobain, Aisne, France, 164–65

Montagne de Paris, Aisne, France, 106, 110, 123

Montagne Neuve Farm, now Meunier Noir, Aisne, France, 111, 119–20, 122, 239–40

Montargis, Loiret, France, 100, 102–5, 113, 137

Montauban, Tarn-et-Garonne, France, 91

Montenvers, Haute-Savoie, France, 98

Monthyon, Seine-et-Marne, France, 108

Montmorency, Val-d'Oise, France, 9, 80, 172, 176, 202–3, 234–35, 239

Montpellier, 4–6, 79, 84, 90–91, 93, 122, 255

Montzéville, Meuse, France, 262n42

Morand, Marguerite, countess (d. 1918), victim of Saint-Gervais, 168, 191

Morand, Marie-Thérèse, daughter of Marguerite Morand, 168–69

Moreau, French army sublieutenant, 114–15

Moreau, Gustave (1826–1898), French painter, 28

Morestier, French surgeon, 94

Morgan, J. Pierpont, Jr. (1837–1913), American financier, 253n55

Morisot, Berthe (1841–1895), French painter, 4, 60

Moulin, French army lieutenant, 109

Mozart, Wolfgang Amadée (1756–1791), Austrian composer, 5, 242n6

Munich, Germany, 5, 61, 267n2

Nadar, Félix (pseudonym of Gaspard-Félis Tournachon, 1820–1910), French photographer, 4

Nahant, Massachusetts, 25

Nancy, Meurthe-et-Moselle, France, 171

Naples, Campania, Italy, 41, 86

Napoleon Bonaparte (1769–1821), French general and emperor, 197

Napoleon III (1808–1973), emperor of the French, 35–36

Nash, Paul (1889–1946), English painter, 194

Nashua, New Hampshire, 29

Neuilly-sur-Seine, Hauts-de-Seine, France, 170, 238, 265n7

New Caledonia, South Pacific Ocean, 91

New York, New York, 22–23, 25, 27, 29, 61, 63, 186, 191, 193, 245n75, 248n29, 250n6

Newhaven, East Sussex, England, 256n43

Newport, Rhode Island, 23, 25

Nice, Alpes-Maritimes, France, 2–4, 276n19

Nîmes, Gard, France, 84, 87, 91, 255n22

Noyon, Oise, France, 135, 152–53, 262n56

Obama, Barack (1961–), US president, 242n15

Olympia, Greece, 42

O'Regan, Margaret, 57, 251n18

Ormond, Conrad, son of Francis and Violet, 45, 49, 57, 75, 158, 239

Ormond, Francis, husband of Violet Sargent, 1, 22, 31, 34–45, 48–49, 54–55, 58, 61, 63, 72–75, 128, 152, 172, 179, 194, 247n11, 248n21, 249n40

Ormond, Guillaume, son of Francis and Violet, 45, 49, 57, 62, 66, 69–70, 72–73, 75, 95–97, 136–38, 144–53, 155–58, 160, 250n12, 257n12, 262n45

Ormond, Jean-Louis, son of Francis and Violet, 45, 48–49, 57, 72, 74–75, 98, 146, 148–51, 237, 257n12, 262n45

Ormond, Louis, husband of Marie-Marguerite Renet, father of Francis, 31–36, 38–39, 43–45, 49, 67, 236–37, 248n21

Ormond, Marc-Etienne, father of Louis, 31–32

Ormond, Marguerite, daughter of Francis and Violet, 45, 48–52, 54, 66, 69, 128, 149–50, 236

Ormond, Mme Louis, née Marie Marguerite Renet, "Bonne-Maman," 31, 33–39, 43–45, 48–52, 54, 57–58, 62, 65–67, 69–75, 77, 95, 97, 99, 104, 128, 137–38, 144, 146–51, 155, 160, 172, 236–37, 239, 246n1, 247n16, 248n20, 249n40, 253n49, 260n5, 266n18

Ormond, Reine, daughter of Francis and Violet, wife of Hugh Pitman, 45, 49, 54, 57–59, 62, 69, 75, 98, 137–38, 146, 148, 154, 174, 192, 221, 236, 239

Ormond, Rose-Marie, daughter of Francis and Violet, Mme Robert André-Michel: passim

Ormond, Violet, née Sargent, "Baby," wife of Francis Ormond, 1–4, 19–23, 25–26, 31, 39–48, 54–55, 58, 62, 65, 71–75, 95, 128, 131, 136, 147–48, 150, 154, 158, 172–74, 179–81, 184–85, 189–90, 192–94, 236, 238–39, 248n26, n30, 253n56, n60, 266n20, 268n27

Orpen, William (1878–1931), Irish painter, 194

O'Ryan, John F. (1874–1961), American general, 200

Oxford, Oxfordshire, England, 62, 97, 145, 152, 154, 157, 251n15

Paget, Violet alias Vernon Lee (1856–1935), friend of Sargent, 4, 43–44

Palestrina, Giovanni Pierluigi da (1525–1594), Italian composer, 161, 264–65

Palmer, Dorothy, "Dos," 54, 58–59, 187

Paris, France: passim

Paris, Gaston (1839–1903), French writer, 37

Pasly, Aisne, France, 111, 123–24

Pau, Pyrénées-Atlantiques, France, 2

Paul IV Farnese, pope 1555–1559, 86

Paul VI, pope 1963–1978, 273

Périlloux, French army sublieutenant, 112

Pernant, Aisne, France, 110

Péronne, Somme, France, 201

Perpignan, Pyrénées-Orientales, France, 5

Perrier Farm or Perrière, Aisne, France, 116, 118

Pershing, John J. (1860–1948), American general, 230

Petit, Georges (1856–1920), French art dealer, 12

Petit-Saconnex, Vaud, Switzerland, 33

Philadelphia, Pennsylvania, 1, 29

Philae, Egypt, 41

Philip IV, king of Spain 1621–1665, 195, 270n64

Philip IV "the Fair," king of France 1285–1305, 80

Phillipps, Claude, 17

Pinaigrier, Nicolas (d. 1606), French stained-glass artist, 161

Pissarro, Camille (1830–1903) French painter, 4

Pitman, Hugo, husband (1934) of Reine Ormond, 236

Pius IX, pope 1846–1878, 6

Plessis-aux-Bois, Seine-et-Marne, France, 108–9

Plymouth, Massachusetts, 25

Pocantico, New York, estate of John D. Rockefeller, 189

Poincaré, Aline, Mme Emile Boutroux, 253n52

Poincaré, Raymond, French president, 171

Pontremoli, Emmanuel (1865–1956), French architect, 239, 276n19

Portsmouth, Hampshire, England, 130

Prague, Czechoslovakia, 5

Princeton, NJ, 29

Punahou School, Hawaii, 10, 242n15

Purtud, Valle d'Aosta, Italy, 53–56, 58–59, 181

Puvis de Chavannes, Pierre (1824–1898), French painter, 12, 14–15, 17, 24–25, 28, 33, 94, 230, 238

Queyras, Hautes-Alpes, France, 252n43

Quiquandon, French brigadier general, 111, 116, 259n28

Raffele, Ambrogio (1845–1928), Italian painter, 53, 58

Raphael Sanzio da Urbino (1483–1520), Italian painter, 5, 218, 268n23

Reading, Berkshire, England, 19

Reims, Marne, France, 27, 105, 106, 133–35, 203, 221, 223, 226, 229, 233, 247n7, 258n16, 260n15

Relliet, vineyard, Vaud, Switzerland, 35, 44, 246n3

Renan, Ary (1857–1900), French painter, son of Ernest, 12, 17

Renan, Ernest (1823–1892), French linguist and philosopher, 17, 37, 41, 53, 93, 185, 210–17, 268n22

Renan, Henriette, sister of Ernest, 210–11, 272n10

Renet, François, grandfather of Marie Marguerite, 33

Renet, Jeanne-Julie, wife of Louis-Adolphe, 33–34, 52, 62, 65, 73

Renet, Louis-Adolphe, father of Marie Marguerite, 33–34, 37

Renet, Louis-Francis, brother of Marie Marguerite, 34

Renet, Marie Marguerite. See Ormond, Mme Louis

Renoir, Pierre-Auguste (1841–1919), French painter, 4, 186, 247n13

Renouard, Paul (1845–1924), French illustrator and engraver, 142–43, 261n38

Reuilly, Paris, France, 139–45, 151–52, 154–56, 158, 160, 174–75, 203, 222, 227, 239, 255n22, 261n33

Reverdin, Emile (1845–1901), Swiss architect, 38

Ribot, Alexandre (1842–1923), French prime minister, 10, 243n17

Richer, French soldier, 105

Rockefeller, John D. (1839–1937), American businessman, 189

Rodin, Auguste (1840–1917), French sculptor, 186

Roe, Fred (1864–1947), English illustrator, 276n16

Roisel, Somme, France, 201

Roll, Alfred (1846–1919), French painter, 12–13, 243n36

Rome, Italy, 2, 4, 24, 48, 68, 86, 88–89, 97, 188, 216, 264n82

Roosevelt, Theodore (1858–1919), president of the United States, 253n59

Ross, Denman (1853–1935), American art scholar, 187

Rothenstein, William (1872–1945), English painter and writer, 194

Rousseau, Henri (1844–1910), French painter, 27

Roussel, Albert (1869–1937), French composer, 263

Roye, Somme, France, 108

Rubens, Peter Paul (1577–1640), Flemish painter, 13

Rubinstein, Ida (1885–1960), Russian ballerina, 252n41

Ruchonnet, Jeanne, Mme Marc-Etienne Ormond, 31–32, 37

Rupprecht, German crown prince and general, 107

Sabouraud, Raymond, French physician, 94, 256n32

Saint-Gaudens, Augusta, wife of Augustus, 23

Saint-Gaudens, Augustus (1848–1907), American sculptor, 23

Saint-Gaudens, Homer, son of Augustus, 23

Saint-Gobain, forest, Aisne, France, 159, 164, 266n13

Saint-Jean-des-Vignes, Soissons, Aisne, France, 106, 112–14, 116, 154

Saint-Malo, Ille-et-Vilaine, France, 261n29

Saint-Paul, Aisne, France, 110, 121

Saint-Réquier, Léon, chapel master of St. Gervais, 160–61

Saint-Servan, Ille-et-Vilaine, France, 137, 261n29

Salève, Haute-Savoie, France, 38, 50, 146, 148, 150

Salies-de-Béarn, Pyrénées-Atlantiques, France, 138–39

Salisbury, Wiltshire, England, 154

Saltonstall, Nora (1894–1919), volunteer ambulance driver in France, 141, 261n36

Salzburg, Austria, 5

San Francisco, California, 7, 186

Sand, George (pseudonym of Amantine Lucile Aurore Dupin, 1804–1876), French novelist, 32

Sandwich, Massachusetts, 25

Sankt Lorenzen (San Lorenzo), South Tyrol, Austria (now Italy), 130, 180–81, 184

Sanremo, Liguria, Italy, 38–39, 42–45, 49–50, 67, 70–71, 97, 149–50, 155, 237, 247n16, 248n21, n28

Sargent, Emily, sister of John, 1–4, 19–22, 39, 41–43, 45, 47, 55, 57–59, 61–62, 64, 70, 74, 76, 104, 128, 130–31, 147–48, 158, 173, 179–81, 184–5, 189–90, 192–95, 208, 210–11, 221, 229, 238, 249n43, 251n18, 253n60, 262n40, 264n71, 266n19, n22, 268n27, 274n42, 276n18

Sargent, FitzWilliam jr., infant brother of John, 2

Sargent, FitzWilliam sr., father of John, 1–2, 19–21, 45, 55, 184, 272n4

Sargent, John Singer: passim.

Sargent, Mary Newbold Singer, mother of John, Mrs. FitzWilliam Sargent, 1, 3, 22, 34, 41–43, 45, 47, 53, 55, 62, 195, 208, 213, 251n18

Sargent, Minnie, infant sister of John, 2

Sargent, Violet, "Baby." See Ormond, Violet

Sassoon, Aline Rothschild, mother of Philip and Sybil, 196

Sassoon, Philip (1888–1939), English politician, 196–98

Sassoon, Sybil (1894–1989), sister of Philip, 196

Satie, Eric (1866–1925), French composer, 263n63

Schubert, Franz (1797–1828), German composer, 72

Schumann, Robert (1810–1856), German composer, 72, 93

Schweitzer, Albert (1975–1965), German-French philosopher and organist, 263n68

Sedan, Ardennes, France, 36

Seiseralp, South Tyrol, Austria, now Italy, 179

Senlis, Oise, France, 135

Seville, Spain, 245n75

Sherman, William Tecumseh (1820–1891), American general and businessman, 23

Sickert, Walter (1860–1942), English painter, 61

Siena, Tuscany, Italy, 195

Sierre, Valais, Switzerland, 150–51

Simmonds, William, painter, assistant to Edwin Abbey, 252n33

Simplon Pass, Valais, Switzerland, 59, 61, 69, 98, 180–81

Sinding, Christian (1856–1941), Norwegian composer, 72

Singer, Mary Newbold. See Sargent, Mary Newbold Singer

Sisley, Alfred (1839–1899), English-French painter, 4, 247n13

Sluter, Claus (d. 1405), Dutch painter, 29

Snyder, Alice Ziska, wife of Milton, American reporter and volunteer in Paris, 170, 264n72, 266n12

Snyder, Milton Valentine, American journalist, 170, 264n72, 266n12

Soissons, Aisne, France, 106–12, 115–16, 119–20, 122–24, 133, 135–37, 154–55, 158, 239, 260n14, 261n22, 262n55

Sommières, Gard, France, 247n7

Sotteville-sur-Mer, Seine-Maritime, France, 98–99, 104, 179, 256n43

Southampton, Hampshire, England, 193

Speed, Lucy, née Landon, 170

Stein, Henri (1862–1940), French historian and archivist, 132

Steinlen, Marius (1826–1866), Swiss painter, 32

Stevenson, Robert Louis (1850–1894), Scottish writer, 23

Stokes, Adrian (1854–1935), English painter, 58, 61, 98, 179, 181, 183, 231, 238, 267n2, n9

Stokes, Marianne (1855–1927), Austrian painter, wife of Adrian, 58, 61, 98, 179, 181, 183, 267n2, n9

Strasbourg, Bas-Rhin, France, 203, 229,

Strettell, Alma, Mrs. Peter Harrison, 21, 54, 58–59

Stroehlin, Henri (d. 1918), Swiss diplomat, 176, 191

Taine, Hippolyte (1828–1893), French historian and critic, 5–6, 9, 12, 37, 242n7

Taine, Thérèse Denuelle, Mme Hippolyte Taine, 37

Terny, Aisne, France, 116–17

Thebes, Egypt, 41

Thury, Jean, French cabinetmaker, 161

Ticknor, George (1791–1871), American Hispanist, 24

Tonks, Henry (1862–1937), English surgeon and painter, 58, 195–98, 204, 270n64, n71

Toul, Meurthe-et-Moselle, France, 100–103, 257n2

La Tour-de-Peilz, Vaud, Switzerland, 31, 35, 236, 246n3

Trient, Südtirol, Austria, now Trento, Alto Adige, Italy, 180, 181

Trieste, Italy, 130

Truro, Cornwall, England, 62

Tuffrau, Paul (1887–1973), French writer, 117, 122–23

Tunis, Tunisia, 1, 38, 45, 172

Tupper, Tristram, American major, 200–201, 271n85

Turin, Piemonte, Italy, 130

Turina, Joaquin (1882–1949), Spanish composer, 263n63
Twain, Mark. *See* Clemens, Samuel Langhorne

Uzès, Gard, France, 89

Vallette, Henri (1877–1962), French painter, 91, 255n21
Varigny, Blanche Meyrueis de, wife of Henry, 9, 37, 39, 43, 66–69, 72–73, 75, 171–72, 176, 239, 253n54,58
Varigny, Charles Victor Crosnier de, 6–10, 37, 74, 80, 90, 254n2, 266n23
Varigny, Geneviève de. *See* Hortsmann, Geneviève
Varigny, Hélène de. *See* Michel, Hélène
Varigny, Henry de, son of Charles, 7–9, 37–39, 43, 66–67, 72–74, 80, 94–95, 100, 131, 155, 171–72, 174, 176, 239, 252n48, 253n54,58, 254n2, 270n80
Varigny, Laurence de, daughter of Henry, 9
Varigny, Louise de, "Love" (1827–1894), *née* Constantin, wife of Charles, 7–10, 80, 242nn11–12, 252n48, 254n2
Varigny, Pauline de. *See* Franckfort, Pauline
Vauxbuin, Aisne, France, 106, 110, 116, 124
Vauxrot, Aisne, France, 110–11, 116–17, 120, 122, 124
Velázquez, Diego (1599–1660), Spanish painter, 14, 17
Venice, Veneto, Italy, 2, 5, 24, 130, 179, 181
Verdun, Meuse, France, 101, 107, 257n2
Vermeil, Antoine, Protestant pastor, 255n22

Vermeil, Edmond, 67, 91, 100, 235, 239
Vermeil, Guy, son of Edmond, 155, 263n60
Vermeil, Jacqueline, daughter of Edmond, 263n61
Vermeil, Max, son of Edmond, 84–85, 234–35
Vernon, Eure, France, 100
Verona, Veneto, Italy, 5
Versailles, Yvelines, France, 11, 237
Vevey, Vaud, Switzerland, 31–33, 57, 91, 150, 237, 246n2, 247n13, 252n44
Victoria, Tomás Luis de (1548–1611), Spanish composer, 161, 264n82
Vienna, Austria, 2, 5, 130, 181, 184
Vierstraat Ridge, West-Vlaanderen, Belgium, 200, 231
Villard, Mme, instructor at Reuilly, 239
Villers-Cotterêts, Aisne, France, 106, 119
Vitry, Paul (1872–1941), curator of sculpture at the Louvre, 203, 223, 234, 246n87, 255n20, 275n7
Vittorio Emmanuele II, king of Italy 1861–1878, 272n16
Vix, Geneviève, 1879–1939), French soprano, 252n47

Wagner, Charles (1852–1918), French reformed pastor, 75, 253n59
Wagner, Richard (1813–1883), German composer, 66, 93
Waitz, Georg (1813–1886), German historian, 242n7
Warren, William (1812–1888), American actor, 25
Watteville, Arnold de, 9
Watteville, Gérard de, 66–67, 69
Watteville, Virginie Marguerite de (*née* Meyrueis), 67, 69–70, 176
Wedgwood, Eliza, 58

Weerts, Jean-Joseph (1846–1927), French painter, 262n38

Wegener, Otto (1849–1922) Paris photographer, 48, 249n50

Weingartner, Paul Felix von (1863–1942), Austrian conductor, 66, 252n41

Wendover, Buckinghamshire, England, 60

Wertheimer, Almina (1886–1928), daughter of Asher, 251n17

Wertheimer, Asher (1843–1918), English art dealer, 251n17

Westphal, Charles (1896–1972), French Protestant pastor, 255n20

Wharton, Edith (1862–1937), American novelist, 131, 186

Whistler, James McNeill (1834–1903), American painter, 12, 16–17, 247n13

White, Stanford (1853–1906), American architect, 23

Widener Library. See Cambridge, Massachusetts

Widor, Charles-Marie (1844–1937), French organist, 158, 263n68

Wilde, Oscar (1854–1900), Irish writer, 18, 244n63, 252n41

Wilhelm I, king of Prussia 1861–, German emperor 1871–1888, 35

Wilhelm II, German emperor, 160, 164–65

Wilson, Edith (1872–1961), wife of Woodrow, 190

Wilson, Woodrow, American president 1913–1921, 190

Woods Hole, Massachusetts, 25

Wordsworth, William (1770–1850), English poet, 86

Worka, Josephine, maid to Marianne Stokes, 267n9

Yockney, Alfred, English arts editor, 194–95

Yoho National Park, British Columbia, Canada, 187

Ypres, West-Vlaanderen, Belgium, 200–201

Zileri, Susie, 75

Zola, Emile (1840–1902), 254n8

Index of Sargent's Works

Architecture, Painting, and Sculpture Protected by Athena, 230

Autoritratto (self-portrait for the Uffizi, Florence), 18

Autumn on the River, 21, color 1

Brook, color 4, 57

By the River, 39, fig. 2.1

Carmencita, 23, 32

Carnation, Lily, Lily, Rose, 17, 19, 54, 58–59

Carolus-Duran, 11, 13

Cashmere, 58

Cashmere Shawl, 60, color 5

Cemetery in the Tyrol, 182

Church, 188, 195, 203, 221, 224–47, 231, fig. 9.7

Church, study for, 227, fig. 9.9

Crucifix in the Tyrol, 182–83, fig. 8.1

Dans les oliviers à Capri, 11

Death and Victory (Widener Library), 200, 207, 230-31, 276n18

Dogma of the Redemption, 48, 52, 182, 185–87, 203, 208, 215–18, fig. 9.2

Dream of Lohengrin, 25

Edouard Pailleron, 11

Egyptian Girl, 41

El Jaleo, 13–14, 23, color 2

En roûte pour la pêche, 11

Entering the War (Widener Library), 201, 230–31, 274n49, 276n18

Fumée d'Ambre Gris, 11

Gassed, 198–99, 204, 207, 222, 272n101, color 13

General Officers of the Great War, 207, 274n37

Girl in a Pink Dress: Reading, 69

Gog and Magog, 187, 218

Graveyard in the Tyrol, 182, color 11

Israelites Oppressed, 47, 213–15, 217, fig. 9.1

John D. Rockefeller, 189
Joseph Jefferson, 25

Lady with a Rose, 13–14, 17–18

Madame X, 9, 15–16, 92, 186,
 243nn41–42
Master and His Pupils, 181
Messianic Era, 187, 218–19, 223, 225,
 fig. 9.3
Miss Frances Watts, 4, 11
Misses Vickers, 16
Mme Edouard Pailleron, 11
Mme Marie-Marguerite Ormond, 43–44,
 fig. 2.2
Mme Subercaseaux, 11, 13
Mrs. Albert Vickers, 16
Mrs. Alice Mason, 17
Mrs. Edward Burckhardt and her
 Daughter Louise, 17
Mrs. Percival Duxbury and Her Daughter,
 194
Mrs. William Playfair, 17–18

Nonchaloir or Repose, 60–61, color 6

Pink Dress, 69, color 9 and cover
President Woodrow Wilson, 190

Rehearsal of the Pasdeloup Orchestra at the
 Cirque d'Hiver, 5, 157, 242n5
Rose-Marie Ormond, 62, color 10
Ruined Cathedral, Arras, 198–99, fig. 8.2
Ruined Cellar at Arras, 198

Simplon Pass: Reading, 61, 64, fig. 3.5,
 fig. 3.6, color 7
Simplon Pass: The Lesson, 61–62, color 8
Simplon Pass: The Tease, 61
Street in Arras, 198
Synagogue, 188, 195, 203, 220–25,
 228–29, 231, fig. 9.5

Three Figures Dancing, 230
Three Graces, 230
Two Girls, 65, fig. 3.7
Two Girls Fishing, 69
Two Heads, 186
Tyrolese Crucifix (oil), 182–83
Tyrolese Crucifix (watercolor), 182
Tyrolese Interior, 181–82

Violet Sargent, 25, color 3

Wheels in Vault, 198, color 12

Zuleika, 55, 251n15

~

About the Authors

Until her recent retirement, **Karen Corsano** was the lead programmer of the Nurses' Health Study and other epidemiological studies at the Channing Laboratory, Boston. **Daniel Williman** retired in 2007 as professor of Latin and History at Binghamton University in New York State. They met in the 1960s in Toronto, where they both earned their graduate degrees in medieval studies, and since 1991 they have collaborated on studies of medieval Latin archives and libraries. By 2003, when they married, they were using their archival skills differently, collecting material for their history of John Singer Sargent and Rose-Marie André-Michel. They divide their time between research, music, and dance, based in Cambridge, Massachusetts, and writing and rustic pursuits at their cottage by Buttermilk Bay. Research and friends combine to call the authors to Europe every year.